ARTS OF ADDRESS

**COLUMBIA THEMES IN PHILOSOPHY,
SOCIAL CRITICISM, AND THE ARTS**

Lydia Goehr and Gregg M. Horowitz, Editors

Advisory Board
Carolyn Abbate
J. M. Bernstein
Eve Blau
T. J. Clark
John Hyman
Michael Kelly
Paul Kottman
In memoriam: Arthur C. Danto

Columbia Themes in Philosophy, Social Criticism, and the Arts presents monographs, essay collections, and short books on philosophy and aesthetic theory. It aims to publish books that show the ability of the arts to stimulate critical reflection on modern and contemporary social, political, and cultural life. Art is not now, if it ever was, a realm of human activity independent of the complex realities of social organization and change, political authority and antagonism, cultural domination and resistance. The possibilities of critical thought embedded in the arts are most fruitfully expressed when addressed to readers across the various fields of social and humanistic inquiry. The idea of philosophy in the series title ought to be understood, therefore, to embrace forms of discussion that begin where mere academic expertise exhausts itself; where the rules of social, political, and cultural practice are both affirmed and challenged; and where new thinking takes place. The series does not privilege any particular art, nor does it ask for the arts to be mutually isolated. The series encourages writing from the many fields of thoughtful and critical inquiry.

For a complete list of titles, see page 329.

ARTS OF ADDRESS

BEING ALIVE TO LANGUAGE AND THE WORLD

MONIQUE ROELOFS

Columbia University Press
New York

Columbia University Press
Publishers Since 1893
New York Chichester, West Sussex
cup.columbia.edu
Copyright © 2020 Columbia University Press
All rights reserved

Library of Congress Cataloging-in-Publication Data
Names: Roelofs, Monique, author.
Title: Arts of address : being alive to language and the world / Monique
 Roelofs.
Description: New York City : Columbia University Press, 2020. | Series:
 Columbia themes in philosophy, social criticism, and the arts | Includes
 bibliographical references and index.
Identifiers: LCCN 2019025487 (print) | LCCN 2019025488 (ebook) |
 ISBN 9780231194365 (cloth) | ISBN 9780231194372 (paperback) |
 ISBN 9780231550789 (ebook)
Subjects: LCSH: Interaction (Philosophy) | Communication—Philosophy.
Classification: LCC B824.15 .R64 2020 (print) | LCC B824.15 (ebook) |
 DDC 121/.68—dc23
LC record available at https://lccn.loc.gov/2019025487
LC ebook record available at https://lccn.loc.gov/2019025488

Cover image: Mariángeles Soto-Díaz, *We Tried Making Diagrams to Understand*, 2019. Analog-digital collage, 8 x 10 inches
Cover design: Lisa Hamm

Excerpts from "Sky" in the epigraph and "Vocabulary," "Conversation with a Stone," "Water," and "No Title Required" in chapter 1 are from *View with a Grain of Sand: Selected Poems* by Wisława Szymborska, translated from the Polish by Stanisław Barańczak and Clare Cavanagh. Copyright © 1995 by Houghton Mifflin Harcourt Publishing Company. Copyright © 1976 by Czytelnik, Warszawa. Reprinted by permission of Houghton Mifflin Harcourt Publishing Company. All rights reserved.

For Jan en Loes

I'm a trap within a trap,
an inhabited inhabitant,
an embrace embraced,
a question answering a question.

Division into sky and earth—
it's not the proper way
to contemplate this wholeness.
It simply lets me go on living
at a more exact address
where I can be reached promptly
if I'm sought.
My identifying features
are rapture and despair.

WISŁAWA SZYMBORSKA, "SKY"

CONTENTS

Acknowledgments xi

Introduction 1
1. Addressing Address 35
2. Kant, Hume, and Foucault as Theorists of Address 60
3. Saying Hello and Goodbye 102
4. Norms, Forms, Structures, Scenes, and Scripts 146
5. Address's Key Constituents: Philosophical Views 169
6. Transforming Aesthetic Relationships 201

Afterword 249

Notes 263

Index 313

ACKNOWLEDGMENTS

My thanks go to Ellen Rooney for conversations that were a huge inspiration for this book. I am more grateful than I can say to Andy Parker for suggesting some time ago that the "address" texts I had shared with him could be a book of their own, and then delicately waiting a couple of years before adding in jest that that really might be two books. Nalini Bhushan, Kathy Higgins, Michael Kelly, Carolyn Korsmeyer, María Lugones, Mariana Ortega, Falguni Sheth, and Elizabeth Weed stretched my sense of address's possibilities. John Carvalho, Baba Hillman, and Eleonora Orlando voiced encouragement and offered incisive suggestions. Special thanks to Vicky Spelman for her unwavering enthusiasm for the project, for commentaries that deepened my thinking, and for the expansive conversations on the topic to which she regaled me.

At Hampshire College and the Five Colleges of the Pioneer Valley of Massachusetts, I enjoyed rich exchanges with Polina Barskova, Christoph Cox, John Drabinski, Ann Jones, Jim Kan, Becky Miller, Jason Robinson, Daniel Kojo Schrade, Anna Schrade, and Jutta Sperling. Resonant chats with Carla Damião, Susana de Castro, and Oliver Tolle took place in the Brazilian cities of Goiânia, Rio de Janeiro, and São Paulo—in lecture halls and museums, around waterfalls, and on rickety bridges.

Giving a brief presentation on address at the Pembroke Center for Teaching and Research on Women at Brown University in an initial stage of this research and not quite seeing how to synthesize the subsequent turns in the debate alerted me to the divergent methodological persuasions that can be

encapsulated in the notion. A conference on address that Rob van Gerwen and I co-organized at Utrecht University in 2000 brought into relief disciplinary divides while also indicating starting points for transdisciplinary investigations of the subject. For clarifying polemics, questions, and insights, I thank Rob and the other speakers: Rosi Braidotti, Paul Crowther, Graham McFee, Berys Gaut, Rob Hopkins, Ellen Rooney, Elizabeth Weed, and the late Richard Wollheim. I'm grateful to many colleagues, friends, and family for perceptive reflections that rolled forward this journey into the meeting points of philosophy, art, feminist thought, critical race studies, and political theory. Their input along the way made it an exhilarating process to come up with a vocabulary that could be responsive to the different kinds of address populating various fields and media. Roundtables on Philosophy and Race and on Latina/x Feminisms, along with transdisciplinary aesthetics symposia organized by Falguni Sheth, Mickaella Perina, Mariana Ortega, Gregg Horowitz, and Michael Kelly also nourished that excitement of a versatile joint endeavor.

Hampshire College, whose faculty unstintingly enters into conversations across fields, has provided a fruitful environment for this study. I thank my colleagues—faculty and staff alike—for keeping alive the fire and shouldering an educational model that fosters inquiries across the humanities, arts, sciences, and social activism. I am indebted to the students for the conviction and drive with which they embark on uncharted paths in the liberal arts, a venture as urgent now as ever, when neoliberal attacks on academia are a consistent feature of life in multiple areas of the globe. A big shout-out to all the amazing organizers, activists, and thinkers who pulled the college through a tight spot, not least to the Hamp Rise Up student movement for its seventy-five-day occupation of administrative offices in the spring of 2019. A ton of thanks to Yaniris Fernandez and Eva Rueschmann of Academic Affairs for their kind and generous financial sponsorship at a moment when budgets were stretched to the max. The support of Amherst College's Political Science Department made all the difference in the final stage of this book. I would like to thank in particular Tom Dumm and Javier Corrales for their warm welcome into their institutional quarters.

Hailing from a range of areas—from poetry and painting to political theory; from ethics to Black and Latin American Studies; and from architecture and sound studies to performance art and dance—the students in my address courses shared their excitement about figuring out their travels through the intricacies of an involved concept. They made the notion work for their own purposes and taught me volumes about the potentialities inherent in address.

Numerous dialogues ignited my thinking while also revealing how much was going to be left open as these pages would draw to a close. I thank Linda Martín Alcoff, Rob Chodat, Colleen Coalter, Mary Ann Doane, Richard Eldridge, Mark Foster Gage, Josh Franco, Cynthia Freeland, James Haile, the late Miriam Hansen, David Kim, Ferda Kolatan, Ani Maitra, Meredith McGill,

Igor Mosterd, Mickaella Perina, Karin Roelofs, Loes Roelofs, Sjoerd Roelofs, Roger Rothman, Sílvia Saes, Mariángeles Soto-Díaz, Peter Stallybrass, Ronald Sundstrom, and Paul C. Taylor for infectious exchanges.

I was fortunate to have the opportunity to present ideas from this book (and its sequel) on different occasions: at Binghamton University; Boston University; Brown University's Pembroke Center; Oberlin College; the Pratt Institute; the University of North Carolina, Charlotte; KU Leuven; Utrecht University; the University of Amsterdam; Amherst College; Smith College; the University Museum of Contemporary Art at the University of Massachusetts, Amherst; the Federal University of Bahia in Salvador, Brazil; the Federal University of Goiás in Goiânia, Brazil; the Federal University of Minas Gerais in Ouro Preto, Brazil; the Federal University of Rio de Janeiro; the Federal University of São Paulo; the Pontifical Catholic University of São Paulo, and SADAF (la Sociedad Argentina de Análisis Filosófico); as well as at meetings of the American Philosophical Association; the American Society for Aesthetics; the California Roundtable on Philosophy and Race; the Colóquio Internacional Filosofia e Ficção; the Dutch Association for Aesthetics; the Mediterranean Congress on Aesthetics; and the Roundtable on Latina/x Feminisms. I would like to thank all those who offered suggestions and points of criticism as the argument took shape.

Cola Franzen kindly granted permission to make use of her magnificent unpublished Cortázar translations. Keepers of book and manuscript collections gave assistance during my forays into their quarters: Bonnie Vigeland of the Harold F. Johnson library at Hampshire College and staff of the Mandeville Special Collections Library at the University of California, San Diego, the Lilly Library at the University of Indiana, Bloomington, and the Biblioteca Julio Cortázar at the Fundación Juan March in Madrid. Their expertise and attention made archival searches pure pleasure.

I'm grateful to Lydia Goehr and Gregg Horowitz for their excellent editorial feedback, which has rigorously sharpened and strengthened the analysis. Especially crucial was their observation that the project should be spread out over two volumes. In one forceful breath, they blew fresh life into a distant quip, although I'm not sure if they knew they were telling me an old joke—they may have thought they were opting for a different form of address. And so, in a roundabout way, the job then was to make that joke come true (plus some fantasies or dreams that had aggregated since then). Other supporters rallied: Anonymous referees provided most thoughtful critical comments and keen ideas for revision, from which the book has benefited tremendously. Wendy Lochner and Lowell Frye at the press offered their energy, enthusiasm, and wonderful editorial insight and finesse.

This book reflects the joy of over a decade of talks with Norm Holland, during which I basked in the bountiful insights emanating from his provocative

queries and from reactions that at times took some unraveling before I could grasp all the marvelous ideas they held. Friends, family, and colleagues shared their emotional generosity as well as their critical acumen and wit, which turns many an address inside out and upside down, illuminating over and over again the spacious room for play that address engenders. My brothers and sister and their partners, and my uncles, aunts, cousins, nephews, and nieces in the Netherlands nurtured the writing from afar and were there to return to for visits, which has been a heartwarming and essential source of vitality. I dedicate this book to my parents, in gratitude for the love and spiritedness with which they keep putting into motion extraordinarily divergent strings of address in so many corners of life, and for their readiness to watch in surprise along the way.

A final word of thanks goes to the editors and publishers of two previous publications for permission to reprint. Portions of chapter 2 are based on my essay "Kantian Mouthliness: Enlightenment, Address, Aesthetics," *differences* 26, no. 2 (2015): 29–60. A section of chapter 6 includes a short segment of my article "Identity and Its Public Platforms: A String of Promises Entwined with Threats" / "Identität und ihre öffentlichen Plattformen: Versprechen und Drohungen," *Texte zur Kunst* 107 (2017): 68–85. Reprinted by permission of *Texte zur Kunst* @ *Texte zur Kunst*, and its Contributors. All rights reserved.

INTRODUCTION

Just about any situation abounds with modes of address. Corporeal beings, we *direct* modes of address at people, nonhuman animals, and things. At the same time, we register modes of address that other creatures, places, and objects direct at us. These modes can involve language, as in a piece of advice or a dialogue. But they often take nonlinguistic forms when, for instance, we sigh, shrug our shoulders, nod, or smile, or observe others doing so. Address populates the spheres of smell, taste, touch, hearing, vision, and proprioception that harbor our sensory experiences. It lies at the core of our encounters with living beings and the material world.

This mundane phenomenon assumes remarkable and strikingly significant forms in our prosaic lifeworlds no less than in highly specialized regions of art, science, politics, and the law. How should we understand it?

This question will occupy me in this book and its companion volume, *Aesthetics, Address, and the Making of Culture*. The first book offers a basic theory of address. The second provides further development and application of the analysis proposed in the present one. While each volume stands on its own, the two studies complement each other: they embark on a continuous process of philosophical exploration whereby theory addresses specific cases and cases address theoretical questions.

Address is all around us. We engage in it. We receive it. These simple facts yield six interlacing motivations for this investigation. A first rationale lies in address's central importance to our everyday lives. The hugely significant role that address plays as a determinant of the contours of day-to-day existence in

current societies calls for theoretical elucidation. This is the first motivation driving this inquiry.

The second motive derives from the present state of the literature. Bringing into focus specific aspects of address, many scholars have offered exceedingly informative and suggestive clarifications of its workings as a factor of ordinary existence. Thinkers like J. L. Austin, Maurice Merleau-Ponty, Louis Althusser, Michel Foucault, Jacques Derrida, Stuart Hall, Barbara Johnson, and Judith Butler shed light on the notion of address by deftly using it and hence demonstrating its fruitfulness. Yet they stop short of foregrounding address for the phenomenon that it is in and of itself. Neither do they make it the subject of systematic analyses. The available literature on address, though chockful of insights and expansive, reveals lacunae. The need to find ways to begin overcoming these omissions furnishes the second rationale for this study.

As the three facts just listed indicate, address is a force of quotidian agency and receptivity. In those capacities, it implements facets of social differentiation. Consequently, it carries meanings that are of vital importance to the elaboration of a feminist perspective on cultural existence and aesthetic life that reflexively engages variables of coloniality and race. In more general terms, careful attention to address's capabilities is required if we wish to devise forms of critical theory and practice that take note of the fashioning of social difference and that seek to channel that productive process, where possible, in valuable directions. These points, elements of which can be implicitly found in the writings of several of the previously mentioned scholars, supply the third rationale for our investigation.

A further reason attaches to the remarkably subtle and varied registers of normativity we put into play by engaging in address. The endeavor to put it under a scholarly lens can yield rapprochements between philosophy's centuries-long slogging away at normative concerns and what appears variably as a wariness, or even disinclination or relative inattention toward these matters epitomizing paradigms of thought in other areas, notably the studies of media, the arts, and sexuality.[1] Exploring address, we can thus start to surmount a theoretical vacuum maintained by divergent disciplinary preoccupations. An interest in developing an adequately sophisticated account of the complex normative endeavors we engage in as participants in culture, the arts, and social existence consequently provides the fourth motive for this inquiry.

Bodily beings living our lives in the midst of configurations of address, we often value aspects of that address as kernels of freedom, whether actual or potential. The kind of freedom in question does not balloon us away from our connectedness with people and things, but can inhere in—even require—states of social equality and solidarity as well as meaningful bonds with our material surroundings.[2] A fifth reason for sharpening our grasp on the notion at the center of this investigation lies then in the intent to illuminate the germs of freedom we carry as emitters and recipients of address.

Finally, there are intimations aplenty of address's abundant potentialities as an instrument of a critical political aesthetics. We can discern this role of address inchoately in artworks and scholarly writings. Yet our comprehension of this function leaves a lot to be desired. It will be the sixth main goal of this investigation to provide such philosophical substantiation. Our understanding of this capacity of address also needs attunement to a renewed vision of what aesthetics is and can do in our current world.

This being a book about address, the question of its own address will strike anyone who gets wind of it: whom does this study address and how does it address them? So I will say a few words about that at the onset, even though I wouldn't want to claim that all address is necessarily intended or, for that matter, altogether clear to the one who is undertaking it. The readers I seek out as my accomplices in this project are those who are ready to tease out their ideas about address in interaction with individual texts, artworks, and quotidian examples from a range of contexts. The current lifeworld we share calls for new notions of culture and the aesthetic. This need arises on account of the links of culture and the aesthetic with matrices of gender, race, class, and coloniality, along with constellations of difference and identity that interlace with these formations. It also follows from the capacities of art and cultural artifacts to make changes in such configurations of sociality. It is the reader who takes an interest in this process of critical reflection on culture and the aesthetic whom I aim to address in particular.

This address brings in its wake—or such is my intention—a presumably yet broader span of readers whose inquisitiveness is sparked by writers such as Immanuel Kant or Julio Cortázar, Frantz Fanon or Stuart Hall, Judith Butler or Barbara Johnson. The list goes on: I'm hoping to round up addressees drawn to artists such as Kara Walker or Pope.L, Nikolai Gogol or Wisława Szymborska, Nagisa Oshima or Clarice Lispector. Works by each of these figures will be considered in these two volumes. Meanwhile, I will be examining artistic productions both as the works of art they are and as sources of theoretical understandings of address.

I'm casting a wide web here, sending sundry arrows toward a diverse constituency of readers. Prompted by the exigencies of my topic, I intend to fashion a mode of address for the text that is rich, theoretically grounded, nimble, and lucid enough to speak to an audience that hails from different fields. On everyone's part, this at times requires some acrobatics, or—to speak with Cortázar—hopscotching. Currently a regular, even expected feature of the intellectual landscape, transdisciplinary methods have attained institutionalization within communities of inquiry (e.g., in feminist and critical race studies, political theory, science and technology studies, and various aesthetics settings). Nevertheless, in places where multiple frames of reference, analytical practices, and rhetorical strategies come together, address can be taxing or create unease, not to mention resistance, especially when interpretive assumptions

are at cross-purposes or serve not altogether compatible commitments. I'm aware of these challenges and the risk they pose of leaving my reader untouched, unconvinced, unaddressed.

And yet, juggling the pressures from heterogeneous discourses, canons, and reading protocols—while straddling and blurring their divisions—is well worth the gamble. For a transdisciplinary form of address can generate revitalized common grounds and shifting controversies. In particular, that mode allows us to excavate resources *within* distinct disciplines (e.g., art production and literary theory; continental and analytical philosophy) that encourage a view of those domains as sharing preoccupations and as being less removed from each other in focus than they might otherwise be understood to be. Disciplinary boundaries, in this context, are under formation.[3]

I don't want to suggest that the different disciplines the text will be calling on are all commensurable with each other or prepared to snug up agreeably in an inclusive, pluralist arena. On the contrary, the zone of friction I propose to embrace is precisely what can give conceptual traction to an inquiry that sidles into debates in an array of fields—even if those fields define themselves in opposition to one another. For example, the notion of what counts as a favorable critical tool, concerning which there is of course a great deal of disagreement across disciplines, undergoes development. While analytical philosophers may shrink from the culturally expansive readings of artworks that this book will carry out and from its interest in the culturally mediated and mediating interval between artwork and public, taking seriously the capabilities for address on the part of audiences gives us tools for theorizing what can occur in this zone; while cultural and media critics for their part may hesitate in front of this study's pervasive focus on our normative investments, the notion of address provides means of handling normative questions without imposing totalizing conceptions of value or meaning. As we stretch and tone up our sense of the territory of address, we will thus also be amplifying our understandings of the ways in which address can and does constitute a beneficial theoretical instrument. Accordingly, working in the rifts between disciplines, we bring these divides into motion. My roster of desired and fantasized addressees thus features philosophers of various persuasions, social scientists, cultural critics, new media theorists, literary scholars, and art historians, to name a few examples.

Part of this book's address to the field of address is to place art and theory side by side. At the same time, certain differences arise, and here disciplinary gaps announce themselves. In my discussion of scholarly works, I will by and large focus on the ideas *about* address that these texts represent rather than the authors' deployment of address in relation to the reader or to other theoretical interlocutors, although I will certainly consider such aspects in writings by figures like David Hume, Immanuel Kant, Michel Foucault, Walter Benjamin, and Gloria Anzaldúa. This emphasis serves the goal of theory-building: making the case for address's philosophical importance requires zeroing in on

theoretical commentaries on the topic. When examining artworks, on the contrary, I look more closely at the address by those works to the reader and to affiliated works, and at their (other) formal properties. This strategy keeps our analysis centered within the domain of the aesthetic and the politics that takes shape in that realm. Neither in my interpretations of the distinctive forms of address of texts or other cultural objects, nor in my readings of the views about address that these artifacts bring to articulation, do I aspire to full accounts (if that were even possible). The point of my analyses is to construe a theory of address, not to present exhaustive narratives of individual instances of the phenomenon.

On pain of stating the obvious, one crucial category of readers I wish to reach (one that, most likely, overlaps in part with the ones already mentioned) includes those who in unforeseen ways are taken by the pleasure of the text. My striving is to convey not only the fascination of the artworks or philosophical and theoretical works under discussion, but also to impart philosophical mirth and a rewarding feeling of curiosity. Those sentiments I would like to attach both to the discoveries yielded by this inquiry and to the way the reader comes upon them. I hesitate to say this explicitly because that might drain the energy from my relation with you, my reader, but given that our topic is address, some self-consciousness and disclosure or, at least, an attempt at transparency about my own address can give us an anchor point from which we begin to reflect on our acts of address.

Taking up a position within a joint scene of address, we can contemplate the way we stand within address more broadly. We can, for example, commence to consider the ways in which we would prefer to encounter or not to encounter address. We can even wonder how far matters of preference bring us in this area where a great deal of address has a certain inevitability. For we may wish all we want to stay unfazed under certain conditions of address, but that may not be feasible. Likewise, we may try to escape with all our might a given form of address but not succeed. Or we may do what we can to achieve a certain mode of address but botch it. Address has us in its grip, although it affects us differently. Both the variability and the systematic nature of its hold on us bear on the social order of which we partake. A bit of clarity about my purported address to the reader can then help us envision a scene of address in which we look at address itself.

Above all, I wish to communicate to my readers a sense of the marvelous (as well as potentially devastating) capacities of address, a sense that will become apparent once we recognize the phenomenon in its full breadth and importance. My aim is to provide the reader with intellectual tools that—besides fostering illumination for its own sake—can be employed to use address in a manner that is aesthetically enticing and politically and environmentally propitious. This task is exceedingly urgent, as we face momentous jobs of address in the contemporary social, political, economic, and scientific arena.

My address in this tract, however, is not oriented solely to those who might be swayed to spend time with the text. It is simultaneously directed at language,

objects, and places—in short, at elements that, for their part, address us (besides addressing also other language, objects, and places). Along with its sequel, this book addresses things like art installations, performances, drawings, stories, essays. Part of my goal in this writing, then, is to be attentive to and to bring out the address that these things make to conceptual and artistic conditions as well as to us (whereby that small word "us" summons a host of questions about address). In this way, I hope to highlight the insights about address that we can find to be encapsulated in that very address by those things. The book at hand and the one that follows it, accordingly, negotiate a variety of what I shall call norms of address.

While we could keep going on at length about the address between us and this pair of books and the world of language, people, things, and places, there will be other occasions to do so, and I now want to brusquely break off this line of thought to speed back to the question that propels this project: what, precisely, might we be talking about with the notion of address?

A GLOSS ON ADDRESS

Address has a capacious reach in both its linguistic and nonlinguistic varieties. A sweeping array of human practices involve address: as cooks, cleaners, lovers, lawyers, doctors, dreamers, runners, readers, gatherers, gleaners, we address and are addressed by persons, places, and substances. Greetings engage us in modes of address. So do humor, kindness, anger, insults, hope, and tenderness. Address is at work in the sphere of things: objects and places serve as wellsprings and vanishing points of people's address. The sight of a public square or cinema can assure us that we inhabit a collective world featuring places where strangers can congregate to share experiences, something that we may desire to participate in by hanging out in the one or entering the other. We consult the barometer or cell phone to have it tell us how much rain might fall today. Listening to my steps as I speed down five floors on a wooden staircase into a hallway that leads to the street, I take delight in their dry, hollow sound. This pleasure is part and parcel of my love for the stairs' worn surfaces, indented by feet over centuries. On a daily basis, lines of address link us to diverse entities: tunes, screeches, clicks, beeps, cracks, theories, poems, photographs, colors, bicycles, lakes, brooms, effigies, bells, computers, pillows, skyscrapers, trash.

We activate plans of address when trying to obtain identification papers, undergoing mammograms, attending a court hearing, or casting a vote in an election. Different schemes of address become operative as we visit museums, make a drawing, dance in the street, and audit public broadcasts. We adjust to changing patterns of address in the course of coming to terms with the loss of a loved person. Such adjustments are also integral elements of the body's

habituation to a new medication or its adaptation to the use of an artificial arm. Structures of address surround us while we count the sparrow population, follow the path of a sea turtle across a beach, or make ourselves up in front of the mirror: undertaking these and countless other acts, we participate in systems of address.

Modes of address are forms of signification that we direct at human and nonhuman beings, objects, and places and that these entities direct at us and at each other. These modes suffuse our capacities in the broadest sense: they occur across the senses and permeate functions of the imagination, cognition, perception, affect, desire, and bodily motility. Address is dazzlingly intimate with us. The interactions we have with living creatures, things, and places unfold within modes of address.

Address, then, pervades our engagements with the world. We participate in *structures* of address (such as those in play in cinemas, schools, electorates, and shops), in which *modes* of address (including looking, reading, voting, and buying goods) are de rigueur. These modes typically embody *norms* of address (criteria and codes governing, among other things, visual display, verbal expression, deliberative processes, and economic exchanges). These, in turn, take effect in *scenes* and *scripts* of address (our comportment upon entering a classroom or a voting booth, for example, being customarily guided by certain standardized scenarios).

By means of the vocabulary of norms, forms, structures, scenes, and scripts, I aim to bring organization to and give an interpretive handle for address. When deploying the term without qualification, as I just did, I'm using it as a kind of mass noun to refer to the phenomenon of address as a whole: absent any modification, "address" designates in a global sense that entire complex of elements and operations that we have in front of us and that we are setting out to investigate in this book. When context leaves no doubt as to my meaning, I also use the term "address" on its own as shorthand for a mode or act of addressing, as in my earlier phrase "my address in this tract" or, say, the formulation "J. L. Austin's address to language."

The colloquial nomenclature of an "address" to parliament or the nation, accordingly, differs from my usage in denoting a distinctly verbal, historically codified form. For the modes that I have in mind occur across the senses and exceed the precinct of specific rhetorical forms. Further, although modes of address, as I understand them, include a wide array of literary figures (e.g., apostrophe and prosopopeia), which are commonly apprehended under the rubric of address, the sense of the term that is of primary significance to this book diverges from the idea of a trope or figure of speech.

Modes of address such as infectious laugher, rebellious glances, and skeptical frowns, whether intended or not, can animate conversations that people strike up with each other and lead to friendships, conspiracies, or other affiliations. Just as address can energize our interactions, it can have a hand in

slowing things down. A screaming match following a clumsy remark may necessitate an episode of cooling off to give hurt feelings a chance to mend. Uncompromisingly adversarial stances may hamstring the process of mediation designed to make possible the resumption of peace negotiations. Blockages as well as areas of mobility through which we funnel our bonds with people and objects stem to a significant extent from intersecting constellations of address. Such arrangements include, but are not limited to labor markets, sexual regimes, and methods of synchronizing time.

Address orchestrates relational life. It shapes the meanings that phenomena carry for us. It props up webs of interpretation we spin. It marks our ways of valuing people and things.

Modes of address exert normative force as elements of matrices of address. The customs officer's request that the migrant display her eye before a camera is a mode of address that transmits and implements a norm of address to and for the traveler intent on entering the country. The voyager is asked to adhere to the norm communicated to her by addressing her body to the camera, enabling the machinery to then address the iris, and allowing the officer to address and be addressed by the resulting data. Forms of address are supposed to match up so that the proceedings run smoothly and a test is carried out correctly. The norms of address summoned by the official become authoritative as ingredients of an order of address involving allocations of national territory, delineations of border zones, and principles for identifying and differentiating population groups, as well as civil, economic, administrative, information-driven, technological, and militarized means of protecting these arrangements. Structures of address constitute strongholds of normativity.

We are often capable of formulating adequate descriptions of situations that dispense with the nomenclature of address, doing just fine by the explanatory and interpretive aims that we have in mind. A benefit of this terminology, however, is that it invites understandings of microscopic elements in view of the broader structural forces that they instantiate. The language of address also encourages perspectives that examine overarching processes for the energies and tensions they display at minuscule junctures. This idiom thereby does not necessarily posit definitive demarcations of what counts as the infinitesimal or the large-scale. The border-crossing case is suggestive of the open-ended traffic between the diminutive moments and the more encompassing frames that address permits and that we will have occasion to observe repeatedly in these books: the links between the functionary's request at the border and the data-collection system harboring the request run in several directions, through multiple planes of social, embodied practice.

Another important advantage of the vocabulary of address is that it draws attention to parallels and incongruities between disparate kinds of experiences, objects, states, and events. In the customs case, it signals correspondences

between civil and military procedures and conditions. The lexicon of address points to the ways in which norms and forms reverberate in divergent sites of activity. While, not uncommonly, other descriptions of the phenomena under discussion in these books can be conceived that suit different purposes, my use of the terminology of address is designed to bring into focus and scrutinize specific aspects of address and to advance our grasp of them.

Address embodies selective orientations toward its addressees or the objects it picks out. Giving a hug, we reach only a few individuals at a time, often no more than one. Saying "hello," sounding a gong, or sending a tweet, we may augment the circle of recipients for our address. While our gestural repertoires enable multifarious kinds of acknowledgments, touchings, and exchanges, and have a great deal of plasticity, they do not extend to just everybody or everything we might wish to hail or get our arms around. Modes of address ordinarily leave gaps of address. Emotions such as indignation, gratitude, respect, disdain, or feelings of hospitality single out specific foci of address from a whole gamut of phenomena, many of which remain unaddressed. For example, when feeling indignant, our emotion is typically directed at specific affronts or injustices that we witness or learn about. Likewise, it is often particular acts of kindness for which we are thankful and a restricted group of travelers or refugees to whom we direct our hospitality. Being in a position to address certain people and things in some way, we are prone to shutting out other persons and objects from the spirals of address that we set into motion. As the phrase "I wasn't talking to *you*" indicates explicitly, address tends to separate addressees from nonaddressees, though this partition does not always fall into place as planned.

Address's intimacies, accordingly, reveal rifts. The affiliations that we bring about through our massive, collective investment in address spread unevenly among constituencies and exhibit the marks of longstanding social hierarchies: gender, racial, and class imbalances pervade visual and sonic orders, among other formations of address. We graft the proximities and distances that modes of address engender onto previously instituted forms of closeness and disassociation. Digital technologies, for example, are widely acknowledged to have reproduced asymmetries prevalent in society before the advent of prolific wireless communication, the ascendancy of the World Wide Web, the explosive growth of data-gathering, and the emergence of social media. Abysses stretch out among addressors, among addressees, and among addressors and addressees. Living beings nestle no less deeply in pockets of nonaddress than in zones of address. Address is a region of voids even as it hosts forms of rapport and contact.

Address and nonaddress, then, go together. The one often stands out against the backdrop of the other. The thin character of an orator's comments becomes apparent in light of our awareness of an ambit of understandings to which he

might have attested but that go unnoted—those riveting themes we had hoped to learn about but that were never so much as broached in his speech. Nonaddress, in this case, informs us of an aspect of address. A reliable way to hint at auras of thought that we take to be inexpressible or not to be brought attention to in a given situation is to promulgate a sequence of stock phrases from which interest is conspicuously lacking. For example, the string of polite remarks made by someone we have reason to believe is furious at us may surreptitiously tell us of her anger. In that case, address intimates dimensions of nonaddress.

Although the modes of address we employ leave gaps and bar individuals and groups from the orbit of connections that they establish, as issuers and recipients of address, we ubiquitously manufacture *some* kinds of attachments and associations. This is inevitable. There is no stepping outside of address *tout court* or beyond the bonds we create in and through address—at least, as long as to some measure we are in interaction with the creatures and objects in our environments. Human existence, at a fundamental level, mires us in modes of address—ones that we currently fashion, ones instigated previously, and ones that are yet to come—thus generating ensembles in the context of which certain forms of address exert retroactive and anticipatory effects on other forms.

A number of the features of address that I have outlined so far—the multiplicity of levels of functioning at which it is operative, the plurality of domains that it informs, its normative dimension, its relational and directional aspects, the specificity of its orientations, its connective and dissociative workings, and its structural facets—come together in an autobiographical fragment by the Chicana writer Gloria Anzaldúa. Describing her efforts to set the terms of her existence herself, Anzaldúa indicates implicitly that as a youngster, she posited her own norms of address and tried to live by them. As a consequence, we are told, she met with disapproval at the Texas-Mexican border where she grew up in the mid-twentieth century. "*Terca* [stubborn]. Even as a child I would not obey. I was 'lazy.' Instead of ironing my younger brothers' shirts or cleaning the cupboards, I would pass many hours studying, reading, painting, writing." Address, this testimony shows, enacts orientations that we realize in the course of our bodily activities: young Anzaldúa addresses books, not shirts or cupboards. Correlatively, address undergirds the bearings that objects and places acquire in relation to people and to each other. Addressing the girl, the books that she reads sit side by side with the paintings that she makes, in contrast to the boys' clothing and the kitchen cabinets in Anzaldúa's home. The social and material forces and alignments linking—or keeping apart—people, things, other living beings, and environments are substantially a matter of address. Indeed, Anzaldúa's rejection of received domestic norms of address bars her from supposedly proper participation in her family's ethos: "Nothing in my culture approved of me. *Había agarrado malos pasos* [I had taken the wrong path]. Something was 'wrong' with me. *Estaba más allá de la tradición*

[I was beyond the bounds of the tradition]."[4] Her violation of norms of address, Anzaldúa notes, locates her outside the limits of her culture, in the perception of others. The suggestion is that this consciousness of her alterity registers not only in other people's awareness but also in young Anzaldúa's own point of view.

Free indirect speech in the text ("*Terca*" [said of children], "I was 'lazy,'" "something was 'wrong' with me") whirls the concepts "stubborn," "lazy," and "wrong" into a realm of splits.[5] Anzaldúa's mode of address multiply and resoundingly intones these notions, getting them to ring out from objects like the iron and in the voices of people such as family members and other childhood interlocutors, as well as—at some distance—her youthful and adult selves.[6] These epithets consequently hover across divides: They float between Anzaldúa's self-understanding and the constructions of her that reach her from other people and things. They traverse the rift between the in-group "tradition," which partially shapes the territory she calls "my culture," and the out-group position, to which that tradition condemns her. They cross the borderline between compliant and rebellious self-perceptions. They drift back and forth between a site of friction and pain and an insurgent stance that carries its own torments and joys. They run between the reader apprehended as a part of and/or beyond the "tradition" and the reader in the capacity of someone who partially enters that tradition emotionally, imaginatively, and, to variable degrees, through memory, by way of the reading. These characterizations, furthermore, flow in Spanglish, connoting a vernacular idiom distinct from, even if symbiotically entwined with both the all-powerful English and a Spanish that carries its own dominance.[7]

Free indirect discourse, in the text, activates a field of experience where what Anzaldúa describes as the "[t]yranny" of culture is visible in its coercive force but also goes in tandem with stances that take a distance from the resulting pressures.[8] This consciousness of possibilities for a critical position and a border-crossing form of relationality qualifies the more abstract, monolithic notion of culture conceived of as a source of address that Anzaldúa encapsulates in a statement such as "Culture forms our beliefs. We perceive the version of reality that it communicates. Dominant paradigms, predefined concepts that exist as unquestionable, unchallengeable, are transmitted to us through the culture."[9] Sustained by cycles of address (webs of transmission, communication, perception), social concepts like "lazy" and "wrong" enjoy a solidity and an existence that is relatively independent of the perspective of any person in particular, a point exemplified by Anzaldúa's free indirect discourse. Yet this very mode of address also fans out to a vast plurality of nodes in a pattern of address where these notions find support. It emanates into the language(s) we speak, into the communal settings enfolding or expelling us, and toward the things we seek out or stay away from.[10] At these junctures, we can swivel those concepts around

and put a different spin on them. Received ideas and established epistemic models can then assume novel orientations.

Normativity takes effect at multiple points in the scenarios of address to which Anzaldúa gestures. The expectation that the girl iron her brothers' shirts or clean cupboards assumes the form of a mode of address that conveys and implements norms of address to and for the girl. She is supposed to obey the norms transmitted to her by addressing her body to iron, clothes, and cabinets. She must make things tidy so that these neatly ordered objects can then adequately address the people who can be expected to wear, see, and use them. The standards of address to which those who wish the girl to do this housework appeal gain their authority as elements of a buzzing constellation of address: this arrangement involves gender ascriptions, racialized colonial histories, technological competencies, pedagogical and child-rearing axioms, aesthetic traditions, ethical practices, boundaries between who and what does or doesn't properly belong to the home, separations between family and nonfamily, understandings of adequate bodily and material comportment, principles for differentiating and demarcating cultures, and conceptual and interpretive frameworks encoded in language, experience, and conduct, as well as social and economic means of policing these items.[11] A dense, multipronged structure of address appears to be in operation.

Plans of address, indeed, take effect in all quarters of day-to-day life. We encounter our fellow humans in scenes of address that we navigate by way of scripts of address. Address, then, serves as a navigational tool. It is an instrument that we depend on to go about our worlds. In putting it to work to handle situations or to bring them about—things we do incessantly—we draw on our *arts of address*: we employ our abilities to create and navigate modes of address. These skills we develop precisely by encountering and engaging in address. We time and again need to assess how we are being addressed by living beings, things, and places. Likewise, we have to decide how we, in turn, are going to address them. Taking stances of and toward address, we thus craft our arts of address. We persistently tinker with these arts, whether we are aware of it or not.

At the same time, address is a condition that precedes our interventions. It is already in place before we enter any scene. We are continually exposed to it, even if the particular forms it takes tend to evolve.[12] Established scenarios of address pervade the planes of love, law, science, art, friendship, education, domesticity, design, indifference, play, finance, food, and mourning. The modes of address on which we settle, that we try out or that we happen to fall into, thus rely for their composition in part on preexisting possibilities for and limitations of address.

In each of the three overlapping capacities that I have just described—namely, as a navigational device, as a set of abilities that we willingly or unwillingly

train, and as an ongoing, mutating state of affairs—address embodies influential parameters of social organization. How does it work? What are its powers?

These questions are at the center of this investigation. Enacting webs of address, we fashion our experiences in collaboration with places, things, people, and nonhuman animals. We adjust the forms of address that we direct at each other to the specific locations that we occupy and the individuals and objects we find there—playgrounds, libraries, galleries, post offices, and bathrooms generally inspire different kinds of address. The looks and sounds of consumer goods, such as necklaces and toys, depend in part on the modes of address that these artifacts can be calculated to encounter and encourage in various populations on certain kinds of occasions. Environments such as dance halls, factory floors, and soccer stadiums come by designs that reflect the roles of people, sites, and things as sources and targets of address. As creators and undergoers of address who bear relations to scores of beings and things, we juggle an immense scope of modes of address.

STUDYING ADDRESS

The concept of address is a key tool of contemporary philosophy and cultural critique.[13] Film and literary theory and feminist, postcolonial, and critical race studies feature the notion. Among its numerous roles—many of which we will have ample opportunity to examine in depth—we can count the following, partially overlapping ones: The concept fuels multiple varieties of cultural criticism and analysis (e.g., Marxist, psychoanalytical, and deconstructive). It informs investigations of the workings of ideology and of the imbrications of modalities of knowledge with registers of power. It is deployed to chart large-scale historical developments of societies and material environments as well as detailed strands of experience engendered by individual texts or objects. The notion drives accounts of the social and political meanings of linguistic utterances and other cultural artifacts. It can be found at work in analyses of the ethics of self–other relations. It undergirds views of the participation of art in the production of social differences. Theorists also employ the notion to shed light on the interactions between artworks and their audiences and to gain insight into the public dimensions of cultural objects.

While the concept of address is in widespread use, it has received relatively sparse systemic attention. It serves far more commonly as an instrument of analysis than an object of inquiry in its own right. Its invocations often carry an air of self-evidence. The notion makes its appearance in contrastive vocabularies and methodologies. Enlisted in divergent approaches, it lends itself, as already suggested, to variable theoretical goals. This state of the literature allows

for a fruitful analytical flexibility: authors designate the pertinent scholarly background for the term and signal the relevant problematic that is under investigation; the notion's provisionally delineated, context-specific meaning becomes visible in the actual use to which the concept is being put, a use in which the meaning of the term, as Ludwig Wittgenstein observed, substantially consists. Context clarifies what is at stake. By and large, this arrangement functions advantageously: even a cursory look across a number of analytical contexts like the one taken in the previous paragraph shows us that the notion of address fulfills an impressive array of conceptual labors.

The state of inattention in which the concept of address as a rule is left, however, typically leads to a mix of two things: First, the theoretical reverberations that the notion sets into motion in particular instances go unexplored. This hampers the forging of connections among distinct perspectives and the traveling of ideas across theoretical frameworks. Narrowing opportunities for conceptual translation, we sequester insights that are able to galvanize each other. Avenues for development of the concept are cut short.

A second consequence of the relative neglect visited on the concept of address as an object of scholarly exploration is that the notion's commitments remain tightly allied to the approaches initiated by specific theorists who are recognized as trailblazers. This illustrious company includes Walter Benjamin, J. L. Austin, Jacques Lacan, Louis Althusser, Michel Foucault, and Jacques Derrida, among others. While this crew of writers has undeniably composed vital segments of a story about address, major portions remain to be told. Address's behaviors outstrip the functions that a cadre of groundbreaking thinkers has predicated of it. Present-day investigations bring into view facets of address that resist being modeled on the terms provided by paradigms currently on offer. In reflecting on the characteristics of address, we must then give a place to phenomena that escape the apertures of received methodological principles. An area of inquiry emerges that clamors for reinvigorated examination.

When we look at the subject in this light, we notice that just as address is a collaborative practice, so is our examination of it. The troupe of investigators peeking into address includes poets, dramatists, fiction writers, filmmakers, sound artists, philosophers, political theorists, multimedia performers, cultural critics, legal scholars, and social scientists. A relatively horizontal organization comes into view that, as we shall see, marks address no less than our exploration of it, which, after all, itself involves a particular type of address. The study of address solicits dispersed evidentiary grounds, a loosening of canonical structures, a dissolution of hierarchies.

A single source that could serve as address's *locus classicus* is lacking. No polemic definitively circumscribes the concept's commitments. No scrutiny authoritatively specifies the terminology through which it is to be grasped. Indeed, the multiplicity and shifting character of the forms of address we have in principle available to us make it implausible that such stipulations would be

desirable or even possible. Hence, we face ample room for experimentation with the concept. A large field of exploration opens up. Once we consider address from a perspective that does not necessarily represent the outlook of any specific writer or school, but that sees an area of interconnected preoccupations arising from a range of sources—a disjointed sphere, to be sure, but a web of understandings, methods, and strategies nonetheless—then we can illuminatingly locate address vis-à-vis a cluster of key notions and questions. Thus, the outline of a theoretical framework comes into view, one that we will be able to flesh out to formulate a more comprehensive account of our theme.

This book, then, along with its sequel, ventures a theory of address. My goal is to deepen and expand the philosophical possibilities embedded in this concept. I hope to make the case for its cultural importance and its effectiveness as a tool of political analysis. The project, in short, is to provide a systematic account of the phenomenon.

The way I will go about doing that—and the commitments incurred by that term "systematic"—reflect both the somewhat scattered nature of my domain of inquiry and the rich theoretical potential that strikes us wherever we turn. My own mode of address to my material will be to go down those sinuous paths that can be spotted and to pick up on and create a conceptual order. The correlative mode of address to you, my reader, is the invitation: come along!

Meanwhile, a couple of sites of major current theoretical investment stand out that apprise us of a considerable swath of transparent grounding and provide a clear idea of some of the features that matter so much about address. Two reasons why it holds particular significance within current theoretical perspectives are its functioning as a linchpin for formations of subjectivity and its role as a vehicle for the political dimensions of artworks and other cultural productions. To signal the place of address in these approaches, I will take a quick glance at the relevant literature.

SUBJECTIVITY AND THE POLITICS OF CULTURAL PRODUCTIONS

Numerous theorists understand address as a ground of subjectivity. To give a short sample of this influential strand of thought: Walter Benjamin and Roland Barthes regard address as a condition for experience and desire, respectively.[14] Maurice Merleau-Ponty folds it into our perceptual (and linguistic) intertwinement with the world.[15] According to Louis Althusser, institutionalized mechanisms of address undergird the emergence of subjects within ideological regimes of recognition and misrecognition.[16] For Judith Butler, our subjective being is bound up with the opacities inherent in the address that we make to others and

others to us.[17] More than that, in her view, address is a pivotal mechanism of forms of public assembly.[18] In María Lugones's account of oppositional subjectivity, superimposed modes of address that we direct at divergent constituencies can offer resistance to entangled oppressions and serve to advance coalition-building.[19] Barbara Johnson traces textures of address entwining people with objects, textures that allocate features characteristic of things in places where we tend to find attributes typically predicated of subjects, and the other way round.[20] Uncovering how actors in texts by Edgar Allan Poe, Jacques Lacan, and Jacques Derrida are invested in "getting even" with each other, she observes how, concerning these exchanges, as a commentator puts it, "[t]he last word is that there is no last word."[21] Rather than seeking to gain the upper hand in a contest, Johnson can be seen to expand, multiply, and stretch the operative lineages and frames of address and to reshuffle the similarities and differences between the subject-positions implied by them. Patricia Williams shows how forms of address can wield racial and gendered power through their differential distribution of agency and object status among subjects.[22] Many more theories locate important facets of subjectivity in factors of address.

Subjectivity, in these kinds of approaches, is generally understood to develop in interaction with nonsubjective, or at least not wholly subjective elements, whether market routines, linguistic formations, norms of recognition, configurations of objects in space and time, governmental procedures, legal arrangements, or political ideologies. The notion of address thus informs decentered perspectives of the subject. In other words, address supports views of subjectivity as a coincidence and gathering of culturally situated forces. The conscious experience, will, and intentions entertained by and motivating people thereby constitute just some of the factors that shape personhood or forge parameters within which individual lives take form.

The present strand of theorizing understands frequently drawn distinctions between agency and subjection, self and other, action and passivity, forming and being formed as diffuse separations rather than sharply divided polarities. Address appears in this outlook as a figure that trespasses imprecisely delineated boundaries (such as those between person and thing, acting and undergoing, the domains of the conscious and the unconscious), while simultaneously modifying norms, venturing into altered normative domains, or replacing already operative norms with other norms. The manifold forms of address flowing between human beings, things, places, and nonhuman or not fully human creatures in Franz Kafka's novella *The Metamorphosis* offer us a taste of the itinerant propensities of address and the normative turbulence they can produce. Think, for example, of the shifting modes of address surrounding food, mouths, door locks, tables, coffee pots, and brown liquids in the Samsa household upon Gregor's transformation into a buglike being, and the ethical, aesthetic, and political mayhem these changes betoken.[23]

Given address's nimble trafficking between the poles of subject and object, it is not surprising that theorists rely on it to analyze the encounters between cultural artifacts and their audiences, thus investigating the engagements—actual as well as potential—linking certain kinds of objects with assemblies of subjects that these objects are assumed to index. Treading in the passageways between the two, address would appear to be a prominent site of contact between art and its various publics. Indeed, calling attention to the powers of address that become visible in the latter zone of interaction, Barbara Johnson and Miriam Hansen, among others, throw light on the politics of literary and cinematic works by showing how modes of address activate, draw on, and rework registers of social differentiation and identification. In their approaches, address can be observed to support orientations and solicitations that artworks direct at publics in concrete historical settings. In this capacity, it embodies simultaneously aesthetic and political forces mobilized in a field where cultural productions meet with their audiences.

Both lines of theorizing on address I have just sketched will receive ample attention, with varying degrees of emphasis, in both volumes of this investigation. I will begin to underscore the workings of address as a ground of subjectivity in the present book and carry the theme further in the next. Address's operations as a site of simultaneous aesthetic and political meaning will also surface in later discussions of David Hume's, Walter Benjamin's, Roland Barthes's, Gloria Anzaldúa's, and Frantz Fanon's views and in readings of a range of artworks, but will come to prominence more fully and explicitly in the second book.

THE CONCEPT'S EXPANDED USEFULNESS

While scholars marshal the notion of address to clarify subjectivity and furnish insights into the relations between aesthetics and politics, its productivity vis-à-vis these objectives is more expansive than has so far been acknowledged. The notion's fruitfulness, moreover, stretches well beyond these agendas. The enlarged usefulness for which this investigation makes a claim will become evident through, among other things, considering the everyday functioning of address and its role as a catalyst of trajectories of culture-building.

These interweaving lines of inquiry will make their mark throughout this study. A short story by Jamaica Kincaid, a poem by Wisława Szymborska, and a collection of stories by Julio Cortázar will shed light on the quotidian workings of address while at the same time raising questions about the underpinnings of global culture. Examinations of Immanuel Kant's turn to address as a pillar of enlightenment and the aesthetic system that David Hume founds on address will call attention to address's culture-building capabilities, capacities

that we will further scrutinize in readings of Kincaid's and Cortázar's narratives. These stories simultaneously send us back to the quotidian world, pointing to day-to-day circuits of auditory, spectatorial, gustatory, dialogical, and polemical address.

Exploring address across multiple genres of art and sectors of life, we will arrive at certain constants. In writings as diverse as those of the authors above, address will appear to undergird constructions of normativity, agency, relationality, order, and aesthetic meaning. Artists such as Martha Rosler, Nagisa Oshima, Clarice Lispector, and Pope.L, as we shall see, deploy modes of address to bring about changes in webs of aesthetically mediated relationships.

Examining the core devices that address has as its disposal, I will suggest a simple proposition: *modes* of address embody *norms* and *forms* of address that govern *scenes* and *scripts* of address, which play their part within *structures* of address. The constituents and mechanisms highlighted here are responsible for a good portion of the workings of address. We will see these elements and procedures at work in art, theoretical texts, and segments of ordinary life. My thesis provides an anatomy of the field of address. The nomenclature of forms, scenes, scripts, and structures of address is already in circulation in various contexts. However, the conceptual architecture propping up this lexicon is seriously underanalyzed. I am newly coining and adding to the existent vocabulary the term "norm of address," even if the concept it denotes can be recognized implicitly in works by scholars like Hume, Kant, and Anzaldúa.[24] None of my five key concepts has been adequately theorized to date. By way of my proposed model, I offer an account of the anatomical makeup of the field and give a paradigm for analyzing the collaborations among address's core components. Major functions of address can then be traced to the joint workings of these devices: the five dynamically interconnecting nodes that I identify underlie address's functioning as a vehicle for individual and collective agency, its distinctive relational operations, and its centrality to aesthetic and political life.

FROM AESTHETICS TO ADDRESS AND BACK

As the convergence of this study's interests in the everyday and in projects of culture-building already suggests, the aesthetic—a domain of theory and practice that brings together these two foci—will occupy an important place in our reflections. Aesthetics, after all, considers art and quotidian life in view of the cultural investments and collective possibilities that they exemplify. One major strategy driving my account will be to consider address in light of a broadened conception of the aesthetic, a view that the notion of address, I have argued elsewhere, simultaneously enables us to advance.[25] Address and aesthetics are

fundamentally bound to each other. This investigation affirms their mutual entwinement by using aesthetics to theorize address and by using address to further our insights into aesthetics, which in turn will enlarge our view of address and its powers.

This method will inform our discussions at many junctures. Examples include the cases of Hume and especially Kant, two philosophers whose writings are widely considered to have been of paramount significance to the Western notion of the aesthetic. Kant, intriguingly, locates a mode of address at the heart of enlightenment in his famous article, "An Answer to the Question: 'What is Enlightenment?'" An exposure of the workings of this mode of address will bring out challenges that Kant's view of enlightenment presents for his aesthetics and is suggestive of an augmented conception of Kantian aesthetics. Hume's aesthetics also undergoes a shift when we see it as radiating from the distinctive script of address that he champions in his foundational essay "Of the Standard of Taste." The altered aesthetic configurations that become evident once we recognize the role that Kant and Hume give to address then feed back into the capacities accruing to the forms of address in which these philosophers ground the aesthetic. These changes, further, can be seen to reflect on the notion of culture to which they subscribe.

In accounts that see aesthetics in the first instance as either the theory and interpretation of art or as a type of *aesthesis*, that is, a form of sensation and perception, the far-reaching involvements of the aesthetic with address may come as a surprise. These views, however, do not do justice to the involved structure of aesthetic meaning, experience, interaction, and value. By contrast, on the broadened view of aesthetics on which I call in this study, address quite clearly saturates the aesthetic through and through. Given the significance of art and aesthetics to the analysis that follows, an explanation of what I mean by the aesthetic is needed, one that reveals how address pertains to this domain.

The field of the aesthetic, in my usage of the term, encompasses an assembly of conceptually inflected, socially embedded, multimodal engagements among persons, things, and places. Normative force comes into play in aesthetic territory. Specifically aesthetic meanings take residence in objects, actions, experiences, and sites of production, consumption, and exchange. Aesthetic phenomena are elements of materially supported, historically unfolding webs of relationships. These relationships are traversed by modes of address. Address, here, thus enters the aesthetic as a structural constituent.[26]

While practical and cognitive meanings are important ingredients of aesthetic experience, aestheticians commonly believe that these registers alone cannot do justice to the particular meanings that matter to people in the aesthetic domain. Rather, there is a specifically aesthetic dimension to life that, even if it sustains varieties of moral, political, economic, and epistemic signification and content, remains irreducible to those elements. The aesthetic

concerns, then, a distinctive aspect of existence that involves the creation and presentation of objects, the realization of events and interactions, and the undergoing of sensorially and cognitively embedded experiences of such things and happenings.

Meaning, in the aesthetic domain, is experiential in a basic way. It is charged with value, in the sense that we, for example, can find interest in it or, in a similar vein, consider it of little consequence. We incorporate such meaning in habitual, institutionalized structures of being and relating. The aesthetic thus constitutes not simply an individual, personal, private, or momentary reality, but sustains communal, supra-personal, and public modalities of making and being that evolve over time. Aesthetic experience, accordingly, engages us on collective levels, as members of publics or groups: for example, as hip-hop audiences, film spectators, or jazz performers; as adherents to national styles; as rescuers and destroyers of animal species that are threatened with extinction; as admirers of specific artists.

Address supports the aesthetic as a pillar of relationality and collectivity. It lies at the core of what the aesthetic is about philosophically. The present investigation both draws on this understanding of the aesthetic and seeks to advance it.

Unfolding in aesthetic territory, the study's argument will attest to the centrality of address to the projects of what I would like to call a decolonial, critical race feminist aesthetics. By this, I mean a stance intent on thinking through the ties of the aesthetic with modalities of race, gender, coloniality, and class (among other variables interlacing with these registers) in view of a concern for justice and equity. This stance includes a wish to dispel theoretical obfuscations along with epistemic and aesthetic impediments inherent in deep-seated traditions of injustice and inequity. The ties between aesthetics and coordinates of social difference revolve in part around forces that are to be vehemently challenged, such as our immersion in racist and misogynist templates of perception, the affiliations we bear to (neo)colonial matrices of expropriation, and our investment in LGBTQI-phobic aspects of embodiment. Yet at the very same time, they extend to our attempts to creatively leave behind and obstruct these historical sedimentations—efforts worthy of being cherished.

In question, more generally, are what I call patterns of aesthetic relationality: the registers of social being to which we appeal as a society and that we put into effect on an ongoing basis both draw on and produce aesthetic elements that mediate shifting relationships linking people with people, people with things and places, and things and places with each other. These aesthetic relationships are a focal point of the decolonial, critical race feminist stance sketched here in rudimentary fashion and that I seek to foster in this book.[27] Part and parcel of this position is a rethinking of modern configurations of space and time in light of histories of domination. I have in mind an open-ended, at once practical and theoretical agenda. This venture has been launched implicitly

already by many artists, scholars, curators, and activists. At issue are the entwinements of the aesthetic with facets of structural differentiation that pervade a broad array of phenomena in the fields of culture and the arts, humanities, and sciences. This line of exploration is attentive both to the troubled workings of the aesthetic in various orbits of our social functioning and to the vibrant role that aesthetic activities can and do play as elements of an inventive, collective engagement with systemic parameters of difference and identity.[28]

Not surprisingly, this outlook on aesthetics, sociality, and politics bears on the mode of address of these two books. My commitment to elaborating and participating in a decolonial, critical race feminist aesthetics implies for the address of these volumes that I want to maintain an open-ended conversation that recognizes the necessity as well as the difficulty of modifying formations of race, class, gender, sexuality, and coloniality (in their reciprocal determinations) that are embedded in our daily, aesthetically productive and aesthetically engendered interactions with people, things, and places. Purporting to foster this kind of open exchange, my reading practice acknowledges and respects my interlocutors' autonomy, as well as the similarities and differences that arise among their scholarly/artistic stances and between those stances and my own writerly positions and persuasions. The goal thereby is to make productive both the affinities and disparities among a plurality of approaches. I also wish to activate places where these parallels and disjunctions have sedimented while yet remaining malleable. In my mode of address to my material and my reader, I then aim for a multivoiced dialogue, alert to breakdowns and eager to channel the analytical focus at moments of impasse or nonencounter between perspectives to points where joint exploratory freedom and imagination can be unlocked on new terms.

Like the view of the aesthetic deployed in this inquiry, my notion of address, from the onset, will be capacious in scope. The notion will embrace a more sweeping ambit of phenomena than address is typically understood to encompass, at least in its explicit formulations. It is address as this versatile concept, which applies to an array of more or less pronouncedly symbolic states and ranges over sundry media, genres, and periods, that will be so crucial to aesthetics and to critical praxis, broadly conceived.

CATEGORIAL DEMARCATIONS: HOW INCLUSIVE IS THE NOTION OF ADDRESS?

The concept of address, inclusive as it is on my account, subsumes processes that are frequently set apart from one another. In accounting for language and communicative interactions more generally, theorists often distinguish

unequivocally symbolic functions from outright nonsymbolic processes. They recognize fundamental distinctions between, on the one hand, intentional registers of signification (whereby the term "intentionality" captures the way in which a sign can be *about* the world, that is, capable in principle of connoting or designating elements in the world) and, on the other, modalities that lack such dimensions of so-called sense, reference, and aboutness. The relevant differences capture pivotal aspects of our conscious and nonconscious experience, our intersubjective relations, our engagement with our physical surroundings, and the nature of the material world. It is usually important to recognize these aspects, notably in interpreting phenomena such as human action, linguistic meaning, and the behaviors of natural and humanly mediated events. In my descriptions of address, I will accordingly signal such distinctions regularly. Yet these qualifications will not receive as much weight in my analysis as is common in approaches in the philosophy of science, mind, and language, and will often go unmarked. My reason here is not, in the first instance, the fact that the applicable differentiating features are notoriously difficult to pinpoint and a matter of vehement debate, but that the directionality and relationality of address to which I have pointed demand a framework that takes into account a profusion of symbolic acts, occurrences, states, and meanings. Many of these elements unambiguously qualify as symbolic in view of well-honed operative significatory conventions. An example of such an unequivocally symbolic event would be our calling a friend on the phone in the hope of catching up with her. Other situations such as, for instance, our being addressed by the wind when feeling its touch on our skin, are less conspicuously symbolic in character and come by their characteristics as forms of signification in a manner that draws markedly on an experiential context that can be presumed to be in effect. This kind of context is also operative, of course, in the case of symbolic forms that are immediately recognizable on the basis of solidly standardized conventional practices. However, it retreats into the background when such a system assumes an automatic character and can be taken for granted. I thus wish to include in the notion of address both emphatic forms of signification and forms that can be called significatory in an attenuated or less clear-cut sense.

Inanimate objects and events fulfill complex roles in our lifeworlds in virtue of which it is illuminating to see them as having capacities for address. We time and again experience objects and events as carrying orientations toward human and other living beings and toward other things and occurrences. As social creatures, we generate webs of interactions in the context of which we are addressed by artifacts, substances, and happenings such as movies, theater performances, symphonies, faucets, toilets, grains, spices, beams of light, rushes of water. These entities' address links up with people's address, including that of cinematographers, actors, musicians, designers, custodians, farmers, bakers—people who make or produce those kinds of entities. And these makers' and producers' address stands in connection with the behaviors of users

and consumers who engage in practices of viewing, listening, eating, wasting (a group that, of course, coincides in part with that of the makers and producers). Address, conceived as a constituent of the rich bodily interactions in which we participate, concerns fine-grained operations linking our behaviors, sensations, and feelings with those of others and with the material and social forces affecting us. It transpires also between occurrences and things and between things: a self-driving car follows directions from a navigation device; a drone that has veered off-course surveils a lake.

The view put forth here does not entail that every case of relationality or directionality within the realm of signification qualifies as a case of address. While I employ a working definition of address in this book, I stop short of laying out conditions that pinpoint for every event, process, or situation whether or not it is a mode or instance of address. Devising such criteria goes beyond the scope of this investigation, although our inquiry may in the end shed light on how we might want to construe them. Rather than declaring all relationality, directionality, or mediation in the sphere of signification moments of address, I want to draw attention to a realm of experiential roles and possibilities: given the functioning of objects and events in our lifeworlds, it is illuminating to recognize that address can run between living beings, between occurrences, between objects, and between places, as well as between the elements belonging to these different classes of entity. There are, of course, crucial differences between these axes of address that I would not want to diminish, some of which concern contrasts between literal and metaphorical meanings.[29] But these different vectors of address are also in important ways in operation in one another, yielding interlinkages in which language plays a significant part. Cultural theorist Walter Benjamin and literary critic Barbara Johnson cite many instances of this intertwinement among language, people, things, and places, an entanglement affirmed also by phenomenologists such as Maurice Merleau-Ponty.[30] I thus see this book as further fleshing out our sense of the ways in which these elements are in action in each other.

In considering the scope of address, it is worth noting that objects can address us in ways that they were not necessarily designed to do. Just as my friend's yawn may address me in a way that she did not intend, the stool that was once meant for toddlers to sit on might now address older children and adults as a platform for reaching the cookies on the upper shelf or for making proclamations. Intentions are of varying importance to modes of address. Think of the difference between an accidental dial and an ordinary call you make with your cell phone. While address often takes intended forms, it is also frequently unintended, as already intimated by the idea that it can run between things (e.g., errant drone and lake) and between events and people (e.g., wind and skin).

The broad notion of address that I am sketching here is far from unknown to us. It can be found at work in much of our thinking about society and material existence, at least implicitly: under the rubric of culture, we often signal

address in an expansive, richly diversified sense. Reflecting on culture(s), we typically see people's engagement with each other as mediated by and mediating their engagement with things, events, and places; we conceptualize things, events, and places in connection with each other, and understand the norms, forms, and powers that shape the relevant engagements as crisscrossing the realms of humans, objects, and environments. This attentiveness to address as a site of relationships and interactions among people, things, and environments also frequently marks our deliberations on the aesthetic and the everyday.

A parallel becomes visible between the domains of culture, the aesthetic, and the everyday, the three fields that this study brings together in order to theorize address and to strengthen and amplify the concept's philosophical resources. In each of these areas, we encounter an incipient, even if in many ways inchoate view of address as the intricate and wide-ranging phenomenon to which I am calling attention.

This investigation, then, takes a multiplicity of orientations, capacities, and forms to be central to the workings of address. We would lose track of the plurality characterizing the field of address on a scheme that seeks to exhaustively carve up this area into full-fledged symbolic and nonsymbolic varieties. Moreover, the fact that we are talking about address, which I have described as a realm of signification, constitutes no adequate philosophical ground favoring a stance that prioritizes either of these types or reduces one to the other.

Given the plurality of norms, modes, scenes, and scripts that the notion of address encloses, the interminable and dispersed dynamics that it denotes, and the hazy boundaries separating different forms and structures from one another, the concept of address sketched so far may strike some readers as being overly wide-ranging and diffuse. A notion so general and fuzzy, one might object, spawns explanations of everything in terms of everything else and hence is bound to be empty. However, it is precisely because address is, so to speak, everywhere and does so much that it demands theorization.

While address undeniably exhibits a certain amorphousness and encompasses a multiplicity of entities and processes, it is important not to mistake such indefiniteness and plurality for an absence of organization. Indeed, we must be alert to the potential generativity of elements that are not readily pinned down along given categorial lines. As already suggested, rather than establishing a set of necessary and sufficient conditions for the kinds of significatory processes that constitute address, I use my working definition to explore instances and lay out a field of operations. Refraining from further cordoning off the notion in advance of this investigation, I give the concept a stretch that at later stages can invite new ways of corralling, steering, and comprehending it, ones that take cognizance of the capabilities and potentialities opened up here. Dimensions of address that strike us as nebulous or fleeting may in fact signal a productive classificatory elusiveness, an indeterminacy that is conducive to

slippages between forms and facilitates structural transpositions. As we shall see in the case of Julio Cortázar's story collection *Cronopios and Famas*, such indefiniteness can point to mobilities and forces populating the plane of address.

Address is a systemic phenomenon. It is part of the makeup of our experiential worlds. By considering utterances and other symbolic phenomena at the level of address, we can make visible ways in which these elements participate in structural registers of experience and modalities of power. The notion's broad scope serves this epistemic agenda; it permits us to identify connections (and disjunctions) that exceed entrenched boundaries between domains, such as the divisions between subjects and objects already mentioned, but also alleged separations between minds and bodies, economic and social or psychic arrangements, or cultural and political constellations. A deliberate loosening of certain categorial demarcations in the conceptualization of operative norms, forms, and structures likewise supports our ability to recognize continuities and discontinuities across received delimitations. A wide reach and some carefully administered degree of classificatory indeterminacy are then inherent in the analytical repertoire through which the notion of address enables us not only to bring into view operations that abide by institutionalized cartographies but also to shed light on procedures that elude the hold of these arrangements. A principled inclusiveness and categorial amenability, in short, are among the attributes that render the concept of address of fundamental significance to the projects of critical theory and agency.

The flexibility and range of the notion of address do not stand in the way of its philosophical utility. I have already indicated that it enjoys a rich presence in the history of philosophy. We can spot it in discussions ranging from Plato's reflections on art to Jacques Rancière's aesthetics and his accounts of spectatorship and teaching; from Johann Gottlieb Fichte's take on the necessary summoning of free individuals by one another as a condition of selfhood and justice to his "addresses" to the German nation; from Hegel's understanding of individual self-consciousness as requiring mutual recognition among subjects to his chronicle of collective forms of life and genres of art in terms of patterns of recognition; from Merleau-Ponty's view of our intercorporeal being-in-the-world to Fanon's decolonial thought and reflections on race and language; from Mikhail Bakhtin's perspective on the novel and on language's polyglot, dialogical character to Gilles Deleuze's theory of cinematic strategies that invoke a people who are yet to come into being; from J. L. Austin's exposure of felicitous illocutionary acts as doing things with words rather than carrying a truth value to Rae Langton's invocation of the capacities of audiences to shore up or thwart the illocutionary force of forms of hate speech by giving or withholding authority to/from these acts; and from Johnson's feminist uptake of her psychoanalytical and deconstructionist interlocutors Lacan, Derrida, and Paul de Man to Stuart Hall's and María Lugones's accounts of

coalition politics.³¹ As the reader may surmise, the notion of address pertains to domains that are frequently analyzed in the language of communication, expression, subjectivity, normativity, lifeworld, form of life, interaction, performativity, and experience. More than that, it is crucial to them. Perhaps one of the reasons why address has not received the synthetic examination it warrants is that its presence in these different precincts has not been sufficiently noted and attended to. It bears emphasizing that address is not equivalent with any of these territories. As our analysis proceeds, its intimate connection and conceptual overlap with these related phenomena will emerge with increasing clarity.

These linkages, along with the fact that address encompasses a variety of things, do not imply that the notion of address does not have specificity or fails to bring specificity to the interpretations and explanations in which it functions. The definition I have provided—modes of address are forms of signification that we direct at people, nonhuman creatures, things, and places, and that these entities direct at us and at each other—indexes a distinct phenomenon. Our understanding of address, which enlists and builds on this definition, will receive elaboration in the course of these books as we learn about the different appearances of address and its features, mechanisms, capacities, and roles.

The purpose of this volume and the one that follows it is not to clarify every aspect of address or every dimension of the domains in which we will trace address's operations; indeed, I will not venture full-fledged accounts of things like subjectivity and experience, nor take a stab at explicating intentionality (the "aboutness" of signs), a notion I simply take for granted.³² The goal, instead, is the more modest one of uncovering a cluster of key features of address and showing how these central characteristics are responsible for a number of address's important capacities. Given these limited aims, significant aspects of address and major facets of the phenomena that I seek to clarify by way of the notion of address will demand illumination from other corners—projects numerous scholars have already undertaken. A measure of theoretical restraint will then characterize this exploration.

A somewhat different kind of restraint, meanwhile, allows for a productive and much-needed exploratory freedom: holding off from imposing certain already-presumed conceptions of our symbolic functioning onto our field of inquiry, we can identify the notion of address I have sketched—which encompasses both intended and nonintended states and generously flows to and from things—in Jamaica Kincaid's story "Girl," as we shall see in chapter 1. Rather than a sign of theoretical slippage or the hallmark of a vague concept that spawns nebulous contentions in an ambit where others have furnished precise and definite accounts, my inclusive notion of address serves as a catalyst for investigation.

In its most bare-bones terms, the methodological scaffolding of this study can be expressed as follows: Scholars employ the notion of address to do

important explanatory and interpretive work. Many artists elucidate the notion in an implicit manner. Running with my definition of modes of address as forms of signification we direct at people, nonhuman beings, things, and places, and they at us and each other, I develop a theoretical framework—the apparatus of norms, forms, structures, scenes, and scripts—that I show to be at work in artistic, scholarly, and quotidian cases. This apparatus is substantially responsible for crucial workings and capacities of address that become visible if we look at my cases. These functions include processes and resources that theorists designate by way of vocabularies of address that are different from mine. Rather than dismissing these idioms, I propose that it is the matrix of constituents and mechanisms that I will describe that is operative across a wide array of relevant frames and contexts of analysis and can be seen in action in those realms. If we do not recognize the central components and joint operations that we are about to unearth in the following pages—or so states the argument of these books—we lose sight of powers and nuances that demand theorization.

Worries about a lack of analytical specificity and definiteness may arise from yet another angle. As a part of my investigative strategy, I shall bandy about the word "address" quite liberally. This means that I will at times call events or processes by that name that do not always need to be seen as such and for which we might ordinarily want to use different terms. This deliberate practice I consider a form of translation. It is not meant to supplant or declare null and void the language in which we commonly tend to describe the event or process in question or to foreclose other technical denominators. Rather, it is a tactic of reading afresh or, in other words, a de- and recoding I employ to foster the development of our account of address. It amounts to a method of philosophical experimentation. For, by putting to use the concept of address in a variety of settings, picking up on the ways it is already being used—implicitly or explicitly, sporadically or endemically—and getting experience handling it in divergent situations, we will progressively articulate and give increasing substance to what it might mean, do, imply, and so on. In that way, we will be building the concept.

This strategy has a downside. The impression that this abundance of address talk may give the reader is that I am turning things into address that aren't really that. Consequently, the notion of address may seem to be excessively inclusive and, therefore, suspect. It might appear to be vacuous, along this novel route. Rather than attempting to block this backfiring of my strategy by exercising linguistic moderation vis-à-vis the term "address," which would curtail the space for inquiry and experimentation that I wish to open up, I intend to clarify from the start the methodological purposes that the strategy serves. By putting the notion into action, we will endeavor to learn what work it is capable of; alert to its use, we will grasp the meanings that accrue to it, or at least a good portion of them.

It bears repeating that the concept of address arises within multiple philosophical optics, methods of social criticism, and traditions of artistic inquiry. As we find it there, we will probe it through its concrete occurrences. By asking new questions, we will strengthen and lay bare its meanings. Our talk of address, with its unflinching references to the phenomenon, thus will always serve to bring out specific sides of it and theorize them in connection with each other.

Three common understandings of address may stand in the way of a recognition of its breadth. The first one stems from speech act theory, which is often enlisted in accounts of address. Speech act theorists typically make assumptions about the conditions that render performatives felicitous or infelicitous, without giving much thought to the norms and forms that shape the relevant criteria of success.[33] But what criteria are in effect and where do they come from? How do they operate? What grounds them? These questions are generally left untouched, with the result that our understanding of the actual workings of performatives is rigorously limited. The framework of address promises to make progress on these issues. By looking at the structures of address embedding performatives, and by considering how norms and forms of address traverse these structures, we can hope to attain further insight. While making that argument goes beyond the scope of this study, what will become evident in the course of several of my readings is how perusals of address, in the sense proposed here, turn up facets of artworks that scrutiny of illocutionary forces, instances of interpellation, and performative acts leaves untouched.

Another recurrent notion of address identifies it with figures of speech or a rhetorical use of language. Address, so understood, would concern primarily modes such as the vocative, anthropomorphism, or direct or indirect discourse, to give a few examples. While such forms and tropes constitute an important province of address, they far from exhaust it. On the contrary, they emerge in a more expansive field that not only includes nonlinguistic varieties but also embeds these deployments of language in a web of corporeal, linguistic, social, and material address that extends beyond a repertoire of figures, no matter how extensive. To adequately theorize the workings of tropes as forms of address, we need to comprehend them as elements that function alongside other kinds of address, in short, as subspecies of the pluriform area of inquiry under investigation in this book. And whereas investigations of figurative language have a strong track record in clarifying aspects of address, broadly conceived, this is not the only way to go about it: we eventually stand to learn a thing or two about rhetoric by considering address in the sense proposed here—even if that will not be the primary goal of this study, and even if philosophical lexicons such as the one in this book cannot ultimately take their leave from the figurative.

A last widespread conception of address centers it in the idea that cultural productions address certain audiences while leaving other audiences unaddressed. Address, on this view, concerns mainly a pairing of, say, movies or songs with the publics they attract or engage in a particular manner. Once you

have a sense of which empirical audience is drawn to the film or album or has a certain reaction to it, you can then claim to know what the address is: the object addresses those individuals; by contrast, it doesn't address the people who didn't notice or bother with it, or into whose sphere of awareness it could not have entered in a given fashion. The address thus corresponds with the outreach to a public that actually experiences the work or responds to it in a specific way. The addressee of a cultural production is, accordingly, that empirical public. So address, we can all agree, is a readily circumscribed topic on which we have a good handle; no need to complicate it. This line of reasoning, however, quickly becomes more involved than the idea of a one-to-one correspondence of work and audience suggests.

If we ask what kinds of experiences and interpretive conditions characterize the empirical public—the audience apprehending the work—then a set of norms, values, and historically emergent reading practices becomes pertinent. How do works appeal to audiences? How do publics come about? How do works anticipate audiences and audiences arise in exchange with works? A richer notion of address is called for to adequately probe what goes on between the two. Indeed, to develop an approach that can aspire to bring out how films or music take form and come by their meanings in interaction with the societies encompassing them and how those societies, in turn, evolve in engagement with films or music, we need a more wide-ranging conception of address than that of an object–audience matchup, which downplays the productivity of address in shaping experiential propensities, material relations, and patterns of collectivity in excess of what ties specific constituencies to specific cultural objects.[34]

A broad notion of address, one that surpasses available conceptions of it, is a prerequisite for doing the kind of interpretive, at once normatively engaged and formally attentive work that is the hallmark of the humanities and social sciences. This notion is implicit in major presuppositions in these fields. Highlighting and theorizing it, as I aim to do in this investigation, will strengthen the analytical methods available in these domains and advance the forms of cultural literacy and cultural practice more broadly that these important intellectual preoccupations make possible.

CRITICAL DILEMMAS

Philosophers Theodor W. Adorno and Michel Foucault have devised solutions to the problem of the embroilments of critical strategies in the social formations that these methods seek to contest: if oppositional gestures arise within the very arrangements that they challenge and bear the imprints of these structures, how can they be truly critical? As these theorists have revealed, in a thoroughly commodified society such as ours in which subjects fulfill specialized

roles and power is highly differentiated, critical praxis—aesthetic and otherwise—of necessity assumes multitiered, internally refracted, and ambivalent forms.[35] Part of the aim of this book is to investigate how address can be mobilized to engage the dilemmas that follow from this situation.

Address, in Cortázar's *Cronopios and Famas* stories—as in much of his other work—enacts rule-bound scenarios in order to spotlight the unscripted, which it then enlists to signal absurd moments and points of pliability inherent in scripted scenes and events. Regulation and human freedom, conditions that, as philosophers and social theorists have shown, are profoundly interdependent, enter thereby into dynamical interactions. Modern, colonial frames of space and time display tiny snippets of motion, diminutive flitterings, minuscule bodily actions, and parceled-out physical stretches in Cortázar's narratives. These elements carry ambiguous orientations and confront spatial and temporal orders with points of material incongruity. Following Cortázar's lead, I will use the notion of address to throw light on the possibilities of freedom and the plasticity of constraint discernible in late-capitalist global societies, where power admits of no outside, but for that reason does not prevent us from orienting it in alternative directions.

Taking up this simultaneously sociopolitical and aesthetic condition as a question of address, Cortázar highlights how it implicates views of life and death, of activity and passivity. He investigates how this condition calls for modalities of art and play—modalities, to wit, that give shape to our capacities to forge connections with people, things, and places. He explores how it conjoins registers of invention and rule-governed behavior, control and recalcitrance, fluidity and stagnation. He also demonstrates how it activates forms of openness and closure. By bringing these involved conceptions to an understanding of our positioning in corporeally and institutionally embedded aesthetic histories, I will begin to consider the notion of culture from a newly ignited aesthetic perspective, one that takes cognizance of the capacities of address as a site of cultural agency in our late modern epoch.

For a brief example, I return to Gloria Anzaldúa's writing. Anzaldúa uses the notion of address to reveal implicitly how cultural productions such as her own narratives can intervene in mutually entwined configurations of culture, aesthetics, and the everyday. In presenting the stories she tells as open performances addressing persons, objects, and places, among other entities, rather than as closed objects of a sort that she associates with (certain kinds of) Western art, she understands the aesthetic and political dimensions of the narrative forms that she construes as immanent in evolving webs of relationships (social, spiritual, historical, cosmological, ecological) that they purport to reorganize.[36] Funneling relations between socially situated makers and recipients of objects, address amounts to a level of meaning at which cultural productions both participate in existing patterns of social differentiation and can work to

reshape them. In these relational capacities, address serves a wide range of critical projects of collective meaning-making.

Whether it concerns our orientations toward a film, an educational institution, an abortion clinic, a piece of legislation, an instance of scientific evidence, a poem, or a monument, address supports relationships and implements registers of social differentiation. Its relational functioning and its connections with aspects of social difference, as this investigation will indicate, help to make the notion a crucial instrument of critique.

THE "ART" IN ARTS OF ADDRESS

On the picture of address that I will sketch, humans accompany each other in a profusion of more or less inventive, fruitful, and specialized regimes of address of varying degrees of standardization, conventionality, and codification. Our relationships are in motion as we adopt modes of address toward each other or fail to do so. Stepping into and away from plans of address and carrying along on routes of address we are discovering, we exercise the arts of address that we have fabricated.

A brief clarification is in order of what I have in mind with the notion of "arts of address." Typically, when referring to art in this book, I will be using the concept of art in its ordinary (even if controversial) rough-and-ready sense, where it refers to practices such as poetry or painting and their like. Yet my reference to art in the phrase "arts of address" is looser than that. By "arts of address," I mean our capacities to create and negotiate modes of address. In naming these abilities "arts," I aim to give expression to the element of fashioning and training involved in acquiring and fine-tuning these skills. Additionally, I intend to make room for the registers of experimentation, improvisation, and play that can mark the exercise of our arts of address and that can be instrumental in shaping them. I also wish to acknowledge the potential for delight and understanding that our capacities for address hold out, and to underscore the vibrant powers of meaning production that we can realize through the mobilization of these capacities. More broadly, I want to give expression to the proximities between the two kinds of arts, including the fact that instances of our arts of address can be exceptionally powerful, astute, and striking, and sometimes match socially stratified arts in their organization and effects.

What the vocabulary I propose does *not* imply is a conception of address as a specific art form, like sculpture or music. Neither do I want to construe any given art form or even the arts in general as paradigmatic of our capacities for address. That outlook might be productive, but it would require further

argument and qualification. My objective in making a distinction between the two kinds of arts, I should note, is also not to specify their precise parallels and differences or to propose a rigorous dividing line, but rather to avoid confounding them in principle, which might get us lost in issues that are secondary to this investigation. Key to the nomenclature of arts of address, as I see it, is the idea that we can cultivate these arts. We can build, boost, and polish them, or let some of them slip. And we often actually do several of those things at once in deploying the arts of address we have crafted.

Our capabilities for address are indeed resources that we can use. This use is not a take-it-or-leave it kind of affair, for these propensities concern our responsiveness to our environment, including our selves. On the whole, these abilities fulfill tasks for us that we cannot do without. While the capacities for address available to us involve the operations of instruments and technologies, these elements in many ways function as devices, methods, and designs of a sort with which we are astoundingly closely (if unevenly) entwined as human beings and communities. With the term "art," in the phrase "arts of address," I wish to draw attention to the meaningful yet open-ended forms that these faculties take and to our inability to simply cast them off, stand beside them, or replace them in any wholesale sense. By means of this terminology, I also aim to signal how thoroughly these abilities are involved in our being in the world and with others.

Having made a distinction between our arts of address and the specific art forms by which we are surrounded and that we may practice—a distinction that, again, it is not my point to render hard and fast but rather to acknowledge in principle—it is important to recognize the major significance that the latter have for the former. Part and parcel of our presence in bonds of address vis-à-vis people, nonhuman creatures, things, and places is our emplacement, as participants in contemporary global societies, in traditions of art. These art practices enter into our arts of address in countless crucial ways, although, as I have stressed, there are disjunctions between the two kinds of art.

Our arts of address decidedly include the rhetorical skills elaborated by theorists such as Aristotle and Quintilian. Rhetoricians have long taken note of the normative character of linguistic address and the potential effects of such address on its recipients. Aristotle, for instance, champions norms of address when he urges the orator, as a matter of duty, to address "men of a given type" rather than individuals, to favor "regular subjects of debate" over lengthy, complicated, impossible, or artificially induced topics, and to avoid "high finish in detail" while face to face with public assemblies.[37] Quintilian likewise advances a normative form of address as he counsels the orator to use indirect turns of speech such as "I appeal to you, hills and groves of Alba" or "O Porcian and Sempronian laws," and celebrates this kind of apostrophe, that is, a "diversion of our address from the judge" as a "wonderfully stirring" rhetorical figure, one that "give[s] life and vigor to oratory."[38]

Aristotle and Quintilian represent an early strand of address studies. But address, it bears emphasizing, is broader than rhetoric. While rhetoric is surely an art of address—and perhaps the form that one, at first glance, might associate most closely with this description, given the prominent affiliation of address with verbal modes—it is one among many. The same goes for established art forms such as film, dance, stand-up comedy, pottery, and weaving. These forms extend over crucial, partially overlapping areas of address and are valuable arts of address. Yet both the field of address and the capacities for address that I call arts of address are more encompassing than these specific, variably institutionalized forms.

That said, we stand to learn voluminous amounts about address from the work of artists. This learning is reciprocal: the arts substantially are and involve arts of address on the part of artists and publics. So we also learn a lot about entrenched or emergent art forms and types of cultural production by musing on the broader arts of address that we can engender and have already brought into being. The chapters that follow will take a close look at an array of artworks. The insights we will garner from artists such as Jamaica Kincaid and Julio Cortázar will be pivotal to a theory of address. Perhaps their artworks can even offer us occasions to brush up the arts of address we have manufactured up to this point, or to venture untried ones.

◉ ◉ ◉

A succinct overview of the principal themes in each chapter may be of use to the reader as a rough map of the argument of this book. Chapter 1 begins by examining how address in fictional narratives by authors Jamaica Kincaid and Wisława Szymborska orchestrates modalities of relationality, normativity, aesthetic meaning, agency, and order. Philosophers David Hume, Immanuel Kant, and Michel Foucault, as we will see in chapter 2, likewise foreground these functions of address in their accounts of, respectively, the aesthetic, enlightenment, and discourse. Exploring our emplacement in structures of address, Julio Cortázar's collection of stories *Cronopios and Famas*, which I will discuss in chapter 3, underscores the ways in which we can leave behind confining orders of address and their attendant types of normativity, relationality, agency, and aesthetic meaning, only to reencounter them elsewhere in a different form. As readers of Cortázar's narratives, we are alerted to, even woven into collaborations between language, people, things, and places that keep us in line but, at the same time, allow possibilities for change, fostering transformations that, no matter how minute, can escape given paradigms of the habitual and the perplexing. Besides marking a role for address in these transformations, Cortázar's tales shed light on granular aspects of address's functioning that fall through the mazes of Hume's, Kant's, and Foucault's analytical grids. This is where the thesis I will propose provides some theoretical openings.

Chapter 4 offers a basic framework for theorizing the kinds of operations to which Cortázar draws our attention by emphasizing address's fundamental relationality and directionality and describing the joint workings of five central constituents of address—namely, norms, forms, structures, scenes, and scripts. Scholars such as Frantz Fanon, Walter Benjamin, Louis Althusser, Roland Barthes, Gloria Anzaldúa, and Judith Butler also implicitly or explicitly enlist elements of this conceptual apparatus in identifying dimensions of subjectivity, intersubjectivity, materiality, and institutionality based on address. Looking at their views and at the same time taking into consideration the roles of objects and places in trajectories of address, chapter 5 points to the participation of address in a wide range of procedures and functions. We see the apparatus of address at work in formations of subjectivity, collectivity, experience, desire, and reading. Address fulfills these tasks as a determinant of factors such as linguistic, technological, and institutional mediations along with object-based and object-oriented arrangements. And yet, the conceptual framework presented in chapter 4 yields a simultaneously more fine-grained and broadly ranging, multifocal optic for analyzing the field of aesthetically suffused relationships than the theoretical approaches just mentioned. This renders further elaboration of my proposed framework desirable. Chapter 6 takes a first stab at this challenge, turning to artworks by Martha Rosler, Nagisa Oshima, Clarice Lispector and, most recently, Pope.L. On the basis of these cases, I will probe the critical capacities of address in view of several ethically, politically, and aesthetically troubling social realities—ones having to do with matters of gender, race, poverty, and coloniality. This concluding chapter will show how modes of address by artworks and audiences can occasion shifts in existing patterns of aesthetic relationality. Quick and spotty as this précis remains, in the range of figures and motifs it brings together, it already reveals some glints of a spirited, transdisciplinary field of address studies.

At any moment, innumerable strands of address dissipate, materialize, fold into, build on, and take over from one another. Our address to address will immerse itself in these movements. It eschews comprehensiveness because address hastens onward, carrying people, nonhuman animals, and things to novel scenes and sites. I hope that the account that follows will help to incite other stories about address that will have to be told. Joining numerous partners-in-address in disentangling existing streams of address, making new currents, and fashioning different junctions, we will tease out what we have at stake in the phenomenon.

1

ADDRESSING ADDRESS

Rattling off a seemingly interminable list of rules directed at a young woman, the well-known short story "Girl" by Antiguan-American writer Jamaica Kincaid foregrounds address as a force in day-to-day life. In her poem "Vocabulary," which describes a halting exchange or, rather, a conversational breakdown between a Polish and a French interlocutor, Polish poet Wisława Szymborska likewise examines address's quotidian capabilities. Kincaid and Szymborska bring to light crucial aspects of address: its capacity to support or erode orders of relationality and human agency. Address, as Kincaid's story and Szymborska's poem suggest, fulfills these tasks, in part, as a carrier of norms and a vehicle for aesthetic meanings. Vital labors of address, then, come together rapidly in these narratives. For several centuries, these operations have also caught the notice of philosophers. I will begin with the literary pieces and then turn to the philosophy. Examining the workings of address that speak from the two narratives, this chapter documents several of address's major characteristics, namely its activities as a ground of normativity, relationality, agency, order, and aesthetic meaning. Chapter 2 will then explore the analogous roles that philosophers have given to address. Cued in by the fictional works, we will bring philosophical insights into focus. The result of these two chapters will be an initial grasp of the functions of address as a pillar of social organization.

TOPPLING A NEOCOLONIAL REGIME OF GENDERED ADDRESS

Jamaica Kincaid's "Girl" concatenates a string of rules. Virtually the whole narrative consists of directives. These address the young woman denoted abstractly, impersonally, by the title of the story. The title's reference to her could barely be more generic. Although the vernacular epithet "girl" performs illocutionary acts of calling out, naming, and conferring a gender identity, these interpellations do little to substantiate a character. Yet in the reader's imagination, the girl comes to stand out with arresting vivacity, present in place and time, in the company of other people, animals, plants, and things. She takes shape as the addressee of the precepts that keep flowing, one after the other:

> This is how you smile to someone you don't like too much; this is how you smile to someone you don't like at all; this is how you smile to someone you like completely . . . be sure to wash every day, even if it is with your own spit; don't squat down to play marbles—you are not a boy, you know; don't pick people's flowers—you might catch something; don't throw stones at blackbirds, because it might not be a blackbird at all; this is how to make a bread pudding; this is how to make doukona; this is how to make pepper pot.[1]

Aggregating pedagogical stipulations appear to be designed to turn an Antiguan teen into an acceptable or, more than that, proper young woman. Apart from what we can tell from the title, the declarations, along with a couple of interjections that may be attributed to the girl and two questions that she is asked, we learn nothing about the person she is, the longings impelling her, the perceptions giving her pause, the way she stands in the world. Avoiding storytelling, yet handing the reader rich materials for a narrative that remains to be composed, Kincaid invites us to see address at work. Her eschewal of narration notwithstanding, I will continue to call the text a story, included as it is in a collection of stories and enmeshed as it becomes with the reader's narrative contributions.[2]

Kincaid's story illustrates several philosophically pertinent facets of address. Because the rules outline behaviors that qualify as good or bad, the tale treads normative territory. The fiction thus enables us to gloss ties between address and *normativity*. Since the proclamations purport to influence the connections that the girl entertains with the persons, animals, plants, and objects in her surroundings, the story alerts us to the functioning of address as a motor of *relationality*. In view of the far-reaching scope of the social, material, and experiential concerns gathered under the mandates' jurisdiction, the text draws attention to the significance that address holds for *aesthetic meaning*. Given that

the decrees seek to govern the girl's conduct, the narrative provokes questions about the nature of her capacity to act as an independent though broadly interconnected person in the world, challenging us to clarify bonds between address and *agency*. As the rules index various types of institutional regulation marking cultural life, we are led to ponder the links soldering address to *order*.

Address runs in several directions in the narrative. "Girl" spurs the reader to reflect on the modes of address that are being aimed at its protagonist, as well as on the modes of address with which this character meets the proclamations coming her way. The paths of address reaching from rules to girl and from girl to rules unfold within a plane harboring reader and text. Flows of address that transpire between girl and precepts both feed on and fuel flows of address that occur between story and reader. By examining the trajectories of address leading to and from the girl (and to and from the reader), I will shed light on the operations that address performs, as it orchestrates modalities of relationality, normativity, aesthetic meaning, agency, and order.

From the first moment, the instructions enjoin the girl to adjust her behavior to a spatial and temporal matrix that is presumed to be in effect. This structure matches days of the week with tasks that are to be carried out and places where this must occur, while also offering a model for repeating these jobs: "Wash the white clothes on Monday and put them on the stone heap; wash the color clothes on Tuesday and put them on the clothesline to dry." The presence of a requisite order of things established, the commands that follow notify the girl of further ways in which she ought to align her actions with the codes governing the organization of everyday existence, from large designs to tiny details.

Prescriptions alternate with prohibitions ("don't walk barehead in the hot sun; cook pumpkin fritters in very hot sweet oil"). The imperatives opening the story feed into points of schooling and guidance ("this is how to make a bread pudding").[3] The novice is told how to grow okra and dasheen, how to sweep, lay the table, and behave toward others. There are lessons on sewing and ironing. The recital of duties and responsibilities goes on: alongside fundamentals of food preparation, the girl receives instructions for concocting medicines not only to cure colds, but also to terminate unwanted pregnancies. Accumulating precepts apply to the catching of fish and the bullying and loving of men. An incantatory quality pervades the story's address to the reader: requirement following upon requirement, the commands sound as if disposed to ring on indefinitely.

A principle of perpetuation runs through the actions and omissions that become incumbent on the girl, underscoring the sense of infinite accrual the list impresses on the reader: Quite a few maxims apprise the girl of specificities that erupt within the activities they ordain. Endeavors such as smiling, sweeping, or setting the table do not represent merely single kinds of undertakings.

Distinct instances of these pursuits dictate different ways of handling them. Besides the sweeping of a corner, in a sardonic multiplication of cleanings, there is the sweeping of a whole house and that of a yard, which warrant admonishments of their own. The girl must reckon with divergent standards of smiling and of laying the table that take effect, depending on the likeability and importance of the addressee at the receiving end of these chores. With each routine leading to the next and small-scale yet decisive qualifications flaring up within deeds of the same type, we see how the chain of pedagogical injunctions could in principle carry on inexhaustibly: further particularities can always yield additional requirements to which the girl will have to answer. The precepts that are actually being formulated appear to be just a fragment of a forever-expandable list of regulations.

Kincaid's text assembles specific modes of address—a series of prescriptions and instructions—that seek to regulate the girl's modes of address. There are rules about eating, speaking, walking, and singing: "always eat your food in such a way that it won't turn someone else's stomach; on Sundays try to walk like a lady and not like the slut you are so bent on becoming; don't sing benna in Sunday school; you mustn't speak to wharf-rat boys, not even to give directions; don't eat fruits on the street—flies will follow you."[4] Accumulating directives impart an equalizing momentum to the occupations they seek to govern. Indeed, whether food, sex, cleanliness, or love is at stake, or health or pregnancy, or, for that matter, looks, respectability, or social demeanor, it is all the same: these sectors of life involve modes of address that are liable to codes of adequacy that are being announced to the girl. The story's address to her address gathers these quotidian domains in a single, horizontal plane.

The exhortations that the story visits on its protagonist intimate a sexual order and a gendered division of labor. For example, besides telling the pupil to exhibit suitably ladylike forms of bodily comportment, the commands offer advice as to how she should iron her father's shirts and trousers and, as noted before, sweep the house. These guidelines attest to a distinctly gendered world that plausibly allots the task of raising girls to women. We seem to have entered a sphere of feminine agency.

Two decrees feature a first-person speaker who is intent on keeping the initiate from becoming a "slut." Can we infer, as numerous commentators have done, that this "I," who worries about the young woman's respectability, is the girl's mother?[5] Since the father in the story serves as a beneficiary of the trainee's prescribed adeptness, a mother may well adopt the place of a presumed educator, complementing and fostering the familial arrangement. Indeed, we can surmise that it is a maternal teacher who transmits to her charge her own grasp of means to expel undesired fetuses, and who hands down to the neophyte the intimate experience she has reaped with what makes for an attractive blouse ("when buying cotton to make yourself a nice blouse, be sure that it doesn't have

gum on it, because that way it won't hold up well after a wash.").⁶ As a part of her pedagogical endeavor, this tutor would be inculcating miscellaneous pieces of social and domestic knowledge. She would be relating understandings of the natural world to the youngster. Additionally, she would be in the business of rearing her protégée by supplying insights into emotional, sexual, and amorous relationships across genders. A highly proficient, multifarious maternal authority appears to be called for to fit the role we are imagining. However, the story makes no mention of a mother or, for that matter, any other female caretaker. The stipulations that the narrative puts forth float freely, held together, in the first instance, by their didactic portent.

The detached quality of the maxims strengthens our awareness of the fact that they serve to instill trajectories of address in the young woman and her surroundings. Leaving the dictates unbound to any readily identifiable source of agency that we may imagine behind them, Kincaid brings into focus their organizational role—their job of orchestrating the modes of address that the girl will be enacting and undergoing. The normative force of the rules stands out. Because the story directly addresses a "you," a person who, apart from this address and the initial hailing by the title, remains for the most part unspecified, the reader from time to time in imagination assumes the position of this addressee. Slipping into such sites of imaginative identification, we catch an intimate taste of the purported regulative import of the rules. Acts of identification and the readerly consciousness of an entreaty reinforce one another. The intense awareness that the story induces of a normative appeal being made on someone who is unswervingly being singled out, an individual who could be the reader, encourages moments of identification with the rules' addressee.⁷ These instances of identification simultaneously heighten the reader's sense of the disciplining endeavor that is taking place. Regardless of the exact impulses driving the relevant imaginative and identificatory processes, a certain openness, a remoteness from individualizing specification, the sense of a freestanding verbal presence, arise both at the level of the addressor and the addressees of the precepts. The resulting space of unmoored connectivity incites us to ruminate on the traction that norms do or don't acquire in a realm of address marked by gaps as well as linkages between people.

Gathering edicts without anchoring them pronouncedly in an addressor or addressee, the narrative foregrounds some fundamental questions about the precepts' normative status: What are the rules about? Why follow them? What fuels and grounds them? How does the language in which the rules are cast bear on their functioning? Irrespective of the answers that we ultimately might wish to provide, the powers of normativity marshaled by the aggregating decrees take emphatically as their field of operation the girl's modes of address. It is specifically the practice of the normative regulation of address by address that the story places in the forefront. The leverage exerted by the decrees applies to the

multimodal forms of address that the girl directs at language, people, places, objects, animals, and plants.

What shape does female agency take in this orbit? The forces that the rules bring to bear on the girl's modes of address gain their momentum and make their effects within a vast web of relationships. This relational network, we can assume, comprises maternal mentors and other female teachers from whom the girl learns her lessons. However, these figures appear to be surrounded by many other foci of address. Normativity, in this context, proliferates widely; Kincaid disseminates it across numerous points of agency and investment, preventing codes and standards from congealing primarily around the young woman's connection with a maternal authority figure. While arguably the narrative calls forth a mother's voice, it simultaneously decenters this presence, locating the girl in an extensive field of addressors and addressees.[8] We get a taste of what it is like to understand culture as a web of address, a web that *demands* certain modes of address.[9]

For the child or adolescent in the story, becoming an appropriately gendered woman of a certain class, race, and geographical place involves adopting the right kinds of modes of address in engagement with the modes of address coming from language, people, animals, plants, and things. This insight has implications for the role of proper and improper modes of address: these modes fulfill their functions in webs of relationships interconnecting persons, and persons and objects. Relations of this sort in the fiction revolve around, for instance, the preparation and sharing of meals: "this is how you set a table for dinner with an important guest; this is how you set a table for lunch; this is how you set a table for breakfast; this is how to behave in the presence of men who don't know you very well, and this way they won't recognize immediately the slut I have warned you against becoming."[10] Tailored to specific categories of eaters, whom the hostess addresses by way of the table and by way of the modes of address that the table directs at her visitors, this object supports connections among eaters, and among those who prepare and ingest food. The relevant relations also surround clothing: "this is how to hem a dress when you see the hem coming down and to prevent yourself from looking like the slut I know you are so bent on becoming."[11] The dress locks into regimes of seeing, that is, into given modes of addressing clothed female bodies, modes that govern sexualized social liaisons. The relations in question coalesce around love: "this is how to love a man, and if this doesn't work there are other ways, and if they don't work don't feel too bad about giving up."[12] This pronouncement effectively declares: here are some modes of address that are decisive with respect to the conduct of your amorous life; give them a try and see what happens. Don't get stuck in modes of address that prove not to be successful; instead, pitch your efforts of address elsewhere, in places where they can generate relationships of greater ardor or delight or less failure. Pertinent relations further require

keeping away flies and red ants; they imply shielding one's head against the sunlight and preventing dasheen from making the throat itch when eaten. Address engages the body in all of its material, symbolically efficacious relationships. As such, it invites quite momentous normative projects from its human participants. What glimmers here, again, is a notion of culture understood as a web of address that *calls for* certain forms of address on the part of its participants—forms surrounding, for example, the handling of meals, clothing, emotions, and other elements that carry gendered connotations.

The rules exhibit piecemeal aspects of relational governance through address. But these dimensions converge in broader, interlacing movements. Within the relational system comprising human beings, an arrangement of which Kincaid's story offers a snapshot, relationships that individuals enjoy with people, other living beings, things, and environments mediate one another. These different kinds of relationships infuse each other. They commingle, and their interweaving occasions further relational consequences. It is these conspiring effects that the directives strive to manipulate as they set out to usher the child, whom they enjoin not to "squat down to play marbles—you are not a boy, you know," on the pathway toward becoming an acceptable and perhaps even an honorable woman.

Modes of address, Kincaid helps us see, play an important part in the relational constellations that the story invites us to consider. They sustain material relationships among subjects, and among subjects and objects. More than that, they help to *orchestrate* such relations. Indeed, modes of address steer multiple, intersecting strata of relationality. We can recognize their organizational functioning at many levels in the story, including the patriarchal delimitations within which the relevant material and intersubjective relations unfold, the neocolonial social, economic, and political bracing that these relations enlist,[13] their heterosexual makeup, and the patterns of racialization that they evince. An influential font of organization, throughout all this, concerns aesthetic matters, such as the looks of articles of clothing and the tastes of foods. Address's relational productivity, in the fiction, conspicuously mobilizes aesthetic experience, form, and action. These elements pervade the relational modalities that Kincaid activates.

To bring into focus the manifold aesthetic registers in which address takes effect, I call the matrix of relationships that I have identified *aesthetic relationality*. By this I mean the aesthetically inflected and productive relationships that we bear to each other and the material world.[14] Kincaid gives aesthetic elements a prominent role as ingredients of the relational itineraries that the assembled rules aspire to establish. Such facets include the taste of pumpkin fritters cooked in hot sweet oil, the pleasurable look of a blouse or dress, and the sensory desires and aversions experienced by the body in space ("this is how to spit up in the air if you feel like it, and this is how to move quick so that it doesn't fall on

you"[15]). They also include aesthetic responses to the modes of address that human and nonhuman animals register from other persons, beings, and things. Implicitly, the rules make visible the ubiquity of these responses: we encounter instances of them in an allusion to people's reactions to the girl's manner of walking, in references to their interpretations of her squatting and singing, in an invocation of the flies' attraction to the fruit that the girl might eat on the street, and in connection with her own potential recognition of a man's bullying her. As "Girl" suggests, aesthetic practices of various sorts constitute fundamental determinants of the relationships we inhabit vis-à-vis one another. More specifically, aesthetic apprehension and response (such as people's expected impressions of and likely reactions to the girl's dress, the table she lays, and the food she makes) fulfill intricate structural roles in realizing and thwarting our relationships. Indeed, in order to acknowledge the complexities of the operative structures of relationality and address, we must recognize their aesthetic dimensions, that is, take note of the ways in which these patterns draw on and give rise to aesthetic projects, habits, values, experiences, pleasures, and displeasures.

I have argued that the commands that Kincaid's story recites instantiate modes of address that function to control the modes of address and relationship that the girl assumes with respect to others and the material world. At the same time, bundled together, the dictates to a certain degree empty each other of their ostensible force. Overwhelming in length and detail, the inventory emphatically informs the reader of the instructions' status as orders. Questions arise as to their authority. What is the point of these commands? Where do they come from? What supports their legitimacy? The girl's relation to the directives is by no means transparent.

So far I have proceeded as if the chronicle progresses uninterruptedly. In fact, it halts occasionally to make room for a question ("is it true that you sing benna in Sunday school?"), an explanatory piece of information that doubles as a warning ("you are not a boy, you know"; "this is how a man bullies you"), or an interjection by the girl. Sounding for the first time, the girl's voice answers her tutor: *"but I don't sing benna on Sundays at all and never in Sunday school."*[16] The street smarts of popular song, we are asked to believe, remain isolated from the plans of knowledge production inculcated by formal schooling. Modes of address then seem to keep to their designated location. The student's interposition—slightly out of place—registers that her behavior is in observance of the spatial and temporal strictures on which the pedagogical voice insists. Although the girl's denial that she sings benna on Sunday or in Sunday school attests to a point on which her conduct conforms to the rules, this belated testimony simultaneously inserts a distance between the precepts and her actions. Following a number of commands upon the initial question about her singing benna in Sunday school, and separated by several subsequent orders from a later

interdiction on this activity, the pupil's retort points up a mechanical aspect characterizing the injunctions. The series appears to advance at a somewhat autonomous pace. It proceeds relatively independently of what the girl is and takes herself to be about. The disjunction between the two frames of address—the teacher's and the pupil's—heightens the uncertainty surrounding the student's relation to the decrees.

Insubordination is a possibility that prescription implicitly drives home. Dictates, after all, are the kind of things one can flout. They disclose a disciplinary agenda, which also uncovers the sway held by exactly those contravening forces that appear to require regimentation. The reader's consciousness of the precepts inadvertently brings to our awareness propensities on the part of the young woman that are capable of eluding regulatory control. There is another way in which the pupil's rejoinder casts doubt on the influence of the rules.

Redundant in its twofold disclaimer ("I don't . . . at all and never"), the girl's statement reveals that the realm of dissent is no smaller than that of compliance. Each instruction hands her a potential point of rebellion. The "kettle logic" intimated by the double negative exponentially amplifies her prospects for transgression.[17] A single command may be resisted in a variety of ways. While the story's amassment of miscellaneous edicts foregrounds the normative force accruing to them, multiplication in the narrative simultaneously undercuts their power to lay down the law by suggesting correlative opportunities for insurgency. The girl's next interruption likewise incites a shake-up of the rules.

The second time we hear the pupil's voice, her interjection is even more cryptic. With the list continuing to expound how things ought to be done—"this is how to make ends meet; always squeeze the bread to make sure it's fresh"—a question all of a sudden chimes in: "*but what if the baker won't let me feel the bread?*" Ostensibly acquiescent, the student seems to go along with the directives, dutifully soliciting further instruction in the face of a hurdle that can be imagined to obstruct the process. Without missing a beat, the organ of didacticism recovers itself to wrap up the story with a counter-question: "you mean to say that after all you are really going to be the kind of woman who the baker won't let near the bread?"[18] Instantly resuming verbal agency upon the girl's intervention, the pedagogue detects a possibility for deviance from the correct path of address. Abiding by the instructions may ultimately fail to transport the pupil to the place where she ought to be. The teacher confronts the girl with the possibility of not ever becoming an acceptable or good woman, regardless of whether she does or doesn't do what she is told. The girl may be destined to be a slut; this may be the assumed default position, the place that she is being taught to address others from, and the site at which she is addressed by others.

Evidence for this organization of address appears earlier in the story. The pedagogue's counsel that "this way they won't recognize immediately the slut I have warned you against becoming" renders the margins between being

recognized as a slut and being or becoming one rather slim. The teacher leaves no doubt as to the great likelihood that the girl is going to be seen as a slut, it probably just being a matter of time before she is found to be one. The instructor's hope would be that this verdict can be forestalled a bit. Issuing rules, she helps the girl give this interval some stretch. The success verb "recognize" signals that a slutty reality has settled in, which "they" can simply tag to perceive it to be going on. Under the regime of address connoted by the rubric "slut," the girl can barely escape being seen as such.

In fact, being perceived as a slut—the label's logic appears to entail—is just a hair's breadth away from becoming or already being one. Neither girl nor pedagogue would appear to be in charge of the criteria by which she will be judged to be a slut or not. Correspondingly, both characters lack the power to create or control the norms of address that govern the setting they inhabit. Their world is regulated by preestablished norms of address. This is the field of action by which the girl is surrounded. The structure of address harboring her shouts out, as it were, from every corner and in every direction: You are a slut!

If the girl, moreover, grows up to become a person who is to be kept at a distance from the bread, she may even fail to qualify for the standing of proper sluttiness. In taking up the project of realizing modes of address that observe criteria of appropriate femininity, the girl treads a dazzlingly narrow path. This route, her tutor notifies her, is quite likely doomed to leave her without bread.

Having us contemplate the prospect that the girl is bound to become a slut, a bad or indecent slut at that, or, worse, someone who is constitutively barred from the sphere of femininity or sexual being and perhaps even that of full-fledged subjectivity or humanity, Kincaid problematizes modes of address attendant on racialized and colonial constellations of gender. The story asks us to muse on the theme of gendered address: if the chances are that the girl will never become a passable or good woman, why should she gear her address toward becoming one? On what grounds should she lend credence to a set of directives that gauge her address by unattainable standards of femininity? I would suggest that we can see the roots of the girl's suspect sexual and gender status in the operations of a racialized order of gendered address that as a rule prevents Caribbean subjects of African and/or Amerindian descent from becoming proper women, ordinarily reserving this category for whites of a certain class, while throughout retaining a substantial degree of elusiveness.[19] An internally ruptured configuration of address of this sort posits disparate sets of gender criteria. Upholding norms of black as well as white femininity, it evaluates an African- and perhaps Amerindian-Caribbean girl by ideals that, in principle, remain out of her reach, yet to which she is nonetheless required to measure up. Meanwhile this system also scrutinizes the forms of address that she undertakes, down to the minutest detail, for the subtlest signs of sluttiness or sexual aberration, judging the girl in accordance with standards that

drastically restrict the scope of admirable types of femininity open to African- and/or Amerindian-Caribbean people, and that limit the degree of commendability these individuals can expect to achieve as gendered subjects.

Kincaid highlights the implications of a divided gender scheme for the girl's position within a system of relationships brought about by address. The story examines tensions that arise in a field where differential gender codes come together, ones that pertain to the realms of supposedly adequate and inadequate femininity (the latter involving deviance within what are considered feminine domains and precincts of the human or a slipping away from those territories altogether, perhaps alongside a withdrawal from what is conceived as the sexual). These divergent gender norms remain incommensurable; they presuppose asymmetrical racial positions on the part of the individuals to whom they apply, and imply heterogeneous frames of racial meaning and embodiment in which these standards participate. In short, multiple kinds of gender criteria traverse the field of address inhabited by the girl, her tutor, and the baker. The story incites reflection on the pressures occasioned for the young woman by the confluence of such contrasting codes as these strains play themselves out in webs of relationships and address connecting these three characters and other members of the implied community in which the narrative can be imagined to take place.

Given that the story's closing question calls into doubt the prospect of the girl's ever satisfying the commands, what follows for the directives? What for the girl's relation to them? What is the power of the instructions if the goal to which they aspire is unreachable? How should the girl address an order of address that purports to orient her address toward an aim that, the odds are, she is predisposed to miss? What are we to make of a system of address that admonishes a person to adopt various kinds of address while also informing her that doing what she has been told to do will probably lead her nowhere or, at least, not where she is exhorted to go?

Before considering what these questions entail with respect to the goings-on within the story, I want to step aside briefly to spell out a philosophical implication. I have already gestured toward a notion of culture as a pattern of address that poses requirements for people. What now becomes evident is that by linking culture to address, we can bring into view the functioning of culture as a domain from which demands issue. "Girl" attests to the workings of culture as an order of address that deploys a proliferation of norms that are operative at the level of everyday activities. Over and above that, the story points to the multiple ways in which actors can address the pull of these normative standards and injunctions.

In the face of the portended futility of the mission underwritten by many, if not all of the declarations, their normative authority, to some extent, dissolves. Legislative ground drains away from the list. The orders lose a sense and

meaning that they previously seemed to have. Their significance appears to be arbitrary. Yet the story's final query also creates a new incentive for the pedagogical voice. The closing exchange clarifies that a certain degree of appropriate womanhood is at stake in the girl's relation to an ordinary thing like bread. Some passable level of femininity, not ultimately up to standards, but satisfactory with respect to the conduct of daily life, is required of her to channel everyday existence along desirable lines: she has to be able to squeeze the bread to see if it is fresh.

The story's final question inflames the threat of the girl's sluttiness and heightens the importance of averting this menace. Hence, it establishes a need for injunctions. The ineradicable risk of licentiousness warrants a perpetual attempt at discipline. The specter of the wanton woman justifies an enduring educational agenda. Kincaid depicts a cycle of—in important respects—empty rules urging her protagonist to make headway toward a continually receding goal, and to ward off a hazard that can never be dispelled. No end to this process is in sight. However, the girl is an active participant in this system of address and doubtless is well aware of the epistemic impulse on which the educator's disciplinary endeavor depends: surveillance. For self-monitoring and oversight are precisely what the decrees set out to inculcate. The student surely knows that the slightest sign of dissent or of something being out of order casts suspicion on what kind of woman she is. Her query about the bread subversively triggers the tutor's heedful skepticism.

Inciting the teacher to address the subject of the pupil's proximity to the bread, the girl lures the regulative voice into an area of address where the instructor's vigilant attentiveness fails to preserve a separation from the very domain over which she keeps watch. The pedagogue is provoked to elaborate on the bread and to engage the matter of closeness to or distance from it as an element of her (the teacher's) address; what is more, the student gets her to address the bread as a site of sexual investment. Certainly, the substance appears as an object of dubious respectability within the teacher's address. This, however, makes the bread no less attractive, and perhaps more so. The girl has planted the tutor in an eroticized structure of address in which modes of address take on equivocal relational orientations.

The image of the bread is suggestive of a basic human artifact that results from a vital kind of material creation and fulfills an elementary communal role. The productivity to which the idea of the baker and of bread-making alludes requires physical work of a sort that involves strength and delicacy. This kind of bodily activity and the edible objects it brings into existence evoke rich sensory nuances.[20] The notion of a nearness that allows for touch intensifies these phenomenal associations. The figure of the bread triggers potent tactile, visual, gustatory, auditory, and olfactory imaginings. The trope is effusively

open-ended in its implications. Connotations of a quotidian phenomenon that is integral to people's health, which the girl might put in jeopardy should she come too close, intermingle with erotic implications, ranging from an indefinite awareness of sensory desirability and physical pleasure to intimations of sexualized human body parts: vaguely intuited testes, breasts, labia, limbs, bellies. Though pronouncedly individual—an object to the senses of vision, taste, hearing, smell, and to feelings of density, elasticity, and movement, when touched—the bread capaciously subsumes a whole range of experiences and things.

The everydayness of the bread allows for a ready extrapolation of its attractiveness and its suspect nature to other material arrangements that fall under the jurisdiction of the directives adduced in the story. Likewise, the bread's aesthetic qualities—its feel to the touch when squeezed, its potentially fresh or stale taste, the mysterious materiality it represents—and the importance of putting to the test these properties through sensory experience, promptly transfer to different aesthetic domains. The ambiguous connotations of seduction and threat that attach to the bread then come to pervade the list of commands. The orders soften. A gush of delight and enticement emanating from the bread disarms the catalogue of rules. The story's final exchange locates the dictates firmly within the field of aesthetic sensation, pleasure, desire, and normativity that they address.

And this field of address is really very expansive. What Kincaid exposes is a structure of address enveloping language, people, things, plants, and animals, in the context of which particular situations and materials acquire their meanings. Basically any action can be slotted into this scheme. The bread makes its appearance after the instruction about spitting up in the air "if you feel like it" and immediately following the guideline as to how the girl should make ends meet. The regulations govern a vast realm of desire, ranging from necessities concerning material survival in an economic system to highly idiosyncratic and mischievous aesthetic wishes, from inevitabilities to the most mercurial and contingent yearnings.

In the labyrinthine picture of aesthetic desire and distaste that emerges here, who is to say what the girl should do? The voice? The baker? What grounds the injunctions? When the command that the girl wash the white clothes on Monday appears at the same level as the precept indicating how she is to move speedily so as to keep the spit she has blown into the air from falling onto her, the voice seems to be undercutting its own standing, making fun of both itself and its protégée, spurring the latter to take pleasure and getting her to laugh, in turn. An enigmatic fabric of relations and address crops up between the girl, the voice we imagine behind the decrees, the baker, and the implied members of the community.

The arbitrariness suffusing the precepts permeates not only the girl's but also the pedagogue's relation to the rules. Do the directives add up to a repertoire that the teacher could ever get right, or fully master? What of the language in which they are cast? Can the educator attain proficiency in a fund of prescriptions to be formulated in a colonial language? How far do her cultivating skills carry her with respect to the task of raising a citizen of the nation, of a commonwealth, of the globe? If the girl is most likely to become a slut, what, if anything, has prevented the teacher from doing so? Is she a slut herself?[21] What is her relation to the rules and to the "standard" non-Creole English language in which they are couched?[22] How close can she get to the bread?

With Kincaid's depersonalization of the "mother role"—the dispersal of a central maternal presence across multiple loci of address—the story also departs from the phantasmic, yet persistently potent notion of the mother as the transmitter of culture and language. The idea of the mother tongue and, more broadly, of the cultural competency a maternal agent is expected to bestow on the child comes apart in the story.[23] The legacy of imperialism in the English-speaking Caribbean, Kincaid indicates, includes a scattering across a profusion of sites of the mother's mythical authority to engender cultural continuity. Nonetheless, the fantasy remains in effect. The resulting tensions pervade the patterns of address harboring child and pedagogue. Standards of address pull these characters in antithetical directions; vectors of address are at variance with one another in the web of address they support. Girl and teacher occupy jointly a system of conflicting racialized, gendered, class-inflected, and (neo)colonial norms and forms of address. This structure, Kincaid suggests, precludes these characters' attainment of an ultimately "appropriate" texture of address to the world. But the story mobilizes the gulf separating actuality from the norm, in the given circumstances, to combat the asymmetrical ideals to which both girl and pedagogue are held accountable. The fiction turns the relevant racial, gendered, class-based, and colonial divides into a place where a variety of modalities of address and relationality can and do take off.[24]

Kincaid opens up an extensive space of possibilities between her protagonist and the orders. The young woman's connection with the rules appears to be far from equivocal; it admits of many kinds of uptake. Compliance and internalization, on the one hand, and insubordination or withdrawal, on the other, represent but a few positions within a web of relationships that also gives rise to states such as humor, seduction, and delight. The glimpse of playful rambunctiousness that shines through suggested dealings with spit and bread hints at a whole range of aesthetic actions and experiences that exceed clear-cut, one-dimensional attitudes toward a set of authoritative dictates. An altered array of norms of address bursts forth. The sphere of sensual pleasure, jests, eroticism, and bodily attraction subscribes to norms of address that are tangential

to those of adequate gender performance. Novel registers of agency come to light. New ways spring up of being alive to language and the world. Girl and pedagogue have entered into a zone where they together can set their own criteria of desirable and undesirable address. The relationships linking Kincaid's characters to each other and connecting these characters with things turn out to be pliable.[25] They appear to be liable to change as multitiered, aesthetically mediated interactions unfold. The orientations that the youngster bears toward the rules acquire a similar malleability.

Kincaid's story indicates that modes of address flowing from and toward regulations help to organize patterns of relationships. Further, the narrative attests, modes of address (such as the ones adopted by the girl and the pedagogue) acquire their capacities and limitations in the context of structures of relationality and address. Coloniality and the nation are among these systems, as are the matrices of gender, sexuality, race, and class with which colonial and national formations intersect.

Transformative possibilities arise in the webs of address that Kincaid activates in "Girl." Modes of address (such as the girl's response to the rule about touching bread) display their productivity in the interwoven fields of normativity, agency, relationality, aesthetic meaning, and order. Sizing up and handling address turns out to be a fundamental human capacity. It constitutes a crucial facet of our joint presence in the world, a dimension on which we are able to draw in order to bring about alternative configurations of language, objects, power, meaning, pleasure, interconnectedness, and bodily life.

The narrative attests to the importance of address, understood in the broad sense laid out in the introduction to this book. I have defined modes of address as the forms of signification that we direct at people, things, and places, and these entities at us and each other. Address, so conceived, includes intended as well as nonintended states. It runs prolifically both to and from things and between people. "Girl" shows the importance of this inclusive view of address to an account of the social order and to the forms of normativity and difference that order encompasses: the notion of address, as I have described it, is vital to our grasp of the sites of control and unruliness, of susceptibility and agency marking our lifeworlds, and to our comprehension of the ways in which we can negotiate paths within these arrangements while also getting them to shift.

Kincaid's testimony to the resourcefulness of address and to the intimacy of our involvement with it centers on a deflationary gesture. Diminishing the ostensible force of the precepts, the story indexes elements of fluidity in a circuit of address that is also marked as unmovable and resistant to change. An ingenious voiding maneuver on the girl's part upends a constellation of address, one that encompasses a multiplicity of forms. Yet the pliability of systems of

address does not always turn on acts of evacuation. Neither does our ability to effect changes within what we experience as restrictive formations of address invariably require emptying moves. We can trace a contrary operation in Wisława Szymborska's "Vocabulary." Staging an apparently contracted, diminished dialogical scene, this prose poem deploys a strategy of inflation instead of reduction in order to wring initially unacknowledged possibilities for interaction from a structure of address that is conceived of as confining. As in "Girl," schisms across which characters navigate registers of relationality, agency, normativity, and aesthetic meaning assume a certain malleability in Szymborska's narrative, owing to the workings of address.

REPLENISHING SEEMINGLY VACUOUS LANGUAGE

In "Vocabulary," the narrator, who we can assume is a female Polish poet, enters into a dialogue started by another woman, who is presumably French.[26] Their talk is short. They pronounce at most four very brief sentences. The poem begins with the French woman's remark, "'*La Pologne? La Pologne?* Isn't it terribly cold there?'" Having voiced these queries, notes the narrator, the French woman utters a sigh of relief.

In explanation to the reader, the narrator advances the recent increase in international communication within Europe: now that so many countries have been cropping up, the weather, she observes, has become the safest subject of discussion.[27] This theme, indeed, won't cease to occupy the narrator for the length of the poem. Following her commentary on the woman's opening questions, she offers us the reply that she would *like* to give her interlocutor. This answer, however, remains undisclosed to the French woman. For the greater part of the poem, the reader then listens in on the poet's interior monologue—a disquisition on the art of Polish writing in its climatological overdeterminations.

Going along with the national cliché that the conversationalist addresses to her, the narrator wishes to fill the woman in on the sartorial attributes that the Polish literary world owes to the weather: "'Madame,' I want to reply, 'my people's poets do all their writing in mittens. I don't mean to imply that they never remove them; they do, indeed, if the moon is warm enough.'" Having reviewed the outfit typical of the Polish poets, the narrator turns her unspoken exposé of her country's literary scene to the style and substance emblematizing the artistic production by the nation's authors. "'In stanzas composed of raucous whooping, for only such can drown the windstorms' constant roar, they glorify the simple lives of our walrus herders.'" The pastoral genre in Poland, we can infer, is marred by a climatologically induced lack of fit between form and

content of expression, compelled as it is to synthesize frenzy with the plain and quiet. Discordant emotional tonalities afflict other Polish forms as well, such as the lyric poetry of the "'Classicists'" who "'engrave their odes with inky icicles on trampled snowdrifts.'" Exalted subject matter takes the Polish writer to lowly locations. The unvoiced literary chronicle covers one last category: "'The rest, our Decadents, bewail their fate with snowflakes instead of tears.'" Adumbrating the living conditions of the poets of the latter school, the narrator concludes her mute survey by citing an obstacle that the Polish weather throws in the path of these sorrowful authors. "'He who wishes to drown himself must have an ax at hand to cut the ice. Oh, madame, dearest madame.'" The elements pose severe difficulties of expression and self-representation for the Polish writer.

Indeed, as can be expected, the narrator, a Polish poet herself, confronts her own trouble in the department of verbal communication. Offering out loud the obliging reply she wants to make to her fellow conversationalist presents a problem. The right words won't allow themselves to be summoned. She fails to recall the French word for "walrus." And she is unsure about "icicle" and "ax." A more compressed answer is in order. The work's opening inquiry ringing once more before the text draws to a close, "'*La Pologne? La Pologne?* Isn't it terribly cold there?,'" the poet's rejoinder follows in the final line: "'*Pas du tout*,' I answer icily." As the French woman had already surmised, and can find corroborated by the tone of the riposte she has provoked, it is indeed quite cold in Poland—notwithstanding the content of the words the poet offers in reply. An inane, prefabricated set of meanings seems to carry the day in the prickly arena of multicultural exchange. And yet, with the chills creeping up on the reader, might Szymborska be blocking a confident dismissal of somebody's stumbling efforts to bridge linguistic divides? It is here where Szymborska's strategy of semantic escalation asserts itself.

No matter how vapid it may initially appear, by the end of the poem the French woman's query encompasses a vast world of meanings tying art to nationhood.[28] The answer that passes the narrator's lips likewise condenses rich understandings. Szymborska's closing verse casts a freeze over the narrator's voice, stopping in its tracks the torrent of implications that the poet has unleashed without so much as uttering a sound. In the final line, Szymborska imbues the weather question with a performative force that belies the narrator's denial: the woman's saying that it is cold, or implying this by way of a rhetorical question, makes it so.[29] The narrator reverts to a glacial idiom. She adopts a chilling mode of address. It is overdetermined that she should speak coldly; this is what she is expected to do as a Polish poet. Satirically, the narrator dares the reader to hear in her answer the insignas of the putatively hypothermic "Polish" climate. In Poland it is cold, and the Polish poet assumes icy forms of address because the French woman speculates that it must be

cold there. The frosty meteorological conditions that Szymborska calls forth infiltrate the weather query that resounds in the verses. A wintry gust blusters through the sparse language of cross-cultural communication, filling the arctic plane that the poet inserts between the question and its rejoinder. It is chilly because the French speaker intimates it is. This is true, however, not for the reason she thinks it might be, as a matter of climatological fact, but on account of a linguistic circumstance: because of the ways the poet in the poem puts the language to work. Here, we see in action the compound meanings that the term "cold" assumes in the course of the women's exchange. Apparently minimalist language turns out to be mobile and prepared to absorb unforeseen implications. Szymborska infuses the adjective "cold," an item in a contracted transnational vocabulary, with an expansive semantic resonance. The word displays an unexpected power to precipitate possibilities of meaning that it had seemingly foreclosed.

Replenishing an ostensibly empty verbal symbol with unanticipated meanings, Szymborska achieves a shift in the structure of address embedding the French woman's question. The apparently harmless language of clichéd conversation displays a treacherous side. But Szymborska's semantic stratagem carries its disruptive effects further. The narrator tells the reader what she *intends* to say to the questioner. The distance that the narrator takes from her interlocutor's question ("Oh, madame, dearest madame") and the gap that she inserts between her own spoken words and her unvoiced commentary have the reader wonder whether the woman might not be navigating a similar chasm. What might she have wanted to ask the poet? What can her grappling for a topic of conversation have been about? Whence her consternation? What did her words "say"? Distilling the implications encapsulated within the woman's inquiry, Szymborska fills it with a yet more compendious space where alternative meanings may take off, ones to which the narrator herself does not necessarily have access, just as the French conversationalist grasps at most the slimmest indication of the narrator's silent reflections.[30]

"Vocabulary" levels the cosmopolitan scene of address that it sketches. Shifting its aesthetic center from French woman to speaker, the imbalanced field of global address totters, to even out in a mutual confrontation with linguistic impediments. Amplified strategies of listening and speaking appear to be called for when linguistic barriers and platitudinous cross-cultural fascinations threaten to shut down exchanges. Exposing a faltering on both sides, the text institutes a relatively egalitarian plane of interaction where we could meet these kinds of impasses with an enlarged set of norms of address. This includes norms of listening and speaking that are attentive to yearnings for address that already cross the obvious kinds of boundaries separating interlocutors from each other—even if that may not be immediately evident to the dialoguing parties themselves.

Two people, both "Europeans," appear to be talking past each other. Altogether different visions and exchanges than the ones that they convey to each other may and actually do fan out around the words they formulate. Perhaps the sheer presence of the Polish poet among the French or in an international Western European setting was enough to establish a chilly condition. This may have rendered exchanges cold. It may have frozen the flow of the conversation, stifling comprehensibility under mounds of ice. No matter how long, in the French woman's view, her country has been around or how temperate she takes its climate to be, this country yields at most a provisional, foundering frame of reference for an episode of global small talk; likewise language, the poet's preeminent medium, fails our narrator. A verbal impasse ensues. The weather turns out to be a not altogether innocuous topic for either the French conversationalist or the narrator, whose commentary reorganizes the site and structure of address from which we imagine the two characters to speak and hints at yet-to-be-invented norms of address that we can bring into being as we tarry in verbal borderlands.

To leave things there, however, would be to underestimate the powers of poetic address Szymborska grants her narrator. The icy mode of address of our narrator's pithy reply to the weather question outstrips the limitations of her vocabulary. She, in essence, puts across the lengthy answer she wishes to give. It is cold in Poland! The coldness, moreover, is a part of poetic language: it inheres in artistic form, content, and modes of production and address. Speaking *as* a poet, and as a Polish poet at that, who shrewdly handles the sorts of discrepancies between literary form and content to which she alludes, the narrator communicates the frigidity. Temperatures run subzero in a deeper sense than the French woman is aware. What is more, the narrator ensures that she and the woman are talking poetry (even Polish poetry, and in French translation, of all things), not solely climate.

On top of that, Szymborska gets the two to discuss some poignant attributes of her own art. The narrator's withheld answer both confirms and revokes the socialist realist notion of lyric poetry as a private, as opposed to properly socially engaged affair.[31] In conformity with official communist dogma, the narrator keeps her poetic/prosaic involvement with odes, lamentations, and nature imagery to herself. And yet she displays these poetic forms in their collective standing—celebrating their ties to "my people" and to schools of Polish poetry whose distinctive behaviors and stylistic principles she divulges. By engaging her narrator in a saying (the monologue) alongside a nonsaying (the monologue remains unspoken) accompanied by an indirect showing (through the curt reply), Szymborska, furthermore, ironizes a dissident dealing in hidden meanings, a practice that she at once enacts and subverts.[32] Dramatizing entrenched socialist realist tenets along with oppositional, lyrical protocols yet setting itself apart from both them, the poet's own artistic

intervention into Polish genres—which encounters the political in sites of interiority while simultaneously enveloping such interiority in the social and material world at large and highlighting tensions between individual experience and collective conditions—ends up under discussion by our two conversationalists.[33]

The duo even broaches the topic of language's standing in the natural/cultural environment and the question of the powers that poetry might bring to this. What does it mean to suggest that it is terribly cold in Poland? Does that way of seeing things presuppose a glacial form of address? How is the notion of ice at work in this judgment?

"Vocabulary" appeared in the 1962 collection *Salt*, which contains several other poems that speak to these questions about language and the material world. *Salt* includes the renowned "Conversation with a Stone." Having the narrator repeatedly "knock at the stone's front door," the object refuses to let her in over and over again. No matter how unmovably the stone rejects the narrator's entreaties, it is rather talkative and would even have had the final word in the poem if not for some subject's representation of its last utterance: another quite loquacious speaker who, ambiguously, is either the poet or the narrator, or both at once. "'I don't have a door,' says the stone." End of poem. We hear the stone's address and at the same time detect the limitations of that address, since it takes a narrator/poet to report it. We also register the limitations of the narrator's and poet's and, by extension, our, the reader's, address—the stone refuses entry; the poet shows how our own imaginatively produced "sense of taking part" in the stone (as the stone puts it) is in play in apprehending the object as a thing that can engage in actions like brushing off human demands or declining access.[34] Language here functions as an element of the speaker's (and reader's) partially imagined, reciprocal interaction with the stone. Coldness, in the sense of a mutual nonengagement between poet and object, is out of the question in this poem's take on the human–environment encounter, even if other kinds of coldness, such as the inaccessibility of the so-called thing in itself or the indifference saturating the unrestrained conceptual constructions in which we couch our surroundings permeate the interchange.

Salt also features the collage of disjointed voices speaking of matters such as time, sound, love, and violence in "The Tower of Babel." Again, the status of perception is at issue: its truthfulness, its participation in dreams or sleep, and the potentially misfiring—to others, who speak different languages, not altogether decipherable—projections we place on the material world and the polis. The question, again, is what kinds of interactions with others and contact with the world our diverse languages, our inside/outside positions, and our attempts at entry or departure can engender.

"The Tower of Babel" finally informs the concluding image of the poem following it, called "Water":

How light the raindrop's contents are.
How gently the world touches me.

Whenever wherever whatever has happened
is written on waters of Babel.

Even if the totality of what occurs to us can be marked on the streams of experience that traverse the mythical city of Babel, where this wealth of phenomena is only partially legible and transmissible to individual readers and authors, the very raindrop resting on the narrator's index finger remains light—that is, translucent, of little weight, illuminating. World history does not weigh down either drop or finger. No matter what histories the water carries or how many identities it assumes, a concrete scene of address between narrator and raindrop can allow for a delicate touch.

"Water"'s final verses sketch a reciprocal shaping of experience that remains outside the realm of possibilities for the national poet of "Vocabulary." Contemplating the drop that has landed in her hand, the narrator can reach the water without first having to grab an ax to break the ice. Language supports a mutual address between speaker and water. Szymborska contrasts their dehierarchized interaction with exchanges in "Vocabulary" where either nature or the poet dominates the other: the encounter between speaker and raindrop averts the scenario where a frosty climate unilaterally imposes whooping verses on the poet; this encounter likewise escapes the one-sided construal of the environment perpetuated by the kind of poets who "engrave their odes with inky icicles on trampled snowdrifts." Whereas Szymborska satirizes these lopsided artistic stances in "Vocabulary," she presents a more finely attuned, equipoised alternative in "Water." For the French conversationalist in the former poem to intimate that it is dreadfully cold in Poland, accordingly, is to adopt a *cold* mode of address in the sense that a subtle interplay with nature or her purported interlocutor is missing. This form of address threatens to confine the dialogue to the domain of *idées reçus*. It circumscribes an aesthetically and epistemically restrictive relational standpoint. The narrator undauntedly disrupts this formation of address.

Entering a commonplace exchange, Szymborska turns small talk inside out and outside in to produce poetry. She, tellingly, does this in the form of prose—"Vocabulary" is a prose poem. In the same gesture, she examines the capabilities and constraints that shape language's encounter with the world.

As "Vocabulary"'s reader is left to conclude along with the French woman, there is no running away from poetry's ability to make meaning happen at points where one might have given up on it. A guarded use of language that churns out predictable sayings cannot escape poetry's ability to imbue speech with a perilously uncertain mode of address.

Poetry, meanwhile, slaloms around the repetitive scripts in which the French conversationalist tempts the narrator to ensnare it. It shrugs off the nationalist hailing hazarded by the doubling direct address "*La Pologne? La Pologne?*" It deftly avoids restating what the rhetorical question "Isn't it terribly cold there?" seductively asserts in advance. If the French woman recruits language in its doubling capabilities, coaxing it to voice ideas that have antecedently been understood, poetry, in "Vocabulary," sabotages the force of this address. Yet the French woman is not the only one who exhibits a taste for parroting.

The narrator opens her desired retort with the severe appellation "Madame." This direct mode of address construes her interlocutor as a woman who is to be set straight. She would benefit from a good lecture. The narrator redoubles this pejorative gender interpellation at the end of the narrator's soliloquy, with the exasperated "Oh, madame, dearest madame." The woman's desire for chit-chat assumes the connotation of stereotypically feminized triviality. Now, the realm of the downright mundane is patently not a territory that Szymborska's poetry shies away from. Day-to-day details like that it happens to be a Thursday, "a shadow" that "skims through [the narrator's] hands," or a sign forbidding walking on the grass hold a significance that her oeuvre explores untiringly.[35] By nonetheless casting the French woman as someone who—clueless of language's vibrant and experimental currents—wields a deadening power to flatten discourse, the narrator reiterates a conventionally gendered understanding of prosaic existence. Indeed, in rejecting the orbit of pedestrian quotidian repetition, the narrator betrays her own repetitive form of address. To make matters worse, she repeats verbatim the French woman's opening queries. If tedium portends trouble, the poet-character decidedly is not above it.

The narrator's detailed, wished-for reply, however, is never vocalized. The answer that sounds instead, the icy "*Pas du tout*," deflects the typecasting force of national labels as well as gender denominations. Poetic language, in "Vocabulary," circumvents our categories' capacities to impose restrictive notions of identity. Neither the insistent "*La Pologne*" nor the adamant "Madame" achieves the obvious interpellations at which it aspires. The poem, further, shows femininity and the nation to be conspicuously in action as registers of poetic meaning, without being superseded under the banner of a difference-evading globalism or in the name of a conventionally dismissive outlook on feminized linguistic gestures. The sting of confining interpellations notwithstanding, woman and narrator initiate a collaborative exchange. They together create an icy atmosphere and engender the meanings that the term "cold" encloses at the end of the poem.[36]

A last twist in the poem's address attaches to the category of the human being and its connections to language and the world. Are we so sure that the narrator's "*Pas du tout*" simply denies that it is "terribly cold" in Poland? Just how icy is this reply? How icy is our reading of it? Both the reply and our reading of

it may have shut out relational possibilities and blocked questions. Was "*Pas du tout*," in actuality, the right phrase for the narrator to have hit upon? Rather than the exact thing to say, it may have been closer to those words she came up with for "icicle" and "ax," which she was too unsure to utter. And that uncertainty invites us to ask what it means for human beings to talk about natural and cultural conditions using such labels as "cold" or "terribly cold." Do those ways of speaking foster our being alive to language and the world or do they diminish it? If the narrator started out by razing a French woman's epistemically privileged geopolitical stance and next dislodged a gendered separation between poetry and the everyday, she is quite plausibly extending this democratizing gesture to the characteristics of poetic speech more broadly. Accordingly, she would be seeking to topple language's power to lord it over the material and social world. She, still more generally, could be favoring relatively egalitarian forms of address among human beings and their environments. The question arises then as to what that entails for the meanings of "ice" or "icy." What kinds of speech or silence can a state of iciness provoke? Where do icy speech or silence come from? What presence do we want iciness to have as a part of our sense of language, things, places, and one another? In what ways does the term "icy" link up with the world? Szymborska here probes the nature of aesthetic concepts and the experiences they can inform, engender, and organize or, for that matter, preclude.

Launching an already scripted verbal ritual, the French woman "coldly" raises a question to which she essentially provides the answer. Her mode of address is cold in the sense that it treads already understood ground. As Szymborska puts it in her Nobel prize acceptance speech, "knowledge that doesn't lead to new questions quickly dies out. It fails to maintain the temperature required for sustaining life."[37] Icily, the narrator halts this line of exchange. Together, the two interlocutors inaugurate a less frosty exchange in which neither of them can play it safe. Opening up a mutually invigorating game of shifting connections among language, speakers, and world, Szymborska converts a single rhetorical question into a whole expanse of questions and breathes new life into aesthetic states of "coldness" and "iciness."

The mutual address between raindrop and speaker in "Water" imbues the water with lightness and, conversely, affords the speaker a gentle touch by the world. Sardonically, this address at once calls forth experiential, imaginatively modulated meanings and holds off dimensions of destruction, expropriation, sexuality, and beauty that become apparent in other forms of address to and by the water (as in remarks like "O Water. / . . . you have carried off / houses and trees, forests and towns alike / You've been in . . . courtesan's baths"). Szymborska brings this duality of imaginative openness and closure to the ice in "Vocabulary" as well. As the speaker in "Water" observes, "On my index finger / the Caspian sea isn't landlocked." We are invited to take the iciness that in

"Vocabulary" penetrates narrator, French woman, language, and global interaction on a similar voyage as the speaker in "Water" does with a raindrop. And as we go that route, our address ineluctably takes on variable gradations of coldness.

◎ ◎ ◎

Wisława Szymborska's and Jamaica Kincaid's works parallel each other in the sense that both narratives call into question the powers of certain modes of address. If the story combats the efficacy of a form of address (that of a command or instruction) by detracting from the meaningfulness of that form, the poem resists the force of a mode of address (a clichéd insinuation) by heightening that mode's semantic import. Kincaid plays up language's ostensible power to control people in order to expose this capacity as in part empty; Szymborska depicts language as apparently vacuous (the French woman's queries) or deficient in its ability to make a difference (the poet-narrator's interior monologue and reply) before bringing out the resources inherent in these states of perceived poverty.

"Girl" and "Vocabulary" both activate possibilities in the fields of address harboring exchanges between interlocutors. Apparently unmovable, deadlocked structures of address display initially unsuspected potentialities for meaning and relationality. Alternative configurations of address become visible. Frames of address attendant on constellations of national culture, coloniality, femininity, materiality, and global exchange exhibit an unforeseen unwieldiness and undergo shifts. Forms of address realign in tandem with broader matrices of address. Altered sets of norms of address come into play, ones that open out onto revised sites of communicative exchange, bodily being, and registers of power.

Kincaid and Szymborska join each other in featuring characters who navigate chasms between structures of address. These rifts include pedagogue–neophyte divides, gendered colonial splits cleaving norms and codes, and linguistic gulfs separating national or regional cultural traditions. Both authors highlight the significance of human capacities to juggle disjointed elements of address and to proceed at meeting points between multiple systems of address. It is in traversing fractures between formations of address that come into contact with each other that the girl in Kincaid's story and the poet in Szymborska's poem pry loose forms of address that unsettle the boundaries and organization of established structures of address.

Constellations of address and the partially porous zones between them, as these two writers show us, are spaces in which people negotiate forms of agency, embark on or shy away from interactions with other people and with things and places, take up or hold off the normative forces pervading aesthetic

relationships, and occupy stances vis-à-vis orders of social being. It is address in the inclusive sense that I sketched in the introduction to this volume that supports these operations.[38]

Scrutinizing the capacities of linguistic modes and traversing partly contrastive perspectives on these capacities—one deflationary, the other inflationary—Kincaid and Szymborska reveal the labyrinthine, quotidian workings of address. Whether by sabotaging the power of verbal forms of address when it presents itself as formidable or by animating it when it seems to dwindle, the two authors articulate an outlook that has antecedents in Western philosophy: like this story writer and this poet, philosophers emphasize dimensions of relationality, order, normativity, agency, and aesthetic experience that they ground in practices of address. In the next chapter, we will consider three views to this effect—those of David Hume, Immanuel Kant, and Michel Foucault.

2

KANT, HUME, AND FOUCAULT AS THEORISTS OF ADDRESS

Across epochs and areas of Western thought, scholars develop stances on address. Philosophers have long grappled with facets of relationality, normativity, aesthetic meaning, agency, and order that are centered in address. This chapter will examine three moments when philosophy recruits the notion of address to conceptualize relational orders that embody norms, harbor aesthetic practices, and foster paradigms of agency. I will show how Immanuel Kant, David Hume, and Michel Foucault rely on address as a mechanism of social development and a pool of epistemic and experiential resources. While enlisting address in this constructive capacity, these philosophers charge it with aesthetic, moral, and political tasks. In this way, they begin to theorize facets of the culture-building capacities of address.

Kant, Hume, and Foucault, we will find, both recognize and neglect dimensions of address that Jamaica Kincaid's tale "Girl" makes visible. Returning at several junctures to this story, I will uncover gaps in their theories of address. These points will inform our investigations in the chapters that follow.

The cumulative force of these first two chapters will be to bring into view the workings of address as a mainstay of social organization. Lending theoretical development to the themes of relationality, normativity, agency, order, and aesthetic meaning identified in chapter 1, and to the question of culture, my account of Hume's, Kant's, and Foucault's theories of address will be selective. My goal is not to furnish a full-scale narrative of what address does for these scholars, let alone to provide an account of the philosophical puzzles lurking

behind each case. Neither will I pay much attention to the manner in which these theorists engage specific philosophical interlocutors through their distinctive strategies of address. The purpose of this chapter, in the first place, is to advance our understanding of address, building on the cues taken from Jamaica Kincaid and Wisława Szymborska.

A further aim of this chapter is to offer a historical perspective on our subject. Rather than following a chronological exposition, I will proceed from what at first glance appears to be the most restrictive treatment, one that focuses on linguistic and, over and above that, rational modes of address, to approaches that progressively take cognizance of a broader range of modes. Our discussion of the three philosophical outlooks will thus start with Kant's account. From there, we will move on to Hume and, lastly, to Foucault.

ENLIGHTENMENT AS A PLAN OF ADDRESS

Immanuel Kant defines enlightenment substantially in terms of address. In one sense, his famous essay "An Answer to the Question: 'What is Enlightenment?'" straightforwardly advocates acts of omission: the suspension of political abridgments on intellectual debate. Free scholarly discussion is to make possible enlightenment, that is, humanity's liberation from self-inflicted immaturity (*Unmündigkeit*).[1] If rational discourse is permitted to take place unrestrictedly, humans can hope to cast off their dependency on others who speak for them (*Vormünder*). They will be able to become autonomous thinkers and agents. Kant takes this change to be incumbent on us. We will have to overcome barriers that, owing to our own action or inaction, stand in the way of our ability to think and act for ourselves. Indeed, we face a moral responsibility to achieve such enlightenment. The ability and will to propel ourselves into this phase of intensified, ongoing development, are vital in his eyes to our prospects of fashioning a scheme of existence worthy of humanity. The elimination of political limits on intellectual freedom is a necessary step forward on the path Kant sees stretching out before us. But, as has been widely acknowledged, it is far from enough. A notion of spirited cultural exchange animates the enlightenment project he envisages. For Kant, the process of enlightenment amounts to a public endeavor: he imagines a form of cultivation that must be realized by a community of addressors and addressees. He enlists address in roles analogous to the ones we have seen it to carry out in Jamaica Kincaid's story "Girl": address, according to Kant's "An Answer," undergirds modalities of agency, order, relationality, normativity, and aesthetic meaning.

New angles open up in this Enlightenment text when we examine it in terms of address. While commentators, to my knowledge, have not focused explicitly

on this element of his account, a reading along these lines dovetails with contemporary strains in Kant studies. Scholarship on his philosophy has made momentous strides in illuminating the cultural conditions for enlightenment that he recognizes implicitly and clarifying the ways in which education, media technologies, and patterns of communicative interaction may foster or obstruct enlightened existence conceived on a Kantian model. Two lines of commentary have been crucial to this endeavor: First, philosophers have shown that Kant conceives of enlightenment and reason as social, historical, and political phenomena.[2] Second, theorists have ascribed various roles to the aesthetic in Kantian understandings of the advancement of enlightenment and the progress of reason over time.[3] Through a close analysis of the workings of address in "An Answer to the Question: 'What is Enlightenment?,'" I wish to further these avenues of inquiry. By scrutinizing the procedures of address Kant postulates in this essay, I will bring out the starting points he forges for lines of aesthetic agency and participation that have political bite, carry social import, and mobilize expanded possibilities for ethical interaction. Unnoted commitments and demands will appear to be cocooned within his view of culture-building.[4] Kant's essay yields important insights for the theory of address and for aesthetics. At the same time, the outlook on address he propagates is overly restrictive and calls for aesthetic critiques that embrace the full array of modes of address that we enact as addressors and addressees.[5] I will offer the figure of the *mouthly* in and beyond Kant to create space for reinvigorated engagement with the appeals that he embodies in his views of enlightenment, aesthetic and otherwise.

Forging culture and procuring a mouth of one's own

From the beginning of his essay, Kant places address at the forefront of his preoccupations. He begins his inquiry with the dictum that "enlightenment is man's emergence from his self-incurred immaturity [*Unmündigkeit*]." This adage immediately situates enlightenment in the realm of address by opposing it to a kind of "mouthlessness" or voicelessness. The unenlightened lack a capacity for a sort of speech.[6] They are not capable of fully representing themselves in official platforms for address; others must think and speak for them. Accordingly, they are to embark on a process that renders them *mündig*, an aim, philosophers have recently noted, that Kant's phrase associates with the possession of a mouth (*Mund*).[7] The term mündig, indeed, bears an etymological link to the word Mund. This lexical path, however, does not transparently run to the name for the bodily organ; it is presumed to skip the mouth on the way to the label for the hand and, yet more prominently, to the notion of protection. The Kluge *Etymologisches Wörterbuch der deutschen Sprache* derives the

adjective mündig from the archaic, feminine substantive Mund, meaning "protection" (*Schutz*) and connects it with a legal capacity for self-protection and self-representation. Kluge observes that this use of Mund, in Germanic, carries metaphorical connotations of the hand. It and other dictionaries provide a different derivation for the masculine noun Mund, signifying "mouth."[8] Even in the absence of direct etymological routes, the mouth would seem to have a special pertinence to Kantian enlightenment. Kant's reasoning suggests that humans are literally to overcome a certain inability to deploy the mouth as an organ of symbolic participation in a world of language.[9] The condition of self-imposed immaturity that he urges us to remedy amounts not simply to an unfulfilled stage of rational progress but involves a material relation to speech that has yet to be realized. This changing material engagement in speech will at the same time imply transformations in people's relationships with themselves, with one another, and with the world of things. Persons need to acquire a mouth, or a corporeal organ for verbal address, of their own. This mouth will grant them a voice: it will endow them with a faculty of linguistic articulation that is to be made a productive force within the organization of their concrete social and epistemic surroundings.[10] Enlightenment, for Kant, necessitates advancement toward distinctly verbal emancipation. We must overcome a collective corporeal impairment of an ability to speak.

Kant attributes the bodily and linguistically marked type of immaturity afflicting humanity to a lack of audacity and determination that keeps people from thinking for themselves. A large segment of the population displays a lazy, cowardly, and fearful reliance on the judgment of others. Many persons dwell contentedly in their tutelage and have even become fond of it. These flaws are to be superseded in the course of a gradual process of change, one that effects a "true reform in ways of thinking." Dispelling the obstacles that stand in the way of our using our own minds requires, in particular, implementation at the level of society of a form of intellectual freedom. At the time of his writing, according to Kant, only a few individuals had successfully cast off self-inflicted immaturity by "cultivating their own minds."[11] Crucial as these accomplishments are in his eyes, he holds that individual learning agendas cannot realize the potential for enlightenment that he discerns. Indeed, more sweeping measures are in order. The state of impeded development that he attributes to the majority of people necessitates a collective response: institutional arrangements must protect public conditions of possibility for rational discourse. Kant envisions a cultural pedagogy. He advocates an itinerary of human progress that is to be supported by political safeguards. Enlightenment, in his view, can and will result from the "freedom to make *public use* of one's reason in all matters."[12] The so-called private deployment of reason, namely the kind of reflection and expression one carries out within the confines of one's job or in the context of other limited social contracts, may be justifiably curtailed; such abridgments

of speech do not pose principled problems. In Kant's assessment, such private use of reason is an altogether different matter, however, from the public use. The latter activity, he observes, "must always be free, and it alone can bring about enlightenment among men [*unter Menschen*]." Kant's wording evinces an interest in a relational phenomenon: at issue, for him, is a process that should take place *among persons*. His description hints at a field of relationality that fans out among people, crossing the borders of distinct functional collectives.[13] Address becomes a concrete, readily legible element of the Kantian view of enlightenment once he ventures into a clarification of the idea of the public use of reason, the practice he expects to inspire such a vital cultural trajectory.

As we bring into focus the functioning of address in Kant's theory, it is important to take note of the vast import of the developments he advocates. At stake are the nature of government, the character of people's humanity, and the quality of their culture. Kant unsurprisingly predicts that the free public use of reason will lead to the advancement of "public insight."[14] But he also indicates that he expects a more resplendent chain of effects from this freedom, a more momentous upshot, a more cutting turnabout. An affective transformation is part and parcel of what he has in mind. An indolent, anxious, and satisfied deferral to others' ideas must make room for courage and a confident investment in one's own understanding.[15] The spreading of a "spirit of freedom" is to promote a process through which "[m]en will of their own accord gradually work their way out of barbarism." By training our propensity for free thinking (a proclivity Kant calls "an inclination and vocation"), he declares, we can enhance our capacity for free action. The shift in mindset that he believes we can achieve if we hone our potentialities for free thought may then also be assumed to affect governmental decision-making. With enlightenment taking off, political institutions are bound to discover that it can be to their own advantage to treat "man, who is *more than a machine*, in a manner appropriate to his dignity."[16] Formidable ethical and political achievements turn on the modes of address that are to underwrite the public use of reason. Kant's enlightenment project posits a dynamic structure of relationality, agency, normativity, and order (and, as we shall see later, aesthetic meaning) that exemplifies nothing less than civilization: barbarism is to be put behind us.[17]

Address constitutes a pivotal juncture in the trajectory that is to lead to the realization of this evolving condition. How does Kant expect address to fulfill this role? What part does it play as a dimension of the public exercise of reason? Mouthly address of various kinds would appear to suffuse the culture-building project that Kant embeds in his pedagogical view of the public use of reason. In what follows, I will examine how the mode(s) of address that he posits might function as a motor of cultivation. While showing how his ideas about address occasion newly surfacing themes and demands, I will also give him a hand in weaving his readers into the structure of address for which he makes a case.

Kant's article, as it happens, solicits readerly gestures of this sort. The text quite effectively addresses its reader in the form of an appeal to get on with the enlightening process. Positioned as an *answer* to a question under debate at the time of the essay's writing,[18] this reply is designed to propel the reader to a suitably enlightened/enlightening place. Kant incorporates an instruction into his answer. Not simply translating the Latin phrase that he declares to be the enlightenment's motto, *Sapere aude!*, he directs this imperative to the reader when he follows it up with the emphatic, augmented command, "Have the courage to use your *own* understanding!"[19] This latter injunction, we are invited to imagine, exemplifies the rational autonomy it prescribes. But in case we, for our part, fail to be persuaded to put this directive into action—despite Kant's inventive modeling of the requisite comportment for us—he makes a promise: many good things will happen if you leave the public use of reason free. This promise he backs up with a threat: if you don't leave such reasoning free, barbarism is doomed to endure. The constellation of address that he assembles (involving answers, dictates, modeling, promises, and threats) thus ingeniously bolsters his entreaty to the reader.[20] And, as he insists, we had now better get to work, in the process brazenly dispelling our infatuation with *Vormünder*—guardians or "foremouthers" (including Kant himself?).[21] I will, then, use his invocation of address as a starting point for an inquiry into address within and beyond the frame of his essay, and as an entry into the question of what his Enlightenment text suggests for a contemporary notion of culture-building.

To recapitulate, Kant understands enlightenment substantially in terms of a form of address. As I have noted, the free public exercise of reason, in his view, constitutes a prerequisite for enlightenment. Besides being a necessary condition, this public practice also constitutes a sufficient one: Kant takes it to actually be capable of producing the type of enlightenment on behalf of which he campaigns. He writes, "For enlightenment of this kind all that is needed is *freedom*. And the freedom in question is the most innocuous form of all—freedom to make *public use* of one's reason in all matters." Elucidating what this idea entails in his account, he offers the following definition: "[B]y the public use of one's own reason I mean that use which anyone may make of it *as a man of learning* [*als Gelehrter*] addressing the entire *reading public* [*vor dem ganzen Publicum der Leserwelt*]."[22] Enlightenment rests on a form of address, namely, the mode we assume as persons of learning addressing the reading public.

A host of questions immediately arise when we probe Kant's explanation: How does an addressor who adopts the mode of address that Kant foregrounds make her or his address? By what material means? In which medium? Through which conventions and forms? A key dimension of Kant's theory is that one does not have to *be* a man of learning in order to *address* others as a man of learning. In principle, anyone would appear to be able to address the public in the role of a man of learning. The gap Kant crafts between being and addressing grants the enlightenment process he champions a crucial openness: whether

or not the addressor is learned or enlightened, addressees stand to learn from the pronouncements that the addressor conveys in the capacity of a man of learning, enabling these assertions to serve as kernels around which (further) enlightenment can come to fruition. Enlightening effect, in this view, has the potential to flow liberally from countless sources.[23]

Kant creates room for democratization in the plane of knowledge. Anyone can, in principle, adopt an address as a man of learning—or so the ideal stipulates. The broadening sphere of deliberation and contemplation and the expanding field of conversation, debate, and exchange he heralds, will then also be able to permeate the mechanisms of power that we help to bring into being through the exercise of our socially embedded epistemic capacities. But the flip side of this openness is that Kant leaves untouched important aspects of the mode of address he identifies: What are the conditions that make possible an address as a man of learning to the reading public? What role is this public supposed to fulfill to make this happen? How does a public assembly of addressees come about? What standards of reading are in effect? Through what mechanisms does the reading public succeed at encompassing potential as well as actual readers? Presumably a man of learning does not always think or address other people as such, but may, as Kant implies, address them as, say, a worker serving in a specific job. What, then, differentiates the relevant kind of thought and address from other types of observation and address? In all likelihood, the criterion for address as a man of learning is not solely the targeting of the address at the reading public, for then the qualification about address *as* a man of learning would seem to be superfluous. So what orientation must the man of learning (or a person who has yet to attain such learning) assume toward the public in order to actually address it in this role? And for this address to occur, does the reading public to which the address is directed have to be capable of responding to it with understanding? If so, what does that involve?

Addressing a public as a "man of learning"

Kant provides a number of proposals that flesh out the mode or, better, modes of address he puts forth. These views offer us pointers for thinking about the questions to which his definition gives rise. The following is a list of seven of Kant's formulations as they appear sequentially in his essay.

1. [I]nsofar as this or that individual . . . considers himself as a member of a complete commonwealth or even of cosmopolitan society, and thence as a man of learning who may through his writings address a public in the truest sense of the word [*mithin in der Qualität eines Gelehrten, der sich an ein Publicum im eigentlichen Verstande durch Schriften wendet*], he may indeed argue without harming the affairs in which he is employed.[24]

2. [H]e cannot be reasonably banned from making observations as a man of learning ... and from submitting these to his public for judgement.

3. [A]s a scholar, he is completely free as well as obliged to impart to the public ... his carefully considered, well-intentioned thoughts.

4. [A]s a scholar addressing the real public [i.e., the world at large] through his writings, the [individual] making *public use* of his reason enjoys unlimited freedom to use his own reason and to speak in his own person.

5. [E]ach citizen ... would be given a free hand as a scholar to comment publicly, i.e., in his writings.

6. [E]cclesiastical dignitaries ... may in their capacity as scholars freely and publicly submit to the judgement of the world their verdicts and opinions.

7. [T]here is no danger ... if [the head of state] allows his subjects to make *public* use of their own reason and to put before the public their thoughts.

As these statements indicate, Kant refers to a variety of norms, forms, and structures, as well as platforms, of address. Sometimes he describes a relatively minimal act of presentation before a public, in which the reasoner conveys ideas and comments to this public (as in 3 and 7, where the addressor imparts thoughts to and puts them before a public, or in 1, where the addressor turns toward or directs her- or himself to [*sich wendet an*] the public). Demands for bare-bones acts of transmission and reception exist side by side with more substantial requirements for judgment (2, 6). In several instances, Kant specifies a medium of communication, such as speech (4) or writing (1, 4, 5). Addressors and addressees meet one another in structures of address in which the audience for the thinker's utterance is called upon to respond to this address with an examination and judgment of the very opinions and verdicts that are being communicated (2, 6) and in which viewpoints can be exchanged in writing. A range of forms, norms, and structures of address appears to be in effect.

Significant variability likewise attaches to Kant's delineation of the relevant public. The initial definition of the free public use of reason makes mention of the "entire reading public." Subsequent elaborations, however, omit the connection between a public and reading, or take the existence of such a link for granted by invoking writing. In one instance, Kant appears to hedge the public by speaking narrowly of the reasoner's public ("his public" in 2). But far more frequently, he suggests that the "true" and "real" public involves "the world at large" or the full assembly of all members of society (1, 4, 6, 7), which, accordingly, could be what he has in mind when alluding to the reasoner's proper public.

Kant adumbrates multiple forms of address (conveying observations; speaking; writing; reading; turning toward addressees; putting thoughts before them; submitting opinions and verdicts to their judgment). He takes such forms of address to be directed at different, presumably partially overlapping collectives of addressees (the universal public, the reading public, unspecified

particular publics). He also considers these forms of address liable to divergent norms of address (addressor and addressee both are to make judgments, or the addressor must present thoughts to the addressee; addressees must receive the judgments or thoughts being communicated to them, thereby completing the act of transmission). The arrangement of addressors and addressees, of forms and norms of address Kant imagines, presupposes extensive structures of address. Modes of address deploying various media of address come together in scenes of address that take place in platforms for address.

Kant delineates a system of address by way of the seven statements I have catalogued. What implications and requirements does this organization entail for the functioning of address?

Kantian publicity and the media of address

Scrutinizing the framework of address that Kant embeds in his construction of enlightenment, we come upon three challenges that we should take up as actors who wish to foster morally, politically, and aesthetically propitious orientations within cultural existence. Challenge 1 asks that we explore the convergence of general with more specific, empirical formations of publicity. Challenge 2 incites us to consider how we can recognize an expanded array of meanings and levels of collective organization that we mobilize as addressors and addressees, and acknowledge their divergent ties to forms of publicity. Challenge 3 insists that we democratize enlightenment by affirming the contributions of a wide range of bodily functions, including the mouthly and beyond. I will show how these three charges arise from the configuration of address in which Kant grounds enlightenment. I will also signal the resources he provides for handling them, along with the limits that attach to those resources and that, from within his theory, necessitate our building further on his suggestions, as we develop our critical visions and practices of address.

Intriguingly, Kant is not at pains to sort out the differences and relations between the various norms, forms, and agents of address he postulates. As mentioned earlier, apparently bare-bones demands for transmission and reception exist side by side in his theory with more substantial requirements for judgment; likewise, Kant makes reference to more narrowly and more broadly circumscribed audiences (notably, the reading public and the world at large). This variability leaves us with a view of enlightenment in which strands of meaning conceptualized as grounded in a universal public and as activated within specific publics coincide with one another. Address, for Kant, plays out in diverse registers of collectivity.[25] The task arises to recognize how strata of generality come together with relatively particularized, empirical constellations of publicity to shape situations of address (challenge 1).

Kant's language of the "real" or "proper" public might be taken to dispel the challenge just outlined by suggesting that publicity, in the true sense of the phenomenon amounts, for him, to a purely formal state of presentability, legibility, and communicability within a universal assembly of addressors and addressees. Kant's transcendental view of reason as a universal capacity (in contrast to his notion of a socially situated competency) indeed attests to the importance that publicity in the form of a potentially universal platform for address enjoys in his theory.[26] But this type of publicity does not encompass the role he gives to more narrowly circumscribed public realms. Kant espouses an actual historical process. He theorizes a cultivating movement that he sees taking off from concrete social and epistemic arrangements. The path of progress he traces mobilizes resources lodged in the sporadically enlightened, yet widely benighted formations of public life that he, among other cultural commentators and participants in a public (or semipublic?)[27] debate on the matter, witnesses in his surroundings. The challenge to sort out the relations between different forms of collectivity stands because Kantian enlightenment activates multiple orders of publicity.

A coincidence of forms that are general and restricted in scope also marks Kant's approach to the *media* of symbolic interaction that are to support enlightened existence. The notion of a sparse act of presentation-before-a-public appears alongside references to specific technologies of exchange, namely mechanisms of speech and writing. A brief examination of the role of writing will illuminate that of media and conditions of address more generally. From there I will turn to the activities of the mouth as a vehicle of (and obstacle to) enlightenment.

Kant posits a special bond between writing and publicity, in the sense of a potentially universal scope of address. He offers several accounts of this connection. Forging a relatively weak link, he describes the reasoner as speaking to "the real public (i.e., the world at large) through his writings" (4). Here, Kant understands writing as the presumed medium for addressing a universal public but stops short of declaring the written word a necessary condition for such address. Intimating a stronger alliance, he suggests that address as a man of learning to the universal public *implies mediation* "through [the addressor's] writings" (1). An even stronger tie surfaces in the observation that the reasoner "would be given a free hand as a scholar to comment publicly, *i.e.*, in his writings" (5, my emphasis). With this remark, Kant equates the public address that we may make in the capacity of a man of learning, with writerly address.

Kant's emphasis on writing as an instrument of exchange has an implicit corollary: for a written address to succeed, it must be received (or, minimally, receivable) by a reader. He recognizes this more or less explicitly when, in his definition of the public use of reason, he speaks of the "reading public," though he withholds elaboration of what he takes to be involved in the public's

reading, and typically leaves the point unsaid; we hear nothing about reading in the seven propositions quoted above, or in the rest of the essay. Other elisions characterize his account of the modes of public address on which enlightenment depends. Addressor and addressee must have a working knowledge of the language in which the relevant writings are cast. A system of dissemination has to be in effect. Reading and writing presuppose a facility with bodily functions and conventions that require training. Besides demanding education, these communicative practices call for tools, materials, surfaces, time.

Address here displays a crucial feature: it enlists the workings of media of address along with a whole apparatus of supporting conditions. The inexorable dependency of each mode of address on media and concomitant cultural arrangements bears on the field of participants who can adopt it. Because address recruits contingent material procedures and settings, the orbit in which it occurs keeps in step with the apportionment of these elements. This results in limits on universality.

The central role media, training, and surrounding cultural constellations play in the realization of address indicates that Kant, in invoking a potentially universal platform for address, simultaneously restricts the scope of publicity. The requisite competencies and instruments are not universally available. His appeal to writing in the same breath that he insists on universality points to impediments constraining the universal reach of the public exchanges underlying enlightenment as he imagines it. Analogous limitations on publicity surface in the many unstated conditions of possibility that must be fulfilled if the mode of address he singles out—namely, the address in the capacity of a man of learning to the public—is to take place. For instance, operative provisions regulating the intelligible use of tools and body parts narrow the accessibility and reach of the modes of address Kant identifies.

Further consequences follow from the indispensable participation of media in the very forms of address they make possible. Kantian enlightenment rallies the cultivating productivity of specific modes of address, irrespective of whether Kant calls on a full-fledged form such as the writerly or makes reference to more skeletal acts of presentation. By virtue of the need for a medium, address posits a delineation of a public and an organization of publicity. Even the quite thin, abstractly described act of putting something before a public involves a form of address that gives shape to a moment of presentation and potential uptake and to a relation between these elements. The laying-before has duration. It happens in space. It transpires among addressors and addressees. Every putting-in-front-of-a-public occurs in a setting that allows participants in the exchange to reach out to or note what they find before them. There has to be a way of getting the object that is to be set before them to a place where they can encounter it. The addressor must hand over a symbolic expression to the addressee, or let an articulation happen in a manner that allows it to be

approached, accessed, registered. The enunciator has to make something tangible in one fashion or another and render it liable to potential apprehension. The idea or utterance that she brings to the public would actually have to end up before this public. It could not be (or be only) running behind, under, above, or through the public. And it could not merely speed by but would have to stay around long enough to become susceptible to being received. The dimension of the "before" suggests that the public is imagined to be in a place where it can be addressed as a collective by what comes in front of it. Mechanisms of address undergird the process of cultivation Kant propagates. Given that we have come upon the operations of media of address and arrived at a zone where these media influence (and are affected by) relations among addressors and addressees, we unmistakably have already entered aesthetic territory—a field where aesthetic elements mediate relations among persons, and among persons and things.[28] This will become even clearer later on.

As the plethora of details and alternative courses of action that spring up here attests, numerous specific constructions of the forms of bringing-to-people implied by the movement to the before-a-public are possible. The generic type of address Kant hypothesizes is, in principle, realizable by multiple kinds of address. But a specific realization must occur if address is to eventuate. Regardless of which mode happens to be in effect on a given occasion of public address as a scholar, the actual form being adopted goes to shape the operative acts of conveyance and apprehension and the relation between these moments of the process of address.[29] This shaping contributes to the delineation of an assembly of potential addressors and addressees. More than that, it takes part in the crafting of the very threads of exchange filling the space of public interaction. Publicity derives organization and substance from the modes of address enacting it.

Every instance of address, I have indicated, involves a mode of address, and this mode of address exerts an impact on the unfolding episode of address as well as on the field of address. When Kant speaks of the address that humans make as scholars to a public, he is thus implicitly postulating the workings of modes of address that influence particular sites and planes of address. He fashions the ambit of publicity and sculpts the organization of public existence that he can claim for the forms of agency, collectivity, and address he endorses. Far from neutral, modes of address mold what occurs within the spheres in which they transpire. The relevant kind of normativity acquires a distinctive character and span of operation owing to the specific norms of address that are in effect.

A corollary of the reciprocal workings of modes of address and constellations of publicity is that the types of meaning and social organization that Kant centers around writing, speech, and thinking exist alongside many other varieties of signification and collectivity that mobilize analogous dynamics between

modes of address and delineations of public life. The writerly, speech-based, and reflective arrangements he postulates occur in parallel with arrangements surrounding practices such as concerts, exhibitions, the celebration of festivities, the construction of buildings, and the picking of fruits. Webs of relationality grounded in verbal modes of address share cultural space with patterns of affiliation based in (or fundamentally involving) other modes. These other modes can advance or detract from enlightenment. Kant's cultural pedagogy reveals gaps.[30] Eager to move culture beyond barbarism, he bypasses potential sources of cultivation as well as of barbarism.

Kantian enlightenment amounts to an ordering of relationality and address that invests specific kinds of agency with a crucial kind of normativity (ones centered in language and thought), while leaving other sorts of comportment in the margins and lending them only a reduced kind of significance (for instance, forms of being and sociality revolving around food, music, dance, sports, games, play, chitchat, jokes, gossip, etiquette, diplomacy, conflict mediation, design, and the circulation of images). While different from the types of thinking and language that Kant applauds, these practices are not easily separable from reflection and verbal articulation.[31] Moreover, culture does encompass these endeavors, and so does barbarism. How can a theory of address lend recognition to the full panoply of registers of relationality, order, normativity, agency, and affect that we bring into existence as addressors and addressees and affirm their disparate connections with forms of publicity (challenge 2)?

Attention to the media of enlightenment allows us to bring into relief a further aspect of the concurrence of general and relatively specific, situated forms of publicity that we have considered. I have indicated that neither the appeal to a potentially universal sphere of publicity nor the concrete functioning of culturally located publics is to be elided from Kant's view of address. These forces, in fact, work together. Actual modes of address deployed by agents within socially situated platforms for address are instrumental in bringing about forms of address that can aspire to universal portent. Purportedly universal modes of address help to give an addressor's engagement in specific forums the expansive reach it can attain. The evolution of print culture in the eighteenth century points to the role that media of exchange play in this dynamic.[32] Existing print cultures permit an orbit of address that extends beyond certain limits of empirical audiences; the embrace of a general public originating within concrete strata of collectivity prompts developments internal to these specific domains of publicity.

Media of address, I have argued, have a significant influence on the operative formations of public life that they bolster and in the context of which they arise. Enlightenment, as Kant imagines it, presupposes the workings of material forms of address, which underwrite its public reach. Pressing these insights further, and probing what Kantian enlightenment, approached from this

perspective, looks like, I turn to the role of the body in his enlightenment project, and in particular to the place he makes for the mouth.

Greater Mündigkeit *and/or mouthliness?*

The mouth, in Kant's theory, advances the cause of maturity, or *Mündigkeit*, and, hence of enlightenment, in the capacity of an organ of speech. But can we expect other contributions from this profoundly versatile body part? Might the enlightenment project, as laid out by Kant, do well to consider alternative, additional modes of actual and potential enlightenment of existence, flowing from the site where lips meet with tongue, teeth, jaw, saliva, throat, and other organs, substances, and cavities?

The mouth is a heightened sign of social, political, personal, linguistic, affective, imaginative, and sexual investment, and it is all these things at once, in shifting, intersectionally charged and active permutations.[33] This site of entry and expulsion, of tingles and moistness, of dry and chapped surfaces, supports an expansive web of material interconnections linking us with objects, places, people, and nonhuman living beings. Countless factors bear on the possibilities that accrue to "mouthliness" in concrete social circumstances. Both incentives to and restrictions on speech stem from myriad sources. Verbal blockages can reside in limits on being heard.[34] Exhaustion and hunger often stand in the way of speech. So do shock, trauma, and histories of epistemic devalorization. A requisite language allowing for verbalization may not yet have been devised. Physical and emotional distances create linguistic barriers. Concrete spatial and affective arrangements may make it hard to reach a place from which to speak to others, as can rules of appropriate verbal address. Contrary effects occur as well. Proximities can spark dialogues. Artworks, questions, and listening capabilities may encourage articulation, as can food and drink. Frequently, new vocabularies inspire verbal experiments, getting us to try out new ideas. These conditions—and there are many analogous ones—are contingent on a broad range of mouthly exploits that surpass the activity of speech itself. Such occupations would seem to have effects of their own on the degree of enlightenment we can attain, consequences that enjoy a certain independence from the connections linking these mouthly deeds with speech.

We do a whole lot of things with the mouth other than speaking. We eat, drink, chew, spit, slurp, smack, smoke, swallow, grimace, smile, kiss, and make love with it. Our mouth takes action when we stick out our tongues or click with them, bare our teeth or grind them in fury, display throats and palates to doctors and dentists, and apply lipstick. The mouth can cringe and growl. We mobilize it in clenching our jaws, blowing bubbles, holding needles when sewing, ripping open packages that fingers are unable to unwrap, shushing others,

or letting our jaw drop in astonishment. It may quiver or twitch rapidly when we are about to burst into tears. Often it gives away small signs of empathy. It is to the mouth that we turn when we lick our fingers to clean them or to flip pages. Sometimes we breathe through the mouth, especially when swimming. Yawns make their way through this orifice. It permits us to hum and whistle, to play trumpets, harmonicas, flutes. It grants us surfaces for touching edible and inedible substances and muscles for moving stuff around and turning it over. The mouth hosts a lively assembly of microorganisms undergoing changes of location and composition in the course of the day. A good many mouths are decorated with little rings or pins. The mouth helps us to vent belches and to expel vomit. Coordinating lips and teeth to shape a narrow funnel, we can arrange to spout noises of indifference or contempt. The mouth takes part in singing. It shrieks and sucks. With the mouth we bite into objects to soften pain or to keep from screaming out. We call on this body part to concoct sounds that transgress the limits of official vocabularies. We employ it in the creation of pronunciations and mispronunciations, with which we adorn the speech we utter. Through a delicate choreography of lips, saliva, tongue movements, interior space, and airflows, the mouth broadcasts our social status, training, positioning in gendered matrices, and ethnic/racial background. Some of the functions in which the mouth engages involve the production of language (pronunciation, and, often, singing). But the mouth, in each case, is instrumental in activities and tasks that exceed a bare-bones enunciation of meaningful language.

What place should we grant these forms of mouthliness in an enlightenment process à la Kant? How should a theory of address accommodate the asymmetries of power and status attaching to the various operations of the mouth? How do the diverse modes of mouthly comportment that we display advance the goals of mouthliness toward which we might wish to orient the efforts of a cultural pedagogy? What does cultivation look like at the level of those uses of the mouth that proceed at some distance from rational speech but nonetheless make up a basic component of our ongoing, everyday development? More fundamentally yet, what does culture amount to, considered from a perspective that recognizes our many forms of mouthly participation (and nonparticipation) in it? What desirable genres of cultural transformation come to light if we broaden our understanding of the corporeal practices and meanings that can and do make for enlightenment? While Kant outlines avenues toward a democratization of enlightenment, a more comprehensive, egalitarian vision of moral, political, and epistemic change should acknowledge the culture-producing possibilities of a wider array of bodily functions (challenge 3).

Kant's instruction manual on enlightenment yields several challenges for a theory and practice of address. I have brought out the need to think through the workings of multiple registers of publicity, to recognize the manifold

meanings and levels of organization that we activate as addressors and addressees, and to achieve democratization by way of an expanded understanding of our bodily comportment. The project of enlightenment Kant envisions, which revolves around a cultivating form of public address that he endorses, charges contemporary agents with these responsibilities. Meeting the formidable entreaty he extends to us in his Enlightenment essay involves engaging this triple challenge. What, reading his directives through present-day lenses, should we ask address to do to in order to realize the kind of enlightened culture to which we should aspire? And what does the pedagogy of culture to which he alludes tell us about a contemporary view of address? The following section briefly takes up these questions.[35]

Publicity, culture-making, and aesthetics: Implications, demands

Address holds momentous importance for Kant. He places vital stakes on the address to the public that human beings adopt as "scholars." This type of address is responsible for the realization of enlightenment. Indeed, in Kant's theory, enlightenment resides in an order of relationality, agency, normativity, and (aesthetic) meaning that he organizes around a mode (or set of closely affiliated modes) of learned address.[36] The system of address he sketches exhibits a coincidence of forces of address geared toward a universal public and states of address based in more narrowly delineated, actually existing webs of publicity. I have argued that a fundamental ground of constraints limiting the public scope of address is to be found in the shaping impact that modes of address exert on the scenes and settings of address in which they arise. We thus have reason to retain Kant's implicit insight that points of contingency collaborate with schemes of universality in molding forums for public address.

The view of address that comes to the fore here provides a blueprint that renders legible varieties of normativity and agency without reducing them to a single type. It is capable of bringing out how normatively inflected registers of collectivity and meaning materialize as we engage in divergent, intersecting contexts of publicity. Besides alerting us to systemic operations, an approach that acknowledges what happens in the plane of address helps us to muster the flexibility we need in order to recognize the manifold permutations of address that shape our various culture-building endeavors.

While Kant focuses productively on address, the complexities of this phenomenon surpass his explicit notion of enlightening address and enlist a wide array of aesthetic registers. The concept of address is an especially useful theoretical tool in contemplating cultural formations because it subsumes linguistic as well as nonlinguistic modes of signification and exchange. But this does not mean that all forms are on the same footing. Modes of address carry uneven

normative weight and implement asymmetrical vectors of power. The words of individuals situated in dominant positions typically have more clout than those of other persons. Turning to language, we activate different forms of energy and influence than when we give hugs, make drawings, play the trombone, bake bread, or plant trees—practices that instantiate distinctive patterns of collectivity. In reflecting on the ways in which strands of generality work together with particular empirical constellations of publicity to shape scenes of address (as demanded by challenge 1), it is therefore crucial to recognize that instances of address do not achieve equal outreach to ostensibly universal forums, nor, for that matter, to particular collective frames. Some formations of address serve readily as models that appear general in scope and applicability; others do not. Westerners tend to grant disproportionate leverage to modes of conviviality associated with white, masculinized European traditions, such as types of oil painting, over and above forms connoting Native American feminized practices, such as genres of basket-weaving. Systemic, interlacing parameters of social difference affect the range of operations we allow modes of address. Address to certain groups smoothly translates into address to a purportedly universal public or to multiple concrete publics, while address to other constituencies tends to remain (or be perceived as) largely or comparatively specific and local. Kant's discussion of enlightenment intimates a notion of culture-making that ascribes a role to idealized forums of publicity, conceived as assemblies of general subjects, as well as to concretely situated, empirical gatherings of subjects. This notion invites us to see traces of each configuration in the other. Though Kant refrains from contesting fundamental power differentials that he incorporates in the trajectory of enlightenment he envisages, he is clearly concerned with fostering cultural stratagems that enable us to critically challenge received formations of epistemic authority and social control. He formulates a plan of cultivation that implicitly asks a great deal from address and the aesthetic.

Seeking to gear the operations of address in the direction of greater insight, or more advanced understanding, Kant privileges the enlightening capacities of rational debate encoded in the dimensions of speech, writing, and reading but neglects the prodigious range of other forms that indispensably contribute to the progress of learning.[37] By reading the mouthly in an optimally expansive sense and working this effusive orbit of bodily movement, longing, experience, things, and action into the Kantian *mündig*, we can take steps toward repairing this omission. Recognizing and enacting the multiple paths along which mouthly conduct and other bodily and aesthetic practices contribute to culture-building, we can make headway on challenge 3—democratizing the enlightenment project by acknowledging the cultivating possibilities of a broad span of bodily functions.

An affirmation of the abundant potential of the mouthly also constitutes progress on challenge 2, which asks for recognition of the plethora of registers

of relationality, order, normativity, agency, and affect that we generate, and impresses on us the need to take account of the disparate connections that these modalities entertain with forms of publicity. Mouthliness supports many webs of relationality (e.g., amorous bonds and legal contracts); it participates in a variety of orders of address (e.g., trade agreements, dental routines, medical regimens, and dietary habits).[38] The mouthly implements multiple facets of normativity (codes of etiquette, standards of pronunciation, criteria of attractiveness, rules governing the pathways of edibles and spit); it undergirds aspects of agency (movement, touch, object-oriented action tendencies, desire, aversion, pleasure, pain) and shapes the contours of various affects (displaying smiles and signs of worry that inform social exchanges). All these modalities of mouthliness, moreover, enter in divergent ways into constellations of publicity.

In the mouthly, we encounter a profusely aesthetic phenomenon that lends invaluable contributions to cultivation. The mouth instantiates a prolific repertoire of aesthetically primed itineraries of address that we bring into being. These include pivotal ways in which we take care of ourselves and others, seduce, repel, love, or violate one another, and bring materials within the limits of the body or drive them out. Aesthetic elements pervade the modes of address that we assume as mouthly creatures. An organ of aesthetic activity, the mouth is a font of critical as well as uncritical impulses. Ample possibilities suggest themselves for thinking about the culture-building propensities we embody in the ambit of mouthly address. To lend recognition to the cultivating capabilities the mouth sustains, we need to comprehend the mouthly in its aesthetic functioning. Fulfillment of the three tasks or challenges I have formulated demands an approach that takes note of the aesthetic operations of mouthly address. Indeed, in virtue of his figuration of address and, specifically, his vision of a cultivating itinerary of address that is shaped by norms, forms, media, and forums of address, Kant has embarked on an aestheticization of enlightenment, a venture that he implicitly asks us to carry further. We, here, see how, considered from the perspective of address, his view of enlightenment effects a broadening of the scope of his aesthetics, beyond what it usually is assumed to be. He alerts us to powerful aesthetic potentialities: resources that he, by the force of his argument, makes it incumbent on us to develop more fully, in excess of the limits of his own account. Implicitly grounding an approach to social freedom in collectively emerging forms of address—signaled here in the form of the purportedly mounting freedom of a progressively enlightened/ enlightening society—the expanded Kantian aesthetic vision we have distilled at this point also opens out onto an enriched and revised notion of freedom, conceived of not solely as rational autonomy and self-determination but understood as fundamentally involving social and aesthetic bonds.[39]

In reflecting on the contributions that address can and should make to present-day pedagogies of culture, we will have to take cognizance of the

immensely diverse range of corporeal and material resources infusing our culture-building endeavors, including aesthetic affordances and proclivities. More than that, we face the task of meeting with critical modes of address the asymmetries embodied in historically established patterns of enlightened/enlightening exchange. Both Kant and Jamaica Kincaid participate in this project. They approach intermingling structures of address with strategies of address that expose ethical and political deficiencies. They also make claims on their readers' modes of address. Kincaid leaves this appeal implicit; Kant formulates explicit moral requirements and outlines an at once social and epistemic and, as we have seen, aesthetic process in the course of which further moral demands can come to the fore that subjects will then have to address. A combination of implicit and explicit, actual and projected solicitations also pervades David Hume's account of border-crossing itineraries of address, which predates Kant's discussion of enlightenment by about thirty years.

A CONDUIT FOR AESTHETIC EXPERIENCE

The essay "Of the Standard of Taste" is a foundational text in aesthetics. In this piece, Hume develops criteria for appropriate aesthetic experience and judgment. By means of these, he delineates a field of practice that is widely regarded as the aesthetic domain, an area of activities featuring distinctive kinds of perception, meaning, and value. While Hume's notion of aesthetic judgment has been studied extensively, a remarkable fact has escaped his commentators' notice: his view revolves around a scenario of address. Reflecting on works of culture *"addressed* to the public," he fundamentally grounds the aesthetic in address's workings.[40] Why does Hume turn to address? What work does it do for him?

The skeleton of his theory is simple: address runs from addressors to addressees and back. A lot happens within this elementary scheme, however. As I will show, Hume fills out his basic plan of address to account for art's culture-building capacities and to circumscribe a progressively evolving, enlarged global sphere of aesthetic perception and creation.

Hume's basic scheme of address: Coordinating creation and reception

At an elementary level, Hume imagines a two-way street between speakers and audiences. He enjoins the former to adjust their modes of address to the dispositions they can expect to encounter in their publics: "An orator addresses himself to a particular audience, and must have a regard to their particular genius,

interests, opinions, passions, and prejudices; otherwise he hopes in vain to govern their resolutions, and inflame their affections." Hume implicitly posits a norm of address to which he holds addressors accountable: a speaker should tailor her address to the predilections of her audience so as to make an impact on that audience's viewpoints, emotions, and decisions.[41]

Like speakers, audiences must comply with norms of address. Cultural productions, for Hume, imply standpoints of observation. In his words, they presuppose "a point of view," in which the perceiver should "plac[e] himself." The listener, spectator, or reader must adopt this experiential position in order to adequately apprehend the work. Hume explains that "every work of art, in order to produce its due effect on the mind, must be surveyed in a certain point of view."[42] To make a suitable response to an artwork, one that allows for an appropriate kind of comprehension and a fitting verdict, an audience, according to Hume, has to calibrate the modes of address that it directs at the artifact by reference to the observational stance that the object entails. He holds audiences accountable to norms of address.

"Of the Standard of Taste" presents a model of address that seeks to attune the modes of address that artists embody in their works to the modes of address with which audiences encounter those objects, and the other way around. Hume envisages a reciprocal coordination between forms of artistic creation and reception. Further substantiating the scheme of address he outlines, he grants it cultural portability. He places it at the foundation of a paradigm of agency that spans national boundaries and historical epochs.

An enlarged plan of address

One of Hume's major goals in "Of the Standard of Taste" is to account for understandings and judgments of artworks that originate in different times and places than the perceiver or critic who is experiencing these works. In his estimation, as I have indicated, observers must adapt the modes of address that they direct at an artwork to the perspective that the work implies. They can do this by actually or in imagination "placing [themselves] in that point of view." This requirement has implications for those who do not belong to the audience for whom the work was designed. In an effort to theorize interpretations of works that cross bounds among disparate audiences, Hume contemplates the case of an oration that a speaker has targeted at a specific constituency, yet that meets with listeners, readers, or spectators situated in other locations and periods. He asks these observers to set aside their differences from the work's purported audience: "A critic of a different age or nation, who should peruse this discourse, must have all these circumstances in his eye [the receptive propensities characterizing the discourse's designated audience], and must place himself in the

same situation as the audience, in order to form a true judgment of the oration."[43] In this statement, Hume appears to refer to a specific kind of historical audience, a socially situated body of observers. The interpretive propensity on the part of observers to shift to a suitably modified point of apprehension (here associated with a concrete public that is being singled out by a cultural production and producer) is to make possible appropriate aesthetic experience beyond narrowly circumscribed boundaries.

Published in 1757, Hume's disquisition on taste appeared at a time in which the public sphere in Britain and other European countries underwent rapid expansion, a development precipitated by the rising middle classes. International commerce was growing. Philosophers and political economists had generated a discourse on the compatibility of consumption, trade, and wealth with moral virtue and, we should add, aesthetic value.[44] Though philosophers of art typically approach "Of the Standard of Taste" as a stand-alone discussion, we can fruitfully see it as part of the current debate. The piece marks a transitional moment characterized by overlapping formations of address: Hume's remarks about works addressed to specific publics go in tandem with comments about works addressed to a general public. While he clearly understands these dual audiences as interconnected, Hume—like Kant in his Enlightenment article of a little less than three decades later—stops short of sorting out the relations between the two. Even if, in the end, his view of the relevant links remains fragmentary, however, Hume's treatment of address informs what to this date remains a profoundly influential approach to this intricate normative area.

In addition to providing a commentary on address and an account of a structure of address with which he makes a contribution to a raging polemic about the ties between virtue and commerce, Hume offers a further intercession into the cultural configurations surrounding his text. Indeed, the essay's address to its own aesthetic setting strays from the descriptive mode in a manner that confers rhetorical and evidential support on Hume's case. Besides explicating an apparatus of standardized taste, the philosopher ventures to institute such a system in a social context that already features elements of this practice, yet that in his eyes falls short of what such an arrangement might look like and therefore necessitates a revised organization. Taste for him is a propensity that we should be concerned to refine; the text "Of the Standard of Taste" itself participates in this polishing process. One of the ways in which Hume, as I argue elsewhere, absorbs his reader into this progressive enterprise, which he takes to evolve over generations, is by recounting—in the present tense, marked by his own emendations, and partially in a free indirect style—a wine-tasting parable that he derives from Cervantes: he supplies an aesthetic morality tale that itself engages in a direct address to his own public. In describing a duo of at first direly underestimated but soon to be properly authorized, indeed

outstanding, judges of wine, the text makes a direct address to the "you" to whom Hume is presenting his standard of taste: "You cannot imagine how much they [the pair of judges] were both ridiculed for their judgment. But who laughed in the end?"[45] This remark raises the stakes for his audience: will we be on the right or wrong side of laughter? How do we make sure to eventually laugh ourselves rather than serve as the object of others' hilarity? Through his sassy, snide, and crafty—partially direct, partially indirect—mode of address, Hume entangles divergent epistemic positions with each other, which results in a merging of voices that includes his own and the reader's.[46] On the one hand, he offers us his standard of taste for our consideration and persuasion; on the other, he attempts to seduce us into a world where this standard is already in effect to a substantial degree. He not only embroils us in progressively improving aesthetic judgments of wine and evaluations of wine criticism, but also in laughter at comic scenarios, in assessments of what is funny, and in a sneer at those who think they can mock others whereas they, themselves, should be the butt of the amusement. In short, Hume sets out to envelop his readers in a matrix of taste in which certain people and objects enjoy an aesthetic authority that others lack.

Part of the strategy of address of "Of the Standard of Taste," I have suggested, is the attempt to establish a distinctive aesthetic order. Hume aspires to the implementation of a model of aesthetically appropriate relationships among individuals, among individuals and objects, among objects, and among cultures. Within this schema, observers, creators, and cultural productions occupy positions marked by variable degrees of excellence. We will become capable of distinguishing the successful makers from the flawed ones and of separating out the dross from the gems in the realm of art. Rank orders arise that offer people and things locations vis-à-vis graded—within each artistic genre, mutually comparable—measures of beauty or artistic goodness, ugliness or artistic deficiency.[47] Hume's essay is thus notable not only for its commentary on the role of address in delineations of aesthetic experience, but also for the interventions that the text, by way of its own strategies of address, purports to make into the sphere of taste: the piece educates and inculcates the reader into the very system of address that it theorizes and valorizes. This acculturating enterprise, moreover, has a rhetorical efficacy. It serves to lend increased plausibility and desirability to the account Hume develops. What, then, to resume our discussion of the essay's proposed model of address, are those precise mechanisms of address into which the text's pedagogical effort seeks to enmesh us?

Having mapped out a basic, reciprocal scenario of address between artists and observers and noted that outsiders to the specific audience to which a work is directed should imagine themselves in the position of that audience, Hume goes on to discuss cultural productions that are aimed at "the public." In such

cases, he proposes an allegedly analogous, yet markedly different appreciative requirement:

> In like manner, when any work is addressed to the public, though I should have a friendship or enmity with the author, I must depart from this situation, and, considering myself as a man in general, forget, if possible, my individual being, and my peculiar circumstances. A person influenced by prejudice complies not with this condition, but obstinately maintains his natural position, without placing himself in that point of view which the performance supposes. If the work be addressed to persons of a different age or nation, he makes no allowance for their peculiar views and prejudices; but, full of the manners of his own age and country, rashly condemns what seemed admirable in the eyes of those for whom alone the discourse was calculated.[48]

Discussing first the situation of address to "the public" in general and invoking the figure of a universal subject, this passage returns rapidly to the workings of more narrowly delineated forms of address, ones taking place in different historical and geographical locales than the observer's own era or nation. A prejudiced interpreter fails to transpose himself from his customary setting to the position of a general observer through abstraction from his particular conditions, doggedly fixed as he remains to his parochial perspective. Thus he cannot enter into a different outlook. Perceptions at which this recalcitrant character arrives are aesthetically flawed. In Hume's eyes, the unmovable perceiver's refusal or inability to adjust his appreciative address to the viewpoint implied by the work discredits his aesthetic experience and evaluation of the object. Expounding on the error of prejudice, and returning to the case in which a work is "addressed to the public," Hume continues,

> If the work be executed for the public, he [the prejudiced observer] never sufficiently enlarges his comprehension, or forgets his interests as a friend or enemy, as a rival or commentator. By this means his sentiments are perverted; nor have the same beauties and blemishes the same influence upon him, as if he had imposed a proper violence on his imagination, and had forgotten himself for a moment. So far his taste evidently departs from the true standard, and of consequence loses all credit and authority.[49]

Aesthetic apprehension goes to ruin in the case of the stubborn observer who sticks to his usual ways. Hume calls for a disinterested mode of perception on the part of the perceiver: specific interests are to be forgotten if appropriate aesthetic experience is to be had. Necessitating imaginative acts as well as endeavors to block and channel the imagination, the experience and transmissibility

of artistic qualities and goodness beyond the bounds of particular audiences presents interconnected requirements for perceivers as well as for creators of artworks: "We may observe, that every work of art, in order to produce its due effect on the mind, must be surveyed in a certain point of view, and cannot be fully relished by persons whose situation, real or imaginary, is not conformable to that which is required by the performance."[50] To create an artwork that can be enjoyed to the utmost and have a suitable impact on its recipient, a maker must orient it toward an appreciative stance that perceivers are able to muster, assisted by their imaginative capabilities. Such observers, for their part, are enjoined to summon an experiential position that the object demands from them. The success of this scenario depends on two parties' compliance with the norms of address that the work activates: the maker is to design the object so that it can achieve "its due effect on the mind" and so that observers can potentially render their situation "conformable" to the situation the object posits; the work occasions an appropriate response by soliciting "a certain point of view" to be mustered (even if partly in imagination) by the observer. Disinterestedness, as an achievement on the part of aesthetic observers whose perceptions are, to a considerable extent, guided and motivated by interests, depends on a stance of address.

Norms of address, in Hume's account, gain a certain independence from makers' and observers' actions and intentions, and from the exchanges that, actually and potentially, ensue among these actors. Hume grounds such norms substantially in works. Artworks and other cultural productions both occasion and answer to standards of address: these artifacts outline a "point of view" for audiences, from whom they are to attain a "due" effect. The coordination of modes of address Hume theorizes involves a delineation of an orbit of agency and normativity for the artwork that is not reducible to the field of norms and action enfolding the work's makers and recipients, even if these two spheres are mutually implicated in each other. The work plays a part of its own in choreographing the exchanges that make up cultural life. We witness here the emergence of the work's status as a public object. This standing exceeds the address that ties the work to a specific audience, defined and confined by its particular historically and geographically delineated characteristics and by its receptive propensities. Hume installs works in a position shaped by a reciprocal attunement of divergent modes of address. The resulting orchestrated and synchronized pattern of address that harbors works underwrites the possibility of aesthetic publicity in a broad, border-defying sense. A work's public character consists in part in the materialization of norms of address that are in effect for creators of works and for observers conceived in general terms. Hume understands such observers not (or not exhaustively) as bound to specific groups at which works may be directed, although this orientation toward delimited

publics has a place in his theory. By contrast, these observers, for him, function as members of a universal public: namely the assembly of participants to whom he refers with the label "man in general."

Address as a motor of cultivation: Aesthetic gaps and glue

A complex structure of address surfaces. Hume turns to address in order to theorize the interactions between the maker of a work, the work itself, a specific audience or set of audiences, and what he takes to be an, or even *the* general public. More than that, he emphasizes facets of address in order to articulate conditions that grant artworks transmissibility across geographical locations and historical periods. Address undergirds a vast swath of social practice in Hume's account. The scenarios of address he chronicles function as a stretchable paradigm of cultural exchange. To recognize the full scope of the ambitions he attaches to the scripts of address that he proposes, it bears calling to mind the broader project of "Of the Standard of Taste." The essay's focus is on the nature of taste. Hume sets out to clarify how we can reach agreement on verdicts of taste, enabling us to valorize or devalorize specific critical evaluations. His goal thereby is the dual one of accounting for the grounds on which the artistic adequacy of cultural productions may be determined and of providing criteria for assessing the validity of perceivers' interpretive responses to these artifacts.[51] Address, for Hume, turns out to be key to these two interconnected objectives: it yields a foundation for aesthetic judgments and experiences that attain the authority to pronounce on the artistic qualities and values of works of art and culture.

Hume uses the notion of address to delineate the contours of a domain of aesthetic experience. He situates makers of cultural artifacts in relations of address with recipients of these objects, relationships that are formative of the objects' characteristics while also being mediated by them. Unfolding within existing sites of public exchange, these relations foster structures of publicity that are in the process of arising within and beyond the limits of distinct spatial and temporal settings. The joint coordination of modes of address among speakers and publics that Hume propounds is an ingredient of the expansive cultural propensity that he denotes with the concept of taste. The reciprocal scheme of address that he lays out takes effect in the field where he sees taste at work. Via this connection with taste, the pattern of address that he weaves around works of art and culture gains a far-reaching presence in people's lives, both at the level of the nation and the individual. This becomes clear if we take a brief look at the role he attributes to taste in the organization of society.

Taste, in Hume's view, feeds into and benefits from refinement in the arts and sciences.[52] His notion of refinement resonates with the idea of the fine

arts—both his and ours—but is broader than that. By "refinement," Hume means a relatively high level of value or fineness that, in his opinion, generally results from an extended process of fine-tuning or cultivation.[53] In consequence of this process, the admirable property of refinement can be predicated of certain individuals and the societies in which they live and come to be embodied in objects and practices. Hume understands the proclivity of taste as a vital source of this progressive development: both fostering refinement and absorbing existing levels of it, taste pervades refined and refining dispositions. Not surprisingly, then, he finds the faculty of taste at play in the promotion of commerce. Boosting a traffic in ever-more-refined/refining objects, the proficiency is able to generate further tastes.[54] Its prospering has all-around beneficial effects. Taste supports the attainment of a free, spirited public sphere; it spurs freedom of government and promotes the well-being of the nation. It boosts virtue, individual productivity, and pleasure. It enhances personal liberty by granting the man of taste increased levels of autonomy and control over his experience of the people, things, and events with which his surroundings confront him. The capacity of taste encourages knowledge and nurtures a state of social and material excellence that Hume labels "humanity." It stimulates the emergence of cultivated social relationships. In short, taste promotes civilization.[55] The elaborate functions with which Hume invests taste transfer to the structure of address that, in his account, makes up the core of this faculty.

As I have shown, Hume organizes the workings of taste to a considerable extent around a template of address. He holds modes of address responsible for normatively laden, mutually responsive creative and interpretive interactions that exceed narrowly delimited epochs and locales and afford increased levels of public and private freedom. For him, aesthetic normativity is substantially a matter of norms that are in effect for acts of making and uptake. Taking place in the interval between speakers and audiences, address instantiates a fabric of interactions between these poles. Norms of address governing these exchanges aspire to the realization of a potentially valuable, coordinated ensemble of modes of address that occurs between addressors and addressees. The relevant modes reach beyond the bounds of distinct publics and sites of production. By positing norms of address to which he holds acts of production as well as reception accountable, Hume fosters expanding possibilities for aesthetic meaning-making, collaboration, and culture-building.

Suitable aesthetic observations, in Hume's account, can and must reach beyond given circles of affiliation and engagement, though these perceptions, as theorists have argued, are not only unevenly accessible to individuals and groups along lines marked by people's positioning in matrices of race, class, gender, and other categories with which these modalities intersect, but also reflect systemic operations of social difference at the level of their contents and structures.[56] Accordingly Hume's claims about publicity and enlarged perception

must be considered in this light. Although pervasive social asymmetries impose powerful systemic limits on the scope that he grants aesthetic experience, he enlists the resources of an expandable plan of address in the service of an evolving, boundary-superseding, purportedly liberty-augmenting order of relationality and agency. The mutually attuned strands of address that he theorizes fuel the wide-ranging field of activity and engagement that we call culture while also establishing restrictions on, skewing, and hampering these affordances.

Hume weaves address into the foundations of aesthetic experience. Reflecting, in "Of the Standard of Taste," on works of culture "addressed to the public" as well as to particular audiences, he forges a scaffold of address around which he models processes of aesthetic production and interpretation. He holds these productive and interpretive practices accountable to standards of adequacy. Requirements regulating acts of creation and reception assist him in envisioning a domain in which normatively marked paths of meaning-making unfold. Creative and receptive lines of address become liable to norms of address: Hume formulates criteria governing the forms of address that cultural producers and productions direct at their audiences; additionally, he describes criteria regulating the modes of address that observers gear toward aesthetic artifacts. With the help of these two sets of norms of address, Hume traces an emerging field of normativity. A web of aesthetic relationships materializes that stretches out among humans (from artist to observer, listener, or reader and back), between humans and things (from artists to objects and objects to perceivers), and from things to things (cultural objects admit of comparative valuations and, according to Hume, evince variable, ideally increasing levels of refinement—as noted before, high value or fineness). Multiple trajectories of address come into being in this plane. Signaling such itineraries, Hume renders address a crucial mechanism of art's public functioning. Implicitly he sees it as a pivot for the kind of cultural life to which we ought to aspire.

Hume's ambitions for his envisaged modes of production and reception are global: standards governing our address to cultural objects, in his view, are to enable appropriate aesthetic perception across spatial and temporal intervals. Social asymmetries among makers and observers make their effects within Hume's vision of address. They reverberate in his picture of those who can and cannot attain the educated sensibilities that admit of adequate aesthetic perception, and leave their marks in the modes of address that qualify as suitable or unsuitable. Nonetheless, even as address embodies gaps between the appropriate and the inappropriate, between taste and a lack thereof—splits that he actively seeks to install in society and manipulate through his own deployment of address vis-à-vis his reader—it functions as cultural glue. Implementing divides and installing bridges, address underwrites an enlarged global sphere of aesthetic perception and creation.

Hume invokes address in its capacity as a bedrock of normativity, order, relationality, agency, and aesthetic meaning. He shares this approach with

Immanuel Kant and Jamaica Kincaid. Like Kincaid's bread and Kantian mouthliness, taste, for Hume (which can be good or bad and stands in need of continual training and improvement as increasingly refined artifacts are being produced[57]) occupies a zone of ambiguity: the bread, the mouthly, and taste each conjoin commendable as well as presumably discreditable tendencies. Hume and Kant respond to the mixture of praiseworthy and objectionable social and epistemic conditions that they observe in their times by theorizing cultivating trajectories that, in their views, are to be fostered by distinctive patterns of address.

While Hume devotes more attention to the fine-grained mechanics of address surrounding concrete material objects than does Kant, both philosophers side together in the attempt to locate expansive, coordinated streams of aesthetic address at the center of a flourishing, freedom-fostering, potentially global culture. As I have begun to suggest in my discussion of Kant, constellations of public and private, global and local address take on more diversified forms than his perspectives and, I should add, Hume's approach suggest. In a similar vein, as Kincaid's story intimates, questions about the scope, the contextual groundings, and the normative underpinnings of cultural developments outstrip in intricacy the processes that these two philosophers recognize.[58] Nonetheless, Kant's and Hume's outlooks pinpoint a theoretically significant convergence of elements of normativity, relationality, agency, order, and aesthetic meaning in the phenomenon of address. Their views signal a set of concerns that remains crucial to our present-day reflections on principles of division and possibilities for alliance across cultural differences, including the gender and racial factors modulating these differences.

As it happens, Kant's account of enlightenment received an afterlife within a twentieth-century critical project that has yielded what constitutes perhaps the most comprehensive account of address currently on offer. In Michel Foucault's reading, Kant's observations on enlightenment inaugurate a distinctively modern agenda of critique. Foucault understands his own theoretical enterprise as a juncture within this very endeavor. He sketches a view of critical address that reaches from fifteenth- and sixteenth-century oppositional stances challenging procedures of governance, by way of the Kantian enlightenment doctrine, to the perspectives of the Frankfurt School and onward.[59] Like Hume and Kant before him, Foucault maps lengthy, wide-ranging trajectories of address. At the same time, he is acutely aware of the prolific entanglements connecting such grand routes with microscopic elements from which these lines gain their impulses and to which they help to give rise. The functioning of details and the place they occupy in relation to overarching frames of meaning are indeed explicit themes for him, just as they are in Hume's discussion of taste.[60] The topic of address is a constant preoccupation in Foucault's writings, even if often quite implicitly. His account is the third and final philosophical view that I will examine in this chapter.

KNOWLEDGE AND POWER AS SYSTEMS OF ADDRESS

Key to Michel Foucault's conception of address is his notion of the interconnectedness of knowledge and power. In opposition to views that regard power primarily as a source of prohibitions, censorship, or blockage, he stresses its positivity, by which he means its proclivity to bring phenomena into being rather than to call them to a halt: power is generative; it has a tendency to intensify in areas, to gather strength, and to venture into new territories. Conceived of as a productive force, it takes markedly heterogeneous forms. Rather than lending itself to characterization in terms of dichotomies such as the binaries of the dominant and the subjugated or the legitimate and the illegitimate, it crosses these divides. Indeed, it flows from and spreads in multiple directions. In Foucault's words, "Power is everywhere."[61]

Among the areas in which power takes residence, according to Foucault, is what he calls knowledge, which encompasses schemas of classification, conceptual presuppositions, principles of interpretation, and methods of evaluation, among other devices. These epistemic elements are factors that operations of power put to use and rely on for their functioning. Conversely, they depend for their workings on mechanisms of power that are in effect in given areas of existence. Knowledge and power are thus conditions of possibility for each other. As Foucault puts it, "power and knowledge imply one another; . . . there is no power relation without the correlative constitution of a field of knowledge, nor any knowledge that does not presuppose and constitute at the same time power relations."[62] In his view, knowledge is not an abstract realm of representations, but lodges in evolving configurations of power; power, for its part, does not amount to a bare kind of leverage or a narrowly specifiable set of forces or array of loci of control, but unfurls in proliferating epistemic registers.

Formations of power and knowledge both generate and are fueled by what Foucault calls variously discourses, discursive regimes, or epistemes. As indicated by the summary remark, "it is in discourse that power and knowledge are joined together,"[63] this terminology denotes the manifold symbolic practices in the context of which epistemic procedures, such as ways of measuring time and space, and heuristic devices, such as interviews, examinations, and reports, exercise social control. The areas of sexuality, the clinic, and the prison are well-known examples of domains that, in his analyses, sustain discursive fields. Here, his major contribution to a theory of address becomes evident: Discourses involve address. They feature and valorize multiple modes of address directed at subjects, objects, and places.

Referring, for example, to an "economy of discourses on sex," which we, in his view, need to explore if we wish to inquire into human sexuality, Foucault highlights the pertinence of questions such as the following: "Why has sexuality been so widely discussed, and what has been said about it? What were the

effects of power generated by what was said? What are the links between these discourses, these effects of power, and the pleasures that were invested by them? What knowledge [*savoir*] was formed as a result of this linkage?" The investigator of sexuality, he adds, moreover, needs "to account for the fact that [sex] is spoken about, to discover who does the speaking, the positions and viewpoints from which they speak, the institutions which prompt people to speak about it and which store and distribute the things that are said." In short, discourse, according to Foucault, is a matter of address. Discourse harbors demands of and provocations to address, such as petitions and incentives to speak or hear, to see, display, or palpate. It encompasses rituals of address that revolve around forms of testimony, questioning, observation, and evidential reasoning, among many other modes.[64]

Multiple modes, compound levels of collectivity, interlocking structures

Rendering address a central constituent of discourse, Foucault attributes a number of features to it that are germane for our purposes. I will take note of three of them. First of all, address occurs in multiple modes. It takes the form of sensations and pleasure, of perception and analysis, of surveillance and monitoring, of gesture, posture, speech, and even silence and secrecy. Address permeates the functioning of instruments such as clocks and their correlative timetables, places such as bathrooms, and buildings such as schools, hospitals, and army barracks.[65] Foucault insists on the multimodal character of address that we have also encountered in Jamaica Kincaid's "Girl."

The second characteristic of address that he emphasizes is a multiplicity that surfaces in variable, partially overlapping, substantially interconnected, collective bonds that address sustains. In his view, address thus enacts its pluriformity at compounding levels of collectivity. We can find address at work in, among other things, the organization of the state and its political and juridical institutions, agglomerates of populations and struggles between population groups, orders of race and empire, religious practices, the family, and patterns of production and consumption.[66] Taking effect in these different sectors of life, it traverses public forums as well as the economic and domestic arrangements with which the realm of the public is often contrasted.[67] Address is instrumental in shaping the multitudinous patterns of collectivity that we inhabit on a daily basis. Divergent collective formations thereby intersect with each other. Proliferating along multifarious angles, address forms a vehicle for relays that take place between the different planes of collectivity it suffuses, so that what transpires in one sphere can affect what happens in another.

The third property that Foucault underscores is address's systematicity. As his vocabulary of economies, regimes, apparatuses, and mechanisms demonstrates, he comprehends address as a systemic phenomenon. Through the notion

of discourse, he recognizes the workings of *structures* of address. Foucault proposes that we understand discourse in toto as "a series of discontinuous segments."[68] The differentiated aggregates, or discourses, that he postulates embody what I call structures of address. Structures of address host modes of address and allow them to enter into specific kinds of interactions.

Structures of address are partially bounded formations. They are characterized by a distinctive organization of address. A novel, for example, typically has a different structure of address than, say, an edition of a newspaper. The limits circumscribing structures of address are constituents of their particular organization. Whether they are sharply defined, as in the case of the time span of a volleyball match or a court case, or loosely marked, as in the case of the temporal horizon of a person's education or her childhood, these limits are demarcations that we can posit and that separate structures from one another, signaling what does and does not belong to the structure. An entity such as an aquarium or a flower show, for example, ordinarily falls outside the limits of Western systems of human medicalization, whereas those orders do include physical rehabilitation centers, drug treatment programs, and gynecological studies. But the relevant delineations do not comprise closed boundaries, ones that stringently cordon off an inside from an outside. Circumstances doubtless occur where fish and flowers are central to someone's well-being and can figure in a medical regime. The limits of a structure of address, such as the field of Western medicine, are flexible and can extend into the sphere of zoological display or botanical exhibition, as when we learn about the invigorating qualities of flower tinctures or fish oil. Large-scale structures, in particular, which would also include the juridical realm, the educational system, the domain of art, the entertainment and leisure industry, and the sports world, tend to have fuzzy limits.[69]

Foucault leaves room for a significant degree of diffuseness in the delimitation of structures of address. Discourses, in his view, interlock. They link up with each other in webs or networks.[70] There is thus a great deal of traffic between individual structures of address, and we can expect them (or at least many of them) to have significant points of confluence and overlap with one another.

Structures of address, according to Foucault, moreover, are mobile entities: discourses engender new and shifting objects in relation to which they orient their operative modalities of power and registers of knowledge production. Just as discourses evolve and can gain force or, by contrast, exhaust themselves, the relations they bear to each other change over time. And yet structures of address have a certain cohesion. They feature objectives. What holds structures of address together, in Foucault's account, is their functional organization: he attributes tactical functions to discourses. These functions are varied and in flux rather than uniform or stable. Structures of address, for him, can therefore arise and vanish over time.[71]

Foucault describes an interplay between local tactics and overall strategic patterns. A discourse can mobilize its tactical workings in the service of variable and shifting strategic maneuvers. Consequently, one and the same discourse can support contrastive strategies. He indicates, for example, how a lexicon categorizing homosexuality as unnatural advanced a series of homophobic discourses in nineteenth-century Europe, but also supplied conceptual and practical grounds for a homosexual counter-discourse. The converse holds as well: a single strategy can make use of opposing discourses.[72] Foucault argues famously that discourses seeking to free sexuality from repression have been instrumental in enclosing sexual practices with increasing rigor into the discursive regime in which modern sexuality has emerged since the seventeenth century. In this case, partially contrastive tactics, namely repressive as well as liberatory discourses, bolster a more encompassing strategy. Structures of address, as Foucault understands them, thus bring to their contexts of operation not an established set of power–knowledge effects or a stagnant field of action, but a tactical productivity and a strategic integration or conjunction of elements.[73]

Implicitly exploring the workings of structures of address, Foucault throws light on address's systemic functioning. For him, as we have seen, address comes in many divergent modes and instantiates myriad levels of collectivity. Structures of address are marked by a functional organization that invests distinct structures as well as the relations among these structures with a dynamical character. The systematicity of address, in Foucault, thus finds expression in the organizational facets of structures of address, which can be witnessed in phenomena such as the convergences and differentiations, the collaborations and tensions between elements of power and knowledge that pass through variable deployments and degrees of productivity. But the fairly basic view of address that we have identified so far in his work yields a rich approach to a yet broader range of systemic procedures. I will point here in particular to several subjective factors that he seeks to comprehend in systemic terms as he examines the workings of structures of address.

Analyzing the operations of structures of address, Foucault outlines ways in which constellations of address establish conditions of possibility for the subjective positions that are available to individuals within matrices of desire. He invests address with the capacity to forge the grounds for our participation in constructions of what it is to have the moral stature of a human being or, more specifically, what it means to have a certain kind of social identity, such as that of a homosexual, a criminal, or someone deemed to suffer from hysteria. Address undergirds interpretive frameworks for predicating gradations of delinquency, health, and the economic utility of persons. It is in settings of historically shifting patterns of address that modes of recognition of self and others become legible, that specific typologies of human

individuation begin to be plausible and inhabitable, that spheres of market rationality undergo expansion, and that we elaborate modalities of sameness and difference.[74] With the help of the notion of address, Foucault adumbrates a systemic view of human subjectivity, one that allots an important place to the human subject, even if it decenters the figure of the human by rendering it a node within a web of continually developing, interconnected forces that variably spread and dwindle.

As the systemic operations mentioned here already suggest, Foucault ascribes a vast array of capacities to structures of address. These structures, in his approach, are formations that invest behaviors and representations with their significance. They circumscribe polemical fields in which views become intelligible and gain or lose credibility. They delineate arrangements in which pleasures and pains become liable to articulation and acquire their character as objects of desire and/or sources of injury. Constellations of address spawn a yet broader range of effects: they constitute areas of signification and praxis that we activate as we enter into schemes of aesthetic self-creation; they yield materially efficacious horizons of possibility against the backdrop of which we forge intersubjective relationships, take up involvements with objects and institutions, invent individual designs of existence in the flesh, serve as ciphers of economic interests or fungible resources for entrepreneurial selves, and participate in patterns of life and death. The systemic procedures cited here, meanwhile, are suffused with norms.

Normativity and norms

The realm of address, for Foucault, is a normative domain. Power/knowledge formations achieve their regulatory effects through the deployment of norms.[75] The social orders and orderings that he theorizes ground forms of agency.[76] They also undergird a whole range of relational registers: while he emphasizes nexuses of power that make use of modalities of knowledge production, he indicates specifically how these entwined constellations surface in bonds of sexual pleasure and love and in relations between scientist and human subject or population group, pedagogue and pupil, doctor and patient, lovers of the same or a different sex, self and body, consumer of alimentary substance and food or drink, and person and thing.[77] Additionally, sensory and perceptual linkages, such as connections of looking and touching play a part in the patterns of relationality that he recognizes.

In accounting for various kinds of normativity that pervade social domains, Foucault ascribes two particularly significant functions to norms.[78] He accords them a crucial role in the processes of normalization that occur under the regimes of various kinds of power, namely in the investment with normativity

of elements that count as normal or, by contrast, as deviant from the norm.[79] His examples of normalizing figures include schools, conceived of as sites of social regimentation, and the conjugal family, considered as a junction within large-scale stratagems of population control.

An interest in norms also informs Foucault's turn to aesthetics. He understands aesthetics as a constituent of an ethics of the self, an ethics that revolves around elements he calls "etho-poetic." Aiming to theorize certain types of subject formation and, in particular, what he describes as practices of freedom,[80] Foucault observes how we rely on aesthetic norms such as standards of beauty in shaping modes of attention that we direct at the self. We engage in practices of self-constitution that enlist aesthetic criteria as grounds and guidelines for acts of stylization. He stresses, in particular, our stylistic fashioning of our relationships to our desires, both sexual and amorous, but also makes plain more broadly how we develop styles in the spheres of bodily activity pertaining to, for example, food, drink, domesticity, and pedagogy. Evaluating our conduct and form of life on the basis of aesthetic values and in terms of the stylistic characteristics of an artwork, a personal work of art that we are engaged in making, we originate a mode of being that we posit as the goal of the ethical labor we perform on ourselves. As we strive to steer our behaviors toward that desired mode of being, we can then hope to realize a kind of comportment—both a stance in relation to the self and an attitude toward the precepts and codes of subject formation at play in the society—in which we can recognize ourselves. What Foucault regards as the project of attending to or taking care of the self thus involves an aesthetic form of self-making, that is, the shaping of a way of life through aesthetic means and on the model of an artwork.[81]

Foucault refers to the process of self-creation that he traces out with the notion of the arts or aesthetics of existence. These he defines as "those intentional and voluntary actions by which men not only set themselves rules of conduct, but also seek to transform themselves, to change themselves in their singular being, and to make their life into an *oeuvre* that carries certain aesthetic values and meets certain stylistic criteria."[82] The project of self-construction that he has in mind is a purposeful, artistically and aesthetically governed activity in the course of which we develop and enact an attitude toward the self, thereby inventing ourselves on partially aesthetic grounds and enacting a form of freedom.

The philosopher considers this type of self-design crucial in the era in which we live. Notwithstanding the historical focus of his inquiries into the care of the self, he holds that in today's world, we must confront the question of an aesthetics of existence, given that moral systems centered on a roster of norms or rules have come to be of limited relevance.[83] Possibilities for aesthetically driven liberation, in Foucault's approach, are a prominent area of normative engagement in the present age.

Relative, intertwined freedoms and unfreedoms

The concept of address is vital to the dilemmas of freedom that Foucault engages in the areas of the discursive construction of sexuality and the aesthetics, ethics, and politics of self-constitution. He argues, on the one hand, that allegedly liberatory practices can have the effect of embroiling us deeper in the matrices of power and knowledge, conditioning the views of freedom and longings for liberty that inform these endeavors. When emancipatory ventures backfire in this fashion, the wished-for type of freedom entails a more efficacious, expanding form of subjection or constraint. On the other hand, as we have seen, Foucault emphasizes the significance of practices of liberation and sees these as integral to the ethical constitution of the subject. What is more, he understands his own critical outlook as a project designed to allow for a measure of freedom from what has already been conceptualized and assumed.[84] Philosophy, for him, is a self-reflexive activity. Identifying philosophy as exercised today with "the critical work that thought brings to bear on itself," he orients philosophical thought toward the goal of thinking "differently." So conceived, philosophy aspires to a distancing of the self from itself. Foucault speaks of a "straying afield" or a "getting free of oneself." One of the steps by which we can advance toward this altered thinking and changing self would appear to involve our "free[ing] thought from what it silently thinks" or at least exploring to what extent this can be done.[85] Debunking certain liberatory visions, Foucault voices one of his own. How can we reconcile these two mutually opposing approaches with each other?

To see how these contrastive viewpoints can go together, it is worth looking more closely at the two stances he sketches. As a participant in a critical inquiry, he proposes perspectives and methods that bring into view unforeseen possibilities for thought. In making us aware of the simultaneously enabling and limiting functioning of schemes of subject formation, he gestures toward styles of existence that deviate from these schemes and roll out alternative norms. He thus posits margins of freedom inherent in the fabric of power and knowledge enveloping us. The procedures shaping our identities and relationships contain possibilities for change. Foucault's own writings embody perspectives that take a critical distance from the social arrangements he analyzes, thus circumscribing an area of freedom. And yet a feeling of freedom or attempt at liberation, rather than reflecting a point of resistance, can mark a mere confluence between our desires and the orders that encourage and reward them. As is widely acknowledged, our sense of where freedom exists or how it is to be attained may evince a frictionless adjustment to the powers on which we depend, thus belying our impression that we have shaken off the hold that those powers have on us. As noted earlier, Foucault recognizes the participation of practices of liberation in the constitution of subjects. Accordingly, such

practices would appear to be able to both promote and detract from the subject's freedom, inserting a distance from operative mechanisms of power and knowledge as well as assisting them. Withdrawals from strata of power, meanwhile, can bring about new yokes, and strengthened affiliations with techniques of power may provoke disassociations from these elements in a different plane. Placing instances of freedom side by side with episodes of unfreedom and declining to spell out an ultimate resolution as to the question of their connection, Foucault generates a quandary. This, however, does not amount to an irresolvable philosophical conundrum.

Freedom, as is widely acknowledged, is not an absolute but a relative state. It is not only indexed to specific factors *from* which we are or might want to be free, but also tied to the genres of power/knowledge and collective bonds harboring us. These repertoires of power/knowledge and intersubjective relations partially shape courses of action that we valorize, desire, or find pleasure in and that we, with the requisite communal supports, can take it upon ourselves to bring about (freedom *to*).[86] Here, we observe an array of coinciding, qualified registers of freedom and constraint. Foucault traces tensions between these parameters. What we confront is not two starkly opposing stances—one of exhilarating liberty, freed from power and constraint, the other of debilitating inhibition and confinement, devoid of freedom—but a range of dynamically intertwining relational positions.[87] More than that, as Kincaid's "Girl" makes visible, this weave of forces and modes of connectedness sustains intricate meanings that we enfold in our affiliations with languages, aesthetic idioms, people, places, and things. These meanings suggest styles and modes of free/freeing activity in which we can engage collaboratively, as well as states toward which we might want to gear the practices of freedom that jointly we bring into being.[88]

Subjects of modernity, in Foucault's account, inhabit entangled modalities of power and freedom. Address is pertinent to this situation in several ways. Through devices such as irony, modulations into and out of free indirect discourse, and multivoiced forms of speech, he unsettles his own and the reader's stance vis-à-vis moments of freedom and unfreedom.[89] The suggestion is that split, ambiguous, and pluriform modes of address are means that enable us to navigate the heterogeneous, incongruous attachments shaping our positions under regimes of disciplinary and biopower in a manner that is productive of refractions and shifts. These divided modes can foster the creation of freedom under conditions that tend to hamper it even if in some ways those conditions are also instrumental in making it possible. Foucault's deployment of address intimates that fissured, multidirectional, and polyvalent modes of address that operate in a variety of registers at once—registers that are partially at odds with each other—can imbue our engagement with constellations of power/knowledge with a suppleness and dynamism conducive to alternative subjective formations.

The multiplicity and variability characterizing address at the level of its normative and formal characteristics fuel these critical possibilities.

Address's luxuriant normative and formal instrumentarium bears on the coincidence of freedom and power in another way. Kincaid's tale, again, is illustrative. Let's recall the normative intercession that the girl effects by way of her question. The notion of address, the story suggests, enables us to see how strata of freedom and constraint can simultaneously diverge and converge and, yet more fundamentally, interact with one another in a field where *forms* of address embody *norms* of address within *structures* of address.[90] The norms entering the scene upon the girl's intervention, as we have observed, are neither altogether consonant with each other nor wholly disjunctive. The concept of address, conceived along these lines, invites us to hone in on the workings of norms—plural—in contrast to Foucault's targeting of *the* norm.[91] Accordingly, the notion opens out onto a model that challenges us to capture within our theoretical frames an at once broader and more specific assortment of differential valences and qualifications than Foucault directs us toward, which suffuse procedures and positions within power-knowledge nexuses. The concept of address makes possible a granular perspective on the vacillations that emerge in the zones of contact shared by modalities of liberation and confinement.[92] It invites us to encounter complex states of entwined freedom and power in their inhibiting and intensifying mechanisms, their ethical, aesthetic, and political functioning, and the shifting social tendencies they enact, with an analytical specificity matched at the level of theoretical elaboration.[93]

Recognizing the multiple modalities in which address can unfold, marking the ubiquitous activities of address at compound levels of collectivity, and acknowledging the tactical and strategic agglomeration of forms of address in interlocking structures, Foucault understands address as a vehicle for a wide scope of interactions among divergent factors. Under the rubric of discourse, he offers an account of the workings of structures of address that illuminates the dynamics of power and resistance. His own address to his readers (and to various discourses he activates) sharpens his explicit proposals. He theorizes a network of forces that harbors an interplay between trajectories of individuation and differentiation. Local and overarching elements of stasis and movement are thereby partially determinative of one another. A force field arises where we can identify not only constraints of variable natures, significance, and reach, but also manifold and fine-grained patterns of relative freedom where we can pinpoint distinctive coordinates of social meaning (including, of course, what we experience as deficiencies of meaningfulness). Underscoring the normative density and agility that modes of address bring to this vortex of powers and freedoms, the notion of address furnishes tools with which we can hope to think further about these situations, with and beyond Foucault.

Toward a more fine-grained conception of forces and determinations

Foucault describes an open-ended frame of analysis designed to disclose historically emerging schemes of power and knowledge, sensation and pleasure, and temporal and spatial organization. While the method of inquiry that he outlines is highly generative, detailed historical investigations reveal different constructions of sexuality and desire and uncover operations of gender, race, and coloniality that he neglects.[94] His views of subject formation, normativity, agency, relationality, aesthetic meaning, and social ordering remain conspicuously schematic. Modes of ethical subjectivation exceed the mechanisms of self-delimitation that he foregrounds in his discussions of practices of the self.[95] He renders projects of self-design strikingly agent-focused by downplaying their conditioning by existing aesthetic configurations, such as divergent, historically, and geographically inflected conceptions of the artwork and socially entrenched scenarios of desirable aesthetic experience.

How do the forms, scripts, and creative processes captured under the banner of the aesthetics of existence draw on contemporary constellations of art and culture? What influence do concrete material configurations exert on the choices informing self-formation? For Foucault, the aesthetics of existence amounts to a social practice, a type of activity that involves "relations between individuals" and settles in communicative interactions and institutions. He defines it emphatically in voluntarist and deliberative terms.[96] Perhaps the paradigm of the single-authored nineteenth-century realist European artwork supplies a template that can inform an individualizing, freedom-fostering practice of care of the self. The romantic fascination with the figure of the individual artist who, over time, crafts and showcases her own unique style grants a certain plausibility to this self-constituting process. But this view of the matter is not as persuasive in other artistic contexts.

No matter how far Foucault stretches accepted conceptions of an artwork, it is not evident that performance art, graffiti art, experimental cinema, *musique concrète*, Japanese tea ceremonies, Mbuti Pygmy harvest songs, ancient Yoruba sculpture, Paleolithic rock art, Indian ragas, surrealist literature, or contemporary happenings, social practice art, and readymades lend themselves to a Foucauldian vision of ethical self-formation. Even if attitudes toward the self and choices play a substantial part in these artistic modalities, I think we surrender the specificity of these forms if we single out such self-directed orientations and decisions as key to a poetics of life based on such arts. Foucault's foregrounding of self and choice produces a discrepancy between two aspects of the aesthetics of existence to which he subscribes. The idea of a way of living characterized by aesthetic qualities and forms suggests an existential stance that can be modeled on a quite inclusive array of artistic and aesthetic traditions.

This position, in principle, seems to be open to everyone. When it comes to the requirements of a purposefully shaped life as a work of art, however, only a small set of European canons lends itself to exemplary standing. This makes it difficult, contra to what Foucault has in mind, for "everyone's life [to] become a work of art."[97] The notion of a life driven by aesthetic values does not translate swiftly into that of a life lived as an artwork. Not all valuable aesthetic and artistic traditions have a ready place in Foucault's aesthetics of existence. He imposes problematic restrictions on the aesthetic and ethical comportment he expects this aesthetics to sustain. Privileging the existential capabilities of some art forms over others, the aesthetics of existence buys into procedures of normalization organized around parameters of race, coloniality, gender, class, sexuality, and nation, operations it was designed precisely to elude.[98] Foucault's perspective simplifies and elides the deeply rooted sociality of art and the aesthetic.[99]

As "Girl" suggests by having us wonder about the freshness of the bread, aesthetic standards stipulating what things should look like, sound like, feel like, and taste like, what consistency and features they should have, exert a profound influence on quotidian life in a manner that is not and cannot ever be in the hands of any particular subject. Our engagement with bread has an importance that we can give form only partially by means of decisions and choices. The notion of an aesthetics of existence that Foucault locates in the use that we make of aesthetic criteria within patterns of attention to the self leaves aside manifold impulses that procedures of subjectivation derive from worlds saturated by aesthetic experiences, concepts, objects, and pedagogies. Kincaid's tale intimates that aesthetic criteria shape trajectories of culture-making in a fashion that surpasses paradigms of self-stylization and templates for the individual creation of a life modeled on a work of art.

Temporal and spatial orders, along with material artifacts, embody norms and forms of address that shape collective itineraries of cultivation. Aesthetic modes of address pervading circuits of meaning-making and parameters of collectivity and experience enact registers of ethical and political comportment as well as aspects of gendering and racialization to which Foucault lends short shrift. Although he recognizes that "collective canons" and "rules, styles, and conventions that are found in the culture" are partially determinative of the creation of life as an artwork, he overemphasizes the individual and personal dimension of the process of aesthetic self-fashioning.[100] While he acknowledges a vast multiplicity of modes of address as well as manifold levels of collectivity mediated by these modes, a major scope of forms of relationality linking people, things, and places falls beyond his analytical grid.[101] The same point applies to a broad array of norms we enact in the aesthetic realm and the sphere of art.

As critiques of Foucault's outlook, my claims about the omissions in his theory of the correlations between power and knowledge and my observations

about the oversights in his views of subject and culture formation go only so far, because the notions of discourse and normativity he articulates are productively open-ended. Moreover, an exhaustive picture of address is beyond the scope of the possible. The stress Foucault places on a plurality of forces, relations, and normative conditions and on a horizontal account of power/knowledge, among other factors, reveals strands of his approach that can support a richer conception, on his part, of our ethical, political, and aesthetic comportment.[102]

Yet as an account of address, his view leaves much to be said about the ways in which modes of address align with or subvert more encompassing structures of address and instantiate or give a twist to specific norms. Normalization and the setting up and implementation of typologies of normalcy and abnormality are only a subset of the procedures driven by norms.[103] The stock Foucault puts in our thinking otherwise, going beyond ourselves, and "breaking away" from received scripts of sexuality—in tandem with the ways in which he juggles each of these movements through his own mode of address—testifies to thorny invocations of norms that compel theorization.[104] The conceptual architecture established by his formulations along with his genealogical (and archeological) praxes tends to obscure the involved, manifold workings of norms that bear on the dynamic between modes and structures of address. These operations yield a multidimensionality and complexity that we can begin to glimpse from the girl's question in Kincaid's narrative. Norms pervade quotidian functions that fail to join up manifestly in techniques of discipline or biopower or distributions of political and economic utility. Aesthetic criteria, meanings, and desires exceed their deployment in the context of the various arts that Foucault highlights, such as those of government and "not being governed quite so much," as well as the arts of erotics, of love, of living, of the self, of commanding, of using the pleasures, and of various kinds of relationality.[105] Processes of cultivation and culture-making rely on a more intricate array of objects, agents, modes, and structures of address than he recognizes.

Foucault is an important theorist of address because his views of discourse and of the interconnection between power and knowledge elucidate the multiplicity and normative functioning of modes of address, the plural levels of collectivity at which these modes are active, and the systemic operations of structures of address. These are vital insights for an account of address, rendering him a central figure to turn to in reflecting on our theme. At the same time, the notion of address yields a more fine-grained tool for analyzing many of the phenomena that Foucault describes—discursive formations, epistemic procedures, mechanisms of power—than he recognizes. To these must be added the dynamics of freedom and constraint and the workings of social categories that he exposes, the functioning of normativity, the methods of critique, and the operations of aestheticization and ethical subjectivation that he brings to the

fore. We need to call on the notion of address to enrich the conceptual paradigms on which we rely to clarify these matters. Kincaid's story points to some of the complexities that fall by the wayside in Foucault's approach, as do Kant's and Hume's perspectives in various ways. The four chapters that follow will probe address from different angles to bring out the notion's theoretical resourcefulness and to advance our understanding of its detailed workings.

Most immediately, in chapter 3, we will consider several short stories that, like Kincaid's "Girl" and Wisława Szymborska's poem "Vocabulary," explore how forms of address can give a spin to the vitality or depletion of language. These stories will, moreover, illuminate how modes of address can engage the possibilities and constraints of structures of address. They will shed light on the way in which norms of address shape the dynamics of experience. In short, we will examine a range of facets of address that do not quite resonate with Kant's, Hume's, and Foucault's accounts, although these philosophers provide us with some large-scale ideas about the kind of place we might give to these factors in our reflections on culture, our understanding of subjectivity and power, and our engagements with the technologies of ethical, aesthetic, political, economic, and epistemic development.

◉ ◉ ◉

Looking back to the authors discussed so far, we can observe parallels between Foucault's view of address and theirs. Like Kincaid, Szymborska, Kant, and Hume, Foucault devises orders of relationality and address that ground forms of normativity, agency, and aesthetic meaning. Analogously to these authors, he explores the role of freedom in the webs of address he posits. He also shares with his fellow writers an interest in procedures of cultural production and in the actualization of certain transformations of culture.

Compared to his predecessors Kant and Hume, Foucault highlights a rigorously amplified spectrum of modes and structures of address. He broadens the forms of agency, relationality, normativity, and aesthetic meaning of which address can be seen to be constitutive. Implicitly prefiguring the notion of a structure of address through his conception of discourse and his account of the collaborations between mechanisms of power and registers of knowledge, he provides an expansive picture of address's multifarious structural functioning and the systemic contributions that address makes to the organization of societies and the forms of subjective being that we adopt in them. Foucault thus joins Kant and Hume in bringing to our awareness crucial aspects of address.

Enlisting modes of address—forms of signification extending between people, things, and places—in aesthetically marked processes of enlightenment, matrices of cross-cultural and transhistorical aesthetic interaction, and epistemically modulated and generative trajectories of power, Kant, Hume, and

Foucault show address to be at work within and across various patterns of social organization, both macro- and microscopic. While employing their writerly address to the reader in a manner that shapes and finesses aspects of what they say about the phenomenon, these theorists alert us to poignant systemic powers inherent in address, ones that are worthy of our attention. Address, in the sense of the term that I advocate, proves to be a linchpin of social organization in the eyes of three incisive thinkers. Indeed, the concept of address—as we are getting to know it better and amplify our understanding of it by examining the ways in which it is used and in which we can use it—sheds light on forms of social regimentation, interaction, freedom, and transformation and enables us to identify what appear to be potent junctures in these operations and states. It allows us to chart involved cultural forces that these junctures are found to encode. From the perspective of this investigation at large, we are then beginning to cumulatively see—first with Kincaid and Szymborska, now with Kant, Hume, and Foucault—how the notion of address defined in the initially schematic language of forms of signification and then put to work in several contexts incurs a vital ethical, political, aesthetic, economic, and epistemic import.

Notwithstanding the rich and valuable facets of address exposed by the three philosophers discussed in this chapter, their understanding of address's normative, structural, and experiential workings is characterized by gaps, as we have seen. Those I have identified hint at areas where questions arise that necessitate further exploration. In the next chapter, we will seek to advance our understanding of address in these regions by looking at stories by a writer whose address to address scrutinizes address at points where the three philosophers leave off.

3

SAYING HELLO AND GOODBYE

In his 1962 collection of stories *Cronopios and Famas*, Argentine writer Julio Cortázar investigates our relations with everyday objects such as spoons, doors, clouds, watches, and stairs. This preoccupation epitomizes his fascination with the plasticity of reading practices, with the political capabilities of literature, and with the nature of the aesthetic, comprehended as a field of material and imaginative agency—each a major driving force for his oeuvre as a whole. His inquiries in *Cronopios and Famas* take as a central point of focus the trajectories of address that run between people and things, as illustrated by the line, "How it hurts to refuse a spoon, to say no to a door."[1] Indeed, Cortázar locates the dynamics unfolding in the intervals between people and things in settings where people enter into interaction with each other. His stories mutually entwine the quotidian relations that we enjoy with things (and places) with the day-to-day relations that we have with other people, probing, for instance, the chance encounter of two friends in the street: "'How's it going, López?' 'How's it going, buddy?' And like that they think they have said hello."[2] Through such moments, *Cronopios and Famas* examines how the flows of address that link people to other people, along with things and places, give rise to states of freedom as well as constraint and admit of moments of order as well as disorder.

Objects and places meet people with norms, as the notion of a spoon or door that makes a request suggests; people, in turn, hold out norms to objects and places, as intimated by the idea that it hurts to refuse that request extended by the spoon or door. Individuals, further, in the course of an ordinary event—as

when two friends spot each other on the street—confront each other with norms, such as what it takes to say hello or goodbye in some way that is adequate. The relevant norms, as we also saw in Jamaica Kincaid's story "Girl," then lodge in the quotidian material and embodied conduct of language, persons, things, and places. Undauntedly delving into the vicissitudes of address's functioning as a ground of relationships among language, people, things, and places and, more than that, weaving his readers into these tumultuous proceedings, Cortázar pushes further the rudimentary view of address that we have distilled from Jamaica Kincaid, Wisława Szymborska, David Hume, Immanuel Kant, and Michel Foucault. He is a crucial figure to consider in a study of address because his stories voice groundbreaking questions about the phenomenon. They also illustrate how much is gained by taking seriously the twists and turns of address when it comes to the ethical, political, aesthetic, and epistemic dilemmas that we have in front of us as human actors.

Cortázar addresses address as a puzzle. The setting for its mysteries, for him, is the globe, comprehended as a sphere where distinct quotidian localities stand in interconnection with each other. The characters populating *Cronopios and Famas* reside for the most part in Buenos Aires, even if there are also episodes involving international organizations in Paris. Buenos Aires, accordingly, is the chief place of confluence for the local and global designs that concern Cortázar.[3] He shares Kincaid's and Szymborska's interest in the plane of the transnational. He also matches "Girl" and "Vocabulary" in his juxtaposition of, on the one hand, tactics geared toward the depletion of the capacities of verbal forms of address and, on the other, strategies of linguistic regeneration and revitalization. Representing the arenas of the public and private as interweaving sites of perception, desire, performative activity, and regulatory conduct, he illuminates the experiential, normative, and structural mechanisms of address.

While Cortázar, like Hume, Kant, and Foucault, worries about the limitations of various kinds of restrictive frameworks of address, he scrutinizes the resources of address to manipulate and alter the moral, political, aesthetic, and epistemic constraints that such patterns impose.[4] He investigates experiences and behaviors that might help us pass from situations of entrapment into states of freedom, and asks where such changes in turn might lead us next. Meanwhile, he grapples with the existential consequences that follow from the grip that disconcerting stratagems of confinement and impediment have on us. Even if *Cronopios and Famas* does not ultimately answer the queries regarding democratization, gender, and race voiced in chapters 1 and 2 and generates related difficulties of its own, the tales provide a sustained examination of address that opens up avenues along which we can devise renewed approaches to these themes.[5]

As the observations about the spoon, the door, and the friends in the street already indicate, Cortázar expands our view of the philosophical

underpinnings of normativity, a phenomenon that he spreads out across the different nodes holding together the webs of relationality binding people, things, and places. Supporting the ethical, political, and aesthetic modalities that we enact at those manifold junctures, address, in Cortázar's stories, is not primarily an installer of inhibitions: on top of that, it inaugurates a world of buoyant possibility.[6]

The kind of freedom Cortázar aspires to is that of a creative inhabitation of the interconnections linking us with other people, nonhuman animals, and our material surroundings—an absolutely vital human propensity and achievement. The places where he looks for such freedom are not foremost the instances of transcendence of or autonomy from social forces sought out by a longstanding philosophical tradition, but are to be found in forms of contact and connectedness with living beings and our human and nonhuman environment. At stake, for Cortázar, is a genre of freedom that dovetails with states of equality and inclusiveness and a critical transvaluation of repressive social norms.[7]

Linguistic experimentation is of a piece with this freedom.[8] So are politics, a questioning of capitalist, neocolonial forms of cultural agency and interaction, and reservations about unfettered technological innovation.[9] Apprised as he is of the difficulties of interpersonal contact and the obstacles that can blunt it, unbridled connectivity—of a sort celebrated by generalized fantasies about the benefits of new media or globalization—holds no temptation for him. Constraint, for Cortázar, never vanishes, as we shall see, but assumes evolving forms. Nor does he regard the absence of bounds and limits as an ideal. His commitment to freedom veers away from entrenched modes of white, European masculinist empowerment as well as from an investment in gender binarisms, even if his stance itself deploys misogynist and exoticizing tropes. Indeed, with their subtly political tenor, their inventive questioning of accepted social and interspecies hierarchies, and the alternative imaginaries they fashion, Cortázar's texts resist conflating freedom with a valorization of the individual at the cost of meaningful bonds with others.[10]

Given his philosophically incisive conception of freedom, we can fruitfully place Cortázar's unwavering pursuit of this theme on a par with the studies of the topic by his contemporary and fellow Parisian Michel Foucault. Since both writers, moreover, stress distinctive, partially overlapping aspects of freedom, I read the Argentine artist's investigations of human interconnectedness as complementing the French philosopher's studies of power relations, and the other way around. More than that, Cortázar's figuration of address is to be seen as an inquiry into the possibilities of a critical political aesthetics that challenges the association of freedom with choice in the marketplace and the identification of the aesthetic subject with *homo economicus*, so prominent in modern history.[11]

We will commence our discussion of address in *Cronopios and Famas* with a close reading of the untitled story at the start of "The Instruction Manual," the first of the book's four sections. The philosophical predicaments Cortázar broaches in this story suggest a path of address through the collection. Following it, we will explore how other tales speak to these dilemmas. Meanwhile, *Cronopios and Famas*'s figuration of address will give us an opportunity to look deeply into a collection of stories that, although widely read, has by and large passed below the scholarly radar.[12]

WORDS, BODIES, THINGS, AND MORE WORDS

Verbal symbols, in the untitled opening story of "The Instruction Manual," appear as marks of the habitual. Signaling already given epistemic and ontological frames, linguistic denominations foist familiar forms on our everyday endeavors. According to the first-person narrator, such designations restrict the modes of address of which humans and things are capable. "Castigate the eyes looking at that which passes in the sky and cunningly accept that its name is cloud, its image catalogued in memory," he advises.[13] The directive voids the recommendation it feigns to formulate. A contrary meaning breaks through: beware of the noun! Blotting out the perambulations that we see unfolding in the air, the label shortcuts the exchange in which our eyes engage with the objects of our gaze. Fossilized by language, vision congeals along customary lines. The substantive "cloud" overwhelms sight with antecedently grasped designs. Mobility recedes; polymorphousness vanishes. If, for the narrator, prefabricated terms eradicate perceptual multiplicity, casting material flows into fixed plans of comprehension, the body itself also participates in this conspiracy. The story begins:

> The job of having to soften up the brick every day, the job of cleaving a passage through the glutinous mass that declares itself to be the world, to collide every morning with the same narrow rectangular space with the disgusting name, filled with doggy satisfaction that everything is probably in its place, the same woman beside you, the same shoes, the same taste of the same toothpaste, the same sad houses across the street, the filthy slats on the shutters with the inscription "The Hotel Belgium."[14]

The corporeal needs and intentions driving us to the toilet connive with the names we have for things to sculpt existence into a repetitive mold and to put or keep things in their customary places. With some effort, our bodies separate off the substances that they expunge from elements that they leave nearby,

ready at hand (woman, shoes, toothpaste) and from items that simply persist in being where they are (sad houses, dirty slats). Physical urges, material pleasures, and sensory experiences collaborate with words to give quotidian life its apparent stability. Even linguistic aversions, such as a dislike for a word, may sustain a feeling of dependable ordinariness. Cortázar sees our corporeal sensibilities at work in the delineation of the modes of address that we direct at our surroundings, and our surroundings at us. These forms of activity and receptivity invest established states of affairs with aspects of well-being as well as dysphoria. The brick of the story's first line—the volume that is to be tenderized, the sticky mass that is to be traversed—then becomes a figure through which the tale invites us to ask what we can do when imprisoned by confining structures of address. What modes of address can we adopt in order to loosen up the brick or to get it to budge?

Philosophical questions spring up immediately: In what scripts and scenes of address do we get caught and, in turn, arrest other living beings, things, and events? How do norms of address come by their powers to hold us captive? Where do restrictive forces of address come from? To what extent is it desirable or possible to shake them off? When lines of address are halted, where do we turn to create movement? How might fluid zones permeating precincts of address bolster limits that they simultaneously upend? As he makes visible the participation of the felt, undulating, desiring body in conditions of stasis, Cortázar also registers that body's swings between moments of coagulation and loosening.

The narrator refrains from using the name that he professes to find revolting in order to make reference to the constricted quarters that he visits in the morning. This linguistic maneuver allows him to avert the ossifying effects that he attributes to language, permitting a space for movement to erupt within the fetters of constraint: In the endeavors that he undertakes within the bathroom's perimeters—defecation and/or masturbation—the speaker anchors both his softening routine ("the job of having to soften up the brick every day"), and his attempt to pave a way through an accretion of sticky stuff ("the job of cleaving a passage through the glutinous mass that declares itself to be the world"). He invests these daily modeling practices with a plasticity that restores motion to other solid forms that he encounters in his environment and with which he, metaphorically speaking, "collides." Indeed, the rigid "brick" (or the gummy mass that had already proclaimed itself to be "the world") transfers not only from his bowels' unyielding insides or his erect penis—intransigent as it may remain—to the lavatory's or, perhaps, a bed's rectangular outline, but reappears in the shape of a crystal block that harbors the world itself: immediately following the opening sentence, the speaker pronounces the story's first imperative, "Drive the head like a reluctant bull through the transparent mass at the center of which we take a coffee with milk and open the newspaper to find out

what has happened in whatever corner of that glass brick."[15] Things morph into each other.

What could have been just an outrageous pronouncement on the part of a tenacious glutinous mass heralds a truth: The glass brick reveals its equivalency with the globe through which, according to the story's opening sentence, this volume of compacted feces or stiff male genital was expected to be making headway. Having successfully left the body, and endowed with a suitably viscous consistency, brown and white materials currently reverse direction—they now enter, rather than exit the body.[16] Modes of address and of being addressed shift from object to object. Ingesting his coffee with milk, the narrator presently takes the place of the feces and semen that he was trying to pass, pushing forth his own body through the physical substances that he is compelled to navigate day after day. His body occupies the site of address in which it had initially encountered its own organs and their contents. Elements are in transit. Conversions take place. Evolutions are underway. The brick exerts forces of constraint and offers resistance to the narrator but also displays a certain mobility. Yet impediments continue to hamper the narrator's movements.

We have now guessed: Cortázar devises the image of the brick precisely to explore this coincidence of limitation and possibility. With the glass brick, he gives us a figure whose permutations shed light on the question of what it is to inhabit a structure of address.

The brick, in a sense, appears to be everywhere: in the short fragment that we have read, it has already transferred from clogged-up bodily substances to not only the rectangular space of the toilet and the rectangular form of the newspaper but, even more expansively, to the whole globe, depositing in each of these places its dynamic of liberation and captivity.

Cortázar, here, is decidedly *not* asking his readers to envision a hallucinatory world. Rather, he proposes a metaphor through which we can reflect on our emplacement in corporeal, material conditions in which we deploy address. More specifically, he broaches the question of how we use address to navigate our relationships with language, people, things, and places. In short, he hands us an image by means of which we can conceptualize what, as addressors and addressees, we have at stake in address. He provides us with a figure designed to inspire unprecedented questions about the very nature of address.

Given the richness of the insights that collect around the image of the brick, this chapter will begin to track its transmogrifications.[17] For by way of this image, Cortázar brings the concept of address further than it has ever gone. Let's go back, then, to the premises where the narrator is opening the newspaper over coffee, having just visited the bathroom in his apartment opposite the Hotel Belgium in Buenos Aires.

Reliability is among the elements that bar available paths of progression, as the next command in the story impresses on us: "Go ahead, deny up and down

that the delicate act of turning the doorknob, that act which may transform everything, is done with the indifferent efficiency of a daily reflex. See you later, sweetheart. Have a good day."[18] Customary behaviors inculcate prefabricated modes of address that are responsible for missed opportunities. Mechanized corporeal agendas mask capabilities for change encapsulated within prosaic actions. Sliding by on automatic pilot, the narrator brushes aside a multitude of possibilities crowding in a repeatable gesture. But the forces that have him circumvent transformative potentialities do not lodge solely in him, that is, in his body or words. Traction inheres also in the objects.

Like the narrator, objects exert a pull toward normalcy: "Tighten your fingers around a teaspoon, feel its metal pulse, its mistrustful warning. How it hurts to refuse a spoon, to say no to a door, to deny everything that habit has licked to a suitable smoothness. How much simpler to accept the easy request of the spoon, to use it, to stir the coffee."[19] The stabilizing draw of the ordinary resides in the exchange between persons and things. Artifacts make requests and people offer replies in turn.[20] Things extend modes of address to the narrator, who adopts modes of address to things.[21] Both kinds of modes arise in response to each other, forging a web of relationships between addressors and addressees that enforces a predictable course of events: "Don't believe that the telephone is going to give you the numbers you are looking for, why should it? The only thing that will come is what you have already prepared and decided, the gloomy reflection of your hopes, that monkey, who scratches himself on the table and trembles with cold. Break that monkey's head, take a run from the middle of the room to the wall and break through it."[22] Even if everyday technologies like the doorknob, the spoon, and the telephone sustain only preconceived rituals, our desires aspire to something else. We compose phantom numbers that we would enjoy ringing far more than the ones we actually dial; as for hope, it becomes ensnared in a specter of antecedently specified happenings, sorrowfully split off from the things we crave. We shiver, we waver, we are cold.

The passage's concluding line abruptly calls an end to this dystopian state, however. New imperatives burst in, ordering swift refractory action. And in following this insurgent impulse, we won't be alone. Unannouncedly piercing the swarm of intemperate longings, inspiration spills forth from a sonic mode of address that suspends the rule of the ordinary. "Oh, how they sing upstairs!" The neighbors' auditory visitation trickles down into the narrator's space, ostensibly oblivious to the existence of the glass brick encompassing apartments, houses, the hotel opposite the street, that compartment in which "all of us live."

Other modes of address exceed quotidian dispensations: "And if suddenly a moth lands on the edge of a pencil and flickers there like an ash-colored fire, look at it, I am looking at it, I am sensing the beating of its tiny heart and I hear it, that moth reverberates in the paste of frozen glass, all is not lost."[23] The insect's heart pulsates in the narrator. Animal, human, and space vibrate together.

Motion infuses the moist, sticky matter of the world. Energy and warmth glimmer through the glue that maintains elements in a state of petrification. An intimate responsiveness connects the narrator's and the animal's modes of address. The insect draws near to the writer's pencil and the writer resonates with the insect in the plane of perception, sensation, and affect. An exchange arises, revealing that even hardened glass remains flexible, retaining a certain elasticity. The crystal brick has its gooeyness.

Imperatives overtly shift allegiance at this moment in the narrative. The last orders the story issues—"Break that monkey's head," "take a run . . . to the wall and break through it," "look at it"—no longer pretend to side with the enforcement of habitual modes of address, but explicitly foment rebellion against regulated domesticity. Directly addressing the reader, these commands goad us to join in the narrator's relation with the animal. They incite us to participate in the alternative cycle of address he sketches, one that, not surprisingly, makes a departure from the home:

> When I open the door and look out onto the stairway, I'll know that the street begins down there; not the already accepted matrix, not the familiar houses, not the hotel across the street: the street, that lively forest where each moment can fall upon me like a magnolia, where the faces will come to life when I look at them, when I go just a little bit further, when with my elbows, eyelashes and fingernails, I smash minutely against the paste of the glass brick and stake my life while I press forward step by step to go pick up the newspaper at the corner.[24]

The street promises the unexpected. Every instant can throw itself on the speaker with a radiant, fragrant surprise. There is always the possibility that a colorful magnolia flower sets off to land on the narrator's body. Animating people's faces by way of his gaze, the narrator shifts places with the moth who blew life into him. Unfleshy, mobile parts of his body flittering through the street, he extends the insect's quivering from the domestic arena into the city sprawl. But have we left one system of address for another one?

Cortázar's rehearsal of gendered oppositions between the feminized home and masculinized public life admits of leakages between the two spheres. Just as freedom dwells in domesticity, blockages turn up outside the house. The brick persists beyond as well as within the buildings' circumference. Repetition occurs in the vivacious external world: the narrator's journey induces no more than minuscule cracks in the paste of the glass brick as he makes his daily voyage to buy the newspaper. Like the moth's flapping wings, his sprightly extremities (elbows, eyelashes, fingernails) enjoy a limited range of movement, bound, as they are, to a larger body that keeps bumping into the glass brick.

The story wraps this corporeal condition of hedged liberty in paradox. The narrator's destination springs up suddenly in the reader's experience. The

discontinuous, strung-out passage about the street quoted just before, whose final words tell us about the objective of the trip, that of procuring the newspaper, abruptly draws to a close upon Cortázar's mentioning of this aim. Additionally, the speaker's goal is to be found right at the street corner, which would not seem to lead him that far from home. But precipitously as his target may come about, it arises at the endpoint of an assiduously executed sequence of infinitesimal steps. A lengthy process of accumulating little moments and parceled-out phrases halts instantly, checked by the fetching of the newspaper and the idea thereof. Time and space expand before they rapidly contract. Stretched and shrunk to their limits, these parameters, rather than collapsing onto themselves, enter into a pulsating rhythm, like the narrator's bowels or penis, his sensations and feelings, his eyelashes, nails, and elbows, and the moth's heart.

The narrator repeatedly underscores the smallness of the segments making up his expedition ("just a little bit further," "minutely," "step by step"). The fragmented, microscopic snippets of time and space that go into the project's execution necessitate repeating in order to lead the narrator to the corner. With our learning of the plan to purchase the newspaper, the story comes to an end. The buying sets a bound circumscribing a series of minuscule steps stretching out in front of the protagonist or lining up in his and our imagination. Where does this leave the speaker and the reader, and at which moment? What implications does it have for the structure(s) of address that speaker and/or reader occupy?

Upon the completion of his quest, the daily paper would seem to station the narrator, once more, at the center of the crystal brick, from which he tries to ascertain what is going on in just any nook or cranny of the globe. At the same time, in the hustle and bustle of the street, the newspaper, and the act of getting it, may spring up like a magnolia, for us as well as for the speaker. The story's ending, then, returns us to language—the newspaper's bestowal—in a double capacity. There is a side of verbal symbolism that clamps down on perception, as exemplified for the narrator by the word "cloud," which allegedly narrows his vision. But the instruction detailing the use of this term, "Castigate the eyes looking at that which passes in the sky and cunningly accept that its name is cloud, its image catalogued in memory," also allows a contravening meaning to shimmer through, pointedly insisting that the recommended course of action is something one would *not* want to assent to. The prescription dictates cunning, suggesting that it concerns a linguistic strategy, not a necessity.

It is open to us to adhere to received terms for things or events or to reiterate images these nominations reliably signal. But these choices do not exhaust the range of constellations that we may hatch within this triad—words, objects, and images. We can coax these elements into alternative arrangements, activating other structures of address. This exercise brings out a different capacity

of verbal symbolism, one that the narrator exploits when, refraining from referring by the name that he loathes to a certain rectangular space, he endows the brick with a mobility that enables it to shift from bowels or penis to bed, bathroom, apartment, newspaper, table, wall, ceiling, house, and hotel. The noun's said curbing effect averted, Cortázar's language provokes unanticipated events. It courts situations that speakers have not yet foreseen. He uses words to brew aesthetic relationships that we had not previously concocted.

At the same time, he of course relies on "bricks," namely, on in some sense already established meanings and ways of affecting the reader, in order to create modifications in these meanings and effects and to morph language's relational functioning. I will soon return to the twofold capacities of our linguistic comportment that Cortázar invokes.

Earlier in the story, he introduces a further set of considerations that weigh in on the question of the degree of motion and dislocation that the street affords, and of the structure of address encompassing speaker and reader. Both physical closeness and emotional proximity and temporal development and stagnation enter into a somewhat anomalous relation before the narrator begins to contemplate the street. He writes:

> And it's not that it's so bad that things meet us every day and are the same. That the same woman is there beside us, the same watch, that the novel lying open there on the table starts once more to take its bicycle ride through our glasses. What could be wrong with that? But like a sad bull, one has to lower the head, hustle out from the middle of the glass brick toward the other, who is so close to us, inaccessible, like the picador, who is so close to the bull.[25]

The watch records stasis, not change. It participates in the sameness of things, failing to advance us toward anything. The turning pages of a novel may fan out like the spokes of a bicycle wheel but the ride reaches no further than the narrator's glasses. A lot is to be said in favor of this stability and restrained development, the speaker notes. Mundane domesticity, however, also preserves unbridgeable distances separating us from other beings—a familiar woman as well as nondescript, proximate others—whom it is incumbent on us to approach.[26] We face a task of address. How do the circumstances on the street speak to this responsibility or wish?

As in the case of his meeting with the moth, the narrator's encounter with strangers on the street involves a corporeal exchange that appears to breathe life into both. But like a dance or public spectacle—behaviors in which several *Cronopios and Famas* characters engage—the narrator's daily stroll does not necessarily bring him closer to the unspecified other who is both near and far away. And a movement of this sort, if occurring at all, can only be fraught. The project of getting underway toward a familiar yet strange other whom, resolved

to shake off ingrained habits, we invest with murderous intent, surely revels in a bounteous spirit of aggression. This violence does not magically vanish. The drama between bull and picador, furthermore, extols repetition; it stages a performative uptake of already-given scripts of address.[27]

If the scratching, bumping, and flickering taking place on the street are among the happenings that we initiate when undertaking the voyage of getting closer to the proximate yet removed other being, then an additional part of this exercise, Cortázar makes clear, surrounds the newspaper and the business of procuring it. Besides exposing him to people's faces that increasingly come to life for him as he looks at them, the street gives the narrator language; it offers him access to a daily dosage of printed communiqués, an essential vehicle in getting near to known yet unknown others. The newspaper being its own type of rectangular "brick," however, the scene of address that he can expect to enter by way of it observes its own ritualistic principles and its own aggressive schemata, implementing interconnected proximities and distances between global and national centers and peripheries. Tellingly, the paper is procured on the corner. This location blocks vision of what is around it, but also inspires curiosity as to what is happening in those places on the street where we haven't yet gone, where we cannot yet see. Cortázar thus encodes our immersion in an interminable news cycle—and the coercive molds and packaged novelties it perpetuates—into our movements through the city space.

Making our rounds within the house, between house and street, on the street, like the moth, we both do and do not flutter about in a perpetual crystal room. In other words, while the brick won't be dispelled, persons and animals (people's songs; their bodily movements, perceptions, and feelings; insects' flapping wings; and throbbing animal hearts) cause the translucent compartment that we inhabit to modify its consistency and to reorder its perimeters. A restrictive structure of address may be lifted but another one can be seen to take its place or to remain in effect. The task of address that enjoins us to narrow our distance from certain other individuals in the end remains unfulfilled. Shackles on our address undergo shifts but do not vanish.

I will shortly look more closely at this equivocal situation. At this moment, it is worth briefly taking stock of what the discussion so far suggests for a theory of address. Modes of address sustain complex webs of interactions in Cortázar's tale. They support volatile relations among a range of elements. These include people and their various corporeal states (feelings, sensations, physical urges, wishes, aesthetic emotions, along with registers of bodily action and comportment), things (such as the pencil), places (such as the wall), and symbolic forms (such as verbal signs, images, numbers). Modes of address create intricate forms of organization among these entities.

The web of relationships that Cortázar forges displays the anatomical elements that chapters 1 and 2 have found at work in writings by Jamaica Kincaid,

Wisława Szymborska, David Hume, Immanuel Kant, and Michel Foucault: Cortázar recognizes the operations of norms of address (posited by, for example, teaspoons, doors, bowels, penis, companions, and words, and articulated by commands). He allots these norms a function within structures of address (systems that are signified by the brick and the domestic setting, among other things). Implementing their own brands of normativity, these structures encourage certain experiences and meanings (including a sense of satisfaction, comfort, reluctance, repetition, collision, familiarity, distance) while inhibiting other states (for instance, feelings of surprise and intimacy). The at one level allegedly missing aspects of amazement or wonder and emotional closeness, whose foreclosure by ordinary routines the narrator deplores, nonetheless prominently arrive on the scene at moments of rupture and gain a yet fuller, even if ambivalent place in partially overlapping, partially adjacent orders of address made up by the newspaper and the street.

Among the conditions that the narrator undergoes are states that clearly have aesthetic dimensions, such as the disgust that he feels for the name of the small rectangular compartment. Other aesthetic registers that he recognizes reside in the smoothness of the teaspoon, the sad look of the houses across the street, the bull's reluctance and sadness, the unexpected singing that arrives from above, and the lively character of the street down below.

Cortázar stages tensions between what is possible and real, actual and desired, in a given structure of address. In having us contemplate these tensions, he examines the kinds of aesthetically marked subjective and intersubjective being that it is open to us craft within the social and material matrices that harbor us and our bonds with other people and things.

Cortázar's story exhibits analogies to Kincaid's and Szymborska's narratives in that it grounds fields of normativity, relationality, agency, order, and (aesthetic) meaning in constellations of address. Additional parallels surface among these texts. The opening tale of "The Instruction Manual" deploys semantic measures that also inform "Girl" and "Vocabulary." I have described the evacuating procedure through which Kincaid sabotages a roll of commandments as well as the outpouring of meaning by means of which Szymborska brings to life an ostensibly vapid conversation. The double-edged precept with which Cortázar presents us—"Castigate the eyes looking at that which passes in the sky and cunningly accept that its name is cloud, its image catalogued in memory"—weaves together comparable acts of depletion and flooding. The result is an unsettlement of structures of address and a shimmering of different ones: Cortázar's instruction ostensibly mandates an emptying gesture, proposing a diminishment of perceptual fullness and fluidity. But it also counters such contraction by calling for cunning and by ironically undercutting itself.

This opposing movement effects a different kind of voiding than the slimming that language apparently inflicts on vision and affect. The command

rescinds the verbal and experiential structure in which words curtail perception, reify objects, and observe established spatial and temporal relations. In the place of this reductive template, the instruction posits an order of address in which words crack open stultified frames of significance. The precept thus leaves behind a barren scheme of address to advance a meaning that implements a richer linguistic and aesthetic organization. For Cortázar, evacuation and replenishment join forces in destabilizing and changing frameworks of address and instituting alternative constellations. We stumble on and zigzag around sites of linguistic entrapment to enkindle trajectories of freedom.

The place of address in which Cortázar's story locates its narrator and reader thereby remains far from univocal. The device of the instruction is instrumental in the story's unsettlement of the reader's position. The instructions voiced in the narrative partially target us, the readers of the tale, reaching out to us in the form of a direct address.[28] Besides the first-person narrator, *we* are told to tighten our fingers around a spoon, to punish our eyes, to break through the wall. One reason why the reader is affected by the dislocations that the story occasions in the frames of address it posits is that the story, by way of the address of the instructions, implicates us in the narrative, and vice versa, embeds in our various lifeworlds the fictional arrangement that it assembles.

The tale extends to the reader in an additional way, one that attaches to the encompassing geographical and cultural ambit that the narrative heralds. Like Kincaid and Szymborska, Cortázar conjoins local and global matrices of meaning. The newspaper in the story represents a zone of contact between these two patterns of address: when procured on the street, it provides access to current events in "whatever corner of that glass brick." By way of the newspaper, along with the banner of "The Hotel Belgium," Cortázar then situates his narrative in a transnational setting. The narrator of the story negotiates a vast cross-cultural plane of address, mediated by modes of vision, reading, writing, forms of literary and journalistic representation, perhaps even listening, and walking in the street. The reader's locality, wherever it may be, is potentially touched by these modes. This particular site, which may be any place, is inevitably one of those areas where, the story suggests, if something happens, that event is in principle accessible to the reader. Not a single reader is left out of the informational scope that the story signals. But this communicative orbit rests on mediation. It is a product of address and would not have existed without the operations of forms, media, and mechanisms of address, in short, the elements about whose potentialities and moral and political adequacy the story raises questions.

Unsettled frames of address therefore affect the reader's position, including the reader's act of reading the story itself. The tale exposes both the reader's address to the story and the story's address to the reader to the conundrums of address that the narrative itself investigates. Any reading of the tale, the story

implies, proceeds on contested grounds or, in other words, on a basis shaped, in part, through the very forms of representation, perception, and interaction that are liable to the problematic of confinement and liberation that the story explores. The narrative thus incites us to take cognizance of the bounds and limits inherent in the structures of address that we enact as readers, inevitably construing the modes of address that we direct at the tale as segments of the web of interactions that the story takes to be sustained by modes of address.

Hoping to gain further insight into the dilemmas the story articulates, I want to return to the structures of address that Cortázar explores through the figure of the glass brick. He affirms the powers of constraining and liberatory modes of address but also expresses reservations about our capacities to resist limiting structures. Indeed, the brick, I have indicated, is not just the common, sturdy, reliable building block that we associate with houses, foundations, apartment buildings, and streets, but a perplexing entity that combines the tenacity and predictability with which we are so familiar with unparalleled metamorphic behaviors.

Where does the malleable, gooey substance amassed within the brick leave the characters of *Cronopios and Famas* as well as those who peruse the collection or are writers themselves, such as, presumably, the pencil-wielding narrator? And how does the story construe the reader of newspaper articles and other texts? What does the indeterminate site of address that Cortázar elaborates by way of the image of the brick imply for our presence in problematic orders of address and our abilities to exit, challenge, or undermine them, to somehow register and counter the violence they embody, or to enjoy the mirth they permit?

NAVIGATING FLOWS AND BLOCKAGES OF ADDRESS

Several things travel from place to place in the first story of *Cronopios and Famas*. Clouds wander through the sky. A novel bicycles through the narrator's eyeglasses, its pages spinning in the rhythm of an unremitting fan, parceling out and fragmenting his field of vision. A moth lands on his pencil. The narrator takes a walk in the street. These movements co-occur with forces of inertia. The coincidence of elements of stasis with registers of change sparks questions about address: How do the tale's interlacing strata of stability and transformation bear on the hold that schemata of address have on us? What sorts of metamorphosis are possible within structures of address? What kinds of agency and invention do these structures allow? What forms of relationality, domination, and love do they nurture or foreclose? What kinds of writing can elude the clasp of the brick?

While enlisting the image of the glass chamber to formulate the notion of a confining structure of address, Cortázar at the same time breaks open precincts of blocked address by setting up rhythms and themes that run from tale to tale. In the opening story that we have been scrutinizing, he touches on motifs that he will revisit elsewhere in the book. These include insects, glass membranes, newspapers, toothpaste, a bicycle, a watch, a flower, and items descending from upper to lower floors. Another topic to which he returns repeatedly is the question of the molds into which language presses sensory existence. These recurrent subjects not only link together distinct narratives and get us to fashion ongoing conceptual lines as we hop from story to story, but also convey incitements to address. They are rallying calls that guide the address that the reader adopts toward the stories. Cortázar has sprinkled many such coaxers across the tales.[29] These dispersed instigators encourage us to approach the glass brick of the opening story from the perspective of the actions, motions, and journeys on which characters and things embark in subsequent stories. Following their promptings, I will examine several narratives to see what they reveal about the quandaries that *Cronopios and Famas* centers in address.

The book's four sections one by one evince a strong interest in these matters. The initial one, "The Instruction Manual," whose unnamed opening story we have been considering, is followed by the sections "Unusual Occupations," "Unstable Stuff," and "Cronopios and Famas." In the first three, Cortázar recounts, respectively, unheard-of instructions, seditious behaviors, and metamorphosing substances, elements devised to call into doubt constructions of our social and material universe that we take for granted along with the norms through which we navigate it. The fourth part acquaints us with a cast of fictional beings (cronopios, famas, and esperanzas), some of whom dedicate themselves to unruly activities (cronopios), while other, more deliberate characters pride themselves on their sense of discipline (famas), and yet others have their own marked preferences but display less smarts, flexibility, and imagination than the cronopios and less determination than the famas when it comes to making their wishes true or realizing their achievements (esperanzas).

Each part of the collection reveals entanglements of states of order with acts of disruption that create havoc for the norms, forms, and structures of address underlying order. The ambiguous position in which the opening story places the reader and the narrator vis-à-vis the crystal chamber reappears throughout *Cronopios and Famas*. So how does the pliability of the brick go together with the sticky grip that the glass volume has on those who move inside it? And what does this tell us about the play between mobility and stasis that may arise within or at the border zones between different structures of address?

Before we enter these questions, a quick note to track where we currently are and will be going with respect to the philosophical issues about address that we are exploring in this chapter: Cortázar, as we have seen, grounds webs of

relationality between language, people, things, and places in address. Spreading the underpinnings of normativity across the nodes of these webs, his stories scrutinize the forces of freedom and confinement inherent in our corporeal, affective, cognitive, linguistic, and aesthetic emplacement in structures of address. The opening story of *Cronopios and Famas* gives us a picture of a condition of constraint that, although it takes changing forms and admits of small-scale shifts, does not simply evaporate when we push back against it. By considering the varying appearances that the figure of the brick assumes in a number of other stories in the collection, we can then shed light on the existential position in which Cortázar places us as addressors and addressees who inhabit a social and material world. This aim will occupy us in what remains of the present main section and the one that follows. The subsequent sections of this chapter will then further spell out pertinent philosophical insights about address that can be garnered from Cortázar's investigation.

A wandering line

Schemes of address often leap out at us at the onset of Cortázar's narratives. "The Lines of the Hand," for example, begins with a letter that has been thrown onto a table. The missive harbors an element that instantly leaves its linguistic frame, namely, the story's protagonist, which is a line. The line runs from the letter across a wooden plank of the table. Spending a brief moment with the design of the table top, it next lowers itself by way of one of the legs. The destination that follows consists of architectural patterns: the migrating line traverses the floor to ascend the wall. There, "art" appears: on its upward trip, the line enters a reproduction of a Boucher painting. During its visit to the picture, it traces the shoulder of a woman reclining on a divan. From the representation of a female body part, our character sets off on a long journey that includes a climb over the roofs, a descent by way of a lightning conductor, and a ride on the wheel of a bus on the way to a boat terminal. The transportation system carries our protagonist once again toward a component of a female body, and a leg, at that. The figure takes a hitch on the nylon stocking of a woman who passes through customs to embark on a ship. It then continues aboard to settle in the palm of a hand that is beginning to close itself around the handle of a revolver.[30] Satirizing its renowned namesakes, known as the storylines of the suspense tale and the travel narrative, the line of our story at this point meets its end—the fiction is over.

Crossing from object to object, the straying line of "The Lines of the Hand" leaves for other plans of address the schemes of address in which it has taken up residence, on a path over and through human and animal bodies as well as artifacts. Rather than abandoning narrative or pictorial form upon its

withdrawal from the epistolary mold, however, it invokes such codes all the more poignantly as it turns for dramatic effect to the detective novel, eroticized depictions of feminine bodies, and rooftop pursuits familiar from the action film, rallying a whole repertoire of motifs of romance, travel, and fortune, feminized as well as masculinized, including an enigmatic denouement on a transatlantic liner.

The story brings to the fore an instability inherent in structures of address. Elements can loosen themselves from the constellations in which they lodge. Cortázar endows the wandering line with the ability to vacate structures of address while hopping onto other ones. Shuttling between these, according to the story, we nonetheless continue to enact preconceived representational typologies. When contemplating the voyaging line in tandem with the glass brick of the first *Cronopios and Famas* story, burgeoning varieties of mobility as well as stasis come into view. The line operates like an agent who splits away from the confines in which she, he, or they fleetingly entangle(s) her-, himself, or themselves. Making off from recognized structures of address for other ones, however, the figure replicates familiar scripts of address.

The crystal compartment of the opening story, we can infer, can procure for itself exactly the mobility that the migratory line has garnered. Transferring its reach to altering constellations of address, the brick avails itself of the power to convert changes into a new kind of stability. Like the earlier story, "The Lines of the Hand" sketches a tension between repetition and difference: It is not the case that things always remain the same. Neither do point of departures herald a radical turnover of existent worlds. Rejecting these drastically opposed alternatives while also always keeping them alive, Cortázar posits a polymorphous patchwork of address in which proliferating bursts of activity instigate shifts and turbulences that jell into modified alignments, even if these developments and agitations reiterate certain well-worn stratagems of meaning and ultimately come to rest.

The letter that literalizes the wanderlust emblematizing certain kinds of travel narratives and puts into action the suspense of a detective story points to something else. So do the female bodies within and beyond the Boucher reproduction. These elements signal an additional dimension with which Cortázar invests both the strain and the complicity between transformation and sameness: aesthetic forms, codes, and genres are powerful participants in the contrary pulls between stability and change that occupy him so unflinchingly in his writing.

Verbal upheaval

Language is a full-fledged participant in the volatility that Cortázar, in essence, grants structures of address. This tumultuousness does not belie the logic of

words, but can arise precisely when we follow the principles of naming to their very consequences. Consider the tale with the astounding title "A Small Story Tending to Illustrate the Uncertainty of the Stability Within Which We Like to Believe We Exist, or Laws Could Give Ground to the Exceptions, Unforeseen Disasters, or Improbabilities, and I Want to See You There." The fiction takes the shape of an excerpt from a confidential memo. The memo is classified by a serial number. It is addressed from the secretary of one office to the secretary of another office.[31] The document reports on a terrible confusion. Normally all goes perfectly, the writer assures the reader; never has he witnessed the slightest trouble with the rules. Now, however, things have suddenly become a mess. The bureaucrat explains that a helicopter accident has killed six of the seven members of an international executive board. Their alternates and the one surviving delegate, Felix, convene to appoint new representatives to be selected from a list submitted by the organization's member states. The delegates choose three more Felixes, drawing a joke from the interim president. The votes on the Greek and Pakistani candidates yield two additional Felixes, the scribe continues, Mr. Felix Paparemologos and Mr. Felix Ahib. People become distinctly uneasy. It is up to Argentina to fill the remaining vacancy, which, to the committee's consternation, it does by electing Mr. Felix Camusso. The afternoon paper makes fun of the situation. The author of the confidential report notes that the credibility of the council is in shambles. The bizarre coincidence forces many of the representatives, all renowned economists, to step down. Mr. Camusso requests instructions on how to voice his statement of resignation. In the memo's final reflections, the secretary surmises that the Argentine Felix's letter, along with the dispatches by several other Felixes—in the absence of any legitimate reason for withdrawal, the only desire being that the representatives do not go by the name of Felix—will probably adduce reasons of health and meet with acceptance on the part of the director general. Governmental regularity backfires. Transnational homogenization ironically runs awry when local arrangements are already so streamlined that the further uniformity and generalization sparked by the homonymic personal names—as if they, like regular nouns, denote beings of a certain type rather than singular individuals—collapse onto themselves.

Contrary to the disciplinary influence that the term "cloud" appears to exert over the narrator's vision in the opening story of *Cronopios and Famas*, the names of the committee members undermine the methodical order implemented by a functional administrative unit. Personal names, in this governing body, operate in principle like nouns in that the abstractions that these names impart serve to guide transnational interactions onto orderly paths. Instead of effecting the proper reductions, however, and channeling tidy lines of exchange, the repeating names unleash chaos. No matter how disciplined and well-behaved the Felixes may be, owing to language's workings, their professional comportment resists streamlining in accordance with designated procedures.

Verbal symbols disrupt institutional formations, necessitating linguistic adjustments in what had seemed to be flawless proceedings. Unheard-of cutbacks, at once symbolic and material, ones that slash concrete happenings far more rigorously than the noun "cloud" would appear to divvy up the agitation in the sky, appear to be called for in order to ameliorate the unruliness of naming. The simplifications that language may bestow create complexities of address whose reverberations are far from univocal.

Like the narrative, cinematic, and pictorial templates echoed by the line in "The Lines of the Hand," names, in "A Small Story," assume agency of their own. Cortázar grants words—in unlikely and unprecedented combinations—a supra-personal capacity to bring structures of address into disarray. Linguistic anomalies may create havoc for the apparently impeccable functioning of a system of address. Particular words, uttered at select times and places, can provoke a bending of the operations of authoritative address, precipitating deviations in the ordinary course of things. Even if "A Small Story" marks the situation that it documents as exceptional, both it and "The Lines of the Hand" multiply points of linguistic possibility stretching out within conventional formations of address. Extrapolating from this to the glass brick of *Cronopios and Famas*'s first story, the crystal chamber's distinctive type of order—whatever this order might be precisely—would seem to be vulnerable to incursions from a range of directions by unforeseen linguistic circumstances and events. The tendency of the glass volume to repeat itself in altered forms does not inoculate it against potential disruptions that stem from its own innards.

Proliferating sites of linguistic activity, as it happens, occur also in the collection's opening narrative. Language appears in myriad forms in this tale. Besides the punitive word "cloud," which acts as a relay for memory images, and the dirty sign "The Hotel Belgium," which gives an inkling of transnational histories, promises, longings, and disappointments, we encounter a whole array of phenomena that admit of multifarious linguistic trajectories: there is the newspaper at home and the narrator's opening of it; the pencil that presumably serves him to write down locutions, an instrument that the moth turns into its landing platform and perch; the paper at the newsstand on the corner of the street, which the speaker presents as the destination for his ambulations; and—to return to glass—the novel that, lying open on the table, bicycles through the narrator's spectacles. These elements are by no means unequivocal in the orientations of their address.

Castigating our eyes and striating our vision, or perhaps even breaking the eyeglasses that would allow us to bring things into focus, language may impair the capacity to see, but it also forges openings. Animals and humans embark on processes that move them toward instruments that sustain verbal inscriptions, such as the pencil and the newspaper: a writing object yields a trigger for the moth's as well as the narrator's activity, kindling the insect's fluttering along with the speaker's empathetic uptake; an act of reading (perusing the paper),

amounts to a place of arrival that extends the scope of the narrator's splintered, refractory movements from the home to the street corner and, from there, onward to the distant locations with which the newspaper brings him in touch.

The Cortázar stories we have discussed so far allow us to draw a conclusion about *Cronopios and Famas*'s view of the networks of relationality we inhabit and about the place of language in those patterns: Moving both from and toward linguistic formations, we simultaneously shift our orientations toward human and nonhuman fellow beings and to plants and objects in the world. Language treads within limits represented by glass membranes that it helps to bring into existence, but can also displace or muddle these transparent barriers, perhaps even break them into tiny shards.

If the fetching of the newspaper, then, brings to a close a stage of the narrator's voyage on the street, as the terse ending of Cortázar's prolonged, choppy final passage invites us to imagine, the glass membrane's, the insect's, and the newspaper's nature as material phenomena would also seem to allow for development along different angles. Glass and print surfaces, for Cortázar, have their place in a restless physical order, subjective as well as objective, one that is not altogether discernible to the peering eye. The next story we will examine revolves around a pair of eyeglasses that epitomizes this intangibility.

Physical flukes

If something strange happens, can we actually recognize it? What stories can we tell about it? Do our narratives assimilate the anomalous to previously established structures of explanation or can they make room for events that put pressure on the conceptual matrices to which we subscribe? In "A Very Real Story," Cortázar examines the notion of the perplexing and scrutinizes our capacity to detect that phenomenon when it occurs, and to recount it.

A gentleman drops his spectacles onto the floor. Smashing into the tiles, they make a terrible noise. He is worried because the glasses are very expensive. Against all expectation, however, they survive wholly intact—by a miracle, the gentleman believes.[32] Action is in order: the man prudently cushions the glasses in a case. Precautions taken, he remains unperturbed when, buffered by their cocoon, the glasses fall again to the ground. This time around, however, he finds the lenses in pieces, nestled in their protective container. A bit of time passes before he concludes that the miracle, in reality, has happened only now. Practical reason, it appears, creates a fiasco for the gentleman, one that he had guilelessly averted in the less deliberative phase of his dealings with the material world. Glass exhibits its capricious side.

But what kind of story is it that says that glass can behave like a miracle? And why does the gentleman feel compelled to tell the same story twice, pulling out a set narrative for two different and even contrary events, namely the

tale that a miracle has happened? The stories we tend to tell ourselves about what qualifies as the common and uncommon behaviors of things reveal their flightiness. Just as the material world can defy our expectations, the accounts we give of the unexpected can unexpectedly turn out to be quite fickle, especially when we take cognizance of the reckless defenses that our descriptions put up against the very unpredictability that they purport to recount and of the foolhardy barriers that our interpretations erect against the incomprehensible events that they attempt to chronicle. No preventive actions guard against this. The gentleman's apparently protective linguistic strategy—reading the survival of the glasses through the set phrase of a miracle—unexpectedly invites the unpredictability that it both registers and holds off to rear its head elsewhere: before the gentleman knows it, he is facing another miracle, obliterating the earlier one.

Is language's capacity to have us discern things cheap, contrary to that of the glasses? Or has the time come for the gentleman to spend some good money on his linguistic acuity and to acquire a new model, a more upscale frame? Vis-à-vis language itself, the gentleman is not moved to adopt a precautionary measure designed to safeguard or update his verbal powers of recognition. Rather, he goes about his ordinary business: He has not found it advisable to revise his interpretive template or to refurbish his language's analytical resources. He simply identifies a new—this time allegedly true—miracle, withdrawing a given predicate from the original situation and applying it to a different circumstance. This repetitive scenario, however, clearly leaves him exposed to the risk of further surprises—the occurrence of other extraordinary events for which he has not prepared his categorial and perceptual stratagems.

The mercurial aspect that "A Very Real Story" attributes to the material world we have spotted also in the first *Cronopios and Famas* story: while the rectangular block garners reproducibility and repetition within its variable outlines, the foreseeability that this engenders precludes neither the entry of outlandish singing into the volume's territory nor the unannounced arrival of a flaming moth. In the street part of the vast global chamber that we occupy, the ordinary course of things, moreover, admits of surprises that come upon the narrator like magnolias, which, he declares, may happen just any instant. Pragmatic designs, Cortázar's stories intimate, can bring into existence points of unpredictability that put pressure on our interpretive and observational habits. Order gives rise to elements of disorder. Language fails to shield us from this; a genuinely protective case for language itself, moreover, is not for sale. No matter how set our vocabulary may be (and, as noted before, established, tractable meanings are pivotal to language's operations), the gap between language and reality keeps asserting itself, to our peril. Along with the collection's initial fiction and "A Small Story," Cortázar's tale "A Very Real Story" ascribes moments of

inexorable uncontrollability to our denominative practices and, more broadly, to the webs of relationality and address encompassing people and things.

Doubtless the "very real" story in "A Very Real Story" is about to be superseded by another story. Not only the brick of our opening tale, as we have seen before, but also the stories that we might tell about it are susceptible to conceptual, experiential, and linguistic happenstance in a fashion that we have no way of foreclosing.

Erratic barriers

Glass retains its elusive behavior in "Progress and Retrogression." A fly succeeds in crossing a glass wall. "They invented a kind of glass which let flies through. The fly would come, push a little with his head and pop, he was on the other side. Enormous happiness on the part of the fly." The problem for the insect, however, is that it cannot return, as a Hungarian sage discovers. "[T]he fly could enter but not get out, or vice versa, because it was unknown what was wrong with the flexibility of the fibers, which was very fibroid." According to this Kafkaesque explanation, the animal's intellect and bodily agility are not quite up to the challenge of going back, at least not yet. The fly may in principle be able to unravel the mystery—the narrator's reasoning intimates that the insect did try to decipher how to make itself appear again on the other side of the glass sheet but failed to figure it out. Now it is too late. The damage has been done. "They" (the unspecified individuals whom we can assume to be the scientists and/or designers who invented the glass) are already exploiting the irreversibility that they have brought to light, by building a trap that causes a great many flies to die desperately and that, we learn, destroys the possibility of humankind's bonding together in a state of brotherhood "with these animals, who are deserving of better luck."[33]

Advancement reveals its downside in "Progress and Retrogression." Development throws unrivaled types of ensnarement in the paths of animals and human beings. Knowledge and technology occasion spurts of liberation that deposit their tendencies to backfire along uneven grids. Further, a mindset of experiment and invention can sow the illusion, as it did perhaps for the fly, that apprehending the instruments of captivity allows one to actually prevail over these mechanisms. Grasping the properties of the glass panel would not have solved the insect's quandary, however. The enigmatic qualities of the material pose difficulties for theoretical and practical reason alike.

Traversing the crystal barrier proves not to be the triumph that the fly experiences in its first instants on the other side. Initiatives of this sort may well compound one's trouble. Upon its audacious undertaking, the happy, daring animal cannot bargain for a retreat to safe ground, certainly not once luck slips

away from its species with the fabrication of the fly trap. Haphazard spasms of insight grant humans and animal asymmetrically governable measures of influence over the glass's permeability. Vital conditions of passage remain out of reach to the animal stuck within the box or locked outside of the enclosure. With the crystal's selective porousness, its erratically controllable flexibility, and its mysterious, at best partly ascertainable makeup, Cortázar sardonically gives us to read the coincidence of contrary facets of progress and regression. He displays these entangled processes in their links with imbalances of power. More than that, he connects the medley of forward- and backward-tending forces that emanate from the transparent screen with limits that he ascribes to rationality of a speculative as well as instrumental sort. "Progress and Retrogression" brings into stark view the tenacity of curbs on address.

Like the narrator of *Cronopios and Famas*'s initial story, who puts his life at stake on the street, the fly toys with its life as it embarks on its voyage. This place of risk instills delight for the human protagonist, no less than for the insect. However, Cortázar leaves both characters on the edge, intensifying the likelihood that, like scores of intrepid animals, they must be reckoned among the unfortunate ones who cross over only to get caught on the wrong side of an unfathomable partition.

Rather than mounting impenetrable divides between inside and outside, both the crystal brick and the device walling up flies constitute semipermeable barriers. These boundaries admit of manipulation but also exert resistances that elude the grip of reflective awareness and intentional action. At the same time, Cortázar lends the brick a malleability that the insect trap lacks. The brick is glutinous. Its viscosity allows for movement.

Affiliations and proximities between the crystal volume and another rectangular shape, namely the newspaper, signal additional kinds of plasticity that the transparent compartment may possess. Junctures in *Cronopios and Famas* at which artifacts such as newspapers are liable to molding and folding point to the pliability that, in principle, accrues to structures of address.

Traveling leaves

Object of quotidian reading, yet a thing to be procured on the street and a source of access to particularities in distant locales, the newspaper in Cortázar's opening story enjoys an ambivalent status. Sustaining the customary practice of being read in the morning, the daily reinstalls the glass brick after the narrator leaves behind sites in which the brick had settled earlier. The thin hexahedron that is the newspaper serves as one of the carriers for the thick cuboid that is the brick. Upon a subsequent appearance in *Cronopios and Famas*, however, the paper travels more widely. It lends its assistance to endeavors that outstrip

established morning routines. In the tale "The Daily Daily," Cortázar takes a newspaper on a journey that initially finds its momentum in the object's functioning as a daily but that ultimately releases the artifact from this role.

A gentleman catches a tram, holding under his arm the daily newspaper that he has just bought. When he disembarks from the vehicle, the thing he carries under his arm, however, is no longer a daily, but a pile of printed pages, which he leaves on a bench in the square. Left by itself on the bench, the pile of printed pages changes back into a daily. A young man picks it up to read it. Having finished poring over the daily, he abandons the pile of printed pages on the bench. Alone on the bench, it turns again into a daily. An elderly lady notices it, reads it, and leaves it converted into a pile of printed pages. She takes it along with her to her house and, on the way, wraps it around half a kilo of chard. This, concludes the story, "is what dailies are fit for after these exciting metamorphoses."[34]

An active participant in the ceremonies that humans center around it, the object that is the protagonist of "The Daily Daily" not only changes its nature in response to a mode of address that people direct at it, namely reading, but also—as an ingredient of print culture—in anticipation of the occurrence of such readerly address. Language has no trouble keeping up with the shifting character of the thing. Indeed, the designations "daily" and "pile of printed pages" express these changes pointedly. The item alternately referred to as a "daily" and as a "pile of printed pages" industriously encourages the human exploits that it supports. Its constitution as a material object is of decisive importance to the events that transpire. People and daily/stack of leaves join each other in a ritualistic practice that generates reversible transformations. The voyage of the paper between people involves repetition, a dimension that Cortázar's iterative descriptions mark emphatically. The expedition that the daily undertakes engages bodies and things in well-entrenched scripts of address surrounding the use of print media, trams, and public benches. Concluding the newspaper's oscillations among phases of material identity that, predictably, revolve around reading, however, the object leaves this cycle to enter a state that could not exactly have been anticipated: the heap of sheets goes to wrap up chard in the street on the way from its place on the bench to a lady's house, much like a magnolia might suddenly descend on us when we walk about.

While the agency of the object stands out prominently, that of the human beings handling it retreats. Do people rule the thing or does the thing govern the people who deal with it? The daily roams somewhat randomly, arriving at its readers independently of the precise acts of address that they will be inclined to direct at it. It is of no consequence, for instance, whether the reader uses the paper to check out the ads or to keep up with politics. The lady envelops the chard in the daily regardless of what the paper says. To a certain extent, the daily's peregrinations proceed irrespective of its content, the rationality of

its subject matter, or the exact designs we have on the object. It undertakes its journey in a field of contingency. Its regular functions take shape in a sphere that reveals significant arbitrariness. Happenstance infuses the daily's job as an object of readerly address as well as of other kinds of deployment. The lady might have chosen carrots or radishes instead of chard.

By bringing into focus the trajectory of address that carries the newspaper haphazardly yet steadily from place to place and from person to person—in a literalization of the connective tissue fashioned by information flows in the era of mass communication—Cortázar reveals a plan of address in which malleability pervades the givenness of things, in which room emerges for changes in the typical functions of objects, and in which material proceedings display a contingent and oblique relation with rationality. His framing of the daily's/heap of leaves' address to various people and of these individuals' address to the thing marks the connection between material object and functional artifact as a site of actual and potential transmutations. An unwavering organizer of the relations among persons and things and an indefatigable structure of physical and experiential worlds, address, in the story, nevertheless displays much give and take. Unsuspected designs come to fruition in consequence of these exchanges. The object enlists its human collaborators in an enterprise of aesthetic co-production.

"The Daily Daily" exposes a hedged plasticity that characterizes also the site of address in which the fiction that opens *Cronopios and Famas* locates its narrator and reader. Epistemic constraints limiting the scope of information that can be gathered from the daily, whatever these may be, fail to decisively restrict its exploits. While the newspaper fulfills an iterative task as an object of reading, this role far from fully specifies the escapades on which it can and does start off. A round of repetition comes to a close with a surprising event, the recruitment of the daily to wrap chard. Like the line in "The Lines of the Hand," the newspaper adapts to unforeseen if not altogether unprecedented aims. The object exhibits flexibility of purpose. The extraordinary, once again, shows itself to be immanent in the quotidian functioning of humans, language, bodies, objects, and environments. If our apparently homogenizing mediasphere flattens distinctions among readers and among types of reading, it also favors novel material and symbolic linkages among objects and among human beings. The ebbs and flows of our informational cravings are immanent in more encompassing corporeal and imaginative constellations of address, which include desires for a fresh meal, longings to take a break on a bench, obligations to go shopping, or needs to hop onto a tram. While themselves of course not isolated from information streams, these day-to-day urgencies contribute their own formal and normative impulses to our engagements with media of communication/the material vehicles making up those media.

The presence of the unusual in the usual generates a state of ambiguity, underscored by Cortázar's closing remark that this "is what dailies are fit for after these exciting metamorphoses." Were these transformations exciting? Irony lets us have it both ways: yes and no. The continually entwining orbits of the mundane and the miraculous that Cortázar has set into motion have us in doubt as to our whereabouts with respect to these spheres.

Once again, *Cronopios and Famas* leaves it not quite clear where we are in a frame of address. As he hauls us to unexpected terrain, Cortázar simultaneously keeps us ensconced in the everyday. While the woman's conscription of the newspaper for a chore of cooking and carrying terminates the day's ritual of reading and depositing, of being read and being put down, of curiosity and a flagging of interest, it allows a different set of customs to take effect—habits concerning the buying, transportation, preparation, and eating of food. A daily being just a daily, moreover, and a daily daily at that, the following morning another exemplar will go on sale. The very same cycle is gearing up to get going again, presenting just a slightly different set of possibilities and limitations. We have returned to the equivocal condition of address occupied by the narrator of the book's initial story as he ventures onto the street only to bump anew into the transparent brick.

A baroque artist

The viscosity that Cortázar in his opening story attributes to the brick points to the stretchiness that allows the iterant volume to change shape and accommodate unforeseen occurrences. Among the devices through which he gives form to this elasticity, in that first story, is the image of the sticky paste that makes up the insides of the brick. In turn, this smooth, gummy consistency rematerializes as the silky texture of toothpaste, whose taste fills the narrator of the opening story with a feeling of the quotidian. In "The Particular and the Universal," Cortázar picks up on this constellation of interwoven figures, each of which denotes various degrees of plasticity as well as resistance to change.

Overjoyed by the morning sun and the beautiful clouds dashing through the sky, a cronopio character lavishly spreads ribbons of pink toothpaste from his balcony, exuberantly cleaning his teeth up above. The strips of paste fall onto the hats of a group of famas below, who have gathered to discuss municipal scandals. Profoundly indignant, the famas appoint a delegation that goes upstairs to the cronopio's floor to object to the lack of consideration he has displayed.

The famas, reveals the narrator, protest not so much the cronopio's ruining of their hats as his offense of wasting toothpaste. Although they let him know

that he will have to pay for this destruction, their foremost concern would seem to be a general misdemeanor, a matter of principle: the fact of excessive expenditure. These are the delegation's words:

>—Cronopio, you've ruined our hats, you'll have to pay for them.
>And afterward, with a great deal more force:
>—Cronopio, you shouldn't have wasted your toothpaste like that![35]

The problem is not so much the incidental wrecking of the hats, but the universal abomination of the cronopio's wastefulness.

The divide between the particular and the universal not only contrasts the accidental detail with matters of general principle. It also distinguishes the famas' provincial bureaucratic interests from the brightly proliferating pink strips that the sun and the clouds, in a wave of cosmic resonance, get the extravagant cronopio artist/perceiver to emit over the balcony.[36] Moreover, it separates the famas' abstract deliberations on local outrages, which are potentially of longstanding, generic interest to these characters, from the immediacy of the affront that the cronopio has made, which happens right then and there. In its dispersive, profligate, baroque momentariness, the offense that the creature has committed synthesizes both sides of the binary of the story's title.[37]

In a way analogous to many other narratives in *Cronopios and Famas*, "The Particular and the Universal" stages a disruption of what are often considered respectable social arrangements. An act of transgression destabilizes a structure of address that happens to be in effect, which then restores itself. A slight conceptual shift may be detectable in the relation of the cronopios and famas to the universal maxim that proscribes wastefulness. For if wastefulness is a problem with the cronopio's behavior, the famas's preoccupation with municipal scandals may well outdo him in this regard, as a way of spending the time. Whatever relation to the universal these creatures' activities may have, once the cronopio has paid for the destroyed hats, the normal order of things would seem to resume.

But does everything return to what it was before the cronopio set out to decorate the firmament in swirls of pink toothpaste? Upstairs, in tune with the sun and the clouds, sensitized to the time of the day, the cronopio has achieved the status of the "universal" artist, in contrast to the keepers of the city below. These guardians' aesthetic action-radius stops at their hats, at most occasionally reaching higher. However grateful the famas may be to finally have gotten rid of these hats and come a little nearer to the skies—to have a somewhat less impeded line of vision, to sense with more acuity the air around them—they do this with antiartistic resentment and, more than that, upon the promptings of the cronopio's aesthetic self-abandon. Nonetheless, everyone in the end more closely approximates the "universal." An entrenched structure of address enters an enlarged configuration.

Saying Hello and Goodbye 129

Another baroque artist

Although a structure of address repairs itself upon a rupture in "The Possibilities of Abstraction," this breach leaves a residue and results in a short-lived loss. In this story, Cortázar hauls the paths traveled by the floating toothpaste and the ambling line that we have pondered before into the narrator's eye and mind and, from there, into the institutional space that this character inhabits. His lengthy employment at UNESCO and other international organizations notwithstanding, the protagonist maintains, he has been able to hold on to his sense of humor and to his capacity for abstraction—two modes of address.

Both modes appear to be of considerable influence in shaping the speaker's professional habitat and his current circumstances. We learn that Monday a week ago, the narrator enjoyed himself with the sight of ears visiting his office. The ears subsequently aligned themselves in symmetrical rows in the cafeteria at lunch time. On Tuesday, watches flew over the tables with a back-and-forth movement reminiscent of the action of cutting up a steak. With Wednesday bringing a preference for "something more fundamental," namely buttons, the glass brick reappears:

> What a show, wow! The air of the halls was filled with shoals of opaque eyes which crept horizontally, while alongside and somewhat below each little horizontal battalion, two, three, or four cuff buttons swung like pendulums. The saturation in the elevator was indescribable: hundreds of motionless or hardly moving buttons in an astonishing crystallographical cube. I recall one window especially (it was afternoon) against a blue sky. Eight red buttons sketched an exquisite vertical, and here and there a few small secret pearly disks moved softly. That woman must have been so beautiful.[38]

Both elevator and window, shifting between floors as well as ensconced in a single wall, the brick frames the delicate windings that the baroque buttons weave in space. Next, the movements of abstraction take on a more earthy aspect. The day being the special occasion of Ash Wednesday, hundreds of stomachs arrive holding a greyish pap made up of commingling cornflakes, coffee, and croissants. Orange wedges progress through the digestive system and move between floors of the building. Reduced to a whitish deposit, the orange immobilizes itself between the two arms of a chair, as do eight ounces of tea. But rapidly things return to a more ethereal state.

"As a curious parenthesis," the narrator reports, clarifying that his "faculty for abstraction tends to exercise itself arbitrarily," a puff of smoke can be seen to descend "vertically by a tube," to "split into two translucent bladders," and to rise up again through the same tube. The smoke completes a graceful flourish before proceeding to disperse itself "in its baroque consequences."[39]

Cortázar's side-note—at once verbal and visual—allies the narrator with the baroque artist and this artist's digressive absorption in illimitably proliferating figurations. Like his baroque colleagues, including the toothpaste-disbursing cronopio, our abstractionist produces decorative patterns that immerse us in a world of unencumberedly meandering signs whose ties to utility or referential efficacy have been relaxed.[40]

Be that as it may, his mates in the workplace champion a different aesthetic. Upon his return from a visit to the orange, the tea, and the smoke, the narrator arrives at his office to find his secretary in tears, reading an order that gives her boss final notice. Her superior briefly finds pleasure abstracting these tears into "diminutive crystalline fountains, which came into being in the air and went plash on the bookshelves, the blotter, and the official bulletin."[41] Leading us from barely noticeably gyrating spheres congregated in the glass compartments traced by elevators and window frames to little globes that splash onto the secretary's executive accessories, the narrator directs us back to the orbit of tiny moving segments of the sort we have encountered in the first narrative.

But the narrator would betray his extended inculcation in the manners of an abstracting, administrative frame of mind (along with his reading of Melville,[42] whose scrivener has doubtless set a luminous example), if he would not permit himself one last abstraction: to wit, an aesthetic generalization. "The Possibilities of Abstraction" ends with the observation that "life is full of beautiful sights like this."[43] By way of the liquefying collaborations between food and digestive organs, we end up with corporeal fluids that trickle from the body. The dripping tears exit their anatomical encasing to wet the paraphernalia of bona fide administrative life. The narrator has to quit: institutionality reestablishes itself virtually intact after incurring a small disturbance, which it swiftly, if not spotlessly expels beyond its contours. With his ousting, the international organization sustains no more than a momentary loss. The narrator's literalization of the institution's abstractive bureaucratic principles is decidedly underappreciated by his coworkers (with the exception of the secretary). The breach of a structure of address incites a rapid realignment. At most, a minuscule change has taken place.

And yet the office harbors a moment of aesthetic dissonance or incongruity in the fictional world that the reader envisions. There is a non-negligible residue. Cortázar hands us the visual delight of the tears and their traces. He leaves his readers on the lookout, thrilled at the prospect of a magnolia or a swirl of pink toothpaste that may land on them. And he situates us in the middle of the intoxicatingly perilous lives that we risk while traversing the crystal cells that we build around us. Tremors as well as tingles accompany our journeys between patterns of address. These peregrinations have us quiver, like flittering moths or shivering monkeys.

Structures of address, for Cortázar, thus display minute modifications that settle in shards of movement, in mutating translucent volumes—as large as the world or as small as a tear rolling from the eye of a companion—and in the shifts between reversible positions, including those of the reader of "The Possibilities of Abstraction" and of the narrator, moth, and monkey of the collection's opening story. These changes also take residence in an abiding sense of aesthetic potentiality: the possibility of a turnabout provoked by a dissonant aesthetic occurrence—a point of tension—persists in the universe of Cortázar's stories. In its rectangular appearance of an elevator or window, the glass brick, as "The Possibilities of Abstraction" reveals, can host beautiful things. In the liquid form of the clear, salty drops that can roll from one's eyes, the brick even can have moments of beauty itself. The magnolia and the toothpaste—incongruous aesthetic elements betokening the liveliness of being alive, a different organization of address, and an element of delight—remain on the horizon. They are close; sometimes they are right there.

GOOEY GREETINGS

The last story we will consider in this chapter, "How's It Going, López?," examines what we are encouraged to believe is a diminished structure of reciprocal address harboring an encounter between two people. The narrative revisits the quandaries of human intimacy and distance voiced in the first *Cronopios and Famas* tale.

Salutes between two friends bookend the story. Here is the opening hailing, in the narrator's words: "A gentleman meets a friend and greets him, shaking his hand and bowing his head a little." The encounter, which most likely occurs in the street, draws a commentary from the narrator that immediately follows his initial observation, "Like that he thinks he has said hello, but the greeting has already been invented and this good gentleman is only putting the greeting on for the umpteenth time."[44] All this happens in the first two paragraphs of the story.

A similar exchange, perhaps resuming and continuing the earlier encounter, perhaps marking another occasion, takes place at the end of the tale. "Here comes López," announces the narrator. "'How's it going, López?,'" says the one gentleman. "'How's it going, buddy?,'" says the other. "And like that they think they have said hello," concludes the narrator, thus terminating the story.[45] With the beginning as well as the end of the narrative, Cortázar returns to the field of quotidian repetitions.

Linguistic form, we are invited to deduce, shuts down the window for meaningful action. It sets the stage for uneventful, wholly predictable behavior.

Custom rules. Verbal conformism precludes the chance of contact. Upon the encounter, things continue exactly the way they went before the gentlemen spotted each other on the street and before the narrator got wind of the situation.

And yet that is not the whole story. Day-to-day repetition shows another side as Cortázar revisits the links between relationality, materiality, and form. His dissection of the friends' greetings creates a space in which suddenly a lot is happening. Disassembled into fragments (handshake, nodding, echoing inquiries), the prosaic occurrence of the gentlemen's meeting instantaneously becomes a strange event. Most of the tale unfolds between the two mirroring hailings. These salutes reach into further segments of address, as we shall see. They thus prop up an extensive plane of intertwinings.

Put on "for the umpteenth time," as the narrator indicates, the first set of gestures (handshake and nodding) has already occurred with great frequency before the story even gets going. These communications evidently rest on antecedent forms of address that they reproduce. The second pair of greetings ("'How's it going, López?' 'How's it going, buddy?'") would likewise appear to replicate prior scenes of address of its kind. Besides recalling similar exchanges in their own right, the reciprocal queries hark back to the hailings described at the beginning of the story. The gentlemen, in the end, virtually parrot each other's words, also echoing the parallelism of the initial mutual handshake. Symmetries multiply: there is a doubling of a doubling that, itself, is a doubling. Several strands of connection stretch out from the points of address that Cortázar marks at the start and close of the narrative. The tale gathers its reflections on repetition within the repetitive plan that emerges. Tethers reach in multiple directions, where they meet with further tethers. Simple as the format of the twofold sets of greetings may seem initially, the design soon loses its apparent transparency.

The narrator, for his part, contributes to the pattern of interlacings that arises by way of his doubling responses to the salutes—his twofold observations about the greetings and about what it is that those who engage in those greetings take themselves to be doing. Pretty much duplicating his own phrases, the narrator devises lines of repetition of his own creation. Compounding matters, his statements, like the gentlemen's expressions, presumably reproduce preceding acts of address. Through "internal" self-parroting, he mimics the two parrot-friends. Manifold ties spring up among sites of address.

These bonds vault over the bounds of this particular story and into different *Cronopios and Famas* tales. "How's it Going, López?" parallels other stories we have considered, such as the opening narrative and "The Lines of the Hand," in its insistence that the modes of address that we adopt toward the world, and the world toward us, ritualistically call forth previously established forms and scripts of address.

Where does the magnolia, that, Cortázar has alerted us, might always be around, soar in this story of repetition? How do strips of pink toothpaste take to the air? One place where they emerge is the writing itself, which strings together scenes and figures that stand in ostensibly loose connection with one another. Besides hitching the greetings and commentaries on greetings to prior instances of address, the story assembles disparate textual fragments. The mirroring structure gives ample room to moments of aesthetic incongruity. In fact, a certain disjointedness pervading the writing at first glance strikes the reader more pronouncedly than does the tale's thematic coherence: the narrator may have sprinkled toothpaste and magnolias all over the place, covering many junctures between the dual greetings framing the narrative.

The magnolia and toothpaste exist also in the past. Somewhat abruptly, the discussion of the first greeting gives way to the following description: "It's raining. A gentleman takes shelter under an arcade. These gentlemen almost never know that they have just slid from the first rain to the first arcade by a prefabricated toboggan. It is a wet toboggan of withered leaves."[46] The individuals to whom Cortázar here refers fail to be aware of the remarkable circumstances that bring them where they are. A slippage has gotten them to their current station. They have let that slippage slip away. A wet, moldable, slippery substance is at work that has permitted motion and produced extraordinary, unrecognized effects. The gentlemen have bridged a gap in physical continuity and sutured a void in the history of their consciousness by taking a hitch on a toboggan of leaves, of which we are not told whether it does or doesn't carry printed language.[47] As in the tale "A Very Real Story," whose protagonist twice drops his glasses, Cortázar has strangeness emerge not where his characters expect it but in unanticipated quarters.

Next, the story launches into a discussion of another kind of perplexity or epistemic gap, namely the mystifications affecting the conduct of our amorous lives, which a single cryptic sentence fragment couches in terms of a visual display that eludes not only the gaze, but also the bonding power of syntactic glue: "And the gestures of love, that gentle museum, that gallery of figures of smoke." The ciphers of erotic interaction prove to be performatively embedded and institutionally emplaced—like the artworks, scientific specimens, and historical inventions that compose the collections of objects we put on view—but do not, for that matter, lose their evanescence, add up to readable images, or hide their enigmatic nature.[48]

Cortázar bluntly puts to rest the narcissistic preoccupations and self-aggrandizing fascinations that may variously trouble us or hold us enthralled in the romantic domain by telling us that others have successfully sought what we look for in this area. Indeed, the feats that we try to pull off in amorous territory, the narrator assures (or warns) the reader have not forever been barred

from coming true: "Let your vanity console itself: Mark Antony's hand sought what your hand seeks. And neither his nor yours was seeking anything that has not been found since eternity."[49] The perplexities that we weave around love, the reader learns, are of a different sort than self-directed concerns like the desire to flatter the ego or to sustain a gratifying self-image. Uniqueness is not what is to be expected. The enigma is of a different character than the uncompromisingly singular vision of love won, lost, or never known that one might hope or fear to bring into being.

The narrator elaborates, "But invisible things need to materialize themselves, ideas fall to earth like dead pigeons. The genuinely new creates either fear or wonderment. These two sensations equally close to the stomach always accompany the presence of Prometheus; the rest is convenience or profit, that which always comes off more or less well; active verbs contain the whole repertory."[50] From abstractions, Cortázar moves on to the bodily feelings that the new provokes. A novel cast of characters having catapulted onto the set, the story returns us full circle to the epistemic, corporeal, and affective quandaries advanced in the initial *Cronopios and Famas* story: What possibilities does a conventional order of address allow for human invention and agency? What place does this kind of system accord to the narrator of the opening tale and to the reader of the book?

The remark about active verbs, devices from which Cortázar desists in his truncated sentence about love, inaugurates a commentary on purposeful resolve and principled action: "Hamlet has no doubt: he seeks the authentic solution, not the house door or the road already worn by whatever shortcut or crossroads proffer themselves. He wants the tangent that will smash the mystery into smithereens, the fifth leaf on the clover. Between yes and no what an infinite rose of the winds. The princes of Denmark, those falcons who elect to die of hunger before eating dead meat."[51] The fastidious falcon refuses to ingest dead pigeons—immobilized specters of intangible ideas—even if its own life is at stake. Cortázar pronounces Hamlet, paradigm of ponderous hesitation and prolonged uncertainty, an idealist. Committed to righteous self-origination and beholden to clean hands, this emblem of indecision annihilates the enigmatic. But the stark alternatives of action and nonaction, phantasm and truth, killing and nonkilling represent polarities at the extremes of a far more nuanced spectrum of possibilities. It is to these granular positions and their bodily realizations that *Cronopios and Famas* draws our attention.

In having us contemplate the passage onto the street in "How's It Going, López?" and his opening story, Cortázar envisions a condition of address that is at once more puzzling and closer to the body than the comportment that Shakespeare's protagonist represents, a state that is bound to the commotion occurring in the stomach. The transit toward and past the house door and through the shortcuts and crossroads that we follow outside the home

interposes between two antithetical courses of action and opposing lines of vision innumerable small gradations by which we can orient ourselves.

It is these minute points that allow us to gauge our temporal and spatial bearings and to size up our ties to the world: "When the shoe pinches, it's a good sign. Something is happening here, something that shows us, that in a muffled way places and defines us. Which is the reason monsters are so popular and newspapers go into ecstasies over two-headed calves. What opportunities, what a prospect for a great leap toward otherness!"[52] If Hamlet dodges strangeness by shattering the mystery, the newspaper and other technologies of representation and the canonical arts of courtship shrink away from alterity by transposing difference into a phantasmagoric register. Cortázar, by contrast, imagines an otherness that substantiates in the quotidian routes of address that bodies traverse in interaction with each other and their material surroundings. These trajectories include the prosaic forms of exchange exemplified by daily periodicals, domestic functions, and encounters in the street.

We feel the twinge of repetition shushing shades of resplendent meaning when reading the story's final lines, "Here comes López. 'How's it going, López?' 'How's it going, buddy?' And like that they think they have said hello." A genuine greeting might imply so much more than the formulaic utterances the two friends emit as they catch sight of one another. Perhaps. Aspirations to authenticity, however, Cortázar left behind with Hamlet, surrendering the hope of a pure, self-fashioning subjective stance and the moral stature attendant on this position. Intersubjective exchanges presumably follow a different logic than do processes of individual autopoesis. What, then, differentiates a true from an apparent greeting? What would it be for the two friends to "get it right," that is, to attain a proper mode of address, one that rises to the challenge of a "real" greeting?

The twosome's salutes provoke philosophical quandaries about address. Cortázar embeds a range of dilemmas in the duo's modes of address, at once existential and linguistic, ethical and aesthetic. In many other places in *Cronopios and Famas*, including the opening story, he engages the themes of freedom, invention, and the power of the customary incited by the friends' address to each other.[53] And yet the very scenes of address that the friends enter as they salute one another—two sets of double greetings occurring in the street (or perhaps a single greeting that echoes beyond the instants when it happens)— also shape the characters' and the reader's address so as to suggest an initial reply to these conundrums.

To see this, recall the sudden appearance of the magnolia in the opening narrative as well as the pink toothpaste that the tooth-brushing cronopio artist sends flying through the sky from the balcony in "The Particular and the Universal." Strangely so, the magnolia and toothpaste can pop up at these very moments in the López story, descending upon us: the two companions would

find themselves saying things they did not quite know they were saying, the concrete contents of their linguistic demeanor whizzing rapidly beyond what any abstract conception of "hello" could ever express. Reading through these truncated expressions, we feel the incontrovertible pang of missed love, of relinquished connection, of a "hello" that is in equal measure a "goodbye," of a powerlessness to realize a coveted contact. Situated, however, as the gentlemen's locutions are in a corporeal exchange that unfolds in a locality during a stretch of time, their words achieve meanings that exceed the notions to which the phrases' schematic repetition attests. The same goes for the observations that the narrator voices. Like the two friends whose salutations he interprets for his readers and unlike that other character who lets go of his eyeglasses, he courts the magnolia and the toothpaste in his own act of telling the story, mustering a receptive participation in and curiosity about language and the world that resist the iterative mold of his own assessments of the gentlemen's behaviors.

Language once again reveals its double character as repetition of the same and as strangeness. Cortázar has indicated that the crystal cube of habit threatens to clamp down on verbal exuberance and poignancy. At the same time, however, it may permit us to slither through the volume's transparent membranes over a wet sheet of crumpled leaves—whether printed or shed by a tree. A balancing on the edge of frames of address that both imperil and entice us, that besides constraining us also carry us to hitherto unknown places, appears to be our lot in the universe of *Cronopios and Famas*.

Cortázar's recurring image of the glass brick, as I mentioned earlier in this chapter, serves as a device for conceptualizing our emplacement in restrictive structures of address. Having traced this figure's permutations in a number of stories, we are now in a position to bring together the ideas about address yielded by the tales, and to synthesize the implications of Cortázar's narratives for the workings of structures of address and for address's functioning and capacities more broadly. We shall spread out this task over several sections. As our starting point we will take the questions of change that the stories give such prominence to.

ITERATING STRUCTURES OF ADDRESS AND THEIR PARTIAL TRANSFORMATIONS

The glass brick is a gummy mass that, according to the narrator of the opening story, pronounces itself to be the world. It is a vast, encompassing chamber. It immerses us in clinginess. The stickiness signals the adherence of something that won't give immediately but that also, as many of the stories we have

considered suggest, leaves room for movement. With some wriggling and fiddling, that substance may cease to stay put or to hold on so tightly. The adhesive material clearly does not go away, but grants us space for maneuvering and finessing. It allows an ongoing tinkering that in many ways keeps matters going along already initiated paths, even if it brings about slight differences and sometimes rigorously turns things around before people and objects settle into a novel arrangement.

Schemes and structures of address undergo transformation in *Cronopios and Famas*. At the same time, avenues of mobility run into blockages. Established institutional forms reassert themselves. Frames of address never vanish altogether for Cortázar. Meaning presupposes a measure of tractability and demands a certain kind of order. When change happens, altered configurations of address lock into place. Propelling metamorphosing material routines, the characters and objects populating the collection insistently modify the limits and possibilities inherent in systems of address. The latter take numerous intersecting forms in the stories—institutional, linguistic, temporal, technological, artistic, urban, gendered, racialized, transnational.

While structures of address stay in effect and keep posing obstacles for Cortázar's refractory actors, these constellations generate new playing fields. Shifting matrices of address produce novel requirements and potentialities of address. Quite a few of the book's protagonists—whether words, things, people, animals, plants, or creatures of indeterminate status—meet these demands and opportunities in an improvisational spirit; other figures remain invested in preserving existing orders. These contrastive, though not always diametrically opposed types encounter each other in an unflagging, yet continually morphing contest of address.

Cortázar's stories collectively investigate the organizational capacities that address assumes within our everyday lifeworlds. In his hands, ordinary practices of address comprise sites of meaning, experience, normativity, interaction, and agency that soon appear to be decidedly extraordinary. Modes of address undergird the shifting relations between people, language, things, and places. Forms that maintain order collaborate and enter into conflict with forms that spawn disorder, often to absurd effect. Address, meanwhile, fulfills important moral, political, and aesthetic roles. It supports states of freedom and imprisonment, movement and stasis, companionship and love, enthrallment and aversion.

Cortázar envisions a kind of freedom that resides in our capacity for interconnectedness. This relatively egalitarian, inclusive type of freedom rests on our abilities to craft desirable bonds with people, other living beings, things, and places. It is a creative propensity that is responsive to our needs and desires for meaningful relationships with other creatures and our surroundings. In turn,

this predilection answers to wants, demands, and urgencies, if not longings, that come our way from their side. Cortázar enlists address in the endeavor to bring into existence this genre of freedom. The project of address that he sketches involves our reckoning with the presence of violence in our interactions (recall the iterative oscillations entwining picador and bull) and also asks from us an accounting with zones of historical forgetfulness and unconsciousness that keep asserting themselves (as illustrated by the two friends' overlooking how they got where they were). Crisscrossing those tenacious scenarios, astutely sensitized modalities of humor, play, love, attentiveness, caring, companionship, and tenderness come to our aid as we set about fashioning novel scripts of encounter with language and the world. Cortázar's reply to entrapment—far from privileging situations of unbounded liberty or conditions of turbo-powered autonomy whereby we would transcend the social—favors the minute, fine-grained strategies of address that enable us to meet institutions, forms of governance, bureaucratic abstraction, technocratic invention, transnational hierarchies, consumptive regimes, surging and waning media cycles, and economic profitability with potentialities for critical aesthetic reconfiguration. These potentialities, his narratives suggest, surround us in abundance. The intimacies, the unforeseen, capillary openings, and the instances of heightened, dissonant aliveness we can forge through contingent modes of experimentation and innovation, both within and beyond recognized practices of art and design, are central to the ethics and politics of freedom into which he invites his reader. Cortázar calls on address to enact this sort of freedom and this type of critical political aesthetics.

At this point, I would like to return briefly to the notion of address with which we started off our investigation, to track our shifting conceptualization of it. At the beginning of this book I defined address in terms of the forms of signification that we direct at people, things, and places and these entities at us and at each other. We have subsequently set the notion to work in divergent settings. Cortázar's deployment of address points up involved meanings that we inhabit and put into effect as addressors and addressees. As our examination of *Cronopios and Famas* suggests, our notion of address designates over and above the elementary phenomenon of directional forms of signification identified in our initial definition the poignant forces that we handle and unleash as we engage in webs of address involving language, people, things, and places. Indeed, the concept, as our discussion in this chapter reveals, sheds light on the densely immersive, nonnegotiably telluric, risky, normatively daring day-to-day operations with which Cortázar endows the phenomenon, in its coveted, forgotten, and shunned corporeal and intersubjective reverberations as well as in the many unanticipated, fantastic possibilities it spawns.

This insight brings us to the workings of several particularly salient modes of address in the stories, on whose roles I will zero in in the next section.

LANGUAGE, INVENTION, MEDIA, AND ART AS SITES OF CRITICAL POSSIBILITY AND AMBIVALENCE

While Cortázar's stories focus on quotidian structures of address, these narratives at the same time examine the capabilities of forms of language, literature, art, creativity, performance, imagination, and technology to make critical interventions in stultified structures of address.[54] Motifs of writing such as the narrator's pencil, a novel, and the newspaper, and figures of the visual designer such as the toothpaste artist and the abstractionist, as well as the inventors of the fly trap, evince the stories' investment in the search for modalities that can resist tendencies toward closed-mindedness, nationalism/ethnocentrism, coloniality, and violence fostered by established forms and patterns of address. *Cronopios and Famas* articulates a need to counter and supplant types of language and symbolic functioning that shut off possibilities of perception, thought, and contact. Both innovation and already-existing conceptual schemes thereby amount to equivocal goods for Cortázar, as illustrated by the fly trap progenitors and the character who drops his glasses. *Cronopios and Famas* thus understands structures of address as ambivalent resources, constellations that exert constructive as well as destructive powers. The collection investigates the potentialities for change that these formations allow.

The book's opening story and, by extension, the work as a whole invites being read as an allegory of literary writing or artistic invention more broadly. Cortázar emphasizes the importance of forms of address that create possibilities for alternative conceptual matrices. These new paradigms, according to his stories, mobilize artistic traditions and histories of popular and mass media and, in principle, amount to socially and materially efficacious resources. These renovated schemata help to underwrite the norms suffusing our actions and experiences and yield subtle capacities that we can activate to throw off, if only momentarily, the restrictive molds imposed by received structures of address.

Riveted as he is by inventive, rigorously critical, and conceptually resonant modes, Cortázar, as we shall see, also insists on a horizontal vision that at once recognizes a multiplicity of norms of address and an operative range of interlocking contexts.

A HORIZONTAL PLANE OF RELATIONSHIPS, RELATIONAL FRAMES, AND NORMS

One reason why *Cronopios and Famas*, like Cortázar's acclaimed novel *Hopscotch*, continues to draw a significant readership is that in it, he takes a

remarkably synthetic, broad, and far-reaching interest in address: he explores the modes of address that we direct at people, objects, and places as well as the modes that we experience as directed at us by these individuals and entities, and recognizes the effects that these different modes have on each other. He shows how these consequences play out at divergent levels of concreteness, varying from the highly abstract to the immediately tangible. Scrutinizing the interactions between forms of address in multiple modalities, such as language, vision, hearing, touching, and bodily movement, he locates these interactions in a horizontal plane, envisioning a field of agency, experience, and normativity that is affected by all of those dimensions. He underscores how institutional life—whether in the context of official international organizations such as UNESCO, mass media such as print journalism, or the domains of art and literature—is conspicuously corporeal in nature; he simultaneously spotlights how bodily existence unfolds in institutional settings. For Cortázar, modes and structures of address assume variable scopes and forge shifting connections between the local and the global.

The global, as the first *Cronopios and Famas* story suggests, is thereby markedly local in character: we need to carry out actions (e.g., reading, looking, walking, paying) in the very apartment or street where we happen to abide in order to procure and comprehend a publication such as the newspaper or to see a sign such as "The Hotel Belgium," thus participating in and attaining access to strands of evolving global histories. Depending on such behaviors, global meanings can assume a decidedly local presence. Different modes of address that we adopt lock into divergent, intersecting structures of address, ones that vary dramatically in reach.

Meanwhile, norms of address in Cortázar's stories inhere in people, things, places, and forms of mediation. These norms do their structural and experiential work in each of those loci. Indeed, the normativity immanent in address pervades social existence: we can suffer or enjoy it in all sectors of life, as it crosses divides between public and private, intimacy and distance, the local and the global, subject and object, language and the senses.

Cortázar envisions an expansive, pluriform, horizontally organized, normatively saturated fabric of address. Within this pattern, he singles out a highly influential mode that his stories suggest we can gloss in terms of an embedded type of address.

READING AS AN ADDRESS TO ADDRESS

By means of the trope of the instruction, among other devices, including the dispersal throughout the collection of what I have called incitements to address,

Cronopios and Famas weaves its audience into the problematic of address it studies. Reading Cortázar's book substantially entails addressing and being addressed by the stories' address and by the many facets of address that the stories explore. The readings of the tales that I have performed here, then, testify to the centrality of address as a point of focus for interpretations of works of art and other artifacts.

Cronopios and Famas, I have argued, centers a broad array of formal, thematic, aesthetic, and political capabilities in aspects of address. Fundamental philosophical, cultural, and artistic concepts are at stake in Cortázar's deployment of address as a dimension of narrative form, in his thematic investigation of address, in his engagement with the address of other artifacts, artistic traditions, people, and places, and in the reader's responses to these registers of form and content, which typically are not crisply distinguishable from each other. Caution is advisable when using a work of fiction that is conspicuously *about* address to generate inferences concerning other cultural artifacts, which of course do not all share this emphasis. However, I believe that we can legitimately conclude that Cortázar's persistent experimentation with the theme of address bears out a crucial dimension of reading: the process of reading involves a form of address to address. This view obviously provides not a sufficient condition of interpretation, but a necessary one (and an informative one at that, or, so I hope our discussion so far has made plausible).[55] As the reader, moreover, will have guessed already: the notion of reading as a form of address to address has a pertinence to Cortázar's artistic intervention that resonates poignantly with our endeavor in the present book: this notion fuels a reading practice and prompts a kind of participation in day-to-day existence that sparks heightened modalities of being alive to language and the world.[56]

Cortázar's treatment of address, meanwhile, is suggestive of another illuminating finding regarding the nature of reading: his stories point to address's role in a distinctive kind of interpretive experience.

A SPECIAL KIND OF INTERPRETATION: SEEING-IN AND SEEING-AS

As "The Daily Daily" suggests, depending on our address to the daily, the object can be a newspaper or a pile of printed pages. Our address to the daily influences how we see it. Conversely, depending on how we are addressed by a daily, we can see it as a newspaper or as a stack of leaves. An object's address to us thus affects the way in which we see it. More than that, seeing the daily as a newspaper makes us address it in certain ways (e.g., by reading it) and seeing it as a pile of pages makes us address it in different ways (e.g., by abandoning it,

carrying it, or wrapping vegetables in it). The reverse scenario holds true also: addressing the daily in a certain way (e.g., by reading it or, alternatively, carrying it) makes us see it as a certain kind of thing (as a newspaper or, alternatively, as a thing that we can either abandon on a bench, as the man does when he gets off the tram, or, take along as a thing fit for being used to carry chard in on the way home, as the woman does toward the end of the story). These disparate perceptions involve apprehensions of the object and of our relation to the object as falling under divergent sets of norms, scripts, scenes, and structures (for example, on the one hand, norms, scripts, scenes, and structures concerning the reading of texts, and on the other, norms, scripts, scenes, and structures pertaining to the leaving, carrying, or wrapping of things). I propose, then, that the experiences that philosophers call "seeing-as" and "seeing-in" substantially amount to certain kinds of modes of address. By comprehending these states in terms of the norms, forms, structures, scenes, and scripts on which they depend and that they mobilize, we can give the experiences of seeing-as and seeing-in a syntax, and understand them as the active states that they are.

A related example favoring a conception of seeing-as and seeing-in in terms of address is the commonplace that one person's trash is another's treasure. Cortázar's tale pairs this truth with its obverse, while simultaneously stretching it out within a whole string of people and coiling it into each single individual who participates in that lineage. Seeing an object as something that is of value generally makes us address it in a fuller sense than we are likely to do when we see it as worthless or an element we can just get rid of: in the former case, we tend not only to expose the object to a broader range of modes of address and to be receptive to a wider scope of modes that it directs at us, but often also incorporate a more versatile array of modes into in our apprehension of it as valuable and as the thing that it is than we would if we considered it as ready to be thrown out. "The Daily Daily" owes its satirical bite in part to its play on the coincidence of two phenomena within the logic of an information society: first, a tight proximity between on the one hand, a sought-after object, primed for readerly absorption and, on the other, a piece of rubbish en route to the garbage bin; second, a decisive difference dividing the condition of desirability from that of disposability.[57] Both the proximity and the disparity, I would argue, fundamentally turn on address.

Philosophers have thought extensively about the contents inherent in and the significance of experiences of seeing-as and seeing-in.[58] In their analyses, these perspectival or aspectual experiences typically appear to be less rigorously regulated and more decontextualized than Cortázar suggests address can ever be. Philosophical treatments do not usually embed instances of seeing-as and seeing-in in the rich sorts of patterns of social and aesthetic control and ordering that Cortázar puts up for examination, or in the kind of framework of

norms, forms, structures, scenes, and scripts we have laid out. Given, however, the pertinence that the concept of address turns out to have to the states of seeing-as and seeing-in that intrigue Cortázar, such as the perception of perturbations in the sky *as* clouds, the configurations that the abstractionist observes *in* his institutional surroundings, and the metamorphosing daily daily—which, as many readers probably are aware, echoes resoundingly with the philosophically renowned duck-rabbit image—address appears to be a fruitful avenue for advancing our philosophical accounts of the nature of experiences of seeing-as and seeing-in.[59]

WHAT WE HAVE AT STAKE IN MATTERS OF ADDRESS

Besides testifying to views of what it is to read and offering an enriched understanding of what it might be to see an object under a specific description or to see a certain thing *in* a particular material arrangement, *Cronopios and Famas* speaks to the myriad wide-ranging stakes that we have in the phenomena of norms, forms, structures, scenes, and scripts of address—elements that will be examined in greater detail in the next chapter. Cortázar's stories explore the possibilities of constellations of address, our abilities to manipulate and change them, and their capacities to govern us. Trajectories of address, in his tales, produce volatile transformations, capricious changes, and diminutive, barely perceptible—but, for that matter, no less gripping—alterations in the webs of relationships interweaving people, language, things, and places with each other. However, these trajectories also sustain states of normalcy, reliability, and stability that retain their recalcitrance in the face of the most insistent endeavors to get them to move and bring about a modicum of change.

I have spelled out several roles that address assumes in Cortázar's narratives and discussed a range of features he predicates of it. The experiments he carries out with address draw attention to its organizational capacities and to its moral, political, and aesthetic functions. *Cronopios and Famas* sheds light on the multidimensionality of the relationships and the plurality of levels or organization that address supports. The stories demonstrate the broad grounding of normativity in a profusion of sites of address. Through the figure of the brick, the collection illuminates the tenacity as well as the malleability of structures of address. By means of this image, Cortázar also sketches conditions in which it is uncertain precisely where the reader stands vis-à-vis a given structure of address. The brick, accordingly, is instrumental in bringing home to the reader the complexity of our presence in constellations of address. There is no escaping the dilemmas inherent in this condition, in Cortázar's eyes. Indeed, for him, our freedoms turn out to be at stake in the ways we navigate predicaments in

which modalities of confinement, experiences of destabilizing and restabilizing precariousness, and a sense of recalcitrance, rupture, openness, and escape may coincide and be hard to keep apart. He brings the question of freedom close to that of a critical political aesthetics: our line in "The Lines of the Hand"—the free aesthetic actor that it is—may free itself even more as it embarks on its voyage. Yet it passes through established aesthetic molds to ultimately reiterate some of those preconceived scenarios in its own right. These dilemmas, for Cortázar, are inherent in our emplacement in structures of address.

Cortázar's narratives, further, stress address's importance to reading and to the interpretive experiences of seeing-in and seeing-as. They alert us to the many varieties of linguistic possibility and restriction that forms of address may engender. They reveal how a vast array of norms of address is at work in the shaping of the dynamics of experience. Cortázar attends closely to the encounters that occur between modes of address and the structures of address in which these modes are caught or in which they can effect changes. He underlines the moral, political, aesthetic, epistemic, and existential consequences that follow from the ways in which those encounters happen to play out. The concept of address, our analysis shows, fosters our understanding of these meetings and their consequences.

As may be gleaned from its thematic consistency, *Cronopios and Famas* takes a more expansive view of the factors that can be productive of linguistic depletion and vitality than the short single narratives by Jamaica Kincaid or Wisława Szymborska discussed in chapter 1. By comparison to David Hume, Immanuel Kant, and Michel Foucault—insofar as we have considered their accounts in chapter 2—Cortázar provides a more granular perspective on a host of concrete mechanisms of address and on the different kinds of social and material reverberations attendant on address's components and workings, although there are of course clear exceptions, such as the operations of structures of address, as Foucault conceives of them.

Especially striking, however, with respect to Foucault—but certainly not in a manner that is antithetical to the spirit of his thinking—is the more involved, more capillary, and more multidimensional picture that Cortázar furnishes of the dynamics between freedom and constraint that address supports. The two writers' takes on address and on the ties between it and freedom thus supplement each other in a fruitful way. They emphasize different routines of address, varying registers of power and pleasure, and divergent practices of freedom in partially overlapping zones of activity. Cortázar's emphasis on an aesthetics of interconnectedness and contact with the world and his attentiveness to aesthetic operations that run below the radar of deliberate, intentional action, and choice are a welcome antidote to the overemphasis Foucault's aesthetics of existence places on those elements—this, of course, in contrast to other tendencies in his (Foucault's) analysis.

Putting Hume and Kant, once more, side by side along with Foucault, and comparing this trio with Cortázar, what jumps out in the latter's narratives is an overarching awareness of global forces and cosmopolitan practices of address that goes in tandem with a remarkably perspicacious conception of the profuse operations of norms and forms of address—a view that is more intricate than what we find in the three philosophers, even if Foucault, as can be expected, comes closest of the three to dissecting the quotidian functions of these elements. Cortázar thus advances the concept of address beyond where these thinkers take it.

Whereas *Cronopios and Famas* develops its investigation of address along yet further fascinating angles, I will for now leave these narratives aside.[60] My aim in the chapters that follow is to lay out and highlight the productivity of a basic framework for analyzing address, one that will elucidate several theoretical terms with whose use we have already begun to familiarize ourselves.

4

NORMS, FORMS, STRUCTURES, SCENES, AND SCRIPTS

Address embodies our morphing connections with other living beings and the material world more broadly. We inhabit webs of address that engage us asymmetrically from innumerable sites—human and nonhuman animals, objects, rules, institutions, places. As David Hume, Immanuel Kant, Michel Foucault, Jamaica Kincaid, Wisława Szymborska, and Julio Cortázar implicitly make clear, the trajectories of address that we realize undergird patterns of normativity, relationality, agency, order, and aesthetic meaning. This chapter describes a repertoire of key tools and mechanisms by means of which address carries out these roles. It will put into place a basic conceptual framework for theorizing address.

The previous chapters have at many points paid attention to the workings of norms, forms, structures, scenes, and scripts of address. This chapter will retain that emphasis. These devices are central constituents of address. We use them to navigate, to build on, and to revise the relational and directional orientations that address embodies. We also deploy them in shaping the normative dimensions that suffuse constellations of address. The five elements are vital to address's organizational capacities, and to the regulatory or refractory aspects that can accrue to those abilities. In short, they yield an anatomy of the field of address.

"Norms of address" is a notion that I am newly coining in this book, although it has implicit precedents in the literature, for instance, in David Hume's theory of taste and Gloria Anzaldúa's account of social exclusion and resistance. The nomenclature of forms, scenes, scripts, and structures, by contrast, is

already in circulation in various places.¹ However, the concepts that this language expresses have not yet been adequately theorized. Offering a model of the five jointly operative core components of address, I will deepen our understanding of these elements and provide a paradigm for comprehending their collaborations and the potentialities attendant on those procedures. In this way, I will forge a basic account of the fundamental makeup of the realm of address.

The current chapter will draw substantially on artistic and quotidian cases (including economic, political and legislative examples) and enlist an occasional dictionary entry. The plan, as noted before, is to spell out an analytical vocabulary—the lexicon of norms, forms, structures, scenes, and scripts of address—with which we have already become acquainted in the previous parts of this book. Chapter 5 will then continue this line of inquiry by exploring an array of existent theoretical approaches to these key constituents of address. Rallying these different resources and perspectives, I hope to make a convincing case for the fruitfulness and relevance of the conceptual framework outlined here.

RELATIONALITY AND DIRECTIONALITY

At the heart of the workings of address lie its relationality and directionality. Modes of address occur *between* agents, objects, and places in the context of institutionalized webs of address, such as the educational, medical, or legal systems. We *direct* modes of address *at* one another and material objects and *receive* them *from* persons and things in our surroundings or at a distance.

In and through the specific forms of address we assume, we shape the relations and directions encoded in our particular conditions of address. In other words, as we engage in distinct forms of address, the relations and directions that are inherent in the broader web of address in which we are emplaced undergo shifts. Address's relationality and directionality are fundamental. This does not mean they are stagnant, however. We continually fashion the relations and directions that we enact by way of our address. Indeed, we exercise influence over them by way of the modes of address we adopt. While all address, accordingly, is relational and directional, our modes of address fulfill an organizational role in configuring the particular relationships and strata of directedness that are immanent in the distinct practices of address in which we are involved.

Forms of address, I have indicated, come in linguistic as well as nonlinguistic varieties and occur in all sense modalities. The orientations in which emotions engage us involve modes of address. We adopt modes of address as we console, encourage, seduce, implore, befriend, or challenge each other.

Becoming acculturated in practices of address, such as cinematic vocabularies, musical idioms, languages of love, or the jargon of the banking industry, we acquire normative modes of address, modes that satisfy standards of adequacy governing certain domains of address.

The relational and directional aspects of address and their ties to normativity stand out in Nikolai Gogol's 1836 story "The Nose." In this story, prosaic patterns of address run up against a strange occurrence. The reader is brought face to face not only with the workings of address as a ground for the mundane orchestration of existence in institutional contexts but also with the ways in which that organizational role runs amok—spelling havoc for the address between story and reader.[2]

Describing a breakdown in its protagonist's capacity for address, Gogol's story testifies to the vital importance that accrues to address in its multiple modalities. The narrative, moreover, highlights the inexorable centrality of address as an organizational force in our lifeworlds. Specifically, the tale emphasizes address's functioning as a normatively efficacious site of relationality and directionality. Because the story foregrounds these interrelated roles of address with such clarity while also underscoring their significance—without, of course, explicitly stating these matters—we will consider this narrative in some detail. We will then move on to bring into relief the workings of address in more general terms.[3]

One early morning, close to the beginning of "The Nose," a St. Petersburg barber named Ivan Yakovlevich slices a freshly baked roll of bread. The roll contains a nose. The nose looks familiar. It belongs to a customer, collegiate assessor Platon Kovalyov. Looking in the mirror upon awakening to check up on a pimple that had started to grow on his nose the day before, Kovalyov perceives that his nose is lacking. As we learn from the narrator in an aside to the reader, Kovayov is a status-conscious functionary who wishes to rise in the ranks and delights in his flirtations with women. There is nothing to be done for him but to go about his business with a flat surface in the place where the nose used to be. His daily routines undergo a rigorous turnabout.

A host of possibilities for address that are ordinarily open to Kovalyov are precluded by the nose's disappearance: Walking through the streets of St. Petersburg, Kovalyov decides "not to smile or look at anyone, which was not like him at all." Because he keeps his face covered with a handkerchief to avert people's gazes, he cannot smell anything, we are told, and "he could not have smelt anything anyway, as his nose had disappeared God knows where."[4] Kovalyov has trouble staying on his feet when all of a sudden he spots the nose, which speeds from a carriage into a house, to soon depart again in the carriage, dressed in the uniform of a highly placed official. Running after the nose and following it into the Kazan Cathedral, Kovalyov brushes by the beggar women in the square who normally draw a laugh from him because of the way they cover their faces.

These women's behavior no longer is a laughing matter for the collegiate assessor, who now is given to the same kind of conduct. Kovalyov's distress precludes any praying. When he tries to persuade the nose to return to its proper place, it impatiently extracts itself from their discussion. Charmed by the sight of a pretty young woman, Kovalyov breaks into a broad smile. Recalling the absence in the middle of his face, he catches himself, however, and bursts into tears. The nose, meanwhile, has left the cathedral, presumably to pay somebody a visit. On Nevsky Avenue, a colleague waves at Kovalyov in the hope of having a chat. Our protagonist hastens away. The nose is in a position to enjoy the social life that its previous owner had been in the habit of leading but that currently is out of his reach.[5] Kovalyov is not only incapable of adequately addressing other people, places, and things, but also of being befittingly addressed by them.

Besides enjoying the company of sweethearts and paramours, Kovalyov is a man who is eager to ascend to a more prestigious position. He is even willing to marry on the condition that he find a girlfriend who has enough money to her name. The nose's vanishing, however, forces him to suspend the modes of public address through which he advances these purposes. The loss of the nose violates the norms of address that govern the relationships he entertains with his fellow bureaucrats and potential love interests. The calamity thwarts the professional and amorous path he has outlined for himself, necessitating a chain of diversions and reorientations on his part, until the protuberance miraculously returns to its place. The obstruction of Kovalyov's habits of address translates into the foundering of his everyday social comportment.

The missing nose constitutes an institutional aporia in the story. The tragedy Kovalyov is undergoing is not legible within the structures of address that surround him. Ivan Yakovlevich, the barber who finds the nose in a roll, is castigated by his mean-spirited wife for the theft of the body part but cannot without the greatest difficulty rid himself of it under the surveilling eyes of his friends, the general public, and the police. Its attire signaling a rank three grades higher than Kovalyov's, the nose refuses to address and to be addressed by its previous possessor—it extricates itself from their short conversation—and declines to contemplate the assessor's plea for it to return to its former place. Fearful of publishing false reports and rumors and anxious about being charged with libel for satirizing the government, a newspaper turns down Kovalyov's request to place an advertisement calling for the nose's homecoming. The police commissioner is unreachable, having left his office just before Kovalyov's arrival. The local police inspector in a different office sees no reason whatsoever to postpone his after-dinner nap for an investigation. The doctor is reluctant to put the nose back onto Kovalyov's face once it is recovered, advising that it would look horrible and only make things worse. His recommendation is to let nature take its course. Settling on an explanation for his ordeal, Kovalyov blames an act of revenge on a mother whose daughter he had rejected, but as her response

to his aggrieved letter reveals to him, no such plot lurks behind the nose's vanishing. Ordinary modes of address falter in relation to the nose; they can neither make sense of what has happened nor provide solutions to our character's predicament. Even the return of the nose to Kovalyov by a policeman is of no use because the nose will not stick to the flat spot in the center of his face. The nose never becomes the object of adequate, successful modes of address.[6]

Given the failures of address popping up around the unhitched nose and the fact of its disappearance, where do we, the readers, stand in relation to Gogol's story? The nose is reported to go on regular walks over on Nevsky Avenue. It becomes a spectacle, a public attraction that inspires rumors, opinions, party talk. Narration proliferates. A retired colonel wrestles his way through the crowd to observe the nose in a store that it had been reported to frequent on its walks but is able to see only a lithograph that has been on display in the shop window for over ten years, of a man peering at a young woman fixing her stocking. The colonel complains of the "ridiculous and far-fetched stories" that are duping people. What, if anything, distinguishes Gogol's story from these narratives or us, the readers of Gogol's story, from the people who are done in by those types of accounts? Is Gogol's tale another outrageous fable that should be prohibited from "[m]isleading the public"?[7] Alternatively, does the tale play the reader's modes of reading back into her, his, or their face, like the unsellable voyeuristic lithograph? Could the narrative be leading us astray by preposterously presuming that it is far-fetched? Questions arise about the story's own address.

The nose presents an anomaly for the structures of address that regulate life in 1830s St. Petersburg—the institutions of the family, public conviviality, the police, the press, bureaucracy, love, medicine, religion, literature. It does so, anyway, up to the point that it inexplicably reappears between Kovalyov's cheeks. At that moment, things turn back to normal: "And from that time onwards Major Kovalyov was able to stroll along the Nevsky Avenue, visit the theatre, in fact go everywhere as though absolutely nothing had happened. And, as though absolutely nothing *had* happened, his nose stayed in the middle of his face and showed no signs of wandering off."[8] Besides Kovalyov's now perennially good mood, what remains, with the turmoil in the city presumably subsiding, is a story that calls into question its own address and that emphasizes address's prosaic directionality and relationality by investigating what transpires when these registers go awry and run athwart the normative social edifice that they typically support.

Gogol's narrative attests to the relational and directional operations of address and its functioning as a ground of normativity. The story underscores the central significance of the organizational force that address brings to the social world. It also points to the multiple modalities in which address takes form. I will now zero in on some particularly telling facets of "The Nose" that will assist us in developing a sharper and more general understanding of address

in the two sections that follow. We will then soon be stepping away from the story, although we will at various moments be drawing on it and return to it more extensively in the last section of this chapter.

MODES OF ADDRESS, THEIR PRESENCE IN SCENES, STRUCTURES, AND SCRIPTS, AND THEIR DEPLOYMENT OF NORMS AND FORMS

Covering his face and making uncommon requests of various people, Kovalyov, after the departure of his nose, assumes a comportment that falls short of the criteria for polite, convivial, persuasive, and seductive behavior that are in effect during his encounters on the street or in the office. The ordinary scenarios of interaction that apply in these day-to-day public or institutional settings go awry. To translate this situation into the vocabulary advanced in this book: deprived of standard forms of address, Kovalyov, with the loss of his nose, is forced to adopt modes of address that fail to satisfy the norms of address that are in place in the usual scenes, scripts, and structures of address that organize quotidian life in the city. Consequently, he is catapulted into unfamiliar relational territory.

Here, we see in action several key constituents that shape address's relational, directional, and normative functioning: norms, forms (or modes), structures, scenes, and scripts. These elements collaborate. The different devices are all at work in Kovalyov's predicament. We can capture their joint functioning in the following thesis: modes of address embody norms and forms of address that govern scenes and scripts of address, which play their part within structures of address. This yields a basic framework for approaching address. Indeed, writers such as Nikolai Gogol, Jamaica Kincaid, Wisława Szymborska, and Julio Cortázar activate the central constituents of address brought together in this thesis to reflect on aspects of power and difference, normativity, interconnectedness, and social order. As this point suggests, the idea of norms, forms, structures, scenes, and scripts of address and their collaborative functioning yields a basic conceptual apparatus for analyzing a host of operations of address.[9] In this section I will define this terminology and clarify several fundamental features and activities of address in which we can see these key constituents at work.

Artistic modes of address, such as those of Gogol's tale, are a subset of a broader class of modes of address that includes forms that, in given contexts, count as more or less ordinary (such as smelling), specialized (baking bread, shaving customers' beards), and domain-specific (fixing a nose, conducting a police investigation, taking down a newspaper advertisement). Analogously to

literary narratives, which call on us to read them, events like a gathering of people in the street, a hunger strike, or a carnival demand typical modes of address on the part of their participants such as, respectively, socializing with others in public spaces, refusing food, and dancing. Everyday objects, as Cortázar insists, instantiate modes of address that reach out to people. A radiant birthday bouquet invites a festive acknowledgement of an occasion for celebration. A fence tells us, "keep out."

When a person's utterance or act (say, a hug) assumes a form of address (for example, that of being welcoming, distancing, suffocating, or abrupt), we can frequently say, derivatively, that the person (the hugger) adopts that form of address. In many colloquial situations there seems to be little at stake in distinguishing between an act's and a person's mode of address (as when we judge the mode of address of the hug or the hugger to be tender, aggressive, hesitant, protective, or rushed). But things become rapidly more complex when a lot turns on our assessment of an interlocutor's specific attitude or disposition, say, with respect to romance, a fight, or a political campaign, or in court. Analogous intricacies occur when we try to execute difficult physical acts of drawing, playing an instrument, walking a tightrope, or learning anew to open doors and jars that we were once quite capable of opening, occurrences in which one part of the body can go one way and another a different way. More generally, when it concerns art or other cultural productions, the relations between the modes of address of an object and those of its maker(s) tend to be densely mediated and profusely debatable. Recognizing modes of address requires the work of interpretation, even if in everyday situations the bulk of this reflection proceeds habitually, at a remove from explicit awareness.

Human beings relate to each other via structures of address that operate at the level of the senses, cognition, affect, imagination, fantasy, and desire. *Norms* of address stipulate what count as appropriate, efficacious, or even legible modes of address. Such norms obtain in all cultural domains. They govern genres as diverse as swimming pools, musical styles, newspapers, and quarries, which can be considered to involve *structures* of address—constellations in which addressors and addressees encounter each other and that display patterns of engagement between them. Although formations of address substantially elude our conscious grasp, individuals exercise (varying) levels of control over and through the *forms* of address that they adopt and allow to get through to them. Norms and forms of address, whether local or global in applicability, authoritative or superseded, rigorously codified or improvisational, dominant or oppositional, verbalized or unspoken, enact power. Such power is immanent in multiple *scenes* and *scripts* of address. Our behaviors in concert halls, botanical gardens, and sports centers and as suppliers and consumers of media contents reflect the presence of routinized scenarios of address in which we have various degrees of investment.

The key constituents of address that I have just described work together. Forms of address, we have noted, enact norms of address that play out in scenes, scripts, and structures of address. The joint functioning of these elements is important: none of these core devices determine on their own what is going to happen at a given moment or how a given situation is going to work out. My simple thesis about the collaborative workings of address's central constituents goes a long way in clarifying major capacities and characteristics of address. Among other things, it suggests how expansively we are invested in norms of address, which come with the territory of address. The thesis intimates how profoundly dependent we are on scenes, scripts, and structures of address—factors that affect just which norms and forms we can realize. It also indicates how pivotal modes of address are to the varieties of agency we assume, which fundamentally involve our capacities to navigate address. In what follows of this section, I will make these points plausible by focusing on an array of prominent, quotidian aspects of address.

As Gogol reveals to us through the figure of Collegiate Assessor Kovalyov, people make considerable effort to *orchestrate* the modes of address that they inhabit vis-à-vis the world and others. They monitor the forms of address that they put forth and admit into their spheres of operation. Managing their address to the world, people also manipulate the world's address to them. In hiding the flat spot, Kovalyov forecloses the scopic scrutiny facilitated by others' powers of address. Living in neighborhoods with water, trees, and maybe electricity, in sheds, tents, or houses with closed or open windows, traveling by foot, bike, subway, or car to markets, schools, gas stations, and medical facilities, we adopt modes of address toward our environment that filter the impulses that we emit to others and that reach us.

The tracks of address that we are able to pursue or decline are of decisive influence over our lifeworlds. Modes of address comprise unequally distributed capacities to navigate need and fear, desire and aversion, taste and distaste. They sustain ways in which we give form to states of proximity, commonality, and familiarity but also to distance, solitude, strangeness. In virtue of their reliance on conditioning structures and their domain specificity, patterns of address are unevenly accessible and lock into social inequities. Yet address can also crosscut imbalances of power and wealth. It is marked by an egalitarian dimension that inheres in the pervasiveness of address across so many aspects of our existence.

At virtually all points in life we engage in address. It encodes our becoming in the world and with others. Far from a one-way street, it unfolds in webs in which addressors and addressees engage each other. Decisions about, say, working in a mine, a factory, or the sex industry and about opting for a talk or a fight; *The Nation* or *Essence*; a masculine, feminine, and/or genderqueer friend; prison or the mental hospital; opera or the movies; ripped or whole jeans; a

first- or second-class seat on the train; an adopted child of one's own race or a different one; a trans, intersex, male, or female-presenting body, are choices that enable and preclude our presence in structures of address.

Address frequently functions as a means of differentiation.[10] Fostering or foreclosing forms of access and interaction for the addressor, modes of address distinguish between those addressees who can in principle comprehend them, who can reliably find an expected meaning in them, or who can respond to them with an anticipated reaction, and those addressees for whom they amount to instances of senseless sound, formless scribbling, or inchoate perturbation. The early sense of "jargon" described by the *Oxford English Dictionary* as "the inarticulate utterance of birds" speaks to address's capacities to divide and partition. In this usage, the term translates the boundary splitting off comprehensibility from incomprehensibility into a rift between species, that is, between naturalized categories of being.[11] Gaps of intelligibility tend to correlate via highly complex routes of address with separations between groups of addressors and addressees.

This is not to claim anything as strong as that address always arrives in full legibility at its purported addressees, establishing rigorous divisions between comprehending insiders and uncomprehending outsiders. There are two immediate reasons for this caution. One, given that address involves modes of signification and activates histories encoded in bodies, psyches, and symbolic forms, it falls short of the transparency that would allow the very content that is sent to be received, as is widely acknowledged. Two, address commonly fails to reach its destination without necessarily ceasing to be address, as when your luggage gets lost, my letter to you arrives next door, or we can't make ourselves audible amid an uproar of voices. I am setting aside here and in this investigation more generally the question of the precise conditions of felicitous or infelicitous address. My concern at this moment is with the differentiating and border-establishing capabilities that address derives from its allocation of sense and gibberish, its enactment of readily interpretable signal and diffusely apprehended noise, its use of what are considered normatively adequate and devalorized modes of signification.

If jargon consists of "unintelligible or meaningless talk or writing," as proposed by the *OED*, or of signs that have their proper home in a distinctive group to which the listener or reader does not belong, this confirms the affiliation between distinct modes or systems of address and divergent communities. But the link between address and collectivity is notoriously circuitous.[12] On the face of it, it provides no reason for supposing that all address is necessarily understandable to its addressees. Kovalyov is out of luck in this regard with respect to various characters whom he addresses: He has the greatest trouble articulating the loss of his nose to the newspaper official who records advertisements. He also has a hard time making sense to the nose itself, which he wishes to

convince to relocate to its original place. Kovalyov, in this respect, has some famous literary colleagues who find themselves in analogous positions. Franz Kafka's characters K. (the land surveyor of *The Castle* and the bank clerk of *The Trial*) are surrounded by to a large extent undecipherable signifiers that nonetheless address them poignantly.[13] Address thus does not imply actual understandability by an addressee.

Nor is it the case that those who fail to grasp an utterance on account of a lack of familiarity with the symbol system in which it is cast or those who are unprepared to evince the response privileged by the utterance are inevitably misaddressed or unaddressed. A monolingual speaker of Mandarin Chinese is not necessarily left incorrectly addressed by a monolingual English utterance or text or not addressed at all. The English formulation may address the Mandarin speaker as someone who is left out of the circle of an immediately comprehending public but who, by way of translation, can bring about shifts in that arrangement. Address does not neatly reserve itself for those whom it includes within a community of normative, comprehending interpreters. Yet it institutes provisional, malleable boundaries between those whom it addresses as insiders to a formally and normatively delineated, even if temporary collective, and those whom it addresses as outsiders. A TV commentator whose analysis presupposes familiarity with the week's political developments can address an uninformed spectator as excluded, that is, until she reads or listens up on the news or gleans it from the show's scattered clues. An anti-Muslim remark, directed at a white audience, addresses a Muslim audience member or antiracist audience member of any race as an outsider to the community implicitly hypothesized by the enunciation. But there can also be an effort to beckon Muslims and antiracists and get them to cross over to an outlook that they thought they had firmly rejected. Address at once divides people and brings them together, in a manner that effects more or less equivocal, transient, and flexible social alignments. This is one of the ways by which it accrues power and a reason why it inspires regulatory endeavors geared toward corralling modes of address within the spheres of our influence.

Such disciplinary acts are in wide use. Closing the door or yanking up the privacy settings of a social media account, we relieve others from the burden of our address and shield ourselves from the imposition of theirs. By breaking up neighborhoods, banning books, and outlawing funding for abortions, governments set up buffers that block what they take to be objectionable modes of address. Economic rewards and political sanctions facilitate certain kinds of address between subjects and objects while discouraging others. Exhibition and performance practices nurture distinctive models of address adopted by museums, theaters, recital halls, and cinemas. In refusing to sit next to someone, we can treat this person as incapable and unworthy of address and being addressed. Symbolic formations such as magazines, disciplines, immigration services, and

gender systems correspond with distinctive, even if evolving arrays of subject positions, objects, and modes of address.

No matter how hard we try to organize and command the forms of address that we evince and take up, address to a large extent escapes the addressor's grip. A refutation of its ultimate manipulability is provided by the character of the general in Gabriel García Márquez's novel *The Autumn of the Patriarch*.[14] The dictator's apparent omnipotence collapses into his inhabitation of a totally illusory, dematerialized world, in which the newspapers and radio programs that he is fed are designed solely for him. Subjected to the general's absolutist rule, public life converts into solipsism, paradoxically leaving the potentate in others' hands, without recourse to anything but what they feed him.

Designing individual and collective utterances and styles in the media of language, sound, touch, visuality, sexuality, and motion, we participate in configurations of address that undergird our powers of navigation. The modes of address that we assume acquire normative force and make normative demands in the context of institutionalized systems of symbolically mediated relationships—languages, aesthetic traditions, economic regulations, national ideologies, formations of social identity and difference, legal and political constellations. As these structures shape the forms of address that we inhabit, they confer complex, intersecting kinds of normativity on these forms. This is a source of the importance of address. Address carries normative power of numerous sorts, in nonreducible, interdependent varieties.

We see then that norms of address suffuse the whole field of address. The different kinds of agency we enact involve our abilities to negotiate scenes, scripts, and structures of address in which we are emplaced. We do this by way of the forms of address we assume. The view of the jointly operative key constituents of address I have proposed, then, points to the presence of an effusive, heterogeneous field of norms of address. This perspective attests to our fundamental dependency on the scenes, scripts, and structures harboring the forms of address that we adopt and the norms of address that we actualize. My account also draws attention to the tight connection between the modes of address in which we engage and the agentic stances we assume, which centrally reside in our capacities to navigate address.

Clarifying the workings of norms, forms, structures, scenes, and scripts of address in this section, we have examined the disciplinary efforts with which we approach address and observed how aspects of control go together with elements of elusiveness, a point that also finds confirmation in Cortázar's narratives. We have begun to contemplate the connections between address and formations of difference, power, and collectivity. We have seen how issues of address are normative matters. We have also identified an egalitarian dimension that resides in the pervasive presence of address across so many quarters of life: address surrounds and emanates from everybody, even if in widely

divergent ways. Most importantly, I have proposed a basic thesis that enables us to account for an array of features of address: forms or modes of address enact norms of address that play out in scenes, scripts, and structures of address. No single one of these core devices operates alone or by itself determines how a given situation will work out; they collaborate, which of course also means that they can tend in directions antithetical to each other, as Cortázar's narratives suggest. Among the phenomena that my thesis elucidates are the breadth of our normative occupation with address, our dependency on the scenes, scripts, and structures in which address unfolds, and the importance of modes of address to the kinds of agency we assume, understood as involving our capacity to navigate these modes. The concept of address points to these kinds of phenomena. It helps us to recognize and account for their interconnections. Glossed initially in terms of the modes of signification we direct at people, things, and places and these entities at us and each other, the concept has now received further substantiation in terms of five principal constituents, their joint operations, and an array of functions attendant on those joint operations. We have established a basic anatomy of the field of address.

While theorists, as noted earlier, have deployed lexicons of forms, structures, scenes, and scripts, they have not adequately theorized the concepts in question. More than that, the term "norms of address," which I have introduced in this book, is a crucial addition to this nomenclature. This notion is key to our comprehension of the workings of address. In the absence of norms of address, the four other nodes would lack the dynamism that they have. Indeed, it is hard to conceive how they would function. They would seem to amount to much more inert elements than they actually are, if it is even possible to think of them apart from the spin that norms of address give to the paradigm of address as a whole.

I would now like to weave into our evolving analysis a consideration of the colloquial use of the language of address. By inspecting certain vernacular meanings we associate with the verb "to address," we can shed light on the convergence of several of the features and functions of address that we have uncovered so far.

COINCIDING DIRECTIONAL, NORMATIVE, REGULATORY, AND ORGANIZATIONAL FUNCTIONS

A vehicle of organization, address is instrumental to the achievement of types of cultural order. This point stands out clearly in Gogol's invocation of the "extraordinarily strange thing" that happened one morning in St. Petersburg,[15] an event that, the story shows, is not readily accommodated into the structures of address sustaining the way in which things are usually done in the city, in

short, into the cultural order that is St. Petersburg. The idea of order, as I have indicated at several points in this book, points to an important function of address. This function, it appears, also finds expression in our colloquial language of address.

In a common, frequently invoked sense of what it is to address something and someone, we address messages, letters, speeches, and comments at other people and address whistles and other signs of encouragement or warning at different kinds of living beings, such as cats, dogs, chickens, or parrots. My use of the term "address," as our discussion so far in this book has made clear, patently includes this meaning. But it also embraces a somewhat different vernacular usage.

We often address states of affairs that we take to be in need of repair. Environmental regulation purports to address climate change. The U.S. Congress addresses themes such as health care and immigration policy. Acts of reassurance can address a crisis of confidence. Address, in this sense, purports to introduce a resolution or fix to circumstances that are in disarray. It *tends* to a situation and thereby perhaps takes care of something that requires improvement or mending. Of course this effort can go awry and, within the same kind of deployment of address, we may mess things up or cultivate falsehoods and obfuscations. This vernacular meaning of address, however, has historical precedents that help to elucidate address's broader capacities.

Under the entry for the verb "to address," the *OED* cites as a primary definition "to set in order; to make ready or make right." Among the etymologies the dictionary lists for the term, we find one that resonates conspicuously with this meaning: "to make straight." In addressing an artwork, a person, a thing, a text, an institution, we may be at pains to set it right, to iron out the unruly relations between us, or to traverse a direct path toward our goal. Systems of address such as neocolonialism, regimes of sexuality, the tourist industry, white supremacy, the law, and the market are force fields that tend to line up the directionalities and the relational orientations of address in accordance with certain social norms.[16] These systems thereby establish parameters of order (and, order being a relative notion, typically also realize parameters of disorder). A series of obsolete, subsidiary definitions in the *OED* entry lists "to set to rights; to order, arrange." Day-to-day modes of address, such as the serving of rolls, the picking up of rubbish, and the voicing of requests, encouragements, or reprimands participate in this practice. They constitute symbolic forms that exert normative power and confer organization (or disorganization) on things and on the relations between people and things and between things.

The two colloquial senses of address—the normatively charged, regulatory activity of keeping people in line or of putting things in their place, and the no less normatively laden practice of directing utterances at people, other animals, or things—bear affiliation to each other. In serenading or flinging a shoe at

someone, we may give an alternative organization to our relationship with that person and designate what we take to be proper social sites for each of us. With things going more or less as expected, our offering, en route to or upon arrival at its destination, institutes a measure of a purported kind of order (which, again, can of course also include elements of disorder, as it usually does). People, things, situations, institutions, and projects are perceived to allow for, to demand, and to render prohibitive certain forms of address—in short, they exercise a normative pull over the address that is adopted. By assuming or withholding and receiving or blocking specific modes of address, we negotiate a field of possibilities in which our directional actions and regulatory interventions often overlap significantly with each other. We imbue the orientations inherent in our address with proclivities to tend toward desired states of organization, states that are valorized by norms to which we subscribe.

Directional and regulatory forces converge in a further way. In the context of systems of address, certain classes of people and things count as worthy and capable of making suitable addresses and of being properly addressed while other people and things do not meet the overt or covert requirements that confer this standing. Places, instruments, gatherings, and games tend to implicitly designate specific subjects, objects, and actions as normative addressors, addressees, and forms of address. An ATM postulates users with the right kinds of bank cards. A discussion can presume a white point of view as an experiential perspective and a ground of judgment. A soccer match necessitates the kicking of a projectile that serves as a ball on the part of its participants. Forms of organization are conducive to and imply specific kinds of address that are to take place among subjects, among objects, among subjects and objects, and among subjects, objects, and places. Modes of address enact various levels of order as we direct them at people and things and as people and things direct them at us. When I lift my leg or kick a stuffed animal or a round of tape in your direction, you may take this as an invitation to dance or to start a game of soccer; we temporarily put into effect a new bodily arrangement. The directional activities that address embodies and the organizational labor that it carries out as a regulatory practice are closely related to each other.

There is a particular form of address that conspicuously activates this coincidence, namely, the imperative: what we ingeniously call "orders" exploit the proximities and overlaps between directionality and regulation. Jamaica Kincaid, in "Girl," and Julio Cortázar, in *Cronopios and Famas*, mobilize this convergence. For a different example, consider this passage from the "Manifesto for Maintenance Art 1969!" by visual and performance artist Mierle Laderman Ukeles:

> [C]lean your desk, wash the dishes, clean the floor, wash your clothes, wash your toes, change the baby's diaper, finish the report, correct the typos, mend

the fence, keep the customer happy, throw out the stinking garbage, watch out don't put things in your nose, what shall I wear, I have no sox, pay your bills, don't litter, save string, wash your hair, change the sheets, go to the store, I'm out of perfume, say it again—he doesn't understand, seal it again—it leaks, go to work, this art is dusty, clear the table, call him again, flush the toilet, stay young.[17]

Imperatives encoded in practices of "maintenance art" attempt to control the orientations that we take toward things. The imperative mode strings together the sundry tasks bearing on the woman maintenance worker. Analogously to Kincaid's catalogue of prescriptions in "Girl," repetition consists partially in the sequence of orders flowing to and from the female addressor/addressee. More than that, it settles in the need for the woman who takes care of children, keeps up a household, and makes art to say things again to make herself understood, to seal things again, to call again. The task of the maintenance worker is ongoing. As soon as a command from one side is taken care of, a precept issues from another side, or there is a need to blurt out a directive oneself to keep the children safe and clean. The requirements of self-fashioning, housekeeping, and professional success prescribed by the ideal of the nice-smelling, clean-looking, properly dressed, sexually fulfilled, forever young, working, art-making mother imply a constant engagement with inadequacy or a repair of failure: "correct the typos," "mend the fence," "I have no sox," "I'm out of perfume," "it leaks," "this art is dusty." A form of directionality inherent in the orientation of the addressor to the addressee and to the object marks as mandatory another form of directionality: that between the addressee and the object of the command. Imperatives purport to channel the operative orientations so as to satisfy relevant norms and to create or keep up a desired kind of order.

In thinking about the confluence of directional, normative, regulatory, and organizational facets of address, it is important to be aware that notwithstanding the major efforts that we expend to put things right (straight, in order) through our modes of address, a lot of address is not designed to achieve transparent orientations toward a readily identifiable situation or to move matters unswervingly in the direction of an improved arrangement, but rather to complicate and expand our sense of the sorts of directings, norms, and orderings that are (or could be) in place. This can then have the effect of making things right or in order, but there is no pre-envisioned conception of the things that are to be put into that state; nor is there a straightforward manner of hurtling toward the desired condition of rightness or order. Varieties of wit or humor belong to this category of address. Comedy, motions that are made in jest, and punchy moments of funniness often reveal intricate truths and can push us to put things on a commendable path or to go athwart problematic patterns of reflection and emotion that have sedimented, but do not typically go about these effects in a precisely definable, focused manner. By contrast, these forms

of address engender contingencies that usually have a certain intractability and signal murky aspects of life on which we do not have a sharp grasp. These forms tend to precipitate anarchic, unruly, and obscure experiences. They effect mysterious, irregular, illogical, ambiguous, and paradoxical states of connectedness. More than that, they spark confusing, disorienting, partially illusory, forgetful, and mythical registers of our being alive to language and the world without ultimately controlling these states, for such mastery is constitutively impossible. As Julio Cortázar's and Michel Foucault's outlooks suggest, these elements enter into the intricately interwoven forms of freedom and constraint that we realize as addressors and addressees, and should have a place in our view of address.[18] The potentially wandering or straying kind of address that I have in mind, which is often exploratory in nature and responsive to what happens in the course of a process or right at the moment, certainly involves aspects of directionality, normativity, regulation, and order, but these dimensions are not readily captured under the rubric of a type of straightening out, making right, or setting in order.[19]

I want to avoid caricaturing our important and enduring jobs of ordering or making right, which come in many kinds. Not all of these endeavors are straightforward or deploy an unequivocal conception of the state of affairs they aim at. Indeed, many of these ventures that matter a great deal to us may not fall under these rubrics. Disciplinary efforts often meddle with undertakings that they construe as deviant—recall how Jamaica Kincaid's girl draws the pedagogue into a sensory field that the roster of directives seeks to ward off—and so the notions of ordering and making right have some stretch; they do not entail a single, unidirectional line or orientation toward a condition perceived as straight or good. Another source of flexibility has to do with the norms that can be in play in various conceptions of what counts as straight or right. As the phrases "now let's get things straight" or "let's get this right" suggest, getting matters supposedly straight or right may entail an alignment of ideas with what is known to be false or wrong by the proponent of those proposals. The agenda of setting circumstances straight, right, or in order more generally can inaugurate a plan of action that lends support to an organization prescribed by whatever norm happens to be favored by a given speaker. A further principal meaning of the term "to address" leaves emphatic room for such possibilities: the *OED* offers the definition "To turn to or orientate (something), to turn to face, confront," and furnishes as more specific glosses the two listings "To direct one's skills or energies to some task, goal, or purpose; to devote oneself" and "To take on as a topic for discussion or inquiry, or as a problem to be solved; to deal with, tackle, or confront."

Despite the elasticity of the relevant terms, however, the operations of putting things straight, right, or in order cover only a small part of the field of address. Much address concerns directings, normative engagements, and

arrangings that do not qualify, or qualify only in a thin sense, as ways of straightening matters out, setting them right, or putting them in order. A sign of empathy, a joke, a movement or picture made in jest, a cheerful remark, an expression of dismay, a hilarious turn of phrase, or an apology can change the atmosphere in a gathering of people and reveal the many kinds of directionality, normativity, regulation, and strata of order that are in play, veering off from the project that brought the group together, yet ultimately somehow be conducive to that project's realization. When the members of a collective deliberate over a contentious idea in order to hear out each other's points of view and to see how they might arrive at a fruitful avenue of approach to a situation that calls for a response, they can engage in a dialogue composed of lateral modes of address that carry divergent directings, enact contrastive norms, and gesture toward different levels of ordering, in the absence of an attempt to synchronize their approaches in great detail or to coordinate their efforts at many levels in order to make possible a propitious course of action. Practices of clarification, communication, fine-tuning, humorous provocation, and recontextualization can give situations a useful turn without most illuminatingly being seen as acts of ordering or putting right or straight.

Address supports interlacing patterns of directionality, normativity, and order. Its multidimensionality stands out in Gogol's tale "The Nose." Modes of address, in this story, build on and fold into each other. They thereby reshuffle the directionalities and positions that they encode. A complex pattern of entanglements ensues. The modifications that become visible do not settle in a state of equilibrium or arrive at a resolution. Before investigating several theoretical approaches that ascribe clear-cut jobs to address, a task that will occupy us in chapter 5, it is important to have a good sense of the many ways in which address escapes our ability to channel it toward crisply delineated functions. To highlight the productive shifts that modes of address can bring about in one another even if they do not necessarily converge in a terminating point, I return to Gogol's narrative. The specific roles that theorists will ascribe to address in chapter 5 can then be seen as segments of address's functioning that share space with less readily identifiable operations. Neither the sharply discernable processes nor the less tangible, relatively intractable ones exclude or are more important than the other. So, in order to give an adequately versatile and capacious picture of the types of things that address can do, we will revisit "The Nose."

AWAKENING STRANGE AND DORMANT DIRECTIONS AND RELATIONSHIPS

Gogol's story, as indicated earlier, questions its own address to the world and to the reader. The narrator enters his own tale repeatedly to announce that

events are enveloped by a thick mist that, he notes, makes it impossible to tell what is going on or renders this altogether mysterious.[20] But if the St. Petersburg mist precludes the narrator's epistemic access to the happenings taking place in the story, what other factors might have this effect? How does the narrator even know that there is a mist? From which standpoint does he address us? The story makes a mystery of its own address. Moreover, this perplexity on which the text supposedly reports infiltrates the very form of the narrator's report or, more precisely, the mode of address that the tale adopts toward the occurrences transpiring in the city and toward the reader.

Having several times intervened in his story to comment on the story itself, the narrator in ending gives full rein to his tale's play with the possibilities of its address. "And all this took place in the northern capital of our vast empire! Only now, after much reflection can we see that there is a great deal that is very far-fetched in this story."[21] Only now? The narrator pokes fun at the skeptical reader who has been tapping his powers of ratiocination to arrive at the insight that a lot of what happens in the story is rather improbable. He extends the mockery:

> Apart from the fact that it's *highly* unlikely for a nose to disappear in such a fantastic way and then reappear in various parts of the town dressed as a state councilor, it is hard to believe that Kovalyov was so ignorant as to think newspapers would accept advertisements about noses. I'm not saying I consider such an advertisement too expensive and a waste of money: that's nonsense, and what's more, I don't think I'm a mercenary person. But it's all very nasty, not quite the thing at all, and it makes me feel very awkward! And, come to think of it, how *did* the nose manage to turn up in a loaf of bread, and how *did* Ivan Yakovlevich . . . ? No, I don't understand it, not one bit![22]

Something that even the incredulous reader might not have deemed so implausible, namely Kovalyov's assumption that the advertisement would be placed, can actually be found to be bizarre, as the narrator claims to do. While absurdity spreads and is apprehended in terms of ordinary logic, its extravagance diminishes. With so much strangeness going around—strangeness that is gauged from a viewpoint that accepts the basic fact that the nose has come apart from Kovalyov's face—the preposterousness of the loss of the nose fades; the incident undergoes normalization.

In a countervailing move, the narrator takes absurdity to another plane: "But the strangest, most incredible thing of all is that authors should write about such things. That, I confess, is beyond my comprehension. It's just . . . no, no, I don't understand it at all! Firstly, it's no use to the country whatsoever; secondly, it's no use . . . I simply don't know what one can make of it . . ."[23] Engaging in a meta-address and adopting the position of a reader, the narrator addresses the author's address to the things that befell in the story and underscores the interpretive difficulties that plague the reader's address to the story.

These readerly conundrums appear to abate when the narrator turns from the story back to reality: "However, when all is said and done, one can concede this point or the other and perhaps you can even find . . . well then you won't find much that isn't on the absurd side, will you?"[24] Having only just before assumed the voice of the doubtful reader and apparently favored a skeptical stance toward the story, Gogol now—shifting to a direct address to the reader that takes the reader along in this new turn—preempts his story's dismissal on the grounds of its supposedly far-fetched quality by generalizing the charge of absurdity. Since this attribute supposedly can be predicated of virtually anything, it cannot be used to single out any specifically objectionable features of the story. The narrator, here, reiterates an earlier reflection in which he announces the return of the nose to Kovalyov's face: "This world is full of the most outrageous nonsense. Sometimes thing happen which you would hardly think possible: that very same nose, which had paraded itself as a state councilor and created such an uproar in the city, suddenly turned up, as if nothing had happened, plonk where it had been before, i.e. right between Major Kovalyov's two cheeks."[25] A lot of absurd things occur in the world. Why be surprised if they happen in stories? The skeptical outlook begins to transmute into a position that affirms the story's plausibility. The tale's ending consolidates this shift: "And yet, if you stop to think for a moment, there's a grain of truth in it. Whatever you may say, these things do happen—rarely, I admit, but they do happen."[26] By ascribing the unbelievable character of the story to the improbable nature of reality, the narrator claims realistic content and positive truth value for his narrative. He accommodates the absurdity that had resisted assimilation into the structures of address surrounding it. He gives a place to a phenomenon that had withstood incorporation into existing institutional formations. The narrator embeds the reader in this world where certain kinds of things happen: through a direct address to the reader, he makes the reader part of that universe.

Strangeness, at the same time, spreads everywhere, through the reality on which the story purports to comment as well as the particular portion of reality that is the story. Ordinary structures of address are rendered absurd, including those of literature. Normalized norms and forms of address come into question: "you won't find much that isn't on the absurd side, will you?" This point on the part of the narrator would seem to apply to several norms and forms of address that the story satirizes, namely those embodying aspirations toward upward mobility among civil servants or nationalistic or mercenary goals among authors; those suffusing the institutions of the police, the government, the press, marriage, courtship, and literature; and those undergirding the mundane dynamics of power inherent in bureaucracy, corruption, manipulation, and the quest for status and gain. The story, furthermore, problematizes the norms and forms of address that sustain our sense of normalcy. It

even makes fun of the verdict of absurdity, marking the affiliations of this judgment with restrictive notions of the useful, with a limited conception of what Kovalyov is or is not likely to believe (concerning the attitudes of the news media of his time), and with a narrowly realist mode of reading that the narrator plays back in the face of the skeptical reader. Everyday rough-and-ready diagnoses of absurdity are ill-equipped to distinguish the absurd from the normal. Important kinds of strangeness escape them, including their own. The story alerts us to some of these.

Gogol offers us a self-professedly strange story that raises doubts about the tenability and cogency of norms and forms of quotidian address. But why did it take much reflection to reach the conclusion that a lot is far-fetched about the story? Is there anything that stands in the way of our detecting the extraordinary nature of the course of affairs relayed by the narrator? Indeed, by holding the mist responsible for obfuscating what is happening, as if his tale provides the kind of account that is bound by optical law, the narrator holds off the even more mystifying absurdity of the loss of the nose, suggesting that in Kovalyov's Peterburg things proceed as usual, except for some small perplexities owing to the mist. The story stages a partial effacement of the absurdity that it presents. In this it is not alone.

As noted before, many narratives populate the world of "The Nose." We have already encountered rumors, opinions, false reports, party talk, indignant letters, allegedly libelous advertisements, and voyeuristic lithographs. Some of the narratives—and there are more—contain the strangeness of the nose's loss by normalizing it: they offer it an apparently already-understood place within available experiential scripts. Before accusing Kovalyov of inventing "little" jokes, the clerk in the advertising department of the newspaper recommends that he have the absconding written up by "someone with a flair for journalism," who could relay the incident as a freak of nature so as to benefit youngsters or impart it as "something of interest of the general public." Stories about supernatural events such as dancing chairs and magnetism that had been circulating make it unsurprising to many people that the nose takes a daily walk along Nevsky Prospect at three o'clock in the afternoon. The spectacle of the promenading nose prompts scientific and pedagogical responses: students of the College of Surgeons go to have a look at the curiosity, which now has shifted its strolls to Tavrichesky Park. A prominent lady wishes her children to be shown the "rare phenomenon," supplemented by "instructive and edifying commentary." The recently exhausted repertoire of party stories is replenished, to some partygoers' delight. Others lament the "cock-and-bull stories" that are being disseminated.[27] The nose is encapsulated in a profusion of entertaining, didactic, and investigative scenes, scripts, and structures of address that dampen the strangeness of its detached amblings. Quelled by narrative modalities that clamp down on the bewildering and unexpected, the preposterousness of the

situation becomes hard to recover, necessitating, as we can take the narrator to intimate with a dose of irony, copious amounts of contemplation for the thinker who attempts to sift through the different accounts.

There is yet another twist to this obliviousness. The story that the narrator tells registers the normalization of the bizarre and puts the obliteration of absurdity on display—including the erasure perpetuated by the tale itself. In signaling the narrative elision of strangeness, however, the story also preserves that strangeness, recognizing an absurdity that has not lost its ability to perplex. Gogol never wholly distances the reader from the strangeness of the nose's disappearance but uses to comedic effect the tension between what we find strange and what we go along with or accept as a narrative premise, as when he describes the return of the nose to Kovalyov's face "on 7 April" as something you would "hardly think possible." This remark is funny because the nose's return might not be so very unlikely in light of the "extraordinarily strange thing" that "happened in St. Petersburg on March 25," with which the story opens.[28] If a nose can leave a face and settle into a roll, how astonishing is it that it can go back to the face from which it came? Besides never removing the reader very far from the sense of strangeness attached to the independent undertakings of the nose, the story projects this experience into the quotidian and institutional order of St. Petersburg, locating it in streets, squares, buildings, official discourses, and metrics of temporality.[29] A measure of humoristic, unnerving strangeness irresistibly survives incorporation in a strange story that claims to report on life's strangeness and to convey some of the particularly strange things that took place in the two weeks between March 25 and April 7.[30] The narrator self-reflexively portrays his story as an artistic endeavor that, while it may not sell or be of any use to the country, differs from the entertaining, commercial, pedagogical, scientific, and otherwise useful narrative ventures of which it makes mention, in that, contrary to the other outlooks, it retains an element of discomfiting, comedic strangeness and challenges the very structures of address, its own reportage included, that blot out this strangeness. Moreover, unlike the painting that nobody wants to buy, which without further ado represents a voyeuristic gaze, Gogol's story asks about the constellation of address in which the story itself is lodged, inquisitively addressing its own address.

"The Nose" presents a fabric of overlaying, interconnecting modes of address. The story generates a dense web of address where newly arising modes reach into existing ones to activate dormant or previously unnoticed directionalities and positions encoded in them, which then creates further reverberations in the emerging constellation of address. Rather than bringing to a point of resolution or equilibrium modes of address that engage, pick up on, or reflect back into each other, the narrator crafts multiple layers of address that exert an ongoing traction on each other, revealing the pressures that structures of address exert on the strange along with the pressures that they undergo from

the strange.³¹ The story, in the process, challenges the norms and forms of address that underwrite day-to-day existence in the city. The tale pushes back against the structures of address that support institutional orders organizing urban life, such as the press, the civil service, and the police force. More than that, it probes the narrative capacities that it deploys to get the reader to engage or escape the strange events that it imagines as well as the other strange things that, so it suggests, are our lot in life.³²

Notwithstanding the importance of address with respect to the goal of making things right, straightening them out, or setting them in order, modes of address in and by Gogol's story support orientations that stray alongside and apart from certain markedly goal-directed forms, to activate and sustain a strangeness that eludes established structures of address. While the narrative conspicuously enlists the directionality and relationality of address in this endeavor—a venture that undeniably posits its own ends and purposes rather than straggling from any aim whatsoever—address's order-producing role here retreats into the background. This is a comparative matter: the dimensions of relationality and directionality, on the one hand, and regulation, on the other, take on shifting emphases that vary from context to context. And both come into play in our enactment of registers of freedom and constraint.

This variability is to be kept in mind as we seek to develop a suitably flexible and encompassing conception of our topic. Indeed, the concept of address, as it appears so far in our investigation, leaves ample room for this: The notion fundamentally denotes aspects of directionality and relationality, the normative predilections of which can tend toward states of regulation as well as deregulation, conditions of control as well as elusiveness, and elements of apparent normalcy as well as strangeness. Sharply identifiable operations that may be associated with procedures of straightening out, putting in order, or making right, meanwhile, go in tandem with less tangible processes crisscrossing the distinct orderings we effect.

◎ ◎ ◎

To trace the workings of address and, more specifically, to bring into relief the multifaceted directional and relational forces that it undergirds and the normative dimensions that it sustains, I have described the operations of norms, forms, structures, scenes, and scripts of address. I have added my newly designed notion of norms of address to the already existing lexicon and sharpened our understanding of the workings of the cluster of five elements that we have seen in action at many points in this book. These devices, I have indicated, are key constituents of address. They yield crucial components of the basic conceptual framework for theorizing address that I have offered. They shape address's relational, directional, and normative operations. This chapter has captured

the joint functioning of these pivotal elements in a succinct thesis: forms or modes of address embody norms of address that govern scenes, scripts, and structures of address. This fundamental idea enables us to clarify an array of address's attributes and roles. In short, it provides a model for understanding address, an anatomy of the field.

This field features registers of disciplinarity, control, and regulation attendant on address as well as aspects of refraction and elusiveness. Address, throughout, carries normative force and stands in intricate connections with constellations of difference, power, freedom, and collectivity. An egalitarian dimension appears, owing to address's pervasive, if variable presence throughout everybody's life. Equipped with our thesis, we can recognize the scope of our normative attachments to matters of address, our vital reliance on scenes, scripts, and structures of address, and the crucial bonds between the modes of address we adopt and our agency, conceived of as enlisting our capacities to navigate address. The concept of address comprehends these phenomena in their interconnections. It traces the anatomical makeup of an extensive, profoundly important realm of investments, affordances, and occupations.

In the next chapter, I will explore twentieth- and twenty-first-century scholarly writings that account for a range of distinctive functions of address by way of the key constituents of address analyzed here.

5

ADDRESS'S KEY CONSTITUENTS

Philosophical Views

The framework of norms, forms, structures, scenes, and scripts of address—or, what I have called address's five collaborating core components—gives us tools for exploring the directional and relational forces that address embodies. These forces shape a whole array of address's functions. Not surprisingly, quite a few of these roles have attracted the attention of philosophers. In this chapter, I will show how six twentieth- and twenty-first-century scholars draw on the five key devices (or a selection thereof) to chart specific capacities and itineraries of address. More often than not, these theorists' use of the notion of address remains implicit, rather than gaining explicit articulation; this, however, does not detract from the relevance of the concept to their analyses.

With this agenda, I aim to advance our understanding of the kinds of jobs that address fulfills and the philosophical significance that the notion of address holds. We will solidify our sense of the fecundity of the model of address laid out in chapter 4. On top of that, we shall deepen our grasp of address's pertinence to freedom and to aesthetic ventures that encode a critical politics. My objective is not to assemble a comprehensive set of relevant views, to defend each scholar's deployment of address, or to lay out each approach in its full richness. Among other things, I will in many respects sidestep the forms of address that my six writers direct at their theoretical interlocutors and the scholarly polemics in which they participate. This move, ironically, may seem to cut against the force of this book's argument. Yet, at the moment, these kinds of details remain subsidiary to our main focus: to demonstrate how the

five core elements of address—norms, forms, structures, scenes, and scripts—go about doing their work. Underpinning divergent philosophical methodologies, these devices display a productivity that exceeds their deployment in each specific outlook. Consequently, when stepping back from any one of the six particular commentaries, we will find that our analysis yields a cross-address among different views. The resulting reframing of the theoretical field can eventually be expected to produce new turns in the story we would want to tell about the forms of address with which each perspective encounters the distinctive philosophical arenas that it enters.

My plan, then, is to document the operations of the five central constituents of address in the service of several partially entangled and overlapping goals: At issue will be the ways in which linguistic and cinematic modes of address, as Frantz Fanon indicates, can enforce racial divides and set parameters for states of national and ethnic belonging and nonbelonging. I will go on to examine how concrete intersubjective interactions, along with technological inventions, can occasion patterns of address that undergird historically shifting conditions for experience and mobilize aesthetic and political mechanisms and readings of a sort to which Walter Benjamin alerts us. Next, I will look at Louis Althusser's account of ideology to clarify the ways in which factors of address support the social leverage exercised by institutions. The chapter will continue with the trajectories of desire and subjective unsettlement that Roland Barthes associates with a mutual address among texts and readers. Subsequently, it will scrutinize how Gloria Anzaldúa crafts forms of address designed to inspire aesthetic modes of address among women of color feminists and to avert the hold of restrictive, gendered, racialized, and class-inflected divides between public and private domains. I will then contemplate Judith Butler's account of address as a dimension of social existence in a world in which we are irrevocably exposed to each other's actions, and end by reflecting briefly on the role of places and objects in trajectories of address.

Telling crosscurrents arise among quite divergent perspectives as we read them through the lens of address: given the directionality and relationality of the phenomenon, the concept of address points to the at once material, symbolic, and intersubjective dynamics embedding humans, objects, and places. Within this line of thought, people and the collectives in which they coexist amount to embodied social entities whose trajectories of differentiation and individuation are fueled by regulated and regulating flows of address running to, from, within, and between people, language, and the material world. Fanon, Benjamin, Althusser, Barthes, Anzaldúa, and Butler elaborate segments of the resulting webs of address. They elucidate strata of subjectivity, intersubjectivity, and material existence by attending implicitly or explicitly to the functioning of norms and forms of address as elements of structures, scenes, and scripts of address. We can accordingly see how the five key constituents of address

sustain pivotal cultural forces in collaboration with each other. What will become visible, too, is how our framework yields a simultaneously more granular and more broadly ranging, multifocal optic for analyzing the field of aesthetically suffused relationships than the theoretical outlooks examined here. I will include in the analysis a brief discussion of the norms and forms of address based in and centered on everyday objects, such as articles of food and clothing. Cumulatively, the vignettes that follow give further texture to the motif of culture, broached before in this book through figures like Immanuel Kant and Jamaica Kincaid.

A STRUGGLE OVER RACIALIZED VERNACULAR LANGUAGES

In his account of the dynamics of colonial power, Frantz Fanon attributes an important role to linguistic address. Of particular interest, for our purposes, is his text "The Black Man and Language," the second chapter of *Black Skin, White Masks*.[1] He reveals how, under the French colonial system, colonizer as well as colonized subject linguistic utterances to rigorous surveillance. The French language, notes Fanon, promises the black man possibilities for social advancement. The use of Creole, essential as it is for those who wish to maintain a sense of community with other Creole speakers, constitutes a liability in colonialist ears, however, signifying the speaker's subaltern status. Fanon develops these insights into a broader picture of the disciplinary functioning of linguistic as well as nonlinguistic forms of address within the *structure* of address making up a racially productive colonial system in France and the Caribbean.

In speaking a given language, according to Fanon, we "assume a culture." We take on or even "possess . . . the world expressed and implied by" that language.[2] In other words, a person's mastery of normative *modes* of address—the ones that satisfy the norms encoded in the language—allows this person to inhabit a culture. The forms of address associated with the language delineate the culture that the speaker obtains in acquiring it. Indeed, Fanon observes the enforcement by both black and white people of the creed that speaking proper French for a black man amounts to putting on or appropriating a white world while marking a rupture with his Creole world. This doctrine on the part of whites and blacks measures the modes of address assumed by the colonized by means of an analytical frame that opposes black Antillean cultural identifications and white ones. This method of reading locks the modes of address adopted by colonized and colonizer into a racial *script* of address. Rendering Creole and French mutually exclusive, this script delimits the range of enunciatory options available to blacks and whites. It dictates that one can speak only one or the other of the two languages, embody one identity or the other; it

stipulates that the question of language, moreover, settles that of identity and the other way around. The French language is bound to a static normative origin in the white European nation.[3] The result is a disciplining of people's acts of address. Within the reign of this binary, identity-disbursing, linguistic script of address, the Antillean who returns to the Caribbean from France is impelled to surrender his French idiom in favor of a Creole lexicon if he wishes to join his friends and family in a shared sense of the home community. The script finds confirmation in the white inclination to perceive a tension in the confluence of a poet's Antillean ethnicity and his remarkable command over the French language. Fanon sees this persuasion evinced in André Breton's, among other thinkers', praise of Aimé Césaire as "a great *black* poet" rather than as a great poet per se. In another scenario, following the same script, whites answer the black man's proper French with pidgin.[4] The various *scenes* of address that Fanon cites feature interlocutors who encounter black diasporic men's modes of address with modes of address that are supposed to keep them in line and appoint them to their proper colonially circumscribed place.

Fanon's examples demonstrate how the forms of address assumed by whites and blacks alike serve to restrict the powers and possibilities that accrue to the forms of address undertaken by diasporic black people. These situations, further, expose the social pressures that black Caribbeans face to adopt certain modes of address and not others. Speaking the French language implies one set of possibilities for a black French Antillean and another for a white European. The *norms* of address guiding verbal interactions reflect assessments of the identities attributed to addressors by addressees. If Fanon reveals that in learning to speak French, the Antillean acquires a world, he also shows that this world is forcefully circumscribed by the differential operations of racialized norms of address. Embodying such norms, forms of address impose constraints on other forms of address.

Fanon offers further instances of the regimentation of modes of address by normative forms of address. Under colonial rule, he notes, "the black man who quotes Montesquieu must be watched [*surveillé*]." He adds, "Let me make myself clear: 'watched' insofar as he might start something" [*avec lui commence quelque chose*].[5] Within this system, one mode of address, a black person citing Montesquieu, calls for another mode of address, namely an attitude of vigilant watchfulness. Note the objectifying form in the French: "with him"—with the black man—"something might start off." Here, we observe again the congealing of forms of address into a racial script. The operative racial imperative commands that black learning incite white surveillance and fear. A racialized standard of address by which whites evaluate a black person's forms of address curtails the power of this person's knowledge and creativity and turns an opportunity for dialogue into an occasion for social control.

Racialized norms of address govern cultural genres such as film. Fanon mentions the cinematic requirement that "the black man has to be portrayed a certain

way" [*doit se présenter d'une certaine manière*]. This rule, which stipulates a norm of address, constrains the range of modes of address open to filmmakers and actors.[6] In observing such restrictions, films institute racial differences between white and black subjects, assigning individuals to their allotted places.

Fanon's cases show that we take racial identities and boundaries to mandate forms of address. This is the implication of the use of racially differential norms of address, as entailed by the demand for certain kinds of depictions of black people and by the occasions of the monitoring of black speech. Indeed, Fanon claims that there are "mutual supports [*un rapport de soutènement*] between language and the community."[7] On the face of it, this statement can be taken to affirm a one-to-one correspondence between a language and a cultural identity, as asserted by the binary racial script that renders the use of French and Creole mutually exclusive. A more complex account emerges, however, if we recognize that the group does not exist prior to its language, but relies on an ongoing process of linguistic production. In this reading of Fanon's comment, language plays a part in assembling the community and holding it together. It keeps the collective from dispersing. The support between language and community that Fanon recognizes flows both ways, through manifold interlacing routes.[8]

Enlisted as a tool of division and connectedness, language, in the current reading of Fanon, averts symbolic miscegenation and separates racial communities from presumed outsiders. But this linguistic labor implies the disciplinary practice of enacting modes of address that are capable of regulating other modes of address and of curtailing their powers, as we have seen in the cases of the regimentation of black forms of address by both black and white forms of address. Racial bonds and boundaries do not simply prescribe modes of address but are at the same time products of such modes.[9]

For Fanon, address constitutes a systemic determinant of our subjective being and of the states of collective belonging or nonbelonging that we can actualize. His remarks on language explore the institutional regulation of people's modes of address and take note of the racially differentiated and differentiating consequences of such discipline for subjects' lifeworlds.[10] An antiracist, decolonial agenda of liberation, for him, thus must take effect at the level of the relevant linguistic, cinematic, and, more generally, corporeal modes of address. Our template of norms, forms, structures, scenes, and scripts of address is fundamentally at work in shaping the cultural politics and existential delineations that Fanon recognizes.

CONDITIONS FOR EXPERIENCE

Like Frantz Fanon, Walter Benjamin calls attention to aspects of the structural functioning of address. He highlights media, technologies, and forms of

linguistic address parallel to but, at the same time, quite different from the array of forms that Fanon identifies.[11] My focus here will be on his view of the experiential workings of address.

Address, for Benjamin, functions as a source of the organization, contents, limits, and possibilities of experience. As a temporally and spatially situated phenomenon that we invest with meaning, experience owes its shape and substance in part to the modes of address that we, in the course of our lives, come to direct at other people, things, and environments, and at the modes of address that our social and material surroundings, for their part, direct to us. This formative process, as many have argued, assumes prominent contours in infancy and continues into adulthood in a manner that reveals the enduring influence of early patterns of interaction. In his 1932 text "A Berlin Chronicle," Benjamin documents a temporal and spatial trajectory along these lines that invests antecedent configurations of address with a subsequent or present-day reality. He speculates, for example, how the picture postcards that his grandmother had sent him in his youth—images that held a "magnetic . . . attraction" for him and that transported him, "unable to tear [himself] away," to the very places they depicted—might offer many a clue as to his "later life."[12] Concerning a "sabotage" of "social existence" on the part of his adult self, he muses that its traces may be found in his "manner," developed as a young child during his walks with his mother, "of walking in the city, in the stubborn refusal under any circumstances to form a united front, be it even with [his] own mother."[13] In a passage strikingly reminiscent of Julio Cortázar's image of the glass brick, he describes how our verbal encounters with other people can imbue the language in which they are framed with a peculiar historical force:

> I find in my memory rigidly fixed words, expressions, verses that, like a malleable mass which has later cooled and hardened, preserve in me the imprint of the collision between a larger collective and myself. Just as, when you awake, a certain kind of significant dream survives in the form of words though all the rest of the dream-content has vanished, here isolated words have remained in place as marks of catastrophic encounters.[14]

Later expressions can then have us reenact the earlier disastrous scenario. He illustrates this insight with the recollection of a moment when such a repetition, years after the initial calamitous occurrence, opened "an abyss" before him.[15] Past scenes, scripts, and structures of address, for Benjamin, exert a formal and normative pull on current ones.

At the same time, interests and changes contemporaneous with the composition of "A Berlin Chronicle" disrupt this neat image of temporal organization: Benjamin's project of documenting cities, stretched out over numerous texts and countries; his exile from Berlin; the text's dedication to his son; and the

philosophical and aesthetic strategies of reading and writing he was developing, all shape his historical narrative of the city.[16] They mark not just his invocation of the urban setting, but also the portrayal of his individuality as a city-dweller who is in the process of becoming a cosmopolitan subject, and his characterization of the reciprocal interactions that this persona enjoys with his urban and transnational environment—down to life's tiny details.[17]

A consciousness of this retroactively productive activity of current situations on historical circumstances pervades Benjamin's text. He makes clear that present forms and structures of address go to shape the images and experiences discoverable in a "buried past."[18] Apropos of the image of a Baltic dune landscape that he fantasized in his early years, as a part of the horizons opened up in his imagination behind the "yellow, sandy colors" of the walls of a Berlin train station,[19] he writes,

> But this vista would indeed be delusive if it did not make visible the medium in which alone such images take form, assuming a transparency in which, however mistily, the contours of what is to come are delineated like mountain peaks. The present in which the writer lives is this medium. And, dwelling in it, he now cuts another section through the sequence of his experiences. He detects in them a new and disturbing articulation.[20]

Past experience is to be unearthed in an active process of giving it form, a form crafted within a medium that is the present. Signaling the ensuing plasticity of the past, he equates the "mysterious work of remembrance" with "the capacity for endless interpolations into what has been."[21] The past thus does not statically engender present-day effects, but becomes malleable under memory's exploratory labor, yielding multilayered strata of experience that Benjamin investigates in the text.

Benjamin's address to his childhood world accordingly folds back onto itself. Contemporary structures of address exercise formal and normative effects over prior formations. Glossing the dynamical interchange among historical positions—past and present, neither of which is controllable, altogether stable, or shaped decisively by the other—he turns anew to the terminology of a medium in a reflection on memory that merits quoting at length because of the remarkably manifold, open-ended aesthetic registers it introduces:

> Language has unmistakably made plain that memory is not an instrument for exploring the past but its theater. It is the medium of past experience, just as the earth is the medium in which dead cities lie buried. He who seeks to approach his own buried past must conduct himself like a man digging. This determines the tone and bearing of genuine reminiscences. They must not be afraid to return again and again to the same matter; to scatter it as one

scatters earth, to turn it over as one turns over soil. For the matter itself is merely a deposit, a stratum, which yields only to the most meticulous examination what constitutes the real treasure hidden within the earth: the images, severed from all earlier associations, that stand—like precious fragments or torsos in a collector's gallery—in the sober rooms of our later insights. True, for successful excavations a plan is needed. Yet no less indispensable is the cautious probing of the spade in the dark loam, and it is to cheat oneself of the richest prize to preserve as a record merely the inventory of one's discoveries, and not this dark joy of the place of the finding, as well. Fruitless searching is as much a part of this as succeeding, and consequently remembrance must not proceed in the manner of a narrative or still less that of a report, but must, in the strictest epic and rhapsodic manner, assay its spade in ever-new places, and in the old ones delve to ever-deeper layers.[22]

At once willful and experimental, the mode of address Benjamin elaborates and chooses opens up to each other present understanding and past experience. Of paramount importance is the *mode* of address that the investigator deploys: theatrical, insistent, cautiously probing, carrying a tone; sustaining a bearing, on the look-out for what can be eventually put on view in a gallery, epic, rhapsodic, productive of "dark" enjoyment. This mode of address matters in the fullness and abundance of its formal and normative registers and force. It carries meaning over and above the very form assumed by the product in which the inquiry may ultimately issue—say, a narrative or a report.

What Benjamin consequently forges and envisions is an array of dynamic encounters among assemblies of norms, forms, structures, scenes, and scripts of address that the text puts forth and of which the reader is invited to partake. Enacting and provoking experiential distances and intimacies, self-positionings and withdrawals of self, identifications and disidentifications, nostalgia and renewed possibility, Benjamin sets both present-day and historical structures of address into motion, inscribing disjunctions and tensions into their attendant norms, forms, scripts, and scenes.[23] He brings to light intricate modes of temporal address that can activate and reconfigure historical possibilities as well impossibilities, thus signaling instances of freedom along with constraint.[24]

Assuming the stance of a chronicler, Benjamin addresses his audience from a position within a constellation of address that stretches out and evolves over time, establishing an interpretive stance and authorial position from which he conveys aspects of life in a particular spatiotemporal locale—the Berlin of his youth—to a public emplaced in part in that site, but also, no less importantly, beyond it. Via this move, he extends the formative strands of interaction that he postulates in the text (for instance, in his initial years, between himself and the people, things, and places of his childhood, and later, between himself and Paris, and himself and his son) to his encounter with the reader, and

connects these threads to the lines of linguistic and, more broadly, aesthetic circulation that his audience brings to its interaction with his text.[25]

In the beginning pages of "A Berlin Chronicle," Benjamin situates himself explicitly in a relation of address with his audience. Opening his text with the line, "Now let me call back those who introduced me to the city," he follows suit by tracing out a series of five "voluntary or involuntary" guides who influenced his experience of Berlin: his nursemaid; his mother; Paris, which he notes educated him in the art of the flaneur; Marcel Proust's writings; and Franz Hessel, his partner in his Parisian exploits, with whom he discovered, among other things, an arcade in Berlin.[26] Benjamin represents his account of the urban landscape of his childhood as indebted to the modes of address that used to reach him from these guides—caretakers, close family members, companions, places, books—and that he aimed at them. Not only his experience of the city bears, then, the mark of these forms of address; the same goes for the experience of Berlin that we, in turn, gain through the mediations of Benjamin's address to his reader. Address organizes experience. More than that, it lends experience its specific substance. It must be counted among the conditions of experience.[27]

In a number of influential texts, Benjamin, as is widely recognized, pursues the social and political implications of historically shifting modes of address.[28] He observes that traditional routines of address, such as the telling and remembering of stories, have disappeared due to the erosion of the rituals and the patterns of social interaction that once supported them. In the wake of these concrete cultural transformations, new regimes of address have supplanted the old forms. The changes he witnesses pertain to technological advances and war. They encompass shifting organizations of sensory impulses and collective memory. They inhere in the rhythms and movements of city life, accelerated mass consumption, and the emergence of modern capitalist modes of production. As such, they involve the rise of novel aesthetic forms such as fashion and newspaper layout, as well as montage, whose critical political potentialities Benjamin famously celebrated. Under the influence of these kinds of historical factors, according to Benjamin, new *structures* of address make possible contemporary configurations of experience. Poverty of experience, achieved through the exhaustion and rejection of received orders of experience, creates room for alternative models. The cinema, glass architecture, and the Paris arcades are examples of such new paradigms.[29] Benjamin grounds the possibilities for experience in historically shifting modes of address. Asking what experience amounts to philosophically, in view of its involved contemporary cultural determinations and its vital quotidian and political importance, he lodges it in frameworks of address that undergo displacement as a result of an interplay between retrospectively active and newly sparked ways of seeing, imagining, inquiring.[30] The idea of structures of address and the notions of the

scenes, scripts, norms, and forms that they foster or block are central to Benjamin's critical political aesthetics.

INSTITUTIONAL FORCES

Louis Althusser's analysis of ideological interpellation further adumbrates the connections between address, institutionality, and subjectivity that become visible in Benjamin. His theory brings the elements of norms, forms, structures, scenes, and scripts of address into particularly stark relief.

As Althusser claims in his groundbreaking view of subject positioning, we implement ideologies in the forms of institutions he calls ideological state apparatuses (ISAs).[31] Contending that ideology interpellates individuals as subjects, he accounts in the abstract for such subjection by way of the scenario of a hailing in the street by the police or another kind of agency, "Hey, you there!"[32] Recognizing herself in this address, the individual turns around. In answering to the call that she takes to be directed at her, the person subjects herself to the ideology governing the *scene* of address, and thereby becomes a subject. Two instances of recognition converge in the *script* of address that Althusser posits implicitly in his schematic representation of the recruitment of subjects through address. One, the hailing institution recognizes the subject it addresses. Two, the subject recognizes herself in the hailing addressed at her: "It really is me, I am here, a worker, a boss or a soldier."[33] We can understand Althusser's ISAs, that is, the institutions in which the rituals, practices, and actions through which we form our subjective and intersubjective being are embedded, as making up *structures* of address. These structures feature scenes of address that instantiate scripts of address. Althusser's hailing scenario provides an abstract model for analyzing concrete occasions of address that shape the contours that subjectivity takes within the institutions surrounding us.

Ideological formations of address are omnipresent for Althusser. Individuals are always-already subjects. Contrary to what the hailing scheme suggests, interpellation does not follow a temporal sequence.[34] He clarifies that we incessantly practice rituals of ideological recognition that guarantee that we are subjects. This includes the moments at which he writes his essay and we read his words. Subject positioning takes place in the "most elementary" moments of "everyday life," such as "the hand-shake, the fact of calling you by your name."[35] It happens at the level of "a small mass in a small church, a funeral, a minor match at a sports' club, a school day, a political party meeting, etc."[36] By comprehending these social events as ritualized practices, he insists on the materiality of the process of interpellation. Subjection, in his theory, is a matter of a subject's being "inserted into practices governed by the rituals of the

ISAs." The recognition that this involves on the part of subjects—"They 'recognize' the existing states of affairs"[37]—amounts to their emplacement in institutional sites, which entails their participation in specific ritual practices.

In virtue of its allocation of diversified positions to its addressees, address acquires a socially differentiating function for Althusser. He indicates that the socio-technical division of labor "assigns posts" to individuals. The modes of address undertaken by the ISAs "designate" a place for subjects "as theirs in the world, a fixed residence." Individuals are "appointed" to their roles. According to Althusser, under capitalism, the reproduction of labor power and of the relations of production, which is to ensure that the worker appear at the gate of the factory not just today but also "the next day" and manages to provide for "his" children, requires the reproduction of a competent, diversely skilled labor force. The ISAs are responsible for this function. These institutions endow subjects with the diversified attitudes and skills that enable them to adequately perform their tasks. Here Althusser witnesses the specific workings of ideology: the ISAs provide the ideologies that suit people's social roles. More precisely, the ISAs realize the "concrete forms" that ideology takes.[38] The term "form," as Ellen Rooney points out, is crucial here.[39] The reproduction of labor power occurs "in the forms and under the forms of ideological subjection."[40] Part and parcel of the formal workings of interpellation is the inculcation of *forms* of address. Althusser notes that the education system, which he considers the dominant ISA, teaches subjects a diversified range of such forms of address:

> [B]esides . . . techniques and knowledges, and in learning them, children at school also learn the 'rules' of good behaviour, i.e. the attitude that should be observed by every agent in the division of labour, according to the job he is 'destined' for: rules of morality, civic and professional conscience, which actually means rules of respect for the socio-technical division of labour and ultimately the rules of the order established by class domination. They also learn to 'speak proper French,' to 'handle' the workers correctly, i.e. actually (for the future capitalists and their servants) to 'order them about' properly, i.e. (ideally) to 'speak to them' in the right way, etc.[41]

ISAs teach subjects forms of address (such as genres of speech and modes of control, subservience, respect, and disregard) that are appropriate to their positions. Suitably educated subjects acquire normative modes of address, that is, modes that meet operative standards of adequacy or, in other words, satisfy given *norms* of address. For example, a mayor moves debates to decisions, a rising film star enthralls new fans, a window-washer allows for clear views, and a plumber fixes pipes and assures customers that they have been repaired. Interpellated subjects have available to them *normative forms* of address.

The applicability of norms of address as standards by which a subject's forms of address can be judged depends on the position of that subject in a structure of address. A worker who has been trained to follow orders and her boss who has learned to give them occupy dissimilar positions in the same structure of address, namely the workplace. As Althusser suggests implicitly, the employee and her supervisor are inculcated with disparate forms of address and held to divergent norms of address. At the same time, these two individuals may occupy parallel positions in other structures of address, such as a yearly medical test, a highway accident, or a dating service.

Structures of address, we can see here, entail distinctive sets of institutionalized norms of address. A senate committee hearing observes standardized norms of address concerning vocabulary and conformity to judiciary rules. A dance concert subscribes to norms of address pertaining to movement in space and physical contact. Senators, dancers, soccer coaches, voice teachers, and trash collectors are held to different norms of address; the same goes for a child in a public playground and that same child on a school bench. The normativity of address reflects the variability of positions and structures. We render the norms of address by which we judge people's actions and enunciations relative to their positions within situationally specific structures of address.

Address, for Althusser, underlies the differentiation of subject positions under capitalism. The formal and normative dimensions of address constitute vectors of social, economic, and cultural power. In the context of ideological systems, norms, forms, structures, scenes, and scripts of address differentially constitute subjects as individuals who adopt distinctive social roles. Following Frantz Fanon, Walter Benjamin, and Louis Althusser, we can understand address as a condition for subjectivity, experience, collectivity, and social difference.

These philosophers' accounts of address include conceptions of reading. Addressees interpret the modes of address assumed by addressors. Addressors (who include addressees) size up the scenes of address in which they participate and elaborate the forms of address that they undertake in engagement with operative norms, scripts, and structures of address. Shaped through forms of address, subjectivity, experience, collectivity, and social difference fundamentally engage such assessments in multiple media and modalities: Althusser discusses in this light the subject's recognition of the call that is addressed to her, which is an element of the individual's recruitment by an address. Fanon explores people's surveillance of others' modes of address. Benjamin analyzes a shift in the role of the transmission and reception of stories, which he finds to be superseded by types of information and analysis; meanwhile, he partially reignites storytelling—this time, in the form of his chronicles of cities and by way of the many varieties of documentation and archiving through which he contemplates and imparts to his audience phenomena gathered and observed

in the city. Each theorist postulates processes of reading.[42] Benjamin, Fanon, and Althusser understand interpretation as an ingredient of patterns of address that shape experience, underwrite the bonds and boundaries shoring up and delimiting communities, and mold our subjective being and intersubjective encounters, as well as the ties we have with things and places, such as movies, factory gates, and cities.

READING, DESIRE, FORM, AND PLAY

We can further clarify what might be involved in readerly address by examining an approach that considers address as a practice of reading that is responsive to a text's (object's) form, of which such reading is also productive. According to Roland Barthes, writing in *The Pleasure of the Text*, reading involves a structure of address that, in activating and being activated by links between author, text, and reader, can occasion aesthetic desire. With this view of address, Barthes takes steps to rethink the gendered, erotically coded oppositions embedded in the Western aesthetic binaries of form and matter or body, the personal and the impersonal, the public and the private, and the political and the apolitical.

Barthes characterizes the form of the text that gives pleasure as a function of this text's erotic body: to the question, "Does the text have human form, is it a figure, an anagram of the body?" he replies, "Yes, but of our erotic body."[43] The reader of the text of pleasure creates this body.[44] In Barthes's term, the reader "hallucinate[s]" the relevant kind of form. It is the reader's desiring interaction with the text that generates textual form, conceived of as an erotic body. This interaction involves three interdependent terms: reader, writer, and text.[45] Form establishes a movement between these sites that undercuts crisp separations between the reading or writing subject and the read or written object. The text undergoes an incessant process of production: it is "worked out in a perpetual interweaving; lost in this tissue—this texture—the subject unmakes himself, like a spider dissolving in the constructive secretions of its web." The reader's and writer's making and unmaking are a matter of their participation in the evolving intertextual folds of language. "Plaything[s]" of language, as they "play" with it, the figures of the reader and the writer are both suspended in a vast network of address.[46]

Through the notion of the *studium*, the reader's repertoire of institutionalized cultural imagery and knowledge, Barthes conceptualizes the acculturating forces that organize our interactions with the text. Even if the reader's textual attractions, as he believes, are highly susceptible to social regulation, desire retains a margin of uncontrollability, which, for Barthes, manifests itself in our vulnerability to the touch of the *punctum*, the unpredictably affecting detail.

Acknowledging the ample institutional groundings as well as the elusive specificity of textual pleasure, he affirms both the impersonality and the individuality of the reader's pleasure:

> [I]t is at the conclusion of a very complex process of biographical, historical, sociological, neurotic elements (education, social class, childhood configuration, etc.) that I control the contradictory interplay of (cultural) pleasure and (non-cultural) bliss, and that I write myself as a subject at present out of place, arriving too soon or too late (this *too* designating neither regret, fault, nor bad luck, but merely calling for a *non-site*): anachronic subject, adrift.[47]

The pleasure of the text is liable to structural individual determinants, but rather than reiterating a consistent self, the subject who finds pleasure loses herself and her place in relation with the text. Pleasure bifurcates between a disruptive force that unsettles the subject's position and a regulated, conventional dimension that gives the reader comfort and bolsters her culturally established self.[48]

For Barthes, the allegedly cultural and anticultural or acultural forces of the text implicate the directionality and relationality that characterize modes of address. Speaking to both of these registers of address, his view of pleasure, in one sense, presumes a diffuseness and indirection of the text's orientation toward its reader and of the reader's orientation toward the text.[49] Insofar as textual pleasure participates in bliss, it circumvents the securities of ideology, stereotype, established jargon, communication, institutionalization, and scientific calculability. Accordingly, with the instances of pleasure cited in *The Pleasure of the Text*, Barthes wishes to catch pleasure in the act rather than to govern extrapolation.[50] Aesthetic pleasure, for him, does not lend itself to being captured in a scheme of social or theoretical classification.

In another sense, the text of pleasure assumes an exact orientation. It arrives on target, at precisely the right moment.[51] The reason for this is that in order to give pleasure, a text must single out a reader: "The text chooses me, by a whole disposition of invisible screens, selective baffles: vocabulary, references, readability, etc." Textual pleasure is contingent on the writer's elaboration of a distinctive addressee. The reader must cut a sharply delineated figure to the author, rather than a generic "field, a vessel for expansion."[52] In other words, pleasure fails if the text indifferently solicits a general reader. This condition for pleasure entails a specific mode of address from the author toward the reader.

Directly addressing the author, Barthes deems the following form inadequate: "You address yourself to me so that I may read you, but I am nothing to you except this address." If the reader is to come by textual pleasure, the writer, in her selection of a reader, must go beyond an undifferentiated need for being read. The issuing of a bare demand to just any reader does not suffice from the perspective of pleasure. "The text you write must prove to me that it desires me."

Unless it gives form to such desire, a text is condemned to being frigid or boring.[53]

Taking the stance of the writer, Barthes observes, "I must seek out [my] reader (must 'cruise' him) *without knowing where he is*. A site of bliss is then created. It is not the reader's 'person' that is necessary to me, it is his site: the possibility of a dialectics of desire, of an *unpredictability* of bliss: the bets are not placed, there can still be a game." This game is reciprocal: shifting into the place of the reader, he notes, "in the text . . . I desire the author: I need his figure . . . as he needs mine (except to 'prattle')."[54]

In Barthes's account, a distinctive form of playful address grounds aesthetic desire.[55] Such desire presupposes a scheme of address that consists of mutual relations between reader, writer, text, and form, and that can succeed or fail with regard to pleasure. The concept of address is integral to Barthes's analysis of the movements of textual desire. His notions of the intertext, the studium, and the punctum locate the pleasure of the text in forever-morphing webs of address that enable the reader to enjoy intermittently the allegedly self-affirming pleasures of culture, taste, and language, and, in countervailing movements, to disrupt her position in relation to language and culture more broadly.[56]

Barthes answers a dichotomously eroticized metaphysics and structure of desire that opposes subject and object, form and matter or body, and beauty and sublimity with an aesthetic sensibility and a genre of play that lingers with surface and detail.[57] Veering away from a view of address that grounds generally accessible meanings in a public forum in which subjects can indiscriminately and freely address each other, texts, and places, Barthes finds aesthetic pleasure mired in an array of systemic determinations and contingencies (owing to factors such as education, upbringing, social class, history, and accepted taste) that shape the relationships between readers, writers, and texts and incite playful repositionings on multiple sides that gesture toward alternative relational constellations.[58]

Barthes's views of textual form and pleasure underscore the entwinements of the modes of address of writers, texts, and readers.[59] Reciprocal bonds linking subjects, objects, and sites of enunciation materialize in the form of modes of address. He envisions a web of cultural affiliations and disaffiliations that we create or realign as we, on the one hand, are being played with by authors and their texts and, on the other, initiate forms of play as readers and writers in our own right. Distinct, interwoven, mutually sensitized forms of address prop up, steer, and drive an aesthetic plane of playfully evolving relational positions that, for that matter, is not free from violations, limits, and ruptures. Barthes introduces norms and forms of address (drift or play but do not prattle!) into scenes of address (writing or reading), meanwhile envisioning altered structures and scripts of address (oscillation between comfort and unsettlement; a bodily dialectics of desire).

If Barthes engages in a queering and a degendering or regendering of a Western artistic metaphysics and epistemology that offer us ways of conceiving of aesthetic desire at some distance from a narrowly masculinist, heterosexualist model of meaning and interpretation,[60] Gloria Anzaldúa gives a different orientation to these kinds of reroutings, instigating other paths of desire.

INTERMEDIALITY AND INTIMACY IN WRITING

In a text from the early 1980s, "Speaking in Tongues: A Letter to Third World Women Writers," anthologized in the now-canonical collection *This Bridge Called My Back*—a book that, at the time, forged bridges between the academy, the realm of art, and the broader society—Gloria Anzaldúa approaches the exclusion of feminists of color from the academic and literary worlds as a problem of address. She replies to this difficulty by inventing and sparking modes of address that foster possibilities for aesthetic address among feminists of color and work around certain gendered, racialized, and class-inflected strictures clamping down on the forms of address available to these feminists.

Anzaldúa registers a predicament of address: While women of color, she notes, are gradually attaining visibility in white feminism, "The *lesbian* of color is not only invisible, she doesn't even exist. Our speech, too, is inaudible. We speak in tongues like the outcast and the insane."[61] Hegemonic formations of address, Anzaldúa suggests, render the modes of address adopted by lesbians of color unintelligible. Dominant addressors, further, do not regard lesbians of color as full-fledged addressees. As the culprit, she identifies a white masculinist stance that declines to learn the relevant language or to make the effort to understand what is said. This attitude admonishes lesbians of color to "*[s]top speaking in tongues*" and to desist from cultivating their "*tongues of fire.*" These messages, suggests Anzaldúa, exemplify the writing difficulties that structures of address favoring white masculinist styles of expression present for feminists of color, who can participate in these structures only on the condition that they "put frames and metaframes around the writing" and take a distance from their own lives, from the themes they wish to discuss and the audience they would want to reach.[62]

Anzaldúa revolts against these terms of address and the impediments that they impose on addressors and addressees who are women of color: she assumes a mode of address designed to foster alternative norms, forms, structures, scenes, and scripts of address. On the part of other feminists of color, she encourages modes of address that can be expected to foment those changes. Thus circumventing what she describes as white masculinist constellations of address, Anzaldúa seeks to achieve intimacy with women of color in her

writing.⁶³ To this end, she adopts a direct address to her audience, saluting them, "Dear mujeres de color, companions in writing" and "My dear *hermanas*." As these appellations stress, Anzaldúa casts her text in the form of a letter. She chooses this mode in order "to approximate the intimacy and immediacy" that she wants to attain. The letter is dated "21 mayo 80," gesturing explicitly toward the Chicana/Latina reader. Through a concrete rendering of the bodily posture she assumes as a letter writer who engages in a direct address, Anzaldúa attempts to bring herself close to this reader. The letter opens, "I sit here naked in the sun, typewriter against my knee trying to visualize you."⁶⁴ The "you" who is her addressee—and note the visual/corporeal and erotic/intimate register of the gesture toward the addressee, as opposed to a more abstract imagining—also obtains a place in the scene of address that is unfolding. For this "you" is a particular person who either is found in locales that Anzaldúa goes on to specify in her letter, or occupies sites analogous to the ones she (Anzaldúa) envisages:

> Black woman huddles over a desk on the fifth floor of some New York tenement. Sitting on a porch in south Texas, a Chicana fanning away mosquitos and the hot air, trying to arouse the smoldering embers of writing. Indian woman walking to school or work lamenting the lack of time to weave writing into your life. Asian American, lesbian, single mother, tugged in all directions by children, lover or ex-husband, and the writing.⁶⁵

Adopting the present tense, Anzaldúa engages women of color in their immediate everyday activities and dilemmas, embedding the scene of writing in her own as well as her addressees' prosaic corporeal undertakings and material environments.

Anzaldúa attempts to bring the writing scene near to the quotidian lives of her woman-of-color readers, to whom she reaches out in a further way. Addressing the feminist-of-color reader as a (potential) writer, she counsels:

> Forget the room of one's own—write in the kitchen, lock yourself up in the bathroom. Write on the bus or the welfare line, on the job or during meals, between sleeping or waking. I write while sitting on the john. No long stretches at the typewriter unless you're wealthy or have a patron—you may not even own a typewriter. While you wash the floor or clothes listen to the words changing in your body. When you're depressed, angry, hurt, when compassion and love possess you. When you cannot help but write.⁶⁶

This advice or, in other words, this roster of precepts and recommendations with which Anzaldúa endeavors to banish a quite different set of quotidian commandments that carry authority in the culture, locates the scene of

writing in the concrete places making up the lifeworld of her audience—kitchens, bathrooms, buses, lines, work, floors, sites of cleaning, or any kind of space where emotions or creative simmerings are felt.

Anzaldúa witnesses this overlap of scenes of writing with settings where other kinds of address take place also in her own case. She both situates herself explicitly in a "community of writers" with whom she shares a house and who comment on her writing and represents these writers, or some of them, as engaged in kitchen work—a labor that engenders embodied expressions of ideas, ones that end up in the text: "In the kitchen Maria and Cherríe's voices falling on these pages. I can see Cherríe going about in her terry cloth wrap, barefoot, washing the dishes, shaking out the tablecloth, vacuuming." Having brought writing in intimate proximity with other aspects of life, namely with her friend's cleaning, and recognizing a reciprocal nourishment among these activities—with the voices gaining articulation on the page and her text absorbing their imprints—she dissolves the distinction between these domains: "Deriving a certain pleasure watching [Cherríe] perform those simple tasks, I am thinking *they lied, there is no separation between life and writing.*"[67] The pages of Anzaldúa's letter become a place where her community of writers and the inseparability of life and writing make their presence felt, not only because she writes about her friend Cherríe Moraga's domestic activities or because her text and her mode of address soak up elements of the forms of address that accompany or inhere in Moraga's kitchen work, but also because she incorporates writings by women of color other than herself into the letter: the missive is interspersed with quotations from Moraga, Naomi Littlebear Morena, Alice Walker, and Nellie Wong, among others.

Anzaldúa envisions a writing of feminist stories, a writing that reveals the self to the self, that is a process of self-making as well as a crafting of forms of interconnectedness with others. This writing takes risks and puts the self "on the line." It reaches for parts of the self that have been split off from the self and from others, parts that do not count as normal in dominant eyes.[68] It offers "a margin of distance," helps to sustain the self, and fosters bonds of companionship.[69] Having circumscribed the importance and power of writings by feminists of color, Anzaldúa proceeds to make a plea for this kind of writing:

> I say mujer mágica, empty yourself. Shock yourself into new ways of perceiving the world, shock your readers into the same. Stop the chatter inside their heads.
>
> Your skin must be sensitive enough for the lightest kiss and thick enough to ward off the sneers. If you are going to spit in the eye of the world, make sure your back is to the wind. Write of what most links us with life, the sensation of the body, the images seen by the eye, the expansion of the psyche in

tranquility: moments of high intensity, its movement, sounds, thoughts. *Even though we go hungry we are not impoverished of experiences.*"[70]

While Anzaldúa talks here about the contents of the kind of writing by feminists of color that she encourages, she also speaks of its mode of address, namely its ability to shock the reader into new forms of perception. Writing, as a mode of address, takes up a place alongside other modes of address such as a tactile sensing and not-sensing and a rebellious spitting at the world. As a structure of address, writing comes to be on a par with a meaningful formation of experience that offers sustenance to the writer as well as to the audience signaled by the "we," although other desirable and required material provisions happen to be lacking. Anzaldúa thus understands writing in its connections with different media of address: touch, spitting, vision, moving, peacefulness, listening, a longing for food, and other dimensions of sensation and emotion.

Virtually leaving behind the level of content, she underscores the intermedial, even transmedial linkages between writerly and other kinds of modes of address yet more fully: "*Write with your eyes like painters, with your ears like musicians, with your feet like dancers. You are the truthsayer with quill and torch. Write with your tongues of fire. Don't let the pen banish you from yourself. Don't let the ink coagulate in your pens. Don't let the censor snuff out the spark, nor the gags muffle your voice. Put your shit on the paper.*"[71] Writing, here, comes together with day-to-day bodily activities (such as seeing, listening, dancing, and shitting) as well as with specifically artistic modes of address: visual, musical, kinetic. Anzaldúa incites aesthetic modes of address on the part of and between feminists of color and establishes links between writing and other forms of address, both quotidian and artistic. These bridges counteract oppressive divisions between public and private, abstract idea and bodily existence, the general and the particular, the universal and the specifically historical, maintained by what she considers white masculinist criteria of linguistic expression.[72] In this way she theorizes, adopts, and fosters modes of address that at once escape, resist, critique, and develop alternatives to narrowly gendered, racialized, and class-inflected patterns of interaction among writers and readers, among writers, and among readers. These modes are designed to set in motion trajectories of collective liberation.

Anzaldúa, I have argued, initiates an array of sharply focused strategies of address that are rigorously responsive both to socially exclusionary and potentially more inclusive scenes, scripts, and structures of address, along with their attendant norms and forms. These strategies yield an aesthetic politics that energizes address's abundant directional and relational potentialities to orient them toward the creation of modalities of sustenance, connectedness, and freedom that she places at the core of a joint feminist lifeworld.

Actively reaching into the spheres of existence of her women-of-color readers, Anzaldúa does not merely bring her writing close to her community of fellow feminist writers of color and the everyday spaces such as kitchens, buses, bathrooms, and porches they frequent, but also forges connections with things like food (pizza, apple Danishes); the bread it is necessary to work for; the pens, ink, paper, and typewriters used to write; and the typewriter ribbons that may be too pricy to afford.[73] These objects exert concrete material forces that the writer navigates in her lifeworld and that Anzaldúa incorporates into the structures of address that she ignites. Before I reflect more extensively on the role of objects in trajectories of address, I will consider one last theorist of address.

PRECARITY, VIOLENCE, AND PUBLIC PROTEST

Much of Judith Butler's work engages address, whether in theorizing gender, in commentaries on the writings of philosophers such as Friedrich Nietzsche, Louis Althusser, Frantz Fanon, or Emmanuel Levinas, or in investigating states of precarity and popular gatherings. I will highlight here just a few of the many dimensions of relationality and normativity that, in her view, we realize through address.

The performative theory of gender for which Butler is famous locates a person's gender identity in repetitive utterances that do not, in the first place, describe that identity, but constitute it. These constitutive acts—performances through which we construct gender—answer to historically contingent codes of legibility with a stylization of the body. Given a backdrop of institutional conditions, we *do* our bodies, as Butler puts it.[74] In this perspective, our address to other people and the address with which other people meet us furnish the mechanisms that we deploy to craft our gender positions: gender, in Butler's approach, resides in iterative, audience-directed, culturally conditioned forms of address that are responsive to norms of address encoded in structures, scenes, and scripts of address.

Having in the 1990s placed address at the core of a socially constructionist approach to gendered existence, in the first decades of the twenty-first century she takes further her explorations of address in investigations of the inexorable, mutual interdependencies that bind us together as living beings. Both our status as human beings and the livability of the lives we lead, Butler argues, reside in the bonds of address linking us to other people.[75] The ways in which people's address affects us elude our control and are substantially unknowable by us. This poses the ethical demand to adopt modes of address that acknowledge our own and others' opacity. By keeping in the forefront of our moral considerations and comportment the question "Who are you?" and refusing to close

this question down, we can lend recognition to the epistemic open-endedness required to attain forms of ethical address.[76]

Coordinates within webs of address inform a wide array of experiential consequences. As subjects who are situated in patterns of relationality with other people, we can be exhilaratingly moved by their address but also be touched by it in ways that harm us. More than that, dominant practices of address may abandon us, placing us beyond the realm of the addressable community. Media circuits and technologies often construct the suffering, even death of specific populations as unworthy of grieving.[77] We are unevenly susceptible to each other within structures of address: our basic vulnerability takes asymmetrical forms depending on the location we occupy with respect to systems of technologically mediated address.[78]

For Butler, address is a central component of our subjective being, which is fundamentally relational in character: as corporeal beings, we are exposed to each other's address. While this exposure yields a systemic condition for potentially delightful and invigorating engagement among persons, it also lies at the origin of a lot of damage that we inflict on each other. In the context of historically entrenched structures of address such as patterns of regard and neglect, modes of address (seeing or nonseeing, touching or a withholding of touch) can embody violence as well as love.

In a conversation with George Yancy on the Black Lives Matter movement, Butler observes:

> Sometimes a mode of address is quite simply a way of speaking to or about someone. But a mode of address may also describe a general way of approaching another such that one presumes who the other is, even the meaning and value of their existence. We address each other with gesture, signs and movement, but also through media and technology. We make such assumptions all the time about who that other is when we hail someone on the street (or we do not hail them). That is someone I greet; the other is someone I avoid. That other may well be someone whose very existence makes me cross to the other side of the road.[79]

Scenes of address such as encounters in the street, in other words, are occasions where modes of address enact systemic forms of differentiation, encoding norms stipulating who is and who is not a person of concern, who does and does not qualify as an individual who matters. Under conditions of structural racism, where some classes of people generally are valued and others are to a substantial degree considered disposable, the Black Lives Matter movement practices a "'speaking back' to [the] mode of address" that posits the insignificance of black lives.[80] This counteraddress is a node within a process of building a just social infrastructure that nourishes the lives of all black people and brings about their liberation from antiblack oppression.

Butler has extended her account of performative acts to the public protests that, in the second decade of the twenty-first century, have been organized in many countries across the globe. She focuses on mobilizations that answer the accelerating human and environmental precarity and expendability effected under ever-intensifying neoliberal regimes, with demands for infrastructural provisions that can support the flourishing of life.[81] Practices of public assembly, for Butler, deploy performatives: "we, the people," along with the material supports that the people require in order to be able to lead meaningful lives, do not yet exist prior to the mass public gatherings happening in the streets, but are being enacted in the concrete assemblies that are occurring.[82] These assemblies, Butler argues, actually bring about the collective, materially supported, bodily "we" that the protesters invoke or name. Rather than positing a unified populace or relying on the presence of the full community in the streets and on squares, public rallies feature plural collectives traversed by interdependencies. The protesters are in the process of realizing the very people and public space in the name of whom and which they stake their claims on social and material worlds that afford sustenance to human beings. Marching, chanting, dancing, texting, interlacing limbs, taking videos, and disseminating snapshots, public assemblies thus adopt multimodal forms of address designed to reshape the conditions under which we are exposed to each other and to our material environments. These gatherings, as Butler puts it, "seek to produce the conditions under which vulnerability and interdependency become livable."[83] In short, she places address at the core of social existence, ethical life, and transformative political action. In a range of contexts, she alerts us to the potentialities of modes of address to implement alternative norms of address and to bring about necessary changes in unjustly restrictive scenes, scripts, and structures of address.

BODIES, OBJECTS, SPACES

In the opening story of *Cronopios and Famas*, Julio Cortázar's spoon, as noted in chapter 2, makes a demand on the coffee drinker: it asks to be used to stir the coffee. The doorknob in this tale relays a world of possibilities that the person who would be about to turn it is likely to neglect as she dashes out, using the handle solely for the purpose of exiting the apartment. Yet, as Cortázar reminds us, alternative ways of going about things can settle in the very touch of a spoon, an encounter with a door. The young woman in Jamaica Kincaid's story "Girl" also activates unanticipated material potentialities that were seemingly foreclosed by the ordinary rule of things. The girl's bread—object of touch, reachable or unreachable to her—leaves behind its location in

a disciplinary scheme of interaction, where it has to be squeezed so that the girl can see if it is fresh. Indeed, upon the girl's intercession into this rule, the bread starts to channel a whole array of sensory and imaginative encounters, ones that exceed the object's role in the testing ritual proposed by the pedagogue.

Things and the spaces they occupy, Kincaid and Cortázar indicate, extend promises and make demands on us. These forms of address support our negotiations of social, economic, ethical, political, and aesthetic norms.[84] Subjects and objects, meanwhile, are bound to each other in structures of address; they encounter and affect each other in and through modes of address. The modes adopted by subjects, moreover, display profound interdependencies with those on the part of objects. I will approach these entwinements by following the roamings of some objects—first, the coat with which Karl Marx weathered the cold, sartorial requirements, and poverty, as tracked by literary and cultural scholar Peter Stallybrass; second, a bar of chocolate covered in a printed wrapping and transported to a breezy hilltop, where it enters into purported communication with the rest of the globe. My aim, as with the preceding vignettes, is not to provide any kind of exhaustive treatment of the relevance of address to our mutually intertwined engagements with things and places and with each other, but to mark certain lines of interaction and to schematically signal the ways in which critical strategies of (and reflections on) address are of crucial importance to these aspects of our joint lives.

Things and the demands of respectability, research, and creditors

For Karl Marx, writing in *Capital*, a coat emblematizes the form characteristic of the commodity: that is, of an exchangeable object whose value is stipulated by equivalences to the value of a host of other commodities like linen, coffee, and iron. Yet, as Peter Stallybrass reminds us, there was also another coat in Marx's life.[85] This garment—which, as coats are wont to, had presumably molded itself to its owner's shapes—kept him warm in the winter, at least if it hadn't been put in pawn to pay for food, rent, and writing paper. Marx indeed needed paper, not just to pen *Capital*, but also to carry out his journalistic work, which was required to keep his family afloat. Prop of a life lived at or below subsistence level in London, the coat was constitutively at risk.

In the plane of the subject, Stallybrass notes, the commodity form corresponds with the persona of the European who transcends the world of things like clothes—all those objects that help fashion a human being, that hold memories for him. Commodity fetishism glorifies abstract exchange value: it celebrates, as Stallybrass puts it, "the invisible, the immaterial, the supra-sensible."[86] By contrast to supposedly fetish-worshipping West African people, who were

found to misjudge the value of things, the European, as defined in relation to the commodity, is a figure

> unhampered by fixation upon objects, a subject who, having recognized the true (i.e. market) value of the object-as-commodity, fixed instead upon the transcendental values that transformed gold into ships, ships into guns, guns into tobacco, tobacco into sugar, sugar into gold, and all into an accountable profit. What was demonized in the concept of the fetish was the possibility that history, memory, and desire might be materialized in objects that are touched and loved and worn.[87]

In critiquing commodity fetishism, infers Stallybrass, Marx rejected a disavowal of "the animized object of human labor and love" in favor of "the evacuated nonobject that was the site of exchange." Indeed, Marx counters this dematerializing stance with a renewed valorization of both the making and use of particular objects: "*Capital* was Marx's attempt to give back the coat to its owner."[88] This project of redistributive justice, and what I would call aesthetic revisioning and restitution, notifies us of the importance of the modes of address that reach us from things and that we direct at things, while also calling attention to the interlacings of these two kinds of address.

Tracing the movements of Marx's coat into and out of the pawnshop in London during the 1850s and early 1860s, Stallybrass finds that what Marx could write (journalism or *Capital*) was contingent on what he could wear.[89] If his coat was in pawn, he could not go to the library of the British Museum to get his research done for *Capital*, and had to scramble for money doing journalism. Accordingly, the modes of address that Marx directed at the commodities and the social relations he theorized depended on the modes of address that his coat directed at its surroundings. As the case might be, the relevant circle could either be the people in the streets, the museum, or the reading room, to whom he was to be presentable, or it could encompass the pawnshop owner and the other objects lodged in the pawnshop, rife with the memories, imprints, and smells of people's bodies. Accordingly, the travails of Marx's coat, as analyzed by Stallybrass, demonstrate how a thing's forms of address encode norms of address that are determinative of the scenes, scripts, and structures of address in which we can participate. The modes of address that people adopt toward things, we can further conclude, rely on the modes of address that things adopt toward those people, and toward other people and things. Objects, in their entanglements with subjects, kindle webs of interdependency that shore up action, thought, sociality, and material life.

Highlighting the mutual constitution of person and thing by each other, Stallybrass underscores the tensions between the functioning of objects as entities

that hold memories, carry the marks of bodies, and are animated by love, and their workings as commodities stripped of these roles by the marketplace.[90] Address shapes and crisscrosses these vexed intimacies, shot through with loss as they are. Yet Marx's endeavor to restore the coat to its owner calls on us to take cognizance of the very bonds—sustaining orientations to self and others, connections with history, commitments to life projects—that we enact in the form of our dependencies on things, and challenges us to critically examine our address to the world in light of this awareness. Of course, not all of our attachments to things are equally worthy of being nourished, an insight that, in an era of catastrophic climate change and unabating, even intensifying sorts of precariousness, is all the more urgent to acknowledge as we embark on new trajectories of ethical, political, and aesthetic address, in tandem with a host of things.

I will now move from a story of nineteenth-century attire and poverty to a narrative of food and leisure in a twenty-first-century Western consumer society.

Coated consumption items and their dress-up acts

Having reached the summit of a hill in Amherst, Massachusetts, my friend and I stop hiking to immerse ourselves in the view as well as in a chunk of Green & Black's hazelnut-and-currant chocolate that mounts pleasure on top of pleasure. The shiny foil crackles upon the touch. As I rub my fingers over the ridges between the rectangles imprinted in the bar, the pieces press their contours into the sheet, displaying orderly lines. Portions of chocolate snap off with a thick, dull sound, oblivious to the rows imprinted on them. We celebrate our ascent to the peak of Mount Norwottuck with an ensemble of bittersweet tastes, grainy textures, and syrupy fragrances that commingles with the feel of a breeze and the sight of an expanse of rolling hills, the trees beginning to show their autumn splendor.

As if this is not enough, through the smudges on the inside of the paper wrapper that holds the gold foil, which, in turn, holds the chocolate, we can read:

> The Most Heavenly Chocolate on Planet Earth
>
> At Green & Black's our aim is to create the most delicious chocolate in a manner that helps sustain life on our precious planet. We believe that every step from bean to bar is equally important—whether it's using the finest organically-grown cocoa beans or taking that extra time conching our chocolate to bring out the intense flavor that has become our trademark.

The project of sustainability that Green & Black's envisions would appear to encompass every human and nonhuman stage between bar and belly, between palate and planet, between conching and gobbling. The modes of address that the chocolate directs at us and we at it become vectors of activity in a larger fabric of social and environmental justice. The wrapper's address amplifies the address of the chocolate to its consumers by situating the bar in a planetary frame, and expands the consumers' address to the chocolate. Sitting on the hill, in the woods where the Norwottuck people once lived, eating the chocolate, we can imagine ourselves contributing to the preservation of a livable environment. We are invited to address the chocolate as citizens who handle the globe with care, who endeavor to protect resources that are under threat. We are encouraged to see ourselves acting in consort with those who want the best for the world. Via our chocolate, we can feel in contact with community-spirited people like ourselves as well as with a host of other valuable things that the earth harbors. The chocolate aligns itself with things like recycled toilet paper, biodegradable dishwashing soap, bicycles, vegetarian diets, composters, mossy yards, tidy solar paneling covering innumerable roofs, and proudly proclaimed LEED or Living Building certifications. Biting into our chocolate, looking into the sky over the trees, and sensing the breeze, we activate a patchwork of linkages making up our surroundings, participating in a planetary ecology. The wrapper continues:

> Our Promise
>
> We only buy the very best organic cocoa beans, including criollo and trinitario varieties. Unlike plantation-grown cocoa, our farmers grow their beans under the shade of indigenous rainforest trees alongside other crops like avocado, pineapple, coffee, papaya, and bananas. A canopy of shade trees—mahogany, cedar and teak—are grown above and ginger is occasionally grown underneath. This biodiversity means that the cocoa is more resistant to disease and the crops are not sprayed, so the river water stays clean, which helps preserve the habitat for wildlife.
>
> Sourcing our cocoa direct from the growers, we pay them a higher price than for that of conventional cocoa. This helps them to improve their quality of life and provide a better education for their families and community.

The bar of chocolate becomes a beautiful thing—tasty and healthy, like avocado and pineapple; invigorating, like coffee; nourishing, like papaya and bananas; solid and shiny, like mahogany; spicy, like ginger; diverse, like people and the planet. The promise transmitted by the wrapper situates the chocolate in a place of origin alongside other aesthetically desirable goods and among

valuable workers and their relatives and fellow community members. The chocolate acquires a place within an ecosystem that facilitates vegetative, animal, and human well-being. Addressing ethical demands on the part of contemporary consumers, Green & Black's seeks to embed the commodity that it sells within a moral and aesthetic framework.

The form of address that the company has adopted for the wrapper, that of a social and environmental promise, postulates a reader/eater who will find satisfaction in a narrative that interpellates him, her, or them as a benevolent agent whose consumptive behaviors in the Global North benefit farmers, communities, animals, and rainforests in the Global South. This mode of address comes at the price of the elision of details from the product history presented by the company. Information concerning the laborers' working conditions and the environmental implications of the process of production, transportation, and disposal is omitted. The biological tale we are offered gives us an idyllic but idealized picture of the canopy surrounding the cocoa plants. Mahogany and teak trees take a long time to grow and are often at risk of being logged. How are we to understand the temporality of the narrative? When and how will the promise come true? The complicity of consumption in the Global North in the poverty of families and communities in the Global South and in the destruction of forests and rivers around the world goes unmentioned. Green & Black's has designed its mode of address so as to make privileged consumers feel good about their consumption of the company's product. It counts on the first-world reader's longing for economic narratives that represent third-world subjects as beneficiaries rather than victims of first-world productive and consumptive behavior or as actors who make legitimate redistributive demands on global elites.

The modes of address that the consumer takes toward the chocolate (imagining her consumptive behavior to contribute to its promise) appear to be bound up with the modes of address that the chocolate adopts toward the consumer (holding out a promise via the mediation of the wrapper). Both modes of address rely on a web of relationships among laborers, aesthetic makers, receivers, commentators, and marketers, a network in which they create echoes, inspiring, for instance, fantasized alliances between consumers and environmental activists, along with imagined solidarities among Global North and South.

Analogously to the traces traversing or instigated by Marx's coat, the reverberations occasioned by or settling into Green & Black's chocolate bar point to the ways in which the modes of address of subjects and objects draw on each other and give rise to further modes of address as they wield their relational effects in capitalist social formations. The chocolate bar and its messages adopt forms of address toward its consumers to which we respond as inhabitants of structures of address by which we live. The chocolate also fulfills aesthetic

norms of address embodied in our desires, emotions, and habits. Likewise, Marx's coat, at times of relative solvency, directs forms of address to the occupants and the gatekeepers of the reading room of the British Museum, forms that satisfy certain norms of address. These two sets of norms and forms play a part in propping up racialized, gendered, and class-inflected structures of address—the systemic patterns of exchange underlying markets of labor, of commodities, and of other resources in a capitalist economy. Within institutional structures of address, forms of address are governed by norms of address. Objects help to circumscribe our place in (or on the outside of) structures of address (libraries, shops, circuits of commerce and information; aestheticized patterns of self-fashioning; settler–colonial societies). The reverse also holds true: our place within structures of address (archives, collections, narratives of place, transnational flows of production, trading, exploitation, and consumption) helps to give objects their significance. Address lies at the heart of the relations among subjects, among objects, and among subjects, objects, and social institutions. As suggested by Marx's endeavor to hand back the coat to its owner, a critical aesthetic politics must take as a site of intervention these manifold linkages that can hamper desirable social and ecological possibilities, but also act as incitements to moments of freedom, and to interactions and alliances that foster the life of people, nonhuman animals, plants, and things.

A MULTIFOCAL, GRANULAR VIEW OF ADDRESS

Within institutional structures of address, forms of address (fostered by processes like technological changes, white backlash, or neoliberal consolidations) are governed by norms of address (posited by people, things, and places, such as protesters, teargas canisters, and streets, respectively; or DJs, turntables, and festival grounds). These norms take effect in scenes and scripts of address (e.g., echoing slogans and occupation of city squares across the world; or chanting along with songs and texting in between bands). These arrangements are productive of relationships among people, among things, among places, and among people, things, and places.

Frantz Fanon, Walter Benjamin, Louis Althusser, Roland Barthes, Gloria Anzaldúa, and Judith Butler illuminate facets of these kinds of relational configurations. These scholars use the concept of address to account for aesthetic, linguistic, technological, and institutional conditions, and to signal parameters of life oriented toward and based in objects. In short, they enlist the notion of address to clarify vital cultural phenomena—ones that of course implicate one another in a gamut of ways: smooth, orderly, chaotic, contrarian. Further, these theorists' mobilization of the concept reveals address's participation in

the constitution of subjectivity, collectivity, experience, desire, and reading. This breathtaking list of social achievements on the part of address makes clear, again, that these thinkers map out processes that coincide and interact in all manner of ways, from the gritty and offbeat to the reliable, the normalized; from the shocking to the reassuring; from ways that feed melancholy or outrage to ones that kindle hope. Our six theorists' outlooks, then, supplemented with our reflections on the significance of objects, show how the apparatus of address is at work at the heart of cultural life. These approaches help us see how address shapes the exuberant measures—conflicted or compliant, withdrawn or fascinated, intense or tranquil—of our being alive to and with language and the world.

Having now charted how the apparatus of address composed of jointly operative norms, forms, structures, scenes, and scripts proclaims its presence within a variety of idioms of address—vocabularies that, as it happens, are not all compatible with each other—I propose to extrapolate from this: our model of address is at work across an expansive array of conceptual paradigms, social practices, and sites of inquiry. Reaching beyond the bounds of particular quarters of life, it pertains to virtually all spheres of existence.

Adding just a handful of points to the quite ample evidence we have accumulated so far in support of this view, I would like to signal a few areas in which our model displays an analytical potential that the six theorists' more localized and partial approaches tend to overlook:

Language and difference. Fanon and Anzaldúa disclose the participation of specific kinds of deployments of language in vectors of social difference. Time and again, however, linguistic address not only runs athwart but also outstrips the connectivity-building and -rupturing roles that these theorists identify as they focus on language's operations as a register of racial discipline (Fanon) or intersubjective rifts and bonds (Anzaldúa). Indeed, verbal address activates a more expansive range of mechanisms and effects than these two thinkers recognize, on which our model promises to shed light.[91]

Performative acts and ideological interpellation. Within accounts of performativity and ideology, such as Butler's and Althusser's, it often remains difficult to gauge what the precise force is of a performative modality or a form of interpellation, as compared to the institutionalized social conditions that are in play, and that require mobilization in order to make a performative act felicitous or infelicitous, or to endow a putative interpellation with its effects. This quite common phenomenon, I would argue, does not invalidate these approaches, but results in an explanatory gap between performative intervention or purported interpellation and the social operations attributed to these modes. We can turn our hand to this gap by considering the detailed workings of norms and forms of address in the context of large-scale structures of address as well as granular scenes and scripts of address. Thus we can

strengthen and complicate our understanding of the multitudinous resources for subjective constitution that go to shape states of performativity and acts of interpellation.

The life of things. While our theorists all have valuable things to say about the functioning of things and places, this area of inquiry, speaking in large historical strokes, has not been philosophy's forte, as is widely acknowledged. Bringing together systemic and contingent parameters of our interactions with the world, our model of address signals key junctures in the collaborative functioning of people, things, and places. Equipped with this framework, we can hope to make headway on some of the limitations that the existing scholarship on address has incurred in the domain of things. Thus the theory of address supplements other ventures along these lines.[92] Taking a look at the functioning of things in their locations—such as a coat of repute in a library or a pawnshop; a bar of chocolate, sheathed in gold foil and a printed leaf of paper, that is hauled to the top of a hill—brings into view reciprocal determinations stretching out between objects and our stations within structures of address: a coat can win us a seat at a writing desk in a library or permit us to contribute our bodies' material imprints to a gathering of anonymized items in a semipublic setting; an ecological agenda can serve corporatist purposes by endowing a piece of chocolate with global allure. Addressing and being addressed by objects, and addressing people and places through our address to objects and the objects' address to us, we uphold norms and forms of address in virtue of which we can enter scenes, scripts, and structures of address that, for any one of a variety of reasons, beckon (or tend to expel) us. Here, we see how address undergirds relations among subjects, among objects, among places, and among subjects, objects, and places. Accordingly, the notion of address suggests avenues along which we can tackle some major oversights in the history of philosophy and make further progress on conceptualizing (inter)subjectivity in connection with the effusive material arrangements to which it bears mutually constitutive relations.

Culture. The framework of address gives much-needed texture to the notion of culture. Itineraries of desire and experience and the aesthetic genres and technologies shoring them up take notoriously complex turns. They reveal myriad, contingent orientations and proliferate across divergent vectors of relationality. Benjamin and Barthes have honed and sharpened our methods of cultural analysis so that we can recognize and perhaps even, to some extent, embrace this multiplicity. Yet, as attested to by the counterpoints to their views offered by Fanon, Althusser, Anzaldúa, and Butler, a further move is in order: by zeroing in on an expanded array of aspects of address, we can bring to light a plurality of processes and forces in the cultural arenas spotlighted by Benjamin and Barthes that otherwise eludes our analytical frames.

In this chapter, we have scrutinized twentieth- and twenty-first-century theories that account for a range of distinctive functions of address by way of what I have called its five collaborating core constituents, or a subset thereof. My proposed model of norms and forms of address that are operative within structures, scenes, and scripts of address gives us a multifocal schema for analyzing cultural formations that is at once more fine-grained and more broadly applicable than the scholarly perspectives we have investigated. This model, moreover, theorizes and renders systemic factors that philosophers have disregarded, understated, or treated in a piecemeal fashion. With the basic outlook described here, we have thus developed a synthetic account of address, one that the concept of address as used and tailored in this investigation brings to expression.

The five collaborating key constituents, I have argued, undergird critical functions of address to which theorists draw our attention. In the territory of address, we can see in action a repertoire of core elements that scholars gesture toward by means of divergent vocabularies. My analytical framework thus carries out jobs that scholars describe by way of a range of less comprehensive approaches to facets of address.

Meanwhile, this account picks up on the operations posited by our six theorists. It complements their views rather than overthrowing or supplanting them. The concept of address elucidates phenomena that people denote in the language of subjectivity, experience, desire, communicative interaction, and expression. The notion sheds light on the workings of technology and institutionality. It highlights dynamics of normativity and material existence. It pinpoints parameters shaping lifeworlds and forms of life. Likewise, it underscores goings-on in zones of racialized, class-inflected, and gendered exchange. Last but not least, it signals vagaries of intimacy, embodiment, meaning-making, and publicity. A whole array of social, political, and existential lexicons and insights hints at the workings of complexes of address. The productivity of address that stands out here is in significant ways a matter of address's jointly operative norms, forms, structures, scenes, and scripts. Far from wishing to jettison the vocabularies of subjectivity or object-oriented and object-driven practice, among other cognate idioms, the goal of the model is to show how address is in play in these matters and yields a vital part of the interpretive and explanatory narrative to be composed. Consequently, the concept of address points to the multitudinous functions that attach to the five collaborating key devices. It designates an anatomy whose presence can be discerned in a range of contexts.

Some of these contexts revolve around questions of freedom and a critical political aesthetics, to which the six perspectives we have explored each call attention. Chapter 6 will carry further my investigations in this area by way of

four artistic cases in which aesthetic modes of address spur changes in webs of relationality. Advancing the view of address along that route, we will glance new angles on some of the motifs highlighted in the present discussion. Let us then turn to those finely wrought aesthetic procedures that—as Jamaica Kincaid's, Wisława Szymborska's, Julio Cortázar's, and Nikolai Gogol's narratives doubtless have already had us guess—can be spotted at the meeting points of artistic modes of address and the structures of address harboring them.

6

TRANSFORMING AESTHETIC RELATIONSHIPS

The relationships that we entertain with language, people, things, and places unfold within constellations of address. As addressors and addressees, we occupy positions in technologically mediated, institutionally ensconced, object-oriented, and object-based circuits of address that are productive of our experiences. If address regulates subjectivity, as Frantz Fanon, Walter Benjamin, Louis Althusser, Roland Barthes, Gloria Anzaldúa, and Judith Butler indicate, then it also has the potential to be a productive tool for achieving alternative subjective and intersubjective arrangements, a point of which these theorists are well aware. Indeed, artists and audiences mobilize these critical capacities of address in response to vexing ethical, political, and aesthetic problems confronting contemporary formations of relationality. By dislocating existing structures of address or building on the resources inherent in them, aesthetic modes of address can challenge us to realign the relationships that we inhabit and to tweak the orientations these relationships assume. In this chapter, I will investigate this capability in connection with four artworks: a performance video by Martha Rosler, a film by Nagisa Oshima, a novella by Clarice Lispector, and a sound and performance work by Pope.L. These pieces uncover aesthetic pleasures, pains, and perplexities that can be detected in the fringes of official culture. By examining the role address plays in these cases, we will further flesh out the account developed in the course of this book. Thematic echoes will emerge with previous chapters, regarding the potentialities of day-to-day objects; the links between language, experience, and power; the workings of institutions such as prisons, cities, and transnational

governance units; and figurations of marginality underwriting delineations of class, gender, sexuality, coloniality, and race, to name a few examples.

Each artwork sheds light on social, political, and aesthetic motifs having to do with the ability of artworks to intervene in structures of address. By considering a heterogeneous array of artists, media, and traditions, we will amplify our sense of address's contributions to the artistic and theoretical outlook described in the introduction to this book as a decolonial, critical race feminist aesthetics. My interest, in the meantime, will be first and foremost in exploring address's functioning. The aim is not to offer full-fledged interpretations of works of art, create a continuous artistic narrative, or forge linkages between the different productions. My selection of works is unabashedly eclectic: through my own eclecticism I try to speak to the reader's doubtless eclectic aesthetic repertoires. I would like to connect with you, my reader, not only at the level of our interactions with artistic productions (including the realm of your engagement with works that you might want to think about but that happen not to be in my field of awareness), but at the same time in the plane of the day-to-day aesthetic lives that we live in our various cultures. For this plane of more or less artistically saturated, quotidian agency and experience is a turbulent arena where every one of us takes up some very complex stance within address and can illuminatingly inquire into that stance: perhaps wishing to orient or reorient it in one direction or another, to make true a hope, a promise, a longing, or to ask what a fantasy we nourish may have in store for us.

DOMESTIC MICROINSURGENCIES: MARTHA ROSLER'S REBELLIOUS UTENSILS

Martha Rosler's acclaimed *Semiotics of the Kitchen*, made in 1975, is a highly influential early feminist performance video. The black-and-white piece has a running time of 6:33 minutes. While it investigates various kinds of forms of address undertaken by and toward objects and adopted through and toward language and the body, address, for Rosler, is also a prominent factor in the multilayered framings in which the work participates. In an interview, she remarks about her work in general, but also specifically concerning her videos,

> I want to address a general audience. Sometimes, though, it's useful and important to address an art-world audience. Performance, for example, is generally restricted to the art world, and if one doesn't know that, one's work will be very ineffective. I think video is particularly useful because it's portable and easily available, and it's a form with which people are familiar. My video confronts many of the comfortable patterns of response. So when I'm using the TV set to address an issue, I also take account of what normally appears on the set.

But even though my work is critical of TV, audiences tend to accept it simply because it comes out of the set: it *is* TV, though strange TV.¹

Within a particular form of address to an audience, there can be a tension between the mode of address expected of a medium or object, such as TV or a TV monitor, and the work's purported address to an issue. For Rosler, the manifold meaning-shaping, form-constituting, and aesthetic experience–building junctures in engagement with which the work's address unfolds stand out pronouncedly. Address, as it happens, also takes center stage within *Semiotics* itself. An exploration of the video's figuration of address brings into relief the multiple interconnected orientations that go to shape its aesthetic politics and is crucial to an acknowledgment of the full range of its social and affective interventions.²

Positioned in the kitchen, in front of a static camera, the artist traverses the letters of the alphabet as she calls out the names of a series of cooking tools, "Apron," "Bowl," "Chopper," "Dish," "Eggbeater" . . . all the way down through the Z (figs 6.1–6.6). One by one, she demonstrates the objects' use. Each thing is subjected to a bodily gesture that resonates with its typical function, albeit with some decisive differences: food is nowhere to be spotted, unless it is in the form of smudges on the performer's apron; the affective tone deviates from that of the dutiful, diligent, delighted cook. Sometimes a thing's function is rather regular, as with the Eggbeater, even if it somewhat haphazardly stirs things up; other times, a more ardent deployment stands out, as with the Juicer or Pan, whose imaginary lime and omelet are subjected to strong squeezing and shaking. The Hamburger Press first puts its jaws into some objects in the performer's space but then directly addresses the viewer with its bite. Belying the expectant, often blandly educational, sometimes sardonically friendly declamation of the object's names, the action also frequently acquires a violent element, as with the Chopper, the Ice Pick, the Rolling Pin (fig. 6.2), and the Tenderizer, which respectively destroy, pierce, shove away, and—it looks like—demolish. Indeed, Rosler's dedication takes another target than the usual preparation of a nourishing, delectable meal or communicating how her audience can itself, in a presentable fashion, put that kind of offering on the table for others to enjoy: the artist invites us to participate in a re-visioning of the potentialities of the things as well as a reclaiming of the cook's creative bodily and social actions. These physical movements pronounce rebellious contents; they install an affective, corporeal space other than the welcoming kitchen or beckoning cooking show set.³ Rosler's demeanor, during most of the video, is stern; her design is to examine the sign system that the material objects and a woman's comportment are ordinarily asked to shore up.⁴

Exchanging the power, labor, invention, and generosity of meal preparation in favor of naming, uncovering, and remaking, Rosler faces the viewer—like a culinary show host—from the center of the kitchen. Behind her, the spectator

sees the stove, the refrigerator, and a bookcase holding, among other things, a large volume titled *Mother*. Handling the utensils, Rosler engages in a controlled slamming, slashing, stamping, and throwing out. An uproarious clanking and clattering accompanies a deadpan naming of the things. The observer is confronted head-on with the anger compressed in Rosler's deliberate, precisely defined gestures. In the artist's exhibition, which, besides forgoing edibles, also dispenses with eaters, the implements display the forceful, repetitive material actions to which they expose the foodstuffs on their way to consumption. Rosler's stirring and cutting reveals a vigorous process of forming and reforming substances that is part of the preparation of our meals, as well as of a kind of critical aesthetic and artistic agency.[5]

Semiotics displays the power that the objects exert, along with the exact intense physical gestures that underwrite that power. These gestures do not lend themselves to being readily distinguished from the communication of aggression. They demand a space for the expression of rage and sustain a menace that builds up stepwise after the initial donning of the apron, to lighten up just before the end of the series when Rosler shakes her head wryly in a gestural commentary as if asking in a gentle tone, "Now what was that about?" and adding whimsically, "There you are" (fig. 6.5). Punctuating this affirmation and breaking the previous distance, she folds her arms to complete a tranquil, sovereignly composed, corporeal stance that openly, integrally encounters the viewer's gaze with the now suddenly intimate address: "Here am I, how about you?" (fig. 6.6). The performance video rethinks the role that we give to the body, to the emotions, to the utensils, to the vagaries of intimacy and distance, and to social acts of feeding, presenting, communicating, and receiving as these unfold within certain mundane configurations of experience and meaning.

Countering Julia Child's upbeat conversational pedagogy with a flattened affect, Rosler underscores the vehemence of her own performative movements. Her meticulously articulated, restrained gestures hammer, beat, slash. And we hear them doing so. Along with various imaginary substances that Rosler spoons away from the spectator's field of vision (fig. 6.1), she throws out the fantasy of the happy white middle-class heterosexual US housewife who desires to educate herself in the art of cooking. *Semiotics* defamiliarizes the address of the things to the viewer. The work suspends the viewer's customary address to the things and to the teacher who wields them before the camera. Likewise, it distances and recontextualizes the forms of address privileged by semiotic theory by foregrounding linguistically inflected (and productive) dimensions of care and maintenance work that escape its analytical frames.[6] The video installs an emotional script that seeks out and affirms feelings of dysphoria and indignation, validating an inward- and outward-reaching address by these emotions and encouraging a receptive, open address toward them on the part of addressors as well as addressees.[7] And yet a playful, hopeful

6.1 Spoon

6.2 Rolling Pin

6.3 U

6.4 Y

6.5

6.6

6.1–6.6 Martha Rosler, *Semiotics of the Kitchen*, stills. 1975. Black and white video. Duration: 6:33 min.

© Martha Rosler. Courtesy of the artist and Mitchell-Innes & Nash, New York.

suggestion of alternate social, material, and philosophical possibilities insinuates itself. This tendency both draws nourishment from the work's valorization of fury—finding fuel in the element of release that an outright recognition of dissent can allow—and counterbalances it. A simultaneously acerbic and raucous kind of humor takes shape alongside the stirrings of rage, introducing qualifications, points of wonder, and ambivalences into the work's and the viewer's address to each other.[8]

Rosler breaks the semiotic frame she has set up when we reach the moment the U is supposed to arrive. The camera pans out from her, slightly enlarging the space occupied by the performer to beckon the spectator into in its embrace more fully and broaden the observer's point of view. Assisted by a fork and knife, Rosler's arms go on to outline the final letters of the alphabet: U, V, W, X, Y, and Z. The large U she depicts with her lifted arms that, just about orthogonally bent, hold a fork and a large cutting knife, becomes a direct address to the viewer: the ensemble of gesture, sound, and letter exclaim, "You!" (fig. 6.3). This address immediately cascades into further language, language that self-reflexively interrogates address itself: "What," we are prompted to ask, "is our place in this system of names, of required or insurgent handlings of objects, of movements, sounds, and corporeal communications?"[9] The Y consists of a deep backward bend, with stretched arms and knives in each hand (fig. 6.4). We hear "Why?" The expansive gesture proclaims an amplified query: "Why in the world?" This question resonates within a whole spiral of further questions that the body pronounces: "How spacious is the world?," "What possibilities for freedom does it encompass?," "How far do our arms stretch?" These musings precipitate further ones: "Of what actions are the kitchen implements capable?," "Where can language go, once we liberate it from an ironclad domestic vocabulary—assuming such an idiom really exists?," "What movements are open to the body, the moment that it escapes a given performative lexicon?" The body continues to inquire in ever-expanding circles: "What other objects might it like to touch, what different languages would it desire to speak, what corporeal gestures might it long to engage in?" "What new ways," it asks, "can we create of being in contact with language and the world?"

At once depicting an abstract letter, a word, a question composed of several words, the body now pronounces an aura of soundless questions. The body gets to shine out to wherever its queries may reach. It leaves the apparently rigidly circumscribed system of meanings that had hemmed it in. The letters expose and rewrite the order that the objects help to prop up. The performance launches a publicly legible symbolism for the embodied condition of white middle-class heterosexual women—an idiom sensitized to disaffection, and roomy and daring enough to enter into contact with torrents of domestic ire and flows of humorous rowdiness lurking behind presumptions of joyful care. Boisterously

smashing and lacerating a conceptual paradigm that associates white middle-class femininity with the refinement of a kind of housework, *Semiotics* detaches the kitchen tools from the idealized meanings they enjoy under a televised didacticism and as props for the subjective nurturing for which a spectator might look to mainstream media. Bodies begin to envision their own norms, forms, structures, scenes, and scripts of address. They open new paths to flourishing, satire and the creation of meaning. They point toward reshuffled registers of sociality and interiority.

The scene of address that Rosler stages violates a normative script of address that would consign the culinary pedagogue and her audience to certain habitual roles of providing instruction and imbibing subjectivating lessons. Featuring the kitchen implements as artistic materials and alienating their customary aesthetic use, the performance disrupts standardized domestic and spectatorial regimes of address. Partaking of verbal languages, *Semiotics* declares, the body and the utensils can speak in a manner that we have yet to learn to read and incite trajectories of articulation we have not yet begun to intuit.

Domestic caretaking work, in *Semiotics*, spawns publicly legible meanings that resist compartmentalization within a field of domesticity ostensibly separated from the world of labor and commodifying exchange.[10] The performance video initiates a structure of aesthetic address that refuses to be contained by the gendered relational constellation enveloping normative subjects and objects within a white middle-class segment of the society.[11] *Semiotics* rebukes the limits that define a system of social, material, corporeal, and intimate relationships, while at the same time grounding cultural analysis in quotidian domestic acts. Rosler's gestures with the tools enact social critiques. Highlighting, like Julio Cortázar, the role that ordinary things play as vehicles for social relationships and states of embodiment, Rosler distances the objects' conventional use by a sizable population of actors. She unhinges the relationships sustained by the objects' day-to-day functioning as material supports for the conduct of those groups. At the same time, by mutually playing out against each other "semiotics" and "the kitchen," she calls for a revised affective, intercorporeal, and analytical apprehension of our relational functioning, one that takes cognizance of a broadened array of forms of address.[12]

Through the mobilization of aesthetic modes of address, artists like Rosler attempt to collaborate with audiences to create room for alternative contours of reading, experience, desire, and agency. They seek to transform structures of address in order to revise the relationships between language, people, things, and places and to construe social identity and difference along unforeseen lines. Aesthetic modes of address, in *Semiotics*, serve to reorganize the artistic and social fields and to lend new energies, forms, and norms to the aesthetic, ethical, and political resources that these domains harbor. The institutional

challenges that artworks can thereby pose stand out markedly in Japanese filmmaker Nagisa Oshima's film *Death by Hanging*.

RACE, DEATH ROW, AND THE ALWAYS ALREADY GUILTY: NAGISA OSHIMA'S PRISON DRAMATURGS

Oshima opens his 1968 film *Death by Hanging* by introducing a divided Japanese population who, as reported on a placard, by 71 percent reject abolishment of the death penalty, to the matter-of-fact, prosaic realities of an execution. His own voiceover inquires in a direct address to the audience, "You, who oppose abolition, have you ever seen an execution chamber? Have you ever seen an execution?" The film goes on to mobilize aesthetic modes of address to challenge a carceral structure of address and contest the processes of racialized interaction and subject formation supported by this organization. Critically exploring the gendered ravages of coloniality within a framing that explicitly draws the reader into the story, Oshima's reflection on the philosophical dynamics of subjectivity and history highlights the aesthetic fashioning of our embodied, social comportment.[13] Through its intricate deployment of address, the film foregrounds this dimension of aesthetic production.

As the voiceover describes the placement of the execution chamber in a corner of the prison conglomerate apart from the rest of the complex, aerial shots single out a small building that, in the narrator's words, "looks like an ordinary house." The architectural exposé continues inside. Documentary-style, camera and narrator take us through the plan of the building, identifying the function of each room. The hanging of a young man is in process. The condemned, as we will find out shortly, is named R. This individual, the film gradually discloses, was born in Japan of Korean immigrant parents. We will learn that he has been placed on death row for the murder and rape of two adolescent women, which, to audiences at the time, underscored the parallels with the widely publicized historical case of Ri Chin'u, a Korean immigrant, who in 1963 was executed on similar charges in Japan.[14] But, for now, we see how the prison officials are in the process of carrying out his sentence in accordance with the regular procedures, which the narrator lays out for us step by step.

Shaking and blindfolded, his handcuffs rattling, R is hanged. The last thing we hear from the narrator is that, as the rules have it, when death is pronounced after eighteen minutes, the execution can be considered completed. At that moment in the story, the voiceover ceases. Things don't go as expected this time around. Inexplicably, R survives his hanging. Although he suffers from amnesia, he is undeniably alive. What is to be done? The authorities enter a heated debate on the compounding ethical, legal, medical, religious,

metaphysical, and epistemological dilemmas: Can the prisoner legitimately be hanged again? Has he continued to remain R, the very person who has been found to have committed two egregious crimes? Does he sustain the requisite degree of consciousness and memory that allows him to be held accountable for past actions?

Hoping to sort out these quandaries, the prison officials attempt to restore R's memory. Reading from the court verdict, "In re R, worker" condemned for "forcible rape and premeditated murder," the Education Officer explains, "Understand? This is about you." The mnemonic effort being to no avail, the Doctor, upon the prompting by the Prison Director, suggests trying to "communicate through [R's] senses." Moving from words to deeds, the officials commence a reenactment of the assaults of which R has been accused. Jointly, the Education Officer, the Security Officer, the Prison Chaplain, the Prison Doctor, and the Prison Director stage a performance of the rapes and murders that R has been found to have committed, including the events leading up to them, while the Public Prosecutor and his Secretary look on and at various junctures contribute insights to the discussions (fig. 6.7). The performance of the first assault fails to inspire R's self-recognition. Neither does it ignite his memory. To facilitate R's identification with R, the functionaries re-create the prisoner's supposedly deprived childhood. The kind, mild-mannered R plays his designated part in the theatrical event, first hesitatingly, then going along with the collective imagining. The verdict serves as the script of a play that the actors put on for each other and the condemned, with the officials switching roles among each other.

6.7 Nagisa Oshima, *Death by Hanging*, 1968. Prison officials reenact the crime for R.

6.8 Nagisa Oshima, *Death by Hanging*, 1968. The Education Officer attempts to persuade R that he is R: "That's you! That's R!"

The project being one of enlightenment through the senses, the authorities intersperse their performance with didactic attempts to get R to understand and accept as his own historical reality the part outlined for him by the narrative that is being composed (fig. 6.8). To make sure that R reads correctly the scenario that the officials play out, they explain to him which one of the actors he truly is. Pointing to the Doctor, who is crawling over the ground after having violently and impassionedly wrestled the narrating Education Officer to the ground to subsequently lean over him, in what is supposed to look like a rape, the Prison Director says "R, look carefully! That man in white is you! The other one is a young girl, although she is near retiring age." The Education Officer explains, "R, you killed someone just like this." Shouts the Security Officer into R's face as he jumps up from the Education Officer, whom he just has strangled, "Like I did it!" The Prison Director underscores, "You really are R. That R there is acting out your crime. Understand, R?" (fig. 6.9). Choking the Prison Director, the Security Officer ventures again, "Look, R! This is you."

R wants to know what is meant by "nation," "carnal desire," "a Korean," and "rape," terms used in the court verdict or the officials' interpretations of the esteemed document. The Education Officer provides clarification so that R can follow the proceedings, implicitly revealing the distance between R's world and their version of it. The question "What is rape?" meets with a reply about when you want to give a girl a hug, broken off by, "hmm . . . I've not felt that way for a long time. Will one of you younger fellows explain?" In response to the query

6.9 Nagisa Oshima, *Death by Hanging*, 1968. Prison Director: "That R there is acting out your crime. Understand, R?"

6.10 Nagisa Oshima, *Death by Hanging*, 1968. R on a trip with his siblings.

"What is carnal desire?," R is instructed about an "instinct" that need not be "bad," but "when it's not permitted between some men and women, then it's vicious instinct, carnal desire, criminal desire." The performers give each other stage directions designed to foster R's self-recognition: "Can't you do it more Korean-like?" "Do it more like a Korean." "Can you cry more like a Korean,

please?" Racial fantasies hold together the plot of the performances. R's gentleness stands in sharp contrast to the aggression and sexual desire displayed by the functionaries. Nonetheless, the effort at interpellation continues. "That's right! Now you're R!," the Education Officer observes eagerly and encouragingly. Like the authorities, R gets deeply into the story, finding pleasure in an imagined trip with his younger siblings (fig. 6.10). A collective hallucination ensues.

The polemic in the prison reverberates widely: War histories and postwar accusations of war crimes resurface, an experience that—with most of the functionaries having served in the Pacific War—is replete with unresolved emotions of loss, guilt, resentment, refusal, and shame. Repressed atrocities rear their head. Homosexual longings refuse to be bottled up any longer. The officials blare out anti-Korean and anticommunist sentiments. They recall tortures they have committed and reminisce about the stimulation triggered by a firing squad; they voice feelings of abandonment. Unassimilated snippets of the history of Japanese imperialism make their presence felt. The philosophical conundrums prompted by R's case prove to be anchored inexorably in the political life of the nation.

Oshima shows how the society's predication of a Korean identity for R spurs a feverish, self-nourishing narrative machinery that, no matter how much R's being the presumed kind of R is in question, spins relentlessly toward one outcome—his death by capital punishment. Classifying R as a Korean, the authorities slot their prisoner into a prefabricated script that invests him with pejorative attributes.[15] The functionaries represent R as impoverished. They take him to have suffered emotional neglect and to have been subjected to a deprived upbringing. He is deemed to be deficient in masculinity. No wonder he became sexually perverted and lecherous, or that he accumulated a record of stealing. Without a doubt, he—or at least the R he used to be before his hanging—is guilty of a rape and a killing. How could he not be? In the eyes of the officials, R's racial identity is all-determining. It imbues his utterances and bodily movements with their meanings. R's relationships with his parents, siblings, peers, and, consequently, his young female victims are legible to the authorities as features that are etched into his Korean identity. His status as a racially inferior immigrant delineates a relational possibility space that dictates his and his interlocutors' actions. It catalyzes a web of aesthetic relationships in which subjects (R, his family, the prison officials), objects (the noose, a bike, a dress), and places (the prison quarters, his former high school, the site of the second crime) gain their allotted functions and exemplify admissible stories.

Their deliberations in the prison take the officials through a scintillating array of modes of address. Grave existential conundrums being at issue, they engage in contemplation, declamation, persuasion, polemics, and confession. They fight, make accusations, and carry out interrogations. Stretches

of companionship slip into episodes of animosity.[16] Fantasy and strands of personal history bind together the narrative fragments the functionaries vocalize. Their rolling over each other blurs the boundaries between play-acting and aggressive altercation or sexual romping. Stumbling around with a bottle, the Chaplain reaches a state of delirium. The officials become lost in their own story. Disorientation is rampant. Representing the various crimes ascribed to R, the functionaries act out their own inability to draw the line separating an impartial interest in truth from stereotyped rancor, murderous desire, and rapaciousness from honorable feelings and behavior.[17] The performers enter into the fits of debauchery that the narrative they enact considers an irredeemable feature of R, who remains impassive throughout the proceedings. An episode with a Korean woman named "Sister," who supplies her own oppositional political narrative for him, one that he declines, culminates in an amorous fantasy on R's part. In this idyllic scene, they ride a bike together, roll through the grass, and, in embrace, float on a boat in the river. Commentators have interpreted this lyrical sequence as emblematizing the "free play" of the imaginary.[18] I see the element of freedom surging in this phantasmagoric segment as a facet of the aesthetic modes of address adopted by the characters more generally. So understood, it quite thoroughly pervades the officials' conduct, hinting at behavioral and experiential possibilities that exceed the course of action that carries the day. Indeed, we can extend this point to the strategies of address of the film itself, which signal potentialities for thinking, being, and relating that are not available to the characters.[19]

For a brief moment, R is free to leave (fig. 6.11). The outside light is blinding, however, the freedom too much to bear (fig. 6.12). The enlightenment of the senses suddenly glaring into eyes tutored on the dim intuitions and mesmerizing dream images diffused by an overdetermined legal apparatus, R claims his guilt, then retracts in a flash of insight: "A nation cannot make me guilty." "Well, R," declares the Prison Director, "with such ideas you're not allowed to live." R replies that he is well aware of that and that that is why he admits it: "For all Rs, including you, I'll courageously admit to being R and I will die now" (fig. 6.13). The authorities hang him a second time, with success.[20] Resuming the direct address to the audience of the film's opening, the filmmaker, in his own voiceover, expresses his gratitude to us ("Thank you, spectators, who have watched the film!") for our attention to what has transpired. At the close of *Death by Hanging*, Oshima renews the spectatorial gesture with which he opened the film, absorbing the reader into the aesthetically vibrant, polemical field of address within which he has identified kernels of freedom.

Having his characters shift between different modes of address, Oshima lays bare the ramshackle fictional edifice in which R is enmeshed. Imagination, emotion, sensation, perception, dreaming, bodily attraction, repulsion, and legal judgment appear to be inextricably entangled. A standardized scenario

6.11 Nagisa Oshima, *Death by Hanging*, 1968. R is free to go.

6.12 Nagisa Oshima, *Death by Hanging*, 1968. R is blinded by the light.

of evidential reasoning, incarceration, and sentencing unravels to reveal a drama of interwoven and crosscutting registers of address. The entwinement of the performative scenes that the functionaries stage with an interpretive matrix that delineates racial, national, and class subjectivity brings out the absurdity of the scripts of interpellation applied by the prison officials. Presumed distinctions between guilt and innocence, criminal and victim, slip. A

6.13 Nagisa Oshima, *Death by Hanging*, 1968. R admits to being R, "for all Rs, including you."

plea for the abolishment of the death penalty, the film deploys aesthetic modes of address to rupture an established discourse of security and criminality. Oshima enlists the encounters between disparate modes of address—between documentary and fiction; between socially realist imagery, dream sequences, and comedy; and between multiple performative, dramatic, and corporeal styles—in the project of opening up the social, political, and legal system to a wider space of relational possibility. Aesthetic modes of address, in *Death by Hanging*, undercut an overdetermined construction of race, nation, and class, and offer a political indictment of the institution of capital punishment. On top of that, it is an explicitly aesthetic strategy of address that exposes the gaps in a carceral structure of address and activates unacknowledged dimensions of the workings of this at once cultural and juridical structure: the prison officials enact a performative, cognitively, perceptually, imaginatively, and emotionally resonant, collective education of the senses for the film's audience.

Modes of address are pivotal sites for interventions into the ethical, political, and aesthetic organization of existence. As *Death by Hanging* indicates—along with Martha Rosler's *Semiotics of the Kitchen*—artists devise modes of address to alter the functioning of modalities of identity and difference within webs of relationships marked by institutions such as prisons (or national-legal-political complexes) and television networks. Appearing in scenes of address, modes of address can flout scripts of address and put structures of address in disarray, destabilizing systems of aesthetic relationality. By bringing modes of

address to a state of relative disorder in which a measure of unruliness becomes apparent, artworks can therefore contravene patterns of aesthetic relationships and seek to redirect them. This is precisely Clarice Lispector's project in *The Hour of the Star*.

RENEWING AESTHETIC LEXICONS: CLARICE LISPECTOR'S TALE OF POVERTY

In her novella *The Hour of the Star*, published in 1977, the year of her death, Brazilian writer Clarice Lispector assumes the voice of a fictional author-narrator, Rodrigo S. M., to tell the story of the destitute, ugly Macabéa, a woman in her late teens from the northeast of Brazil. Having been deprived of her parents at a young age and brought up by her aunt, she moves to Rio de Janeiro. She barely makes a living in her profession as a typist, a job she is on the verge of losing because of her typos and the blots she makes on the paper. She is not given to formulating sentences and believes she is happy. From time to time, Macabéa gets together with her boyfriend Olímpico who, wishing to become a politician, drops her for her coworker, Glória. Macabéa usually goes hungry. She sustains her inner life by listening to "the correct time, culture, and commercials" on her favorite station, Radio Clock, which she audits by way of a borrowed radio.[21]

Expelled from normalized social existence because of her repulsiveness, Macabéa nonetheless takes profuse aesthetic delight in ordinary things, especially "unimportant" ones like herself: "[S]he noticed a gate that was rusting, twisted, creaking and with its paint peeling off; a gate that led to a number of small houses making up a block. She had observed all this from the bus. The block of houses was numbered 106 and on a plaque she read the name 'Sunrise.' An attractive name that promised good things."[22] Macabéa finds joy in the aesthetic details she perceives in the margins of the city—elements that often intimate sharply to the reader the young woman's position in, or rather beyond, the acceptable social fabric. She relishes the pings she hears on the radio, which bookend parcels of information. Besides that, in the auditory sphere she savors the signals of the cargo ships that pass by the docks as well as the cries of a rooster. Just as Macabéa loves aesthetic marginalia, Rodrigo loves her. "I adore Macabéa, my darling Maca. I adore her ugliness and her total anonymity for she belongs to no one. I adore her for her weak lungs and her under-nourished body."[23] Notwithstanding his aesthetically fueled love for the character he has created—or perhaps precisely because of it—Rodrigo lets her die after a fortuneteller predicts her imminent encounter with a foreigner who is rich and blond, inspiring in her a longing for the future, which she had never felt before.

The novel denounces the role that beauty and the aesthetic more broadly play in Macabéa's abandonment. *The Hour of the Star* challenges the system of aesthetic relationality in which its protagonist is emplaced, along with the reader and Lispector herself.[24] Lispector's aesthetic critique substantially recruits the work's figuration of address.

Rodrigo, Lispector's stand-in, who is imagined to have written the narrative, assumes a range of contradictory modes of address vis-à-vis his subject and his audience. In having him allegedly tell in a cold and factual way a story that, as it turns out, won't allow itself to be told dispassionately or without adornment, Lispector causes affect to emerge ambiguously as a quality of the hard, objective facts of the matter and as an artifact of a technicolor mise-en-scène or a melodramatic form that the novel suggests literature cannot escape.[25] While Rodrigo, in his own terms, "imposes" himself on Macabéa's being, he is at the same time imposed on by her, unable to demonstrate his powers of abstraction by way of his purported exercise in figuration.[26] Against his stated poetics, he is forced to produce embellishments. He fails to carry out his formalist project of letting words be themselves, an aesthetic practice he shares with Macabéa, who ultimately also lets it slip as she falls for the fortune-teller's narrative.[27] Lispector thus locates Rodrigo in a tangle of contradictions. The different forms of address he adopts (or professes to adopt) destabilize and undercut each other. The reader and writer are swept up in a disjointed constellation of address. As a result, the aestheticized love of poverty on the part of the privileged, who besides Rodrigo include Lispector and the reader, is shown to present these subjects with an aesthetic quandary: the predicament of how, in writing (and reading), to address and be addressed by this material, by the "state of emergency and public calamity" in which the story, as the author-alias-Lispector puts it in the book's dedication, is unfolding.[28] This difficulty eludes the modes of address that Rodrigo (as well as Lispector and the reader) develop in response to it.

Unresolved, this aesthetic dilemma of address calls into question the status of Rodrigo's words. His language is set adrift from its referential bearings. The applicability of the notions of beauty, poverty, and ugliness (and their permutations and substitutions) becomes uncertain. Rather than traversing predictable varieties of "speaking for" or "being spoken for," *The Hour of the Star* features discursive relations of intrusion, compulsion, obsession, appropriation, and surrender that leave intact Macabéa's reticence and affirm Rodrigo's (and the writer's and reader's) distance from her.[29]

The novel's tropes of love and desire augment this distance rather than patching it up. Rodrigo's (and, by implication, the reader's) love for Macabéa is crosslaced with structural indifference, as indicated by his resolute timing of her death, the alleged banality of the story of her life,[30] and the supposed

impossibility of having things turn out more happily for her. His love is partly aesthetic; it is a love of Macabéa's aesthetic life, a passion for the aesthetic sensations, desires, and readings she is imagined to generate. Having her killed by a man, Rodrigo grants his protagonist the death she likes to contemplate in the cinema and on her walks through the streets.[31] Transposed into the melodramatic and technicolor frames supplied by the fortune-teller and the movies, surprisingly, the scandalousness of poverty is underscored by the attractions and repulsions of aestheticization, rather than erased, as Rodrigo had feared.

Yet, though the ability to register the outrage of Macabéa's poverty is presumably an ingredient of a tenable political response, Lispector leaves no room for a triumphant relation to this accomplishment. The novel itself refrains from postulating a pattern of address that provides a steadfast, unidirectional outlook on the good and the truly beautiful. An ethically and aesthetically legitimate attitude on the part of the privileged toward the poor is not in the offing—neither Rodrigo, nor Lispector, nor the reader is absolved of complicity in Macabéa's misfortunes.

The Hour of the Star leaves us with this disenchanted realization, which at one level of the narrative undergoes no sublimatory conversion into hope or energy for the better. The reader's aesthetic life goes on, as does the author-narrator's: "the clouds are white and the sky is blue"; "this is the season for strawberries."[32] The exigency of the accusation undertaken by Rodrigo and the urgency of a narrative that shouts and punches the reader in the stomach dissolve into generic, naturalized aesthetic platitudes.[33] The city, aestheticized by a *letrado*, a man of letters, thus reveals itself to be not the quotidian realm where Macabéa carries out her inventive aesthetic wanderings, but the colonialist bulwark that literature, as many have argued, has served historically to fortify.[34] Closing ranks against the subaltern, the "lettered city," to borrow Ángel Rama's term, blocks out the aesthetic energies and perceptions Macabéa engenders. Literate culture puts an end to the insurgent aesthetic sensibility with which she produces delicate, partially parodic readings of the city—ones that acutely probe Rio's place in a global capitalist system—and initiates new, delightfully imaginative pleasures.

This banishment of Macabéa, the novel suggests in so many words, would entail literature's moral bankruptcy. In turn, it would deal a death-blow to the author-character himself, who, indeed, exclaims sensationally that she has murdered him before bursting out in a series of abstract existential and scientific reflections, which he terminates by deciding that it is time to go and have a smoke.[35] Yet the colloquial remark he utters about lighting a cigarette, along with the comments about the sky and the strawberries, signals concrete aesthetic perceptions, desires, and tastes that make up our experience of space and time and, as such, addresses the reader as an aesthetic agent.[36]

Foreclosing the possibility of a moral or political answer to the conundrum of poverty within the conceptual and artistic framework sketched in the novel, Lispector undermines the language of beauty and ugliness that upholds Macabéa's negligible social being and dictates her abandonment. This language retains many of its traditional conceptual and relational implications. Macabéa's aesthetic pleasures, such as her taste for honking car horns and rainbows, affirm beauty's ties to disinterested perception. Glória's and Olímpico's censure of her observes a link between ugliness and disposability, implicitly solidifying the bonds between gendered beauty and individual and national advancement. The author-narrator's struggle with a character that "[clings to his] skin like some viscous glue or black mud" reiterates racial registers encapsulated within aesthetic categories.[37]

At the same time, however, the novel divests the author-narrator's language of a determinate reality effect. This language becomes extraneous embellishment itself, semiotic excess that renders Rodrigo abject, branding him for expulsion from his own tale. With the dissolution of the author-narrator's grip on his story, the reader's epistemic powers are thrown off guard. Lispector presents the reader's capacity to live up to a social tragedy with its shortcomings. The novel rules out the prospect of an ethical resolution within the aesthetic schemes represented by the narrative.

The Hour of the Star also unsettles established aesthetic hierarchies between Macabéa and Rodrigo S. M., the subaltern and the middle class, by presenting the former—in contrast to her "author"—as a true cosmopolitan actor, someone who accesses the world stage as an enthralled consumer of movies, a discerning observer of cargo ships, and an agent of fantasy who assimilates a blond, Mercedes-driving foreigner with "blue or green or brown or black eyes" into the texture of her longings. Listening to the pings between the minutes and to "culture" on the radio, Macabéa is the contemporary decolonial feminist actor, who in various ways reaestheticizes the trappings of colonial modernity and realizes stretches of freedom and beauty, conceptualized on new terms. At once superslow and superfast, she outstrips the spatial and temporal rhythms of normalized society, eluding strictures of colonial modernity and enkindling a freedom that escapes her fellow human beings: "She lived in slo-o-ow motion, a hare le-e-eaping through the a-a-air over hi-i-ill and da-a-ale." Languid as she may be, she is also quite speedy: "she relished the infinity of time. Her life was supersonic. Yet no one noticed that she had crossed the sound barrier with her existence."[38] Our subaltern character experiences a freedom that is not available to those who conform to the regular social order. Freshly awakened aesthetic insights and resonances spring forth within an otherwise formulaic language of love, passion, authorship, gender, class, and race, occasioning a shifting of aesthetically encoded social differentiations. In this way, Lispector implants

Macabéa in the same sphere as that other champion of creative invention beyond the realm of established normativity: the author-character. Yet Macabéa's aesthetic occupations do not ultimately put things right for her; on the contrary, her fascination with films, foreigners, and fortune-tellers precipitates her death.

Via its self-deflecting modes of address, *The Hour of the Star* dislodges a conventionally aestheticized lexicon of poverty. Invoking beauty's traditional associations with disinterested perception as well as its historical ties to class location and economic power, and putting these connotations to work in a network of address that unmoors the reader's position, Lispector distances these meanings, rupturing the yoke of the beautiful as an unreconstructed, unreflective scheme of judgment and experience. Having shaken up the structure of aesthetic address containing Macabéa and the reader, the novel condemns and attempts to disassemble an exclusionary system of relationships that beauty helps to support.

If the novel reaches the kind of dead end that is familiar from the movies—the killing of a female protagonist—Macabéa's last words, "As for the future," invite us to contemplate the further steps of jettisoning the aesthetic system that results in her demise, and inventing an alternative frame of aesthetic meaning. In the opening dedication, the author-alias-Lispector notes, "This story unfolds in a state of emergency and public calamity. It is an unfinished book because it offers no answer. An answer I hope someone somewhere in the world may be able to provide. You perhaps?" The phrase ". As for the Future ." (*sic*), surrounded by a beginning and ending period, has appeared earlier as one of the titles that Lispector lists for the work. It is also—the closing but not the initial full stop included—the phrase with which Rodrigo imagines starting his story of Macabéa.[39] Given that *The Hour of the Star* weaves us as readers into the aesthetic system that it indicts, it also presents us with various options for address, one of which would be to take up the second-person address and to try to provide a reply to the unfurling catastrophe that the novel claims is in process and that the author-alias-Lispector implies we participate in as we read the story. The novel thus prods us to come up with an alternative aesthetic framework, one that can constitute an answer to the conundrum of inadequately aestheticized poverty.

"The Hour of the Star" and ". As for the Future ." are only two titles in a series that includes, among others, "The Right to Protest," "Singing the Blues," "She Doesn't Know How to Protest," "Whistling in the Dark Wind," "I Can Do Nothing," and "A Discreet Exit by the Back Door." *The Hour of the Star* does not tell us which of these stories we are reading as we are reading the novel, and we may be reading all of them, though they are different.[40] We see here one more way in which Lispector unsettles the system of aesthetic relationality harboring herself, Rodrigo, Macabéa, and the reader. The second-person address to the reader, the multiple norms, forms, structures, scenes, and scripts of address signaled by the titles, and the work's status as a novel in which we are involved

as readers encourage us to create new forms of address and relationship in the state of aesthetic cataclysm that the novel describes as ours.[41] This effort, Lispector insists, is a key ingredient of a critical political aesthetics.[42]

REARRANGING PLATFORMS OF AESTHETIC PUBLICITY: POPE.L'S COSMOPOLITAN WHISPERINGS

Finessing thresholds of audibility, whispers can quietly, but no less conspicuously infiltrate public spaces in ways that incite shifting delineations of aesthetic interaction and that alter relations between mainstream and marginal voices. Whispering—emitted from countless sources and reverberating for lengthy stretches of time, even if interspersed with silences—is the mode of address with which African American artist Pope.L reconfigures a forum for aesthetic publicity. Interlacing live and recorded whispers in two cities and wafting across the ether, his *Whispering Campaign* (2016–2017) reorganizes aesthetic relationships.

The notion of address, as it happens, explicitly informs Pope.L's reflections on his artistic agenda around the time of the campaign. Asked about the polyvocality of the works created under the rubric of his ongoing *Skin Set* project (1997–) and their invocation of sotto-voce speech, he stated in March 2017, "I do think about mode of address. I am drawn to a way of writing, inscribing language that has a grain to it, the grain of the voice as Barthes might say. I like the idea of addressing the audience as if I am standing before them ventriloquizing the object—the very thing my teachers told me was impossible—to create a thing that speaks for you as if it is you, but not you, so maybe more like a talisman or a fetish or a golem."[43] The artist's reference to Barthes recognizes the traces of the erotic, sensuous body in language and affirms the presence of multiple voices in a fabric of material connectedness and intercorporeality. Audience-directedness goes together with silence and indirection. Pope.L signals a dense texture of form/formlessness, value/valuelessness, speaking for-as-if, and mediated language, marked by voice, inscription, and performance. The rich conjunction of elements that his comment centers in address heralds the plentiful capabilities that modulations of address enact as a site of aesthetic meaning-making and a place for questioning in the campaign.

Exploring the subtle, multitudinous powers of address stirred by this sound and performance installation, I will enter into some detail. For, given the work's evanescent and dispersed nature, there is no record that offers ready access to it. The piece itself, moreover, activates the aesthetic detail as a structuring principle. With its self-conscious foregrounding of detail, the work calls for a reading in detail.[44]

6.14 Pope.L, *Whispering Campaign*, 2017. Documenta 14, Kassel, Germany. Photo: Mathias Voelzke.
© Pope.L. Courtesy of the artist and Mitchell-Innes & Nash, New York.

Across Kassel, Germany—where I visited the installation—and Athens, Greece, one could detect speakers during Documenta 14, not only in hidden corners but also in places of high visibility (figs. 6.14–6.17). Whisperers walked through the city, voicing observations and playing recorded passages. Carrying forth the intimacy of soft-spoken communiqués into the public domain regionally and across the globe, radio broadcasts sounded on most days of the week and for many hours every night, on local stations and through online live stream. The whispers at times gave way to snippets of a tune chanted by a male voice in a Southern black US accent, tweaking the work's format. I caught the words "cotton," "union," and "home" in the bluesy melody, which may have alluded to a slave song or to a song of travel in the era of reconstruction. The otherwise hushed sounds of the campaign—along with the stretched-out silences interposed between them—were broadcast from gallery sound systems and from under a car parked in the street (fig. 6.17). One speaker was suspended from a cart in front of a central Documenta venue, Kassel's Fridericianum (fig. 6.14); others occupied inconspicuous places—for example, between men's and women's bathrooms (no "gender neutral" or "all gender" spaces); between exhibition rooms; and below the staircase near a café. Whispers

6.15 Pope.L, *Whispering Campaign*, 2017. Documenta 14, Athens, Greece. Photo: Freddie Faulkenberry.
© Pope.L. Courtesy of the artist and Mitchell-Innes & Nash, New York.

could be heard in parking lots and commercial places such as restaurants, a shopping mall, and a vending stand (figs 6.15 and 6.16).

The tags next to the work's physical props cited as its materials "nation, people, sentiment, language, time," and reported a length of 9,438 hours. Listening to the soundtrack and reading the accompanying leaflet, one audits series of numbers and narrative snippets about blackness, Europe, and place (US–Germany–Greece). There are fragments of stories discussing war and immigration. Testimonies by Syrian refugees recount scenes from the Syrian civil war as well as conditions in a Jordanian refugee camp. The reader/listener is supplied with sundry historical facts concerning revolt and protest. Whisperers report where they walk and what they see. They give descriptions of buildings and other parts of the cityscape, sometimes as viewed in a photograph or on a screen. The voices recite dates and locations of political assassinations in Greece, Germany, and the United States. With great frequency, and for extended periods, male- and female-sounding voices intone the adage "ignorance is a virtue" in German or English. Another, less-often-repeated statement declares, "A nation is a spider with a hole in the middle." Passages in the campaign's three languages—English, German, and Greek—alternate with each other.[45]

6.16 Pope.L, *Whispering Campaign*, 2017. Documenta 14, Athens, Greece. Photo: Freddie Faulkenberry.
© Pope.L. Courtesy of the artist and Mitchell-Innes & Nash, New York.

6.17 Pope.L, *Whispering Campaign*, 2017. Documenta 14, Kassel, Germany. Photo: Nils Klinger.
© Pope.L. Courtesy of the artist and Mitchell-Innes & Nash, New York.

Whispers vary in the degree to which they are spaced out or condensed, and in the speed with which they roll out. Some appear decided, others hesitant. We hear a whole array of more-or-less loud, soft, gentle, harsh, flat, sharp, emotionally resonant, affectless expressions. A good number of the voices sound objective and matter-of-fact in tone, but there are also ones that feel intensely personal. Some pronouncements trickle by word upon word; others cohere tightly into sentences or narratives. In the same vein, the numbers appear in rhythmic intonations.

The four-page newspaper-size brochure accompanying Pope.L's piece—my version, picked up in Germany, is titled *Whispering Campaign: Kassel*—besides giving the performance and broadcast schedule and locations, lists countless textual vignettes that take up the pamphlet's two middle pages, selections of which could be audited at different points. This whisper score starts out with the following passage:

INTRODUCTION (PART 1)
I arrived at the perimeter of the city and was met by three emissaries with large black dots on their foreheads. They looked upon me for a long time as if measuring me for a dark place. Then without warning, they turned and walked away, and I followed.[46]

With this vignette, Pope.L gives us a hint of a poetics for the piece. Paying attention to fragments that as a listener/reader/city wanderer I chanced upon, I too came along, like the narrator of this anecdote. One character, a little black insect now known as an emissary, at the end of the whisper score, not far from the bottom right corner of the second page, points to a line that we can cross, a blank space we can traverse (fig. 6.18). Taking her lead and flipping the page, the next two sides of the newsprint present the wanderer with the factual information about the campaign: places, times, dates. More emissaries show up: these small black bugs crawl all over the map of the work that Pope.L has given us (figs 6.19 and 6.20).[47]

But I would like to return for a moment to the territory of that lone emissary already spotted on the other side. Here we find a visual analogue to the swarming, perceiving bugs: spread across the two pages of the whisper score, thick capital letters make up a profusion of ellipses (or parts thereof) along with other wiggly forms, each composing the slogan (or a segment of it) "IGNORANCE IS A VIRTUE" (fig. 6.21). Letters and the words and sentences that they form function as points of orientation and directionality.

Such verbal-visual collaborations also generate paths for reflection, perception, and movement in a small section set off by thick arrows at the end of the second page of the whisper score, roughly the size of a letter. This portion of the newsprint features an amended, annotated poetic statement titled *(Unclassified) I love Europe Text* (or, for short, *Love Text*) (fig 6.22). The *Love Text* enters the topic of Europe and the European Union. It entangles this subject with the themes of immigration and race, fragmentation, corporeality, time, and history that occupy the *Whispering Campaign* as a whole.

Questions of race, space, cosmopolitanism, and neocoloniality come together early on in the whisper score:

GEOGRAPHICAL COLLAGE—ATHENS
At the edge of the atrium is the end of the picture, and the beginning of another part of the photograph, an electronic photograph. On the other side of this edge is blackness. This blackness, of which I am in, encloses an entire world. I can see this world but I cannot experience it. Or I should say there is a part of me that at this moment sits in this room in Chicago writing and there is a part of me which navigates the darkness and leaps into the black, disappears into its density which is everything and itself. XX And simultaneously there is this other part, this European density: I call it 'My Europe,' which now appears on its knees staring at the rough stone floor of a vaulted passage, a tunnel beneath the east retaining wall of the Panathenaic Stadium built in the fourth century BC in a ravine during the tenure of the archonship of Lykourgos. XXX

6.18

6.19

6.20

I S A V I R T U E
1 9 1 3 7 6 6 7
I G N O R A N C E

6.21

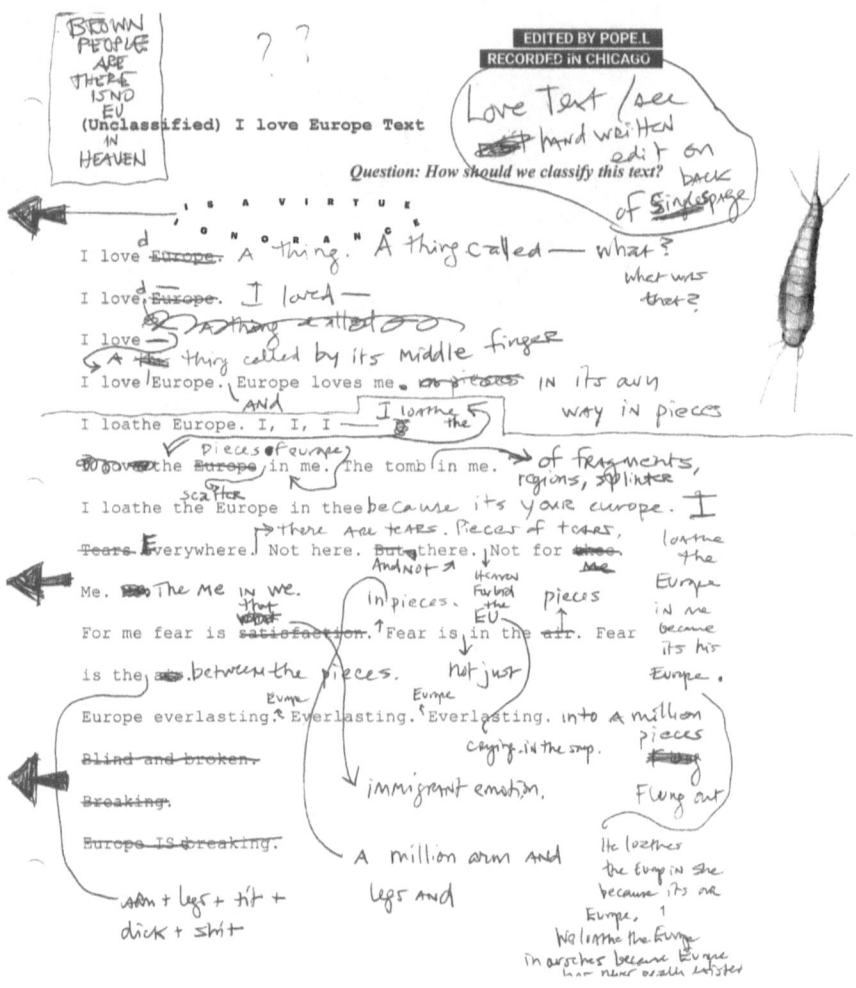

6.22

6.18–6.22 Pope.L, *Whispering Campaign: Kassel*, 2017. Documenta 14, Kassel, Germany.
© Pope.L. Courtesy of the artist and Mitchell-Innes & Nash, New York.

Chronicling Pope.L's perception of the tunnel in the Athens stadium, this passage continues with a description of the historical use of the stadium and of the renovations made to it. The fragment that follows in the score—also part of this particular "Geography Collage—Athens" vignette—has Pope.L/the narrator "walking XX through the tunnel" at the very moment that elements of Kassel's former central train station become superimposed on the Athens architecture. The narrative then carries on with this overlaying and interweaving of observations in different cities, countries (including China and Libya), and continents (including Africa), cast in the campaign's three languages.

Blackness, in the passage just quoted, is multiple: it is on the edge, outside the picture, and, at once, a beginning. It is simultaneously inside and outside the body, which is not only "of" blackness but also in it ("This blackness, of which I am in . . . ;" "a part of me . . . navigates the darkness and leaps into the black"). The world it contains is seen but not experienced. The blackness includes a cosmopolitan part ("this European density") that perceives—that stares at an architectural construction in Athens. This blackness is also internally differentiated: it changes form depending on where one is—at the edge, over the edge, in the tunnel, in Greece, and later in Kassel. Nonetheless, these different kinds of blackness stand in connection with each other. The blackness signaled in the above passage is also the space of perception and encounter with the peregrinating emissaries and with the fragments assembled in the whisper score. This blackness constitutes a type of ignorance—a sort of not-knowing—that can be a virtue.

In their effusive disjointedness, the sonic-textual-visual-performative creations making up the *Whispering Campaign* surpass what is ordinarily heard, read, or seen in the public platforms where authorized culture can see itself reflected, such as established historiographies, broadcast systems, regular newspapers, courtrooms, European Commission meetings, controversies over immigration policy, international trade negotiations, asylum hearings. Pope.L's decentered work brings to awareness repressed voices and nonintegrated data. It highlights the threats of exclusion and silencing extended by official forums for public address (e.g., national art galleries, libraries, media circuits) but also asserts a promise of expanded intelligibility, broadened communication, and renewed freedom.[48] The work floods large-scale transhistorical and transnational trajectories with detail.[49] Mainstream strata of publicity and the identities they can bring to legibility appear as fantasies of transparency. The *Whispering Campaign* shows how urban, national, and transnational constellations of publicity, along with the conceptions of identity they channel, constitutively conceal the constructive mediations by language on which they depend, allocating audibility to select kinds of articulations and versions of history while filtering out other voices and views. The work discloses how these formations of publicity hide the erasures of linguistic expressions they require. The

plenitude of soft voices, temperaments, and silences that the campaign has assembled attests to these elisions of elisions, while also gently yet insistently asserting its own presence as a quiet but, for that matter, not effaceable kind of life, a form of aliveness.[50]

Not just attempts at erasure, but also the residues that those efforts tend to leave behind, come to the fore in Pope.L's "corrections" to his *Love Text*, published in the flyer for the project (see fig. 6.22). Drawing attention to his own edits—the piece proclaims "Edited by Pope.L"—the artist has entered copious handwritten changes into the text's printed words. The first four typed lines making up the body of the text read as follows:

I love Europe.
I love Europe.
I love
I love Europe. Europe loves me.

Supplemented with Pope.L's additions and deletions, these lines say:

I love ~~Europe~~*d*. A thing. A thing called—what?
 what was
I love*d* ~~Europe~~. I loved— that?
 ~~A thing called~~
I love—
A ~~this~~ thing called by its middle finger
I love Europe, Europe loves me. ~~in pieces~~ in its own
 and way in pieces

6.23 Pope.L, *Whispering Campaign: Kassel*, 2017. Documenta 14, Kassel, Germany.
© Pope.L. Courtesy of the artist and Mitchell-Innes & Nash, New York.

Arrows, connectors, and crossings-out run between parts of the text. These figures interlink and interrupt statements. They foster a variety of paths that the viewer can take through the text-image, inciting multiplying resonances between terms. The edits reroute the address of words to other words and thereby to people, things, and places.

Europe, here, is not a frame of meaning that can be presupposed as a ground for aesthetic exchange and cultural agency, hosting Pope.L's artistic persona, the performers, and the listener/reader/viewer. Rather, it is something that

we fashion on an ongoing basis through volatile acts of perception, creation, interpretation, and questioning. This simultaneously backward- and forward-looking process of sense-making leaves legible remainders of elements that we omit as we carry on.

Elisions carry an ominous tone in the *Whispering Campaign*. Although we are confronted with valuable acts of linguistic expunging and blotting out (as exemplified by Pope.L's emendations to his text), the installation also gestures toward a quotidian disavowal of histories of domination and aggression. The campaign announces erasures of violence perpetuated by the mediations that underwrite publicity. In this respect, the installation sides with a cycle of works by a different artist that also contests structures of public address. Not long before the end of the whisper score, we encounter the following segment (my translation):

4 0 1 6
SPY TEXT
October 18, 1977, by XXXXXXXXXX, 1988. From a series of 15 paintings based on photographs of moments in the lives and deaths of four members of the Army Faction, or revolutionaries.

Like Gerhard Richter's series *October 18, 1977* (1988), which, in variable formats and styles, explores facets of the existential outlook, childhood, tastes, living quarters, unresolved deaths, and treatment of members of the Baader-Meinhof Group omitted in the found photographs on which the paintings are based, Pope.L highlights elements, forces, and processes that mainstream media accounts, including photographic representations that become determinative of collective memory, tend to systematically downplay, obfuscate, or leave untouched. Above all, the *Whispering Campaign* calls attention to the faint, proliferating traces (of voices, tales, sounds, commentaries, elisions, questions, dogmas, living beings, instances of brutality and insurgency) that are part of public existence, even if they often go undetected.

Indeed, as I was listening in the basement of the Fridericianum, the whispers were often drowned out by closing bathroom doors, people's talking and walking, roaring hand dryers, rushing water, the clattering of cabinet doors in the locker room, the turning of keys, the dropping of coins in the ledgers of the locks, and the sizzling of bottles of sparkling water being uncapped. On the street near the Peppermint education center, the whispering periodically vanished under the roar of a construction site. In hindsight, I suspect that I had come upon a speaker placed on a cement truck or under a car. But I'm not sure for, at that moment, I was concentrating on the sound and the sonic environment, the phasing in and out of audibility of the whispers. Pope.L touched me

deeply and powerfully with the fragility of certain forms of address: currents of sound and meaning that are so easy to miss, and that are so strong, so persistent, nonetheless. I was struck by my own ineluctable participation in this process of missing—the limits of my attention span, of the scope of my hearing and vision, of my patience, of my readiness to listen, of my sensitivity, of my capacity to understand. Here, as in other places, the recorded voices demanded a special effort to be heard—a determined searching, waiting, and navigating of languages. Even when audible, the whisperings yielded disjointed snatches of representation, not cohesive communications. What could *not* be publicly grasped stood on a par with what one *could* grasp.

Going about our ordinary actions in the city (moving goal-orientedly, going to the toilet, chatting or stepping loudly or, for that matter, cleaning bathrooms and streets, taking out trash, or mixing cement), as Pope.L's sonic composition and performance reveals, we participate in the narrowing of what can be heard, obliterating sounds. The graspable and ungraspable, the audible and inaudible, the noisy and the quiet thus entered into very close connections in the *Whispering Campaign*, with the one appearing as a partial product of the other.

The mode of address that is whispering brought about this reorchestration of ordinary structures of sonic address, coaxing the observer playfully into its game of hide-and-seek, walk-and-find-or-not-find, hear-and-don't-hear. This form of address suspended a forgetting of the constraints of public forums for address and ruptured a sense of evidently legible discourse. Some whispered pronouncements underscore this lack of transparency: "Η γλώσσα παρότι ομιλείται από όλουσ είναι ένα μυστήριο. Sprache ist ein Rätsel, auch wenn sie von allen gesprochen wird. Language though spoken by all is a mystery." Particular concepts, the whispers impress on us, are especially mysterious, such as the notions of virtue, darkness-blackness-light, Europe. The campaign ludically calls into question the at once aesthetic and political structures of address consisting of nations, unions of nations, peoples, and ethnicities, among other racialized colonial topographies.[51]

The idea of loving something hated—signaled by the ambivalent feelings for Europe described in the *Love Text*—is not the end of the story, however. For there is also the notion of hating something loved, which the *Love Text* subjects to textual and material exploration (see fig. 6.22). The following three printed lines undergo editorial amplification and deletion:

> I loathe Europe. I, I, I
> I love the Europe in me. The tomb in me.
> I loathe the Europe in thee

Replenished, split up, redacted, and yielding new paths between words forged by arrows, these lines say:

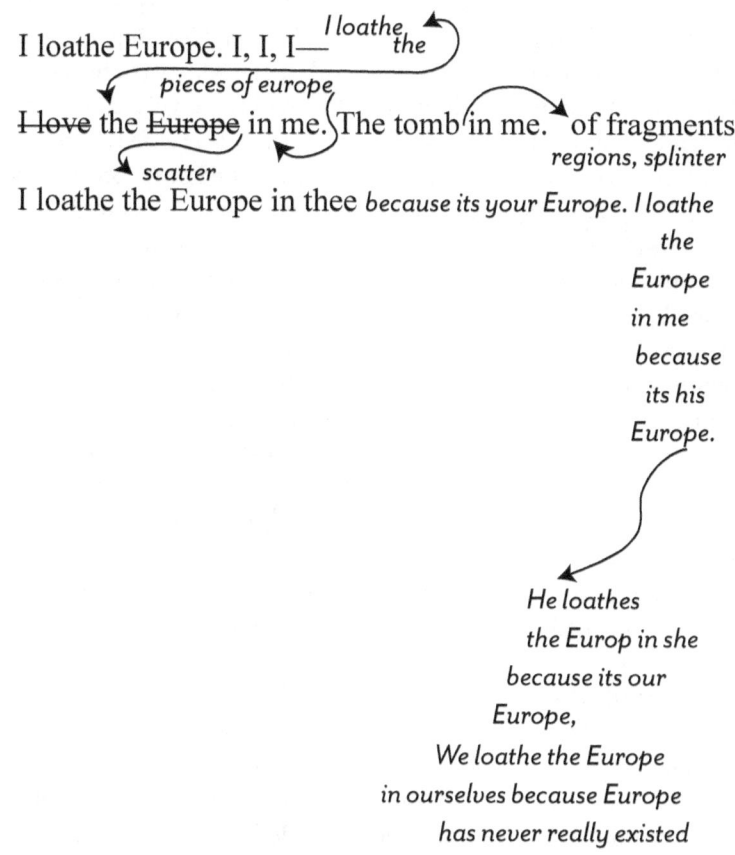

6.24 Pope.L, *Whispering Campaign: Kassel*, 2017. Documenta 14, Kassel, Germany. © Pope.L. Courtesy of the artist and Mitchell-Innes & Nash, New York.

Europe, as it is imagined, doesn't exist. In other words, our ideas of Europe do not encompass what it might be. This goes for Pope.L, generating his *Love Text* in a city in the postcolonial nation that is the US (in the heading the text declares, "Recorded in Chicago"); for the EU; for you or I (the text's addressees); for the individuals whose testimonies fueled the whispers; and for the performers. What we understand by "Europe" isn't quite adequate to what Europe is.

Pope.L displays language in its emptiness or ignorance, as when the notion of Europe figures as a cipher in a supposedly telling formula of love or hatred. He also represents it in the plenitude of the signifying acts it involves, including the edits and silences surrounding expressions. The address of the whispers was often intimate and at the same time emphatically public. In my experience, the whispers sometimes provoked the jolt of a sudden, quite solitary sensation. This happened when I heard them coincidentally or after stretched-out

repetitions and silences. There was a certain intensity to the experience of hearing something in a public place, among others' oblivion. Listening, I felt I transported into a different spatial and temporal orbit. The whispers created a sense of urgency owing to their sounding as if they had to be voiced immediately although they should not be generally hearable: why otherwise the sotto voce?

Late-night or early-morning listening sessions to the hours-long broadcasts of the *Whispering Campaign* via Free Radio Kassel, which I enjoyed, again, as a member of a wide public, but seemingly alone—in the absence of signs of others tuning in—and powerfully proximate to the sound (in the quiet of the night/daybreak, or in the strangeness of listening to so much silence in the middle of day) also created a sensation of heightened intimacy. And yet in the work's opening to the sounds of others and to other ambient sounds, there was the sense of a potential sharing and expansion of the intimacy—Pope.L's work in these respects, along with its partially counterinstitutional gesture, radicalizes and renews John Cage's *4′33″*.[52] The public sphere crafted by the *Whispering Campaign* permitted an exceptional kind of contact with voices, facts, concepts, slogans, testimonies, other people, and urban soundscapes.

A small, squared-off portion of the top left corner of the *Love Text*—which, as mentioned before, is also called *(Unclassified) I love Europe Text*—pronounces in handwritten capital letters, "BROWN PEOPLE ARE THERE IS NO EU IN HEAVEN" (see fig. 6.22). With this phrase, Pope.L links his sound installation to his *Skin Set* project, a vast array of multimedia works (initially mostly drawings, but later also including paintings and sculpture) begun in 1997, of over one thousand objects and counting. Eight of his drawings were shown in different places in Kassel's Documenta Halle. The exhibition included three works made in 2010: *Red People Are My Mother When She Sick and Visiting Me in the Hospital*, *Yellow People Are the Dog's Seed*, and *White People Are God's Way of Saying I'm Sorry* (figs 6.25 and 6.26). Two drawings were dated somewhat later: *Green People Are a Recent Invention* (2011) and *Orange People the Way Things Used to Be When They Were in Power* (2012) (figs 6.27 and 6.28). Reaching back in time, three works from 2001–2002 were also on view: *Black People Are the Silence They Cannot Understand*, *White People Are the Cliff and What Comes After*, and *Black People Are the Wet Grass at Morning* (fig. 6.29).

If skin groupings and epidermal schemas have historically determined identities and continue to designate them in ways that have horrific effects, Pope.L's *Whispering Campaign*, along with these *Skin Set Drawings*, in enlisting the racial-identity formula *par excellence* (namely, "x-colored people are _____"), situates the project of identity representation in the realm of the political imagination by undercutting the commonsense rationality of assertions of identity spurred by skin-readings.[53] Frames for what we might call sk-interpretation are under revision here. The clamorous multitude of colors, letter forms, and phrases and the profusion of sometimes scarcely legible peripheral annotations accompanying centered statements held up by the thin membranes

of low-tech paper signal a huge, vastly collaborative enterprise of rematerializing skin, bodily surfaces, and corporeal openings and enclosures. Pope.L's color equations attest to a flurry of possibilities for invention and being. Granular as well as all-out figuration render stretchable the grids within which they often emerge or that they chalk over and push to the limits. Pope.L provides newly imagined narrative scripts, colors, and forms for the differential "historical-racial" material schemata that mold our day-to-day lives in contemporary societies.[54] He aestheticizes these templates along alternative lines. In the *Whispering Campaign*'s parody of Joseph Beuys's engagement with the coyote in his famous 1974 performance *I Like America and America Likes Me*, Pope.L rethinks the scenes, loci, mechanisms, and interpretive models deemed to be revelatory of identity by following black specks that appear to be (parts of) the bodies of some crawling insects.[55] Shifting the artistic focus from the expectation of represented identities to their linguistic, visual, auditory, imaginative, phantasmagoric, spatial, and intercorporeal trappings, he reenvisions the conditions for publicity that can support a critical social imaginary.

6.25 Pope.L, *Red People Are My Mother When She Sick and Visiting Me in the Hospital*, 2010. Mixed media on paper. 11-1/2 × 9 in (29.2 × 22.9 cm).
© Pope.L. Courtesy of the artist and Mitchell-Innes & Nash, New York

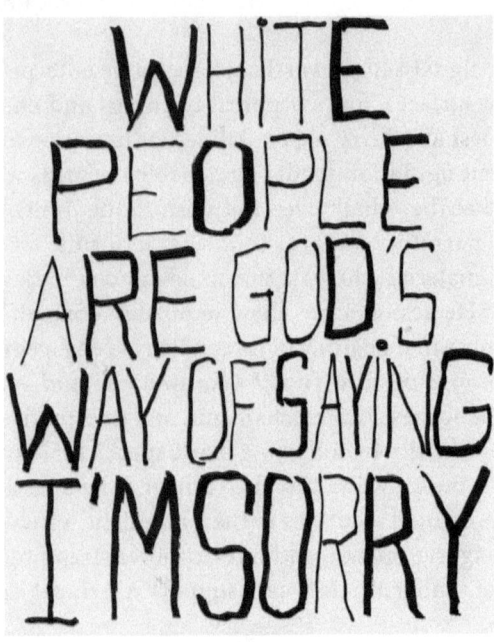

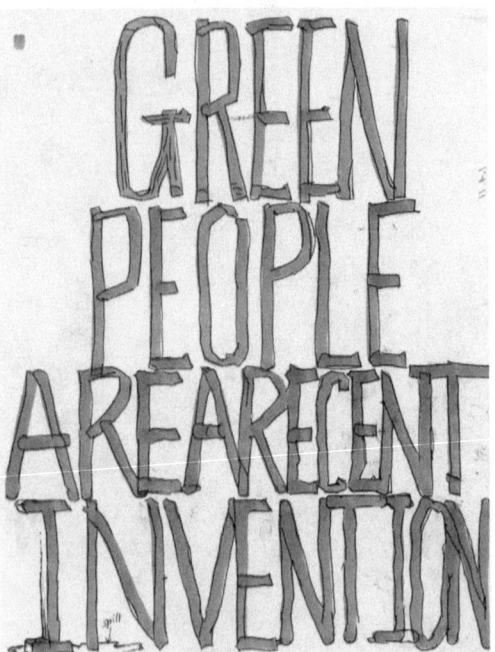

6.26 (top) Pope.L, *White People Are God's Way of Saying I'm Sorry*, 2010. Mixed media on paper. 11-3/8 × 9 in (28.9 × 22.9 cm).

6.27 (bottom) Pope.L, *Green People Are a Recent Invention*, 2011. Marker and pen on vellum. 11-7/8 × 9 in (30.2 × 22.9 cm).

© Pope.L. Courtesy of the artist and Mitchell-Innes & Nash, New York.

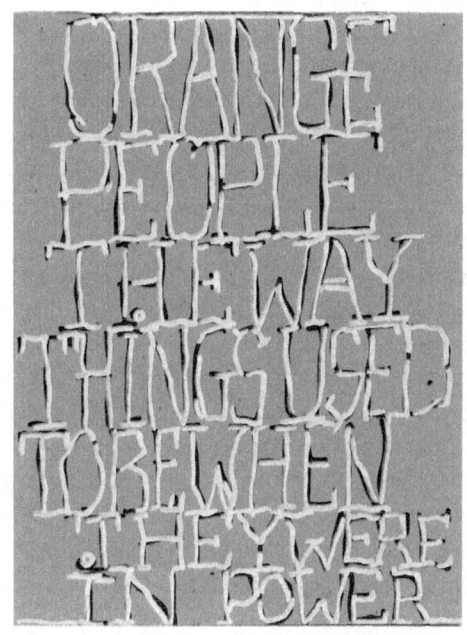

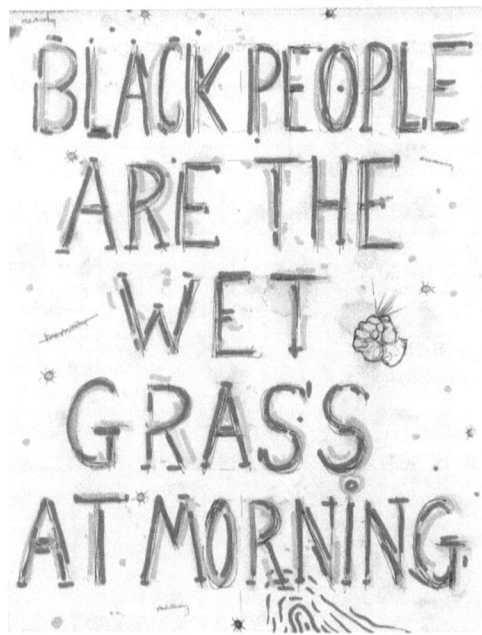

6.28 (top) Pope.L, *Orange People the Way Things Used to Be When They Were in Power*, 2012. Marker on chip board. 12 × 8-7/8 in (30.5 × 22.5 cm).

6.29 (bottom) Pope.L, *Black People Are the Wet Grass at Morning*, 2001–2002. Pen, marker, and paint on paper. 11 × 8-5/8 in (27.9 × 21.9 cm).

© Pope.L. Courtesy of the artist and Mitchell-Innes & Nash, New York.

Identity, understood in customary terms, may not be what emerges from this enterprise. Nonetheless, Pope.L's interventions at Documenta 14 reconceptualize the aesthetic grounds of signification—the forums for aesthetic publicity that we inhabit—so as to render residual markings and effaced narratives communicable and put pressure on the limits of intelligible representation and communicative exchange.

The *Whispering Campaign* mobilizes a mode of address—whispering—to activate other modes of address such as careful listening, waiting, searching, thinking. Weaving the observer into an extended scenario of reciprocal address, it brings to awareness the workings of a distinct set of aspects of address—namely, of multiply embedded and embedding norms, forms, structures, scenes, and scripts of articulation and erasure. In having us think about these conditions of public address and introducing an altered array of elements, the work gestures toward revised platforms for aesthetic interaction and the alternative aesthetically mediated relationships that those forums can imply.[56] The following printed lines receive annotations from Pope.L and are treated to cuts:

> Tears everywhere. Not here. But there. Not for thee.
> Me
> For me fear is satisfaction. Fear is in the air. Fear
> is the air.

These lines become

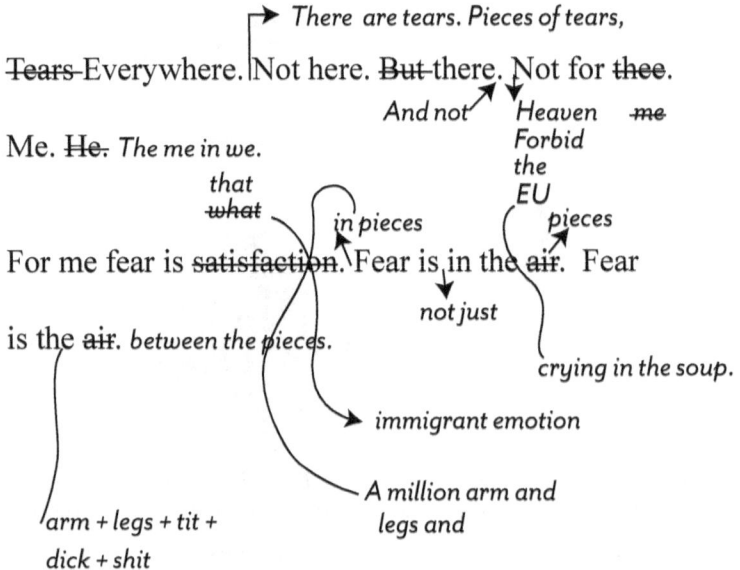

6.30 Pope.L, *Whispering Campaign: Kassel*, 2017. Documenta 14, Kassel, Germany. © Pope.L. Courtesy of the artist and Mitchell-Innes & Nash, New York.

Tears, small fluid globes falling from the eyes, alternate with tears, the rips marking social and geopolitical divisions. Pope.L signals the pain wrought by brokenness and an all-encompassing fear that one breathes. He underscores the sorrow, anguish, and grief that are a response to a state of entombment and the need for forced migration and displacement. This distress stands in contradistinction to a despondency attendant on a sense of entitlement, described as "crying in the soup." The fear Pope.L emphasizes pervades not only the migrant's surroundings or, metaphorically, the air, but has settled inside the body, that is, in corporeal parts and feces: in "arms +. . . ." A free-floating, handwritten mention of "the pieces" links via a curving line to the truncated phrase "A million arm [sic] and legs and." This sentence fragment strikes up a conversation with narratives about bombings in the Syrian war and the destruction of human life effected by such attacks, stories that are related by the whispers.

The loathing of Europe felt by various characters (an "I," a "he," a "we"), including the narrator, has to do with its proximity to people, its being *in* people. At issue in the poetic statement are, as Pope.L puts it, "the pieces of europe *in* me," "the Europe *in* thee," "*in* me," "*in* she" (my emphases). People carry Europe (or bits of it) within themselves. This closeness is at work in the hatred. Moreover, the narrator attributes the loathing to a proprietary partitioning of the different kinds of Europe: the reason he advances for the hate for the instances of Europe (or Europe-parts) that lodge in "thee," "me," and "she" is their being "*your*," "*his*," and "*our* Europe," respectively (my emphases). This social, proprietary condition fuels the revulsion.

The notion of a person or group, meanwhile, is not that of a stand-alone individual or a set thereof, but of beings who are in relation—Pope.L qualifies "Me" with "The me in we." This qualification yields a further affective possibility, namely that of a multiply grounded, diversified yet collective emotion directed at several subject positions: "We loathe the Europe in ourselves." The possessive pronoun here does not denote primarily an "us" or "we" in toto, but also an "I," "you," and "he"/"she," individually. The poetic text ascribes the feeling of detestation to a joint origin, motivation, or fueling source, namely, the fact of Europe's nonexistence. As the *Love Text*'s final words proclaim, "We loathe the Europe in ourselves because Europe has never existed." The term "Europe," no matter how full, rich in meaning, and intelligibly communicative it may appear, connotes a field of questions rather than rapidly or decisively announcing a shared reference or a phenomenon that is located out there, ready to be clearly and informatively designated.

Two question marks float above the *Love Text*'s title. The poetic statement from the start lodges us in an area where assumptions are queried. A question follows that leaves no doubt about its being exactly that: "*Question: How should we classify this text?*" The text's genre unclear, its structure of address is called into doubt. The dual question marks bounce about in the space around the words "I," "love," and "Europe" and near the phrase "BROWN PEOPLE ARE THERE

IS NO EU IN HEAVEN." Prominent aspects of the statement, including its author's site of address (Pope.L's writerly agency, a racially marked position of artistic creation), its narrator's mode of address (loving/hating?), and its subject (Europe) become incitements for reflection rather than pockets of knowledge. There is an unsettlement of textual meaning. Further emphasis on this destabilization flows from the sardonic ellipse "IGNORANCE IS A VIRTUE," interspersed between the question about classification and the body of the text. This ellipse pronounces textual activity to be complicit in a pernicious moral system that endows acts of violent destruction with the appearance of ethical legitimacy. The *Love Text* challenges its own structure of address as well as the aesthetic context in which it is emplaced. The resulting indeterminacy notwithstanding, Pope.L appears to have created an experimental text, perhaps a poem, perhaps a splitting, multivoiced theatrical monologue, that in collaboration with the scattered whispers and the whisper score problematizes a web of relationships connoted by the notions of immigration, Europe, love/hate, tears, and brown people.[57]

While whispering is the principal mode of address through which the campaign dislodges formations of aesthetic relationality, such destabilizations also stem from references to different kinds of media, notably photography, the moving image, and digital technologies. Pope.L links the whispers and the silences they leave with several other liminal and transitory processes in the following passages, which were broadcast in English on the radio during the Documenta and included in German in the whisper score (to appear later with the English and German reversed and at one point, I seem to remember, with Greek in the place of the elements that the whisper score casts in English):

3 1 5 2 5 9 5 5

The environment in which I find myself at the moment is a collage called Europe. Therefore bits of Europe-bits therefore—perhaps perhaps perhaps not Europe itself, in itself—but a pause between Europes—a dust mote between one image and another in a film, or between one eye-blink and another eye-blink in life—

So you can imagine that this space I am now in is more a transit than a place, and so this space I am now in is tricky to traverse— 'cause I am traversing it in my own way, like a whisper across the bones inside someone's ear. I am traversing it—

6 0 2 8[58]

Being in or prosthetically apprehending a portion of Europe amounts to a parceled-out hearing and seeing. The whispers continue:

This space is constructed out of various times, locations, intensities, psychologies, trajectories—possibilities—imaginaries—colored inks, documents, pixels and dung that intersect each other in a multitude of ways, some i am aware of, many of which i am not aware. True, here here here here here

9 2 0 9[59]

The "tricky" crossing or encounter engendered through partitioned hearing and seeing, this fragment suggests, yields a space that is made up of heterogeneous modes and scenes of address, involving a plurality of addressors and addressees. That space of transit where the whisperer dwells and travels reveals a horizontal organization: locations and imaginaries appear in the same plane, and so do drawing or printing materials such as colored inks, texts, minute portions of computer screens that encode information, dung. The mobile space holding the whisperer, moreover, is one of which that temporary dweller or traveler is, to a large extent, ignorant.

The broadcast continues with a passage in English that the whisper score furnishes in Greek, titled "ΚΟΛΑΖ ΓΕΩΓΡΑΦΙΑΣ—ΚΑΣΕΛ" (Geography Collage—Kassel). This segment underscores the centrality of media of address to the parceling of space and place and the shifting experience of the topography, temporality, meteorological circumstance, history, and architecture:

> In this place, the physics of a location can be the opposite from its usual state, for example, upside down or sideways. My current location is fairly straightforward. I am standing. Across from my vertical body is a black-gray street fronted by the blue-gray Friedrich Gymnasium. The building is very flat and photographic. Because this version only exists in a photograph. The building is made of a thick, grainy, blue material that resembles stone. The gymnasium was founded in 1779 by Landgrave Friedrich II and is the oldest such building in Kassel, Germany. Above the gymnasium heavy clouds. It is fall. Perhaps November. In the photograph, the leaves of the trees are brighter than real, or is everything brighter in this depicted space called Europe; a kind of Disney-bright realities;

7 7 4 5

The currently quite straightforward epistemic standpoint on which the whisperer reports, in the realm of color, is less univocal than it seems to be. The passage resonates with another aphorism one hears repeatedly, and that will soon sound many times in a row, "What does Europe look like in the daylight?" But this point of speculation and musing is not where this particular vignette takes us next, at least not before two other whispered passages. First, we hear in

English an affirmation of reality and dwelling in location that the whisper score supplies in German:

> But also an actual place because I am somehow in it right now. This is proof! This is proof! This is proof!
>
> 1 8 8 8

The passage following these exclamations tells both the listener to Free Radio Kassel and the reader of the whisper score of the whisperer's walk by some metal posts in the driveway and, onward, to a metal fire escape. At the bottom of the blue-gray fire escape, there is a shrub, which is red. Notwithstanding the whisperer's affirmation of the real place where she is allegedly located, perception provides equivocal information that is belied by what really is going on.[60] What is actually happening is a function of the temporal and spatial mediations introduced by screens: "It is red. It is as if it is on fire but it is only back-lit by the screen of one time after another or on top of another or inside of another." Part of the epistemic unsettlement that the *Whispering Campaign* produces and of the envisioned splitting of Europe into chunks to which the work gestures thus stems from the workings of digital images and their technological supports and the effects they produce in our relationships with objects and spaces, as well as in our relations with language and people, with which the former relationships reverberate.[61] Indeed, a diffuse "blob" that admits of various readings, several vignettes later in the whisper score, points (in German) to "columns of gray + black + yet more gray + and perhaps pieces of bleached white, that are today's dark dark Europe."[62] The *Whispering Campaign* destabilizes whiteness, light, brightness, and color more generally, along with blackness and darkness.[63] These tonalities and hues traverse digital and actual space alike.

Racial categories, meanwhile, display a fundamental openness to reconfiguration in and through address—an openness that accompanies the dynamics of overdetermination and opacity, of limitation and fluidity, of contradiction and foreshortening, and of positivity and incompleteness or lack by which Pope.L takes them to be traversed.[64] These categories show glimpses of the aesthetic underpinnings as well as the potentialities for aesthetic rearticulation that they accrue within the constellations of public address harboring them.[65] Emphasizing blackness, Pope.L remarked in 2002, "If black is beautiful, it's also green. If we're going to make it possible for 'black' to escape the conventions that deaden it and mark it as less complex than 'white,' we should be open to this idea. What does that mean? That's the struggle. You might have to construct new meanings for blackness. You won't always know what it is."[66] This revisioning endeavor, which implicates a host of other social categories, including other racial categories and color concepts, recruits us in a project of

address to address, one that engulfs us—in systemically and singularly divergent ways—in the task that Pope.L, with another of his works in mind, characterizes as "the audience's job to juggle, swim and contest to find their relation to the issues as I struggled and continued to struggle to find mine."[67]

Address channels this purported intervention into webs of aesthetically mediated relationships by way of two kinds of constructive entities. I want to dwell briefly on these constituents, which provide engines for the process of racial renegotiation and reworking that Pope.L envisages. The first concerns the public platforms of address made up of settings such as cities, streets, transnational organizations, and auditoriums, which stage particular scenes of address. Vis-à-vis these relatively large-scale structures of address, Pope.L aspires to what, again in the context of the different work alluded to earlier, he describes as an "oscillating linguistic theatricality," which opens out onto points of disparity as well as correspondence among the members of the public.[68] The aim here is for a heterogeneous public to have its "differences communicate, collide, disagree, augment each other" at the same time that it takes up the challenge of "hearing (active listening), while our sharedness is given flesh in word."[69] This dual strategy of indexing an orbit of social differences (e.g., regarding race) and simultaneously embodying and recrafting a plane of commonalities (e.g., concerning patterns of perception and protocols of reading) can be recognized also in the *Whispering Campaign* and the *Skin Set* project that the campaign hooks into.[70]

The question of perception or reading and their operations as forms of address bring us to the second constructive entity that I would like to foreground. In both the series and the campaign, Pope.L enlists language in a distinctive capacity for address, namely a kind of "calling." Comparing the language of the *Skin Set* pieces with elements such as sentences or verbal fragments, which he finds overly "object-bound," he advances as his primary linguistic units the presumably more pronouncedly relational, less rapidly reified interlocutionary "phrases or bits or scraps whose ontology is more open, always 'calling' to its cousin-scraps and cousin-bits floating in the conversation."[71] This point invites extrapolation from the *Skin Set* project to the *Whispering Campaign*. Counting among each venture's central structural mechanisms a fabric of fine-grained intertextual, transmedial, and cross-vocal summonings—in other words, a web of modes address—among mutually bonded snippets of language (and presumably other visual/sonic signs, residues, and noises), Pope.L sets into motion a spiral of reciprocally transformative, detailed, linguistic/visual/sonic resonances. Combining large-scale and small-scale strategies of address, his works mark points of freedom within the relational structures undergirding racial existence.[72]

Pope.L's *Love Text*, along with the whispers, ponders various aspects of a huge question: what is Europe? As I have indicated, the campaign probes this

theme in connection with a history of coloniality, racial hierarchy, war, and forced migrancy. If our notions of Europe do not adequately correspond with an existing reality, then how do we apprehend it? These concerns, suggests Pope.L's piece, are in part a matter of address: in and through what forms of address do we cast the relevant questions and how do we address those forms, which in many ways already embody the questions? Neither existing racial classifications nor predetermined geopolitical denominations nor given structures of address, the poetic text intimates, hold tenable, adequately comprehensive answers to these dilemmas. Accordingly Pope.L places us in the thicket of webs of address made up of whispers and the silences they leave. He invites us to track these elements and to absorb them into our paths of address, as we move between emissaries, slogans, streets, maps, poetic statements, screens, songs, radio stations, buildings, and interlinked cities and countries.[73]

Like Jamaica Kincaid's story "Girl," Wisława Szymborska's poem "Vocabulary," and Julio Cortázar's story collection *Cronopios and Famas*, the *Whispering Campaign* traverses cosmopolitan territory. In connection with the notion of Europe, Pope.L combines an element of semantic evacuation—our conceptions of Europe don't match with the reality—with a sustained project of replenishment. The *Whispering Campaign* gestures at numerous trajectories of address through which we can seek to reflect on what Europe could or should be.

Parallels arise also with Cortázar's explorations of our emplacement in stultified structures of address. The visual artist and the fiction writer probe questions of human interconnectedness—intimacy, love, nearness, distance, and contact. They develop cosmopolitan stances and encounter established structures of address with a splintering. For Cortázar, these structures include, among other things, confining patterns of mediatization in which newspapers take part; for Pope.L, they involve a multiply split geopolitical organization that relies on a problematic (as well as a beneficial) kind of ignorance. In the *Love Text*, along with the vignettes he has assembled, Pope.L sketches a cosmopolitan landscape broken up into diminutive pieces and parceled-out elements. Images of miniscule steps and movements likewise characterize Cortázar's conception of the modes of address with which we engage limiting structures of address. Both artists reenvision arrangements of space and time aestheticized under colonial modernity in terms of snippets, segments, specks. Small bits and particles shape the refractory modes of address that they marshal to make changes into structures of address and the webs of relationships they support.

Highlighting fear and confinement (Pope.L through the image of the "tomb" and Cortázar by way of the glass brick), this pair of artists apprehend systems of address (a union of nations for Pope.L; international organizations such as UNESCO for Cortázar) as sites where tears flow. We have seen how the crystal brick, in one of its permutations, becomes the tears shed by an

abstractionist's secretary onto her blotting paper—paper used to limit the visibility of corrections, to keep the edits entered into official communications from spreading all over the page. Wetted blotting paper, even in the absence of an abstractionist boss, promises to restore textual annotations to their full subversive potential. As the *Love Text* has it, tears do not merely flow everywhere, flouting the supposed European wish to stop them at the borders, but are broken up in their own right: "Pieces of tears."

Cortázar's and Pope.L's cosmopolitanisms affirm a baroque reversibility of the high and the low. Human beings enter into vital interactions and exchangeable roles with insects, sardonically playing out against themselves formations of address that position certain kinds of people as nonhuman animals. If Cortázar puts into disarray the relation between mouth and anus or penis, between viscous brown materials that enter and exit the body, Pope.L's *Love Text* shuttles between figures of the air/heaven on the one hand and feces and sexualized body parts on the other, substituting an instance of the term "air" by "arms + legs + tit + dick + shit." In a similar vein, the *Whispering Campaign* places pixels and dung on the same level.[74]

◉ ◉ ◉

Power, dominance, and repression take complex forms in contemporary societies, forms that pervade bodily life. The two artists meet these intricacies with strategies of aesthetic destabilization, dehierarchization, disassembly, and recomposition. Through these modes, they trace distressing and melancholy sides of our existence and mark sources of pain, but also actively search out points where new longings can come into being.

Challenging contemporary geopolitical webs of aesthetic relationality and unhinging elements of colonial modernity, Cortázar and Pope.L open up movements in restrictive constellation of address. Both this story writer and this multimedia artist initiate steps toward reconfigured patterns of relationships among language, people, things, and places.

THEORETICAL ECHOES AND MOVES FORWARD

The six scholars reviewed in chapter 5 place address at the core of configurations of experience, reading, desire, and agency. They underscore address's contributions to the powers and limits of linguistic orders and media circuits. Address, in their accounts, shapes factors as diverse as technological delimitations, segments of public life, and planes of ideology; it makes its presence felt in schemes of institutional existence and strata of interaction across national

and colonial boundaries. It molds experience, leaving its mark on moments of intimacy and distance alike.

The four cultural productions examined in the present chapter navigate similar territory, while also signaling further procedures and areas of functioning in which address is at work. Echoing and adumbrating motifs that we have put under a scholarly lens, they offer outlooks on varieties of freedom inherent in configurations of embodiment, social expulsion, and global and local interaction. The relevant kind of freedom, as we see in Julio Cortázar's stories in chapter 3, does not catapult us away from our connections with others, but emerges within relationships and can foster them in a manner conducive to joint flourishing.

These new artworks disclose aesthetic delights, sorrows, surprises, frictions, and puzzles that arise in the margins of dominant culture. One by one, they mobilize address to transform templates of aesthetic relationality. Each piece enlists modes of address to awaken creative resources embedded in those systems and to initiate responses to ethical, political, and aesthetic problems that also attach to those matrices. The works all develop and put these modes into effect with an eye on necessary social changes to be brought about in collaboration with their audiences. Artists, in this sample of cases, recruit address in critical approaches to aesthetically primed constructions of coloniality and race (Oshima, Lispector, and Pope.L) and to aesthetically modulated registers of gender (Rosler, Oshima, and Lispector). Address reveals its potency, plasticity, and precision as a font of strategies of artistic creation and interpretation.

Exposing the operations of address in and by the different cultural productions, we have distilled these pieces' aesthetic dimensions and unearthed facets of their ethical and political functioning. While my readings can undeniably be fleshed out further, the four cases attest to the functioning of address as a vehicle for the simultaneously aesthetic, ethical, and political meanings of works of art. What is more, our cumulative investigation of the performance video, a film, a novel, and a sound and performance piece demonstrates the productivity of the framework of address laid out in this book: we have put to use the paradigm of jointly operative norms, forms, structures, scenes, and scripts of address in clarifying intertwining aesthetic, ethical, and political interventions into webs of relationships.

In the four artists' hands, categories such as race, class, gender, coloniality, nation, and the global reveal mobilities and cracks. Each in its own way, the artworks confront us with newly aestheticized constructions of social identity and difference, a point that also shimmers in Jamaica Kincaid's "Girl," Wisława Szymborska's "Vocabulary," and Cortázar's *Cronopios and Famas*. The works' tactics of playful unsettlement gesture toward alternative aestheticizations of the categories shaping our social being, and of the plane in which our engagements with language and the world take form. The four pieces push further that

vast project of freedom and critique in which we have so much at stake as a society: they collectively expand our repertoire of decolonial, critical race feminist aesthetic strategies.

Our four artistic cases provide confirmation for the proposal, voiced in chapter 5, that address as allied to the apparatus of collaborating norms, forms, structures, scenes, and scripts is at work in mutating arrangements of sociality, materiality, and experience and the at times tumultuous, at times even-keeled cycles of affiliation and affect that mark those conditions. The notion of address articulated in this book pinpoints an anatomy whose effects are identifiable in an array of analytical contexts.

Deploying modes of address to bring about novel orientations within structures of aesthetic relationality, Martha Rosler, Nagisa Oshima, Clarice Lispector, and Pope.L prod us to reorganize the social domains that support our subjective being. These artists and their works *address* patterns of address that are operative in kitchens, cities, prisons, art worlds, platforms for aesthetic publicity, nations, unions of nations, and other sites of everyday life. In responding to works of art, audiences address the modes of address that artists and works direct at them, as well as the modes of address that organize the relevant social and material spheres. These various sites of address are points where artists and audiences can collaborate to make changes in the webs of relationality in which we participate.

Tied to the joint workings of norms, forms, structures, scenes, and scripts, the notion of address indexes forces and functions that are in action at divergent junctures in the zones of encounter among works of art, the audiences they attract, and the prodigious settings hosting these objects and publics. Seeking out the multitudinous layers of interaction that meet here, both on grand scales and at diminutive points, the concept of address directs us to places where we can realize moments of critical aesthetic agency and bring about unforeseen freedoms and yearnings.

AFTERWORD

Time and again, we call on our arts of address. The young woman in Jamaica Kincaid's story "Girl" needs to figure out how she is being addressed. She has to determine what she is going to do about that address. So she has to address the way she is being addressed. Whether we work in schools, courts, shops, delivery trucks, dining halls, parking garages, archives, museums, concert halls, or the cinema, we, like her, continually navigate such choices. Address is everywhere. And it does a lot. That makes it necessary to talk about it in distinct ways and to think through how it works. We already reflect on address in the course of our ordinary problem solving: How do we address this situation? Do we ring a bell, request a meeting, shout out, apologize, sleep on it, or make a joke? Or, in really expansive terms, how are we going to think about or engage the state of living beings and things in the world? What conceptual, imaginative, affective, perceptual, and material skills shall we deploy in crafting our comportment toward the immediate and more distant states of affairs we confront? Working out stands on these matters means participating in an orbit of address.

What do these negotiations and possibilities look like? The argument thus far has yielded a number of findings, several of which I will gather shortly. With the benefit of hindsight, however, I first want to revisit the topic of the mode of address of this book itself, as broached at the start of the investigation. This writing's address, like any other, implies a give and take; it entails navigating choices and options; together, as author and reader, we have crafted an orbit of

insights shot through with a certain loss. Precisely here, in our address to address, we can once more glean the labor of address itself.

THIS BOOK'S ADDRESS TO ADDRESS

In designing my mode of address to my material, I have attempted to nourish our being alive to language and the world. With the mode devised for this book, I want to speak to the many ways in which we can achieve that kind of aliveness. This has been a persistent motive for my choices of address. The trouble, of course, is that my idea of being alive (or alive *to*) may be your idea of a flat, lackluster type of existence—perhaps a sort of living death—or the other way around. If so, this aspect of my address can backfire: it may leave you cold and unstirred, render the material icy and dry for you. Yet, as it happens, this intention on my part is far from the whole story of that address, no matter how ardently felt.

From the start, you, I, and this book have been addressing questions of iciness, intimacy, connectedness, and gooey clinginess. We have delved rigorously into the very aesthetic conditions of what is to be alive to language and the world. We have considered the states of bricklike stasis and the possibilities for motion, whether quirky or reliable, in grand sweeps or little snippets, that so fiercely and at times uproariously go to shape what Julio Cortázar describes as the "lively forest" of the street. With this phrase, he gestures toward a place—a certain here or now, a then or there—where we chance our lives, where our being alive (and our being alive *to* our environment) is in the wager, where we can give this exuberant (if also perturbing and grating) aliveness form, by means of some mode of address. He investigates what it is like to enact that sort of agency, which consists of our addressing as we are being addressed. The distinctive capacities and incapacities that this mode of being involves hold his fascination. He also explores how we might want to understand the power and powerlessness, vulnerability and desire, freedom and lack of freedom that this fundamental type of connectedness with language, people, things, and places entails.

Cortázar invites us to contemplate how we live with those conditions. It would be too tidy now to ask you—hello and goodbye, dear reader!—to use the dead spots in this text in that fashion. For with you (and perhaps also with my later self—hello and goodbye, future self!), I like to join in a kind of play where our resistances, rebellions, repetitions, dislikes, and fears are part of the game: they come with the territory, along with our affections for certain sorts of philosophy or art; our desires for evolving bonds with authors or other makers of cultural artifacts; and our loves of specific genres of books or other types of

things. So, where, in this text, are the magnolia and the twirls of toothpaste—those unexpected elements of aesthetic incongruity that, Cortázar intimates, can initiate infinitesimal, but not insignificant turnabouts and refractions?

The magnolia and the toothpaste appear conspicuously in connection with the artworks we have considered. For Jamaica Kincaid and Martha Rosler, these figures crop up, as it were, with a mischievous question that sends scenes, scripts, and structures of address into a spin. They arrive on the set when the latter's kitchen objects display their insurgent behaviors; when Nagisa Oshima's prisoner is made alive by hanging; when Clarice Lispector's subaltern character spots a creaky gate; and when Pope.L's panoply of enigmatic whispers rises to the air.

And the magnolia and the whirl of toothpaste are there when a cloud turns out to be a cloud no more! They come along when we start to wonder whether perhaps a cloud was *ever* a cloud. Even if a magnolia, we realize, is a magnolia is a magnolia, how about a greeting, a nose, or a pile of leaves, like a book (if any book today can still lay claim to being a stack of pages)? Our powers of seeing-in, seeing-as, and reading face unrivaled pressures in the era of fake books . . . I mean, fake news . . . I mean, given our current technological and social means of inversion and metamorphosis. It's a good thing that these abilities have the magnificent resources of address to go by!

Part of the address of this book and its dive into the aliveness of being alive involves an effort to attune our conceptual frames—as well as the sensory receptivity of our eyes, ears, elbows, noses, eyelashes, fingernails, mouths, and palates—to an element of mystery and intrigue. I return to Walter Benjamin for a condensed image of the potentialities that language accumulates in this regard. I have in mind, in particular, its capability to embody traces of loss along with its powers of creative (re)assembly and migratory pliancy. Recall that words, for Benjamin, carry histories reflecting the contexts in which we initially chanced upon them. In "A Berlin Chronicle," he tells of the mystique that can surround certain kinds of words, and of how his discovery of several of those signs was a reason for composing the text: "There is one . . . sound that, thanks to the decades in which it neither passed my lips nor reached my ears, has preserved the unfathomable mystery that certain words from the language of adults possess for children. It was not long ago that I rediscovered it, and indeed a number of indivisible finds of this nature have played a large part in my decision to write down these memories."[1] Before Benjamin is going to reveal to us the word, that "one sound," that we now are very curious about, he increases suspense by way of a backstory, including his reader in the very process of sifting and rummaging that he is thematizing. This story concerns the summer months that he, as a child, used to spend with his parents in Potsdam. For the most part, these times have vanished dramatically from his recollection, "unless"—and here comes the fervently awaited word—he "may situate the

asparagus cutting (my first and only agricultural passion) as far back as the garden on the Brauhausberg." The vegetable harvest, the country atmosphere, the eruption of a uniquely impactful feeling against the backdrop of a whole ambit of experiences that have sunk into oblivion have us guess: Benjamin, who at the beginning of "A Berlin Chronicle" had cited Marcel Proust's texts as among his guides to the city of Berlin, has been readying the stage for a transnational, transregional, transmedial, transdomestic, transalimentary madeleine moment. Rife with migratory aesthetic potency, Benjamin's *punctum* will sustain forgetfulness every bit as much as it brings the past back to life. He continues,

> And I have thus divulged the word in which, like countless rose petals in a drop of Rose Malmaison, hundreds of summer days, forfeiting their form, their color, and their multiplicity, are preserved in their scent. The word is "Brauhausberg." To approach what it enfolds is almost impossible. These words that exist on the frontier between two linguistic regions, that of children and that of adults, are comparable to the words of Mallarmé's poems, which the conflict between the poetic and the profane word has, as it were, consumed and made evanescent, airy. Likewise, the word "Brauhausberg" has lost all heaviness, no longer contains any trace of a brewery [*Brauhaus*], and is at most a hill swathed in blue that rose up each summer to give lodging to me and my parents.[2]

Although the association of the "Haus" (home) has slipped away from the word, the currently sheer, weightless term "Brauhausberg" still connotes a regular occurrence, a place to stay for young Walter and his mother and father, a hill dressed in color that arises as if out of nowhere at the start of the season, only to retreat at the end. Apart from the exact mnemonic contents that the word and its sound relay, they introduce a tinge of mystique. A measure of indiscriminateness is of the essence to this aura of expectancy and wonder: the hill is clothed in a monochromatic blue; the summer days have relinquished their distinctive form; they have surrendered their many colors; they have ceded the multitudinous happenings they brought; yet these days are somehow there, looming in the memories that the word summons. Assisted by forgetting, the at once absolutely exceptional and altogether ordinary word nurtures the days' affective presence, their sensory vivacity. Intensely vibrant meanings crowd together in the word, although approaching them is "almost impossible." Almost, but not wholly.

The word is light, yet no less poignant, like Wisława Szymborska's raindrop, which, regardless of how much history it condenses, admits of a gentle touch between world and narrator. The name "Brauhausberg" channels forms of address to and from the world. For Benjamin, the word springs forth as a breathing kernel where language, people, things, and places assume shifting

constellations. A conduit for this morphing, simultaneously thinning and thickening process of meaning-making, it opens up new paths of being alive to language and the world. Along with Kincaid, Szymborska, and Cortázar, Benjamin takes an interest in the ways in which modes of address can discard or awaken the semantic contents encapsulated in given forms of language, propping up states of receptiveness and creativity. These writers bring us face to face with address's power to shape the ways in which signs absorb and let go of contents, accruing historical connotations to then shed them again while perhaps allowing them a furtive existence. In that shaping capacity, address gives form to our mutually responsive encounters with other living beings and our material surroundings.

Analogously to Szymborska's raindrop, Benjamin's composite figure of the Brauhausberg-rosewater/perfume/eau de toilette signals the potentialities inherent in the spirals of material, linguistic, and (inter)subjective participation and funneling this book has examined. Honing in on different facets of these cycles, we have complemented Szymborska's and Benjamin's images with a nineteenth-century costume drama, the tale of a perky twentieth-century spoon and doorknob, and the story of a twenty-first-century chocolate fest. The inventive, form-building and form-effacing, channeling powers of address, with all their intrigue and potential, are capabilities that I have wanted to probe and recognize by way of this text's mode of address, and in my address to the address of theorists and artists, scholarly texts, artworks, and other things. Accordingly, we have kept on the lookout for magnolias that are bound to fall from nowhere and for strips of pink toothpaste that take to the air.

Over half a century ago, the prescient Julio Cortázar launched his brand of what we today call "flash fiction": short stories that—plot, characters, obstacles, resolution, and all—burst into and out of existence, inspiring an encounter with the reader that is as short as it is explosive. Actually, Cortázar's stories would stay around for a while and continue to be widely read. No less colloquial than otherworldly in tone and strategy of address, these tales condense the sociality of urban Argentinian and Parisian café scenes within the renewed cycles of conviviality that beckon us in an epoch when global digital networks enshrine unprecedented possibilities for companionship (and animosity). Through its mode of address, then, this book has incited the reader to keep watch for those very flash fictions that we can intuit at a glance: those anonymous lines of poetry, amateur tunes, satirical spoofs, iconic images, quirky memes, whimsical performances, and oddball tales that go viral on YouTube, Vimeo, Twitter, Instagram, and the like.

Our media society and political landscape call for flash philosophy: critical thinking and theory-building that puts to work concepts that end up functioning a bit in the manner of Szymborska's raindrop and Benjamin's lush rosewater-hill-denomination—or, say, like a spoon, a door, a coat, or perhaps

even a piece of chocolate. These concepts have a degree of responsiveness and stretch that allows them to reach out to our historically embedded, politically ensconced sensorium and imagination and fuel our ties to people, things, and places. Shying away neither from things that happen without a moment's notice, nor from more even-paced regions where events unfurl slowly, these concepts prop up a philosophical language that has the flexibility and span required to travel through art forms, day-to-day occurrences, scholarly disciplines, and political life. The term "address," for now, looms large in that vocabulary.

In working out an aesthetics, ethics, and politics of address for this text that both recognizes tenacious blockages clutching to variables of social difference and identity and acknowledges less tightly strung possibilities for change, I have sought to affirm the tensions as well as correspondences between different perspectives. Under the banner of a unified concept of address, writers and artists have addressed their shared interest in address. A whole array of initially dispersed discourses now make up a joint inquiry, one that yields a new theoretical paradigm. We have in front of us a field for further meetings among divergent positions and for renewed rapprochements and frictions. Although modes of address are rarely translucent to their addressees, as indicated by our extended discussions of artworks and theoretical texts, address unlocks itself in marvelously rich ways to the curious addressor—opening out onto a capacious horizontal plane where art, theory, and the everyday stand on a par with each other.

ASSEMBLED FINDINGS

Given the inevitable demands on readers by a transdisciplinary idiom housed in lexicons other than the ones being rallied at a given moment, I want to succinctly bring together some of the insights that we have come upon in the course of this investigation. The first three have to do with basic aspects of address's functioning.

I. Basic workings

1. *Forms of address enact norms of address within structures, scenes, and scripts of address.* What jumps out from the many colloquial and artistic instances of address we have examined is the functioning of norms and forms in the context of structures, scenes, and scripts. These collaborating core devices are responsible for major jobs that address carries out: its operations as a vehicle for individual and collective agency, its distinctive relational workings, and its importance to aesthetic and political life.

2. Address makes up the nuts and bolts of our aesthetic relationships. Individuals and collectives are socially emplaced beings and entities whose trajectories through space and time materialize in forms of address that flow to and from other people and the material environment. Extending between subjects, between objects, between places, and between subjects, objects, and places, modes of address mobilize and organize the aesthetic relationships we undertake. They exercise these functions as carriers of norms of address and as elements embedded in structures, scenes, and scripts of address.

Forces of regulation and control, meanwhile, go together with moments of refraction and elusiveness. Constraint and freedom alternate with each other. Registers of power, difference, intimacy and distance, semantic plenitude and emptiness, inclusion and exclusion are under formation as we engage in address.

3. Address provides a newly spirited aesthetic view of culture. David Hume and Immanuel Kant offer large-scale visions of cultural development that enlist address as an mainstay of enlightenment and a pillar of an increasingly cosmopolitan aesthetic. Their aesthetics exhibit an amplified scope and spawn a wider set of ethical, political, and historical reverberations as soon as we acknowledge the role that address plays in their accounts. Their eighteenth-century perspectives—along with Michel Foucault's notions of critique, freedom, and intertwining modalities of power and knowledge—challenge us to design a more densely fleshed-out geopolitical and historical outlook on address. Theorists as diverse as Frantz Fanon, Walter Benjamin, Louis Althusser, Roland Barthes, Gloria Anzaldúa, and Judith Butler provide additional substantiation in the territory we have sidled into, where address—and with address, the aesthetic—is operative in the forging of fibers of culture. By delving into the nitty-gritty of artistic address as we strike up collaboration with works of art, we can imagine, think, feel, and create along yet further lines: we are in a position to apprehend the cultural domain from a newly spirited aesthetic perspective.

II. Distinctively aesthetic phenomena

1. Address can be a site of aesthetic incongruities. Julio Cortázar, Clarice Lispector, Jamaica Kincaid, and Pope.L highlight small-scale moments of aesthetic dissonance that can pop up in troubled schemes of address that stretch across nations and continents. These artists point to subtle tensions and fractures that traverse social constellations harboring people who struggle—who suffer and resist pernicious hierarchies and devastating sorts of violation and abandonment. These incongruous aesthetic occurrences can stem from a verbal interjection; abstract forms of auditory or visual perception, such as singling out pings or buttons; a flittering moth; some sudden singing upstairs; the movements of our eyelashes, fingernails, or elbows; or a whisper chanced upon in

the ether or the city. Alert to such events, we can see culture in action in its expansive global reach—as the vastly differentiated structure of address that it is—while also noting its operations in diminutive segments of our prosaic existence, where it not only runs smoothly in a manner that keeps intact an already-built momentum, but where we also, with some ingenuity, can create disruptions and give situations a twist, generating new energies. These incongruous happenings often enjoy an intricate standing at cross-sections of structures of address. A consideration of the detailed workings of norms and forms of address in this refractory arena sharpens the critical lenses that, drawing on philosophers such as Theodor Adorno and J. L. Austin, along with the theorists foregrounded in this book, we can bring to this realm.

2. *The concept of address clarifies the immersion of our day-to-day lives and the art world in aesthetic meaning.* Our framework of norms, forms, structures, scenes, and scripts of address gives us a vocabulary for theorizing the thorough saturation of our ordinary lives and the art world with aesthetic meaning. Norms and forms of address are at work in all the minute settings of our material engagements with the world. Cortázar acknowledges this in *Cronopios and Famas* with his images of the spoon and door that make demands on us. He recognizes the experiential, disciplinary, and potentially rebellious significance of the omnipresent, heterogeneous norms and forms surrounding us, by way of a narrator who demonstratively communicates to us the pain he is bound to feel upon rejecting the spoon's and the door's requests. *Cronopios and Famas* further underscores the prevalence of norms and forms of address in our lifeworlds by having us contemplate what it takes to say hello to a friend we meet in the street while so many comparable events have preceded that particular occasion. In a similar vein, no matter how far its perambulations take it, upon its departure from the epistolary mode, the adventurous line in "The Lines of the Hand" reiterates scenes and scripts from travel narratives, detective stories, romance novels, and murder mysteries (and, we can add, interior design, French Rococo painting, and urban architecture). Aesthetic dimensions mark all these sites of normativity and instances of historically entangled form: the aesthetic pervades language, people, things, and places, as well as the interactions between them, in a manner that the notion of address helps us to illuminate.

3. *Reading, seeing-as, and seeing-in are practices of address.* Interpreting artworks involves addressing and being addressed by them. We can conveniently see happenings in the sky as clouds. A pile of printed pages on a bench can appeal to us as a stack of sheets, a newspaper, or, for that matter, a wrapping to carry vegetables in. On a given morning, we might find delight in the "shoals of opaque eyes" we discern in the rows of buttons on people's bodies. The afternoon perhaps offers an occasion to enjoy (or be put off by) some elegant volutes detected in a trail of smoke. Cortázar's *Cronopios and Famas* stories herald an awareness of the sinewy contributions that the notion of address can make to

our grasp of certain influential philosophical concepts, particularly that of reading—that is, the interpretation of cultural productions—along with the concepts of seeing-as and seeing-in. By analyzing these distinctive activities and states in terms of the norms, forms, structures, scenes, and scripts of address that they conscript, we can recognize their contextual determinations and take into account how they recruit aspects of social and material regulation. Simultaneously, we can also bring out how these practices and experiences admit of an openness and a malleability that allow us to shape them in ways that move sideways from or overturn established relational patterns. By comprehending the pursuits of reading, seeing-as, and seeing-in on the model of address, we thus gain tools to account for their cultural underpinnings and productivity, and for gauging their importance.

III. Culture, cultural agency, and critique

Address carries out a variety of roles in the areas of culture, cultural agency, and critique. The following set of points revolves around these themes:

1. Culture as a source of demands. Reciting rule after rule, virtually from the beginning to the end of the story, Jamaica Kincaid's "Girl" suggests a view of culture as involving demands that we place on our own and others' modes of address. Culture, accordingly, is a highly specific, intensely productive practice of normatively operative forms of address. It is an order that resides in mechanisms of address.

Kincaid's narrative hints at the tight bonds that connect relationality, culture, the aesthetic, and address with each other: relationships require media; they are supported by modes of address. As the story's inventory of "dos" and "don'ts," of "this is how to" and "this is how not to" underscores, culture and the aesthetic profoundly enter into the "how-to" and the "how-not-to" of the relationships that we inhabit with language, people, things, and places. Culture and the aesthetic thus fundamentally enlist address as a productive force. Indeed, cultural practices *call for* certain configurations of address.

Nikolai Gogol's story "The Nose" corroborates this hortatory force and embraces the vagaries it sets into motion—the capricious and mysterious string of events with which life presents us, the obdurate, not altogether controllable paths along which our vulnerability to others unfolds, as well as the open-ended narratives that can affirm those elements. The empty spot in the middle of his face that Kovalyov is anxious to conceal demonstrates how standards of public address go to shore up the cultural order governing existence in the city of St. Petersburg. More than that, the unsightly surface that he wants to shield from his fellow citizens' scopic perusal reveals how centrally those norms of address and those sensitive sites of mutual, though asymmetrical corporeal

exposure revolve around aesthetic matters: they pertain, for example, to the way things look or feel; to what it might mean that they look or feel that way to us; and to the kinds of stories we tell about this.

2. *Our arts of address as providing resources for handling aesthetic, ethical, and political dilemmas.* Kincaid's young woman is a recipient of didactic modes of address, modes that apprise her of the requirements posed by her surroundings. She offers two instances of counteraddress in reply to these modes. Consequently, she shakes off the pedagogical regimen that she is expected to obey in a neocolonial world order shaped by race, gender, sexuality, class, ability, and age. The girl activates her arts of address to outstrip a constellation of address in which she takes part. These arts yield a vast reservoir of resources for negotiating the ethical, political, and aesthetic possibilities and challenges that we face as addressors and addressees populating contemporary cultural spaces.

3. *A ground of agency, critique, and freedom.* We inhabit constellations of address that, more often than not, both exhibit a responsiveness to our shaping efforts and display a capacity to outdo these endeavors. Neither altogether determined by nor wholly exceeding the matrices of address in which we are emplaced, our agency—at the level of the individual as well as the collective—is at its core a function of our capacities to adopt, create, and navigate modes of address.

Agendas of cultural critique centrally depend on the capabilities of modes of address to occasion changes in structures of address—a propensity Kincaid's protagonist astutely puts into effect. Artworks and other artifacts, as attested to by our discussions of stories, poetry, a novel, a performance video, a film, and a sound installation, are vital sources of critical aesthetic modes of address. These objects often point up sites of freedom. The kind of freedom in question tends to be a state that nourishes and is itself nourished by our ties to other people, things, and places, rather than propelling us away from these sustaining forces. In collaboration with the modes of address adopted by the audiences for cultural artifacts and ventured, more broadly, within those artifacts' contexts, aesthetic strategies of address can occasion desirable social changes and initiate unprecedented trajectories of freedom. Aesthetic forms of address flowing to and from cultural productions are indispensable ingredients of patterns of cultural agency and collectivity, elements to which we owe delicately hewn social configurations.

4. *A vehicle for the aesthetic, ethical, and political workings of artworks and other cultural productions.* Aesthetic modes of address, in works by Rosler, Oshima, Lispector, Pope.L, Kincaid, and Cortázar, challenge webs of aesthetic relationships along with the factors of social difference that suffuse them, such as templates of race, gender, and class. We thus see how modes of address can serve as vehicles for the at once aesthetic, ethical, and political meanings of cultural objects. More generally, artworks and other artifacts deploy ingenious modes of address to make their aesthetic, ethical, and political interventions

into the structures of address in which these cultural productions are emplaced. The notion of address proves to be a productive tool for identifying these actions and processes.

5. *A key tool of cultural criticism and analysis.* The apparatus of address undergirds the zone of functioning where cultural productions meet with their publics. Indeed, mechanisms of address prop up the encounters between artworks and the receptive and experiential proclivities that publics bring to these objects. Norms, forms, structures, scenes, and scripts of address, in short, go to shape the ways in which cultural artifacts play into audience propensities as well as the responses that audiences make to cultural artifacts. The concept of address is a key instrument of cultural criticism and analysis.

6. *The contingency of criteria of successful address.* While I have demonstrated the centrality of address to cultural agency, critique, and freedom, my intent has not been to defend particular criteria of successfully critical, aesthetic, moral, or political address, which, by the force of my argument, have to emerge within site-specific constellations of address, and the norms, forms, structures, scenes, and scripts that these arrangements entail. In general, criteria of adequacy do not lend themselves to being established in abstraction from the field of address that they purportedly govern. With this point, I do not wish to deny the importance of normative generalizations. Rather, I want to acknowledge the vigorous interplay with concrete circumstances that fundamentally informs their fruitfulness. By developing an analytical paradigm for comprehending the workings of address, I have crafted a conceptual framework that can assist us in more abstract inquiries into norms, without, however, comprising a substantial and satisfactory defense of such norms itself.

IV. Further social, cultural, aesthetic, and epistemic functions

Completing the quick, item-by-item guide to a transdisciplinary field of occupations presented here, I will offer one final series of vignettes. These items pertain to a diverse array of additional facets of address's social, cultural, aesthetic, and epistemic functioning:

1. *A bedrock of aesthetic publicity.* Hume and Kant place address at the core of visions of public life. In his sound and performance installation *Whispering Campaign*, Pope.L mobilizes disjunctive forms of whispered address to reconfigure public platforms for aesthetic production, reception, and exchange. Address grounds constellations of aesthetic publicity.

2. *A pillar of subjectivity, materiality, institutionality, technology, and desire.* Shaping webs of relationality and the orientations they sustain, the mechanisms of address have their hands in the conditioning of phenomena such as configurations of subjectivity, materiality, institutional existence, technology, and desire.

3. A force of creativity, invention, and play. Writings by authors as diverse as Kincaid, Szymborska, Cortázar, and Gogol bring out finely wrought facets of creativity, invention, and play that inhere in modalities of address. As attested to by Cortázar's figures of the abstractionist functionary, the toothpaste-wielding cronopio, the traveling line, and the metamorphosing newspaper, playful modes of address are a buoyant source of social and material plasticity that can foment invigorating bonds among people, people and things, and things.

4. An instigator of new ties between language, aesthetic idioms more generally, and the world. Refueling but also slimming down language's capabilities—and, by extension, those of other aesthetic idioms—modes of address can amplify or restrict the orbit of possibilities stretching out between the poles of words or aesthetic forms, the people handling them or exposed to them, things, and places. We count on repertoires of insurgent, intricately designed modes of address—both existing and yet to be devised—to reactivate and renew the potentialities of language and other aesthetic media.

5. An instrument of a decolonial, critical race feminist aesthetics. Address, as testified to by work by Kincaid, Cortázar, Lispector, and Pope.L, can help us unyoke contemporary cultural formations from coloniality, conceived of as a constituent of modernity. It is an imminently fruitful device we can enlist in the project of dislodging regimens of time and space associated with (neo)colonial topographies and histories. More than that, as attested to by Rosler's and Oshima's pieces, the notion of address illuminates the interventions of cultural productions in social configurations marked by race, gender, and other intersecting factors. Newly aestheticized conceptions of social identity and difference come to light. Cosmopolitan arrangements as well as mutually constitutive interactions between the local and the global reveal a restless dynamism. Theoretical approaches likewise emphasize the multilayered registers of activity and power in which address takes part.

Accordingly, the concept of address is of the essence to the agenda of a decolonial, critical race feminist aesthetics. Whereas the concrete contours of this position, as I have noted, do not lend themselves to stipulation in the abstract (and my project, again, has not been to make the case for particular forms of desirable address), this stance subscribes to a concern for justice in the arena of culture. It spawns intersectional perspectives on and engagements with the social field. It understands modernity as embroiled with coloniality. This outlook, in principle, seeks to take cognizance of the multiple, interwoven registers of power and parameters of social difference and identity that are operative in given circumstances. The concept of address beckons vociferously within the horizons of a decolonial, critical race feminist aesthetics.

6. Going for bits and pieces, splinters and margins, as a strategy of critical aesthetic address—and onward. Many artists exploit the refractory potentialities of details and of minuscule snippets of space and time. Through this

strategy of address, they challenge the underpinnings of colonial modernity in its entwinements with race, class, and gender. Take Macabéa, the subaltern protagonist of *The Hour of the Star*. A negligible being herself, she is in love with aesthetic marginalia. She relishes the pings she audits via the radio. Think of the minute motions in the street that are the lot of Cortázar's narrator. And recall the "pieces of tears" that Pope.L has entered into his *Love Text*. Kincaid's disassembly of cultural authority into a roster of commands likewise amplifies diminutive sites of critical resistance. These artists bring to a state of unsettlement the temporal and spatial organization that is constitutive of our racialized, class-inflected, and gendered state of colonial modernity. Address is vital to this practice of destabilization and reorientation, which can make room for unanticipated consolidations—crystal "bricks" that take new forms.

7. A critical political aesthetics. If one factor binds together the different theorists and artists populating this book, it is their belief in the powers of address as a mechanism of critical aesthetic intervention that finesses the multitudinous sites where politics take shape. From bricks to wet leaves, from floating pink toothpaste to enticing breads, political form and substance materialize in our strategies of aesthetic address.

◉ ◉ ◉

For many centuries, theorists and artists have ascribed great significance to address. Yet a systematic treatment of our topic has been lacking. Elucidating address's mechanisms and the expansive array of functions it carries out, this book has sought to fill this vacuum.

Having initially linked the notion of address to that of signification—understood in a broad sense as directed at and by people as well as things, in ways that can be intended or nonintended—I have subsequently tied it in a multiplicity of ways to a matrix of jointly functioning norms, forms, structures, scenes, and scripts. This apparatus undergirds shifting patterns of directions and relations and evolving configurations of normativity. Its effects make their presence felt in settings across the arts, politics, and social existence.

Putting the concept of address to use in divergent interpretive and explanatory contexts, I have given it increased articulation and substantiated its import. Indeed, acknowledging the fundamental alliances that the notion sustains with the paradigm of collaborating core elements, we can now understand it to refer to the procedures that that framework postulates along with the potentialities to which that model gestures. The concept of address denotes the anatomical makeup of a vast polymorphous field.

Although the nomenclature of forms, structures, scenes, and scripts has been in circulation, until now these elements have not received adequate theorization. The term "norms of address" is our new addition to the existing lexicon. This notion has appeared to be no less fundamental than the other, perhaps

more familiar building blocks of the concept of address. It is a principal ingredient of this account alongside the four other components. Norms of address are pivotal junctures within the vortex of powers inherent in address. The interconnected labors of the five central devices stand out in many concrete instances. The different constituents need each other to do their work. They function in toto. While it is one thing to draw on a few of the elements of address in a specific context where we set the notion of address to work, it is quite another to theorize their more or less subdued, more or less tempestuous interlinkages. A view that, besides examining forms, structures, scenes, and scripts, also maps out the entwined functioning that these elements realize, together with norms of address, places us in a position where we can reckon with the dynamism, the pliancy, and the pluridimensionality that this book's investigation has pointed up.

Highlighting the key constituents that address has at its disposal and examining their collaborations, I have developed a synthetic view of address, one that identifies elements and procedures that scholars hint at by way of a broad array of analytical vocabularies. Our basic conceptual model has proven to be at work across a range of less comprehensive outlooks on facets of address. Not surprisingly, parallels have arisen between the writings of different theorists, the works of art of different artists, and theory and the arts. We have unearthed previously unrecognized aspects of artworks and revealed new angles in scholarly accounts. Links have arisen among multiple aspects of address: its aesthetic significance, its ubiquity, and its workings as an orchestrator of public life. Reaching across art, politics, theory, and day-to-day existence, our discussions testify to the vitality of address as a tool of analysis and a force of cultural agency. The notion of address turns out to be central to a critical rethinking of culture, aesthetics, and the social.

While there is no single foundational text or artistic movement in relation to which inquiries into address can situate themselves, scores of sources represent explicit or implicit stances on enduring questions about address. As the range of topics, figures, and works traversed intimates, this book has carved out a lively, transdisciplinary field of investigation.

Further insight into address flows lavishly from myriad quarters. For my purposes here, however, suffice it to have developed a basic framework for analyzing address, one that demonstrates the notion's productivity and strengthens our grasp of its powers as a site of agency and critical inquiry. Inspired by many before us and captivated perhaps also by some shrewd fictional characters, we can set out to unravel or dislodge—or even to embrace and magnify—the complexities of address. These entanglements, after all, make us who we are, as individuals and as cultures.

NOTES

Introduction

1. Since the 1960s and '70s, the overwhelming tendency in the theory of art, media, and literature has been to pay sparse explicit attention to the evaluative registers of aesthetic meaning and experience. The late 1990s brought a shift as ethics came to prominence in the field and aesthetics underwent a renewal, especially in connection with politics. Yet the slimmed-down standing of normativity remains a conspicuous feature of the contemporary theoretical landscape. From the side of philosophy, normative frameworks that meet contemporary art with the required finesse have not been forthcoming. The result is a dearth of artistically (and, more generally, aesthetically) relevant reflection on normativity, which this study aims to address. Not entirely unrelatedly, the field of sexuality studies has elided and narrowed a whole ambit of normative considerations under the banner of queer antinormativity. On this commitment and the question of what queer studies might look like without it, see the "Queer Theory Without Antinormativity" special issue of *differences: A Journal of Feminist Cultural Studies* 26, no. 1 (2017). For a discussion of the complexities of norms overlooked by the antinormative paradigm, see Robyn Wiegman and Elizabeth A. Wilson, "Introduction: Antinormativity's Queer Conventions," *differences* 26, no. 1 (2017): 1–23 [11–18]; and Annamarie Jagose, "The Trouble with Antinormativity," *differences* 26, no. 1 (2017): 24–47 [35–44].
2. This is recognized within a tradition of reflection on freedom that includes philosophers such as Jean-Jacques Rousseau, G. W. F. Hegel, and Karl Marx, and the poet/theorist Audre Lorde. For a recent argument, see Cynthia Willett, *Irony in the Age of Empire: Comic Perspectives on Democracy and Freedom* (Bloomington: Indiana University Press, 2008), 4–17, 116–47.
3. This is not surprising, especially if we associate disciplines with forms of address. For an approach along this line, see Ellen F. Rooney, "A Semiprivate Room," *differences* 13, no. 1 (2002): 128–56 [129–39].

4. Gloria Anzaldúa, *Borderlands/La Frontera: The New Mestiza* (San Francisco: Spinsters/Aunt Lute, 1987), 16 (my translations).
5. The free indirect style concerns language that, although mediated by a narrator, in contrast to direct discourse, is unembedded in that narrator's reportage. The reader thus encounters the represented point of view relatively directly, at a remove from the narrator's commentary.
6. While this ringing out from objects involves a metaphorical dimension and differs from the ringing in the voices of people, this metaphorical aspect also points to a literal element that merits theoretical exploration. By means of the language of address, I wish to recognize both components, even if spelling out and fully theorizing what they precisely amount to goes beyond the scope of this book. See also note 29 of this introduction.
7. On the fusions and divisions that free indirect discourse can engender between narrator and character, individual viewpoint and collective *doxa*, standard and colloquial languages, and a character's contrastive perspectives, see Franco Moretti, *The Bourgeois: Between History and Literature* (Brooklyn, NY: Verso, 2013), 98–100; Henry Louis Gates Jr., *The Signifying Monkey: A Theory of African-American Literary Criticism* (New York: Oxford University Press, 1988), 191–92, 202–3, 206–15, 248–50; Barbara Johnson, "Metaphor, Metonymy, and Voice in *Their Eyes Were Watching God*," in *A World of Difference* (Baltimore: Johns Hopkins University Press, 1987), 171.
8. We see here how address, for Anzaldúa, encodes aspects of the multiplicity of being-between-worlds and becoming-with underscored by Mariana Ortega in *In-Between: Latina Feminist Phenomenology, Multiplicity, and the Self* (Albany: State University of New York Press, 2016) and lodges us in the midst of the collaborative, affective/sensory process of critical social and self-reflection described by Andrea J. Pitts in "Gloria E. Anzaldúa's *Autohistoria-teoría* as an Epistemology of Self-Knowledge/Ignorance," *Hypatia* 31, no. 2 (2016): 352–69 [357–66].
9. Anzaldúa, *Borderlands/La Frontera*, 16.
10. Indeed, Anzaldúa's use of free indirect discourse, I would argue, enacts the three different interwoven moments that Cynthia Paccacerqua reveals are part of Anzaldúa's logic of *volverse una*, or, becoming whole. Cynthia M. Paccacerqua, "Gloria Anzaldúa's Affective Logic of *Volverse Una*," *Hypatia* 31, no. 2 (2016): 334–51.
11. Anzaldúa speaks in different words to these and other factors. Anzaldúa, *Borderlands/La Frontera*, 16–21.
12. Judith Butler underscores our exposure to address and emphasizes how address predates the presence of individual addressors and addressees. Judith Butler, *Giving an Account of Oneself* (New York: Fordham University Press, 2005), 34–35, 38, 53, 63, 69–70, 77–78. On the differential distribution of such exposure, see Judith Butler, *Precarious Life: The Powers of Mourning and Violence* (London: Verso, 2004), 20, 30. Relatedly, M. M. Bakhtin discusses our appropriation of words from other people's mouths and from the previous contexts of the words' use. He describes a complex process of adaptation whereby language can gradually become our own. M. M. Bakhtin, *The Dialogic Imagination: Four Essays*, ed. Michael Holquist, trans. Caryl Emerson and Michael Holquist (Austin: University of Texas Press, 1981), 293–94. On our perceptual, cognitive, linguistic, and aesthetic participation in a world of corporeal, cultural interaction that precedes us, see also Maurice Merleau-Ponty, *Phenomenology of Perception*, trans. Colin Smith (New York: Routledge, 1962), 137, 186–88, 193–94.
13. There is, of course, substantial overlap between these fields. With that proviso, a short sample from several areas will be useful. Perspectives in feminist film and literary theory and criticism featuring the concept include Johnson, *A World of Difference*; Hazel V. Carby, *Reconstructing Womanhood: The Emergence of the Afro-American Woman Novelist* (New York: Oxford University Press, 1987); Miriam Hansen, *Babel and Babylon: Spectatorship*

in American Silent Film (Cambridge, MA: Harvard University Press, 1991); Mary Ann Doane, *Femmes Fatales: Feminism, Film Theory, Psychoanalysis* (New York: Routledge, 1991); Rooney, "Semiprivate"; and Peggy Kamuf, *Book of Addresses* (Stanford, CA: Stanford University Press, 2005).

Approaches in critical race theory and postcolonial theory include Gloria E. Anzaldúa, "Speaking in Tongues: A Letter to Third World Women Writers," in *This Bridge Called My Back: Writings by Radical Women of Color*, 3rd edition, ed. Cherríe L. Moraga and Gloria E. Anzaldúa (Berkeley, CA: Third Woman Press, 2002); Gayatri Chakravorty Spivak, "Can the Subaltern Speak?" in *Marxism and the Interpretation of Culture*, ed. Cary Nelson and Lawrence Grossberg (Urbana: University of Illinois Press, 1988); Homi K. Bhabha, *The Location of Culture* (New York: Routledge, 1994); and Dina Al-Kassim, *On Pain of Speech: Fantasies of the First Order and the Literary Rant* (Berkeley: University of California Press, 2010).

Philosophical approaches include Adriana Cavarero, *Relating Narratives: Storytelling and Selfhood* (New York: Routledge, 2000); María Lugones, *Pilgrimages/Peregrinajes: Theorizing Coalition Against Multiple Oppressions* (Lanham, MD: Rowman and Littlefield, 2003); Butler, *Giving an Account*; Stephen Darwall, *The Second-Person Standpoint: Morality, Respect, and Accountability* (Cambridge, MA: Harvard University Press, 2006); Monique Roelofs, *The Cultural Promise of the Aesthetic* (New York: Bloomsbury, 2014); and Richard Moran, *The Exchange of Words: Speech, Testimony, and Intersubjectivity* (New York: Oxford University Press, 2018).

14. Benjamin incipiently articulates this view, which he elaborates in multiple contexts, in "A Berlin Chronicle," in *Selected Writings*, vol. 2: *1927–1934*, trans. Rodney Livingstone and others, ed. Michael W. Jennings, Howard Eiland, and Gary Smith (Cambridge, MA: Harvard University Press, 1999), 595–99. See also Roland Barthes, *The Pleasure of the Text*, trans. Richard Miller (New York: Hill and Wang, 1975), 4–6, 25–27.
15. Maurice Merleau-Ponty, "The Intertwining—The Chiasm," in *The Visible and the Invisible*, trans. Alphonso Lingis (Evanston, IL: Northwestern University Press, 1968), 143; see also, e.g., 133. Maurice Merleau-Ponty, *Phenomenology of Perception*, 360; see also, e.g., 319. Maurice Merleau-Ponty, "Eye and Mind," in *The Primacy of Perception and Other Essays on Phenomenological Psychology, the Philosophy of Art, History, and Politics*, ed. James M. Edie, trans. Carleton Dallery (Evanston, IL: Northwestern University Press, 1964), 167, 178, 186. Maurice Merleau-Ponty, *Signs*, trans. Richard C. McCleary (Evanston, IL: Northwestern University Press: 1968), 45, 57, 73.
16. Louis Althusser, "Ideology and Ideological State Apparatuses (Notes Toward an Investigation)," in *Lenin and Philosophy, and Other Essays*, trans. Ben Brewster (New York: Monthly Review Press, 1971).
17. Butler, *Giving an Account*, 19–20, 53–60, 63–82, 97–101, 132–36.
18. Judith Butler, *Notes Toward a Performative Theory of Assembly* (Cambridge, MA: Harvard University Press, 2015), 9–17.
19. María Lugones, "On Complex Communication," *Hypatia* 21, no. 3 (2006): 75–85 [82–83].
20. Barbara Johnson, *Persons and Things* (Cambridge, MA: Harvard University Press, 2008).
21. Barbara Johnson, "The Frame of Reference: Poe, Lacan, Derrida," in *The Critical Difference: Essays in the Contemporary Rhetoric of Reading* (Baltimore: Johns Hopkins University Press, 1980), 117–18. John Irwin reads Johnson's analysis in terms of the aporetic last word that says there is no such thing as a last word. John T. Irwin, *The Mystery to a Solution: Poe, Borges, and the Analytic Detective Story* (Baltimore, MD: Johns Hopkins University Press, 1994), 9.
22. Patricia J. Williams, *The Alchemy of Race and Rights: Diary of a Law Professor* (Cambridge, MA: Harvard University Press, 1991), 7–13, 19, 26, 33–34, 156–65, 224–26; Patricia J.

Williams, *Seeing a Color-Blind Future: The Paradox of Race* (New York: Farrar, Straus and Giroux, 1997), 40–43.

23. These modes carry wide-reaching normative reverberations. Gregor's address to the door key (which he turns with his mouth) corresponds with his mother's address to the coffee pot (her pushing it over when bumping into the breakfast table as Gregor emerges from his room) in that both forms of address get brown liquids to drip onto the floor. This analogy calls into question distinctions between the neither wholly human nor altogether nonhuman orifices connoted by mouth and coffee pot, between the ambits of bodily experience and material artifact, and between the spheres of intentional animal agency and involuntary human response. The maid ultimately sweeps the bug's dead body away, like trash or dirt. With the evolving forms of address directed at and assumed by Gregor, Kafka causes the partitions inherent in various categories to waver. These categories include class position (e.g., the family's and the maid's), gender difference (think of the father's throwing apples and the mother's shrinking back), and oppositions such as those between person and nonperson, living being and thing, food and nonfood, useful object and disposable element, bounded entity and dispersed stuff. Other distinctions that come under pressure are those between, on the one hand, rebel or victim and, on the other, boss, patriarch, petty bureaucrat, or collaborator in oppression. Franz Kafka, "The Metamorphosis," in *The Metamorphosis and Other Stories*, trans. Willa and Edwin Muir (New York: Random House, 1995). For further discussion of the relevant modes and their ethical, political, and aesthetic import, even if this analysis does not explicitly deploy the terminology of address, see Monique Roelofs, "Taste, Distaste, and Food," in *Encyclopedia of Food and Agricultural Ethics*, ed. Paul B. Thompson and David M. Kaplan (Dordrecht: Springer, 2014; online version 2013, doi 10.1007/978-94-007-6167-4).

24. The lexicon of forms and modes of address is most common. Johnson refers to structures of address in "Thresholds of Difference: Structures of Address in Zora Neale Hurston," in *A World of Difference*. See also Johnson, "Frame of Reference" for the idiom of structures and scenes. The term "script of address" posits a small-scale regulatory structure that is at work in a scenario of address, so we can see this notion as proximate to that of a structure. The concept of a "scene of address" surfaces implicitly in the Derridean terminology of the "scene of writing" (see, e.g., Johnson, "Frame of Reference," 116) and in the common idea of an interlocutionary scene. Butler uses the language of scenes and structures of address widely in *Giving an Account* (see, e.g., 9, 12–13, 36, 39). She links address closely to norms, but for her it is norms of intelligibility and recognizability that are at issue (24–26, 30). These, I would argue, imply norms of address but are not equivalent to them. For an initial deployment of my proposed lexicon, see Roelofs, *Cultural Promise*, 1, 17, 24–25, 215n22.

25. In Roelofs, *Cultural Promise* I follow this approach.

26. I elaborate the notion of the aesthetic sketched here in Roelofs, *Cultural Promise*, 1–2, 8–10, 25–28, 209–11.

27. For an understanding of constellations of gender, race, class, sexuality, and coloniality in terms of structures of aesthetic relationality, see Roelofs, *Cultural Promise*. On links between forms of aesthetic relationality and facets of our being alive to language and the world, see pp. 7, 179.

28. A decolonial, critical race feminist aesthetics comprises an expansive, critical aesthetic enterprise. It is a project of social critique and agency. Its scope is contingent on actual historical moments and cultural or aesthetic locations, and hence open-ended. Although the concrete forms this program takes cannot be anticipated, we can provisionally identify themes and strategies that fall under it. Artists, theorists, and other practitioners have done so implicitly over a great many decades. The present analysis accordingly aims to make a contribution to a critical endeavor that is already being enacted and shaped by many voices

and stances. In allying this approach with a concern for justice and equity, I do not mean to reduce aesthetic phenomena to moral, political, and economic ones, but to gesture toward the many evolving intertwinements among the various dimensions—aesthetic, social, and epistemic, as well as moral, political, and economic ones—that are pertinent to the critical perspective adumbrated here.

29. It may be argued that the language of address is metaphorical when it concerns the address toward and from things and events (as opposed to that, strictly speaking, by people toward people). I would certainly agree that this language includes metaphorical elements, but also want to recognize a literal dimension whose content, force, and implications stand in need of analysis. Exploring the request made by a spoon or door, Julio Cortázar, as I shall indicate in chapter 3, sheds light on the address by and toward artifacts.

30. See, among other works, Walter Benjamin, *The Arcades Project*, trans. Howard Eiland and Kevin McLaughlin (Cambridge, MA: Belknap Press of Harvard University Press, 1999); Benjamin, "Berlin Chronicle," 597–606, 611–17; 628–29, 634–35; Johnson, *Persons and Things*; Merleau-Ponty, *Phenomenology of Perception* and "Intertwining."

31. Jacques Rancière, *The Politics of Aesthetics*, trans. Gabriel Rockhill (New York: Continuum, 2004), 15, 39; Jacques Rancière, *Aesthetics and Its Discontents*, trans. Steven Corcoran (Malden, MA: Polity, 2009), 9–10, 13; Jacques Rancière, *The Emancipated Spectator*, trans. Gregory Elliott (London: Verso, 2009), 8–23, 61, 69–70, 102; Johann Gottlieb Fichte, *Foundations of Natural Right*, ed. Frederick Neuhouser, trans. Michael Baur (Cambridge, UK: Cambridge University Press, 2000), 29–52; Johann Gottlieb Fichte, *Addresses to the German Nation*, trans. Gregory Moore (Cambridge, UK: Cambridge University Press, 2008); G. W. F. Hegel, *Phenomenology of Spirit*, trans. A. V. Miller (Oxford, UK: Oxford University Press, 1977); Bakhtin, *Dialogic Imagination*, 67–68, 82, 279–96, 324, 331–32, 366–70; Gilles Deleuze, *Cinema 2: The Time-Image*, trans. Hugh Tomlinson and Robert Galeta (Minneapolis: University of Minnesota Press, 1989), 150, 217; see also 148–55, 183–84, 187–88; and 215–24. J. L. Austin, *How to Do Things with Words*, second edition, ed. J. O. Urmson and Marina Sbisà (Cambridge, MA: Harvard University Press, 1962); Rae Langton, "The Authority of Hate Speech," in *Oxford Studies in Philosophy of Law*, vol. 3, ed. John Gardner, Leslie Green, and Brian Leiter (Oxford, UK: Oxford University Press, 2018); Johnson, *World of Difference*. For pertinent texts by Johnson and Merleau-Ponty, see also notes 15 and 24 of this introduction. For discussion of some aspects of Johnson's and Rancière's views of address, see Roelofs, *Cultural Promise*, 7–8, 24, 217n39. Given that my aim in these two volumes is to develop a theoretical framework, and not in the first instance—or much more minimally—to provide a history of ideas, I will leave aside several of the approaches mentioned here or engage them only partially. To speak with Johnson, what I am after with these books is not to have the "last word" on the conceptual field embedding the notion of address or on the many valuable contributions to this field, but rather to offer an analysis of several important attributes and workings of address and to foster and enter into an open-ended dialogue.

32. I will also not be developing and defending standards for adequate address, and will refrain from outlining criteria for the precise directionalities encoded in forms of address.

33. This tendency is visible in writers as diverse as Austin, in *How to Do Things*; Judith Butler, in "Performative Acts and Gender Constitution: An Essay in Phenomenology and Feminist Theory," *Theatre Journal* 40, no. 4 (1988): 519–31; Bhabha, in *Location of Culture*; and Rae Langton, in *Sexual Solipsism: Philosophical Essays on Pornography and Representation* (New York: Oxford University Press, 2009).

34. Miriam Hansen's discussion of the concept of the empirical audience in the introduction to *Babel and Babylon* outlines some of the complexities that come into play here. Analogous considerations to the argument I have voiced apply to the idea that address is first

and foremost a matter of the ties between a cultural object and its intended audience. A more sophisticated version of my argument can be advanced against the proposal that address concerns primarily an implied or hypothesized audience. Neither of these views is substantial enough to recognize the historical, normative, and interpretive/experiential complexities at hand in the field where objects and publics come into being and meet.

35. Of relevance here are the (heteronomous) social import that Adorno grounds in art's autonomy and the broken promise of happiness that he attributes to art. Theodor W. Adorno, *Aesthetic Theory*, trans. Robert Hulot-Kentor (Minneapolis: University of Minnesota Press, 1997). Foucault offers his layered conception of tremendously diversified, interacting registers of power and knowledge in part as an antidote to the presumed pitfalls of a less complex view of sexuality as an object of repression that is to be liberated. Michel Foucault, *The History of Sexuality*, vol. 1: *An Introduction*, trans. Robert Hurley (New York: Vintage, 1978).
36. Anzaldúa, *Borderlands/La Frontera*, 66–69.
37. Aristotle, *Rhetoric*, in *The Complete Works of Aristotle*, vol. 1, ed. Jonathan Barnes (Princeton, NJ: Princeton University Press, 1984), Bk 1, $1356^{b}27$–$57^{a}7$; Bk 3, $1414^{a}8$–10.
38. Quintilian, *Institutio Oratoria*, vol. 3, trans. H. E. Butler (New York: Putnam, 1921), Bk 9, 2: 375, 377, 397.

1. Addressing Address

1. Jamaica Kincaid, "Girl," in *At the Bottom of the River* (New York: Penguin, 1992): 4–5. First published in *The New Yorker*, June 26, 1978.
2. The story creates a temporal sequencing of speech acts, so it does qualify as a narration even in a narrow sense of the term.
3. Kincaid, "Girl," 3, 5. On the assumption that the instructions issue from someone's voice, their deictic or indexical dimension within the fiction—that is, their designation of ways of doing things (as in "this is how to . . .")—pronouncedly includes a reference to a nonverbal component involving multimodal forms of address on the part of the person(s) we can imagine to articulate the dictates. By interpolation, we can also take the imperatives ("Wash the white clothes . . .") to be encoded in prescribed actions, rather than amounting solely to verbal commands. Perhaps in some instances the directives do not even involve explicitly verbal articulation. I'm presupposing here that the voice pronouncing the commands is not merely playing itself out in the girl's head, which would also be a possibility. In that case, we can take the girl to be imagining the multimodal modes of address denoted by the directives.
4. Kincaid, "Girl," 3–4. In one of the scarce scholarly sources on benna, Lorna McDaniel characterizes it as a "satiric folk song" that became the basis for early Antiguan calypso. McDaniel mentions a benna by the singer Quarkoo that promulgated politically salient news about a pregnancy that went against religious mores, and notes how the song landed the singer in prison. She also describes Short Shirt's 1977 album *Harawee* as an effort to "revitalize" the benna. In its new form, by which I assume she means the calypso, McDaniel observes that benna emphasizes "political and racial consciousness," including an awareness of oppressive conditions in Angola, Zimbabwe, and Antigua, as in the song "Freedom" by the Antiguan calypso artist Mighty Swallow. Lorna McDaniel, "Antigua and Barbuda," in *The Garland Encyclopedia of World Music*, vol. 2, ed. Dale A. Olsen and Daniel E. Sheehy (New York: Routledge, 2013), 800. The musical genre Kincaid alludes to in the story, which was first published in 1978, can thus be understood to embody socially

critical meanings. Given its narrative context, benna, as Kincaid refers to it, would simultaneously (and perhaps as a part of its political import) seem to carry sexually explicit connotations. For a discussion of benna's appearance in the story as a calypso that uses the language of gossip, see Simone A. James Alexander, "M/Otherly Guise or Guide?: Theorizing Jamaica Kincaid's 'Girl,'" in *Feminist and Critical Perspectives on Caribbean Mothering*, ed. Dorsía Smith Silva and Simone A. James Alexander (Trenton, NJ: Africa World Press, 2013), 213–14. For a brief reference to benna as a postcolonial form in the context of an analysis of women's calypso performances, see Denise Hughes-Tafen, "Women, Theatre, and Calypso in the English-Speaking Caribbean," *Feminist Review* 84 (2006): 48–66 [52].

5. See, for example, Diane Simmons, "The Rhythm of Reality in the Works of Jamaica Kincaid," *World Literature Today*, 68, no. 3 (1994): 466–72.
6. Kincaid, "Girl," 3.
7. Imaginative identification with fictional characters, as is widely recognized, often takes place across gender boundaries, among other lines of difference.
8. The depersonalization of the mother figure also entails a displacement onto the field of address of the propensity to transmit culture and language, a task prominently allocated to mothers, in accordance with pervasive cultural myths.
9. I shall return to this point in the sequel to this book, *Aesthetics, Address, and the Making of Culture*.
10. Kincaid, "Girl," 4.
11. Kincaid, "Girl," 4.
12. Kincaid, "Girl," 5.
13. Especially relevant with regard to the neocolonial underpinnings of the relationships in question is the regulative role that the rules play as instruments of a modern temporal and spatial order. The girl is expected to assist in an adequate choreographing of the material environment, a continued effort that is of the essence to her prospect of becoming a supposedly acceptable or respectable woman. On the entwinements of modern epistemic schemes with constellations of coloniality, including certain delineations of time and space, formations of social and political hierarchy, and systems of expropriation, see Aníbal Quijano, "Coloniality and Modernity/Rationality," trans. Sonia Therborn, *Cultural Studies* 21 no. 2-3 (2007): 168–78. For an incisive exploration of Kincaid's postcolonial engagement with philosophical constructions of space and time in *At the Bottom of the River*, the collection of stories that opens with "Girl," see Jana Evans Braziel, *Caribbean Genesis: Jamaica Kincaid and the Writing of New Worlds* (Albany: State University of New York Press, 2009), 57–77.
14. The concept of aesthetic relationality serves to acknowledge the relational emergence and productivity of aesthetic phenomena. That is, it understands aesthetic matters as fundamentally relational formations and approaches relationships among subjects, among subjects and objects, and among objects as involving aesthetic components. The aesthetic itself owes its nature to the web of relations and address in which it functions. See Monique Roelofs, *The Cultural Promise of the Aesthetic* (New York: Bloomsbury, 2014), 1, 8, 10, 210–11.
15. Kincaid, "Girl," 5.
16. Kincaid, "Girl," 3, 5, 4.
17. The term "kettle logic" refers to a set of mutually exclusive premises advanced in defense of an action, justifications that, as a result of their incompatibility, collectively undermine each other. Freud elucidates this kind of faulty reasoning with the anecdote of a neighbor who, accused of breaking the kettle he borrowed, replies that he never borrowed it, that it was already broken when he got it, and that he returned it intact. Sigmund Freud, *The*

Interpretation of Dreams, 1900, in *The Standard Edition of the Complete Psychological Works of Sigmund Freud*, vol. 4, trans. and ed. James Strachey (London: Hogarth Press, 1955), 119–20. The accumulation of irreconcilable assertions disproves the neighbor's argument rather than strengthening it. Freud observes that the appearance of logic that results when considering each statement in isolation conceals a piece of defective reasoning, and takes this incoherence to exemplify a mode of thought characteristic of the unconscious, something that is partially responsible for its comical effect. Sigmund Freud, *Jokes and Their Relation to the Unconscious*, 1905, in *The Standard Edition*, vol. 8, trans. and ed. James Strachey (London: Hogarth Press, 1960), 62, 71–72, 206, 254–55. In its redundancy, the girl's twofold rejection of the pedagogue's insinuation likewise suggests that she intends her apology to cover up the validity of a different kind of story that would more accurately describe the kinds of things she does (or doesn't do) in Sunday school. Kincaid hints humorously and ever so slightly that it is something else the girl is up to on Sundays.

18. Kincaid, "Girl," 8.
19. This is also a gendered framework of racialized colonial address. In the context of various literary texts and archival documents, Gayatri Spivak recognizes constructions of sexual difference along with attendant figurations of subjectivity and humanity that apply differentially across colonial lines. Among the instances of our colonially inflected, asymmetrical relations to norms of femininity and human standing are cases in which gender or sexual difference is marked only with respect to white colonizers and not, or no more than inchoately, in regard to the colonized. Spivak draws attention to the multiple framings of disparate speaking positions that underwrite reiterations or critiques of imperial constellations of gender and that, alternatively or beyond that, support displacements of imperialist and gendered assumptions to create room for postcolonial constructions of female subjectivity, or to bring out aporias and unsurpassable margins that prevent the relevant frames from lining up with one another in a continuous narrative space. Gayatri Chakravorty Spivak, *A Critique of Postcolonial Reason: Toward a History of the Vanishing Present* (Cambridge, MA: Harvard University Press, 1999), chapter 2. In Kincaid's story, we can recognize a similar fissuring of sites of enunciation and subject positioning around the frames of the metropolitan language and the official institutions of education and religion, on the one hand, and, on the other, of the quotidian arrangements in the former colony (including elements of Afro-Caribbean cosmologies going back in part to West African lifeworlds and systems of thought), with the pedagogue's and the girl's voices and the day-to-day events neither stably allocable within the former, nor in the latter.

 María Lugones coins the term "modern colonial gender system" to account for the differential allocations of gender (and, correlatively, of nongendered and human/nonhuman status) that formations of colonial modernity entail for white hegemonic individuals and for nonwhite colonized subjects and certain classes of nondominant white subjects. María Lugones, "Heterosexualism and the Colonial/Modern Gender System," *Hypatia* 22, no. 1 (2007): 186–209.

 The principled elusiveness of gender identity is recognizable in accounts by theorists as diverse as Simone de Beauvoir, Jacques Lacan, Luce Irigaray, and Judith Butler. I should note that when speaking of femininity and female embodiment or subjectivity and, more generally, when deploying gender designations, I do not subscribe to a binary gender system but wish to acknowledge the multiplicity, the variable operative cultural contexts, and the fluidity of the genders that are to be associated with the relevant categories and pronouns.

20. Like the other edibles in the story, the bread appears to be handmade and, in particular, made by the hands of the baker through an artisanal production process. It does not seem to be a mass-produced food.

21. Kincaid considers this possibility in her novel *Annie John* (New York: Plume, 1986 [1983]), 99–103.
22. Telling in this regard is that the tale's concluding lines even out a linguistic difference between girl and pedagogue. Both student and teacher ultimately echo the other's voice, with a difference in their rejoinders about, respectively, benna and bread. Toward the end of the story, the duo's positions in language thus approximate each other, enabling a joint space of playful critical resonance. On the ambiguous, collective potentialities of a comparable kind of linguistic and literary call-and-response vis-à-vis the colonial educational apparatus in Kincaid, see Victoria Burrows, *Whiteness and Trauma: The Mother-Daughter Knot in the Fiction of Jean Rhys, Jamaica Kincaid and Toni Morrison* (New York: Palgrave Macmillan, 2004), 72–85. Girl and pedagogue, the tale's ending suggests, can build collaboratively on each other's capabilities for imaginative critical uptake of the rules. The role of benna in the story also points to this possibility. On this genre as a call-and-response form that plays out a black vernacular tradition against a colonial patriarchal language, see Simone James Alexander, "M/Otherly Guise," 213–14.
23. "Girl" foreshadows *The Autobiography of My Mother*, in which Kincaid has the daughter, Xuela, who, strikingly, knows English without having to learn it, contend explicitly with the all-pervading reality of an absent mother. Jamaica Kincaid, *The Autobiography of My Mother* (New York: Farrar, Straus, and Giroux, 1996), 7. The tale's deployment of address, which has no match in Kincaid's corpus on the mother/pedagogue–daughter relation, renders it an important contribution to a body of work by Caribbean women writers that recognizes the manifold complex ties between maternal figures, daughters, and countries. For an array of literary and theoretical approaches to such connections that venture beyond what are conceived of as restrictive conceptions of women and nation, see *Reading/Speaking/Writing the Mother Text: Essays on Caribbean Women's Writing*, ed. Paula Sanmartín and Cristina Herrera (Bradford, Ontario: Demeter, 2015).
24. An analysis in terms of address thus reveals richer engagements between pedagogue and girl and opens out on a broader array of stances on their part than views that emphasize the rule of a controlling, humiliating mother who quells any talking back, to be put in her place and to allow for a claiming of the daughter's self as an artist only at the end of *River* or in Kincaid's writing of the text itself. An example of this latter approach is J. Brooks Bouson, *Jamaica Kincaid: Writing Memory, Writing Back to the Mother* (Albany: State University of New York Press, 2005), 25–26, 34. Simone James Alexander describes ambiguous mother–daughter relations mediated by coloniality in Kincaid and recognizes a space for female connectedness in Kincaid's oeuvre that involves fiction, myth, dreams, and history and exceeds the confines of colonial paternalism. Simone A. James Alexander, *Mother Imagery in the Novels of Afro-Caribbean Women* (Columbia: University of Missouri Press, 2001), 23, 24, 45–95. Yet Alexander too closely identifies "Girl"'s pedagogue with a patriarchal, colonizing mindset that condemns female sexuality (p. 55). By directing our analytical gaze to an expanded fabric of intersectionally entangled forces and sites of activity in and beyond the story, my account of address in "Girl," rather than centering coloniality in specific female protagonists and reiterating a masculinist colonial ideology by sidestepping Kincaid's focus on the project of constructing and deconstructing such characters, provides a critical reading of a web of practices, norms, and positions of subjectivity and relationality, identification and differentiation. On the shortcomings of Kincaid readings that "tether empire-building and its implementation" to an individual woman, namely the mother, who then comes to stand in for a colonial power, see Leigh Gilmore, "Endless Autobiography? Jamaica Kincaid and Serial Autobiography," in *Postcolonialism and Autobiography: Michelle Cliff, David Dabydeen, and Opal Palmer Adisa*, ed. Alfred Hornung and Ernstpeter Ruhe (Amsterdam: Rodopi, 1998), 226. Rather than

denouncing individual mothers, Gilmore argues further, Kincaid's concern across autobiographical works such as *River* is with a (self-) representational practice of engendering "subjectivity-in-process" in the form of a series of identities that run "at cross-purposes to the figures of colonial identity" (211, 218). A focus on address alerts us to the multidimensional registers and loci of meaning the tale recognizes.

25. Following out the story's deployment of address, we have brought to light how both pedagogue and girl take up intricate social, corporeal, and linguistic positions exemplifying decolonial feminist aesthetic stances that in various ways engage race and class critically. Indeed, aspects of both characters are aptly seen in terms of the Caribbean feminist figure "daughters of Caliban." On the manifold roles (e.g., regarding intermingling oral and written traditions, local and global idioms, histories of colonial repression and day-to-day creativity, and registers of collective memory, work, home, sexuality, and health) connoted by this figure, see *Daughters of Caliban: Caribbean Women in the Twentieth Century*, ed. Consuelo López Springfield (Bloomington: Indiana University Press, 1997). Whereas a reading of the rules in terms of their ability to performatively institute gender roles can illuminatingly alert us to registers of repression as well as resistance, an exploration of the story's deployment of address underscores dimensions of normativity, relationality, and agency that this approach leaves untouched. Likewise, our discussion of address has excavated meanings that fall beyond the scope of operations that an account that zooms in on the operations of speech acts per se, such as the interpellative workings of the title "girl," is able to unearth. Carol Bailey turns to Judith Butler to offer an insightful reading of the tale in terms of gender performativity in "Performance and the Gendered Body in Jamaica Kincaid's 'Girl' and Oonya Kempadoo's *Buxton Spice*," *Meridians: Feminism, Race, Transnationalism* 10, no. 2 (2010): 106–23. Bailey shows how the speaker in the story instructs the girl as to how she can fashion an "offstage self" (110), create her body as a site of female agency (111–12) and maintain a public persona that eludes patriarchal colonial censure. Approaching constructions of racial and gender identities in *River* via Luce Irigary and Frantz Fanon and analyzing their interplay with Kincaid's narrative use of Obeah, Jana Evans Braziel shows how the figures of girl and mother in the collection pass through morphing states of blackness and femininity and constitute relational subjects as opposed to distinctly demarcated individuals, subjects that, moreover, outstrip hierarchized self–other binaries and that at times even merge. Jana Evans Braziel, *Caribbean Genesis: Jamaica Kincaid and the Writing of New Worlds* (Albany: State University of New York Press, 2009), 21–77. The resulting malleability and fluidity is not endless, but runs into blockages imposed by address's structural functioning.

26. Wisława Szymborska, "Vocabulary," in *View with a Grain of Sand: Selected Poems*, trans. Stanisław Barańczak and Clare Cavanagh (San Diego: Harcourt Brace, 1995). All references to Szymborska poems in this chapter are to this edition. I assume that the woman is French rather than merely a speaker of French because the narrator, in her remarks on the woman's choice of topic, intimates that she apprehends geography from the perspective of a culturally central rather than peripheral point of view.

27. Syzmborska's use of address actually complicates matters in a fashion that I am simplifying here. In attributing the topic of conversation to the appearance of all manner of countries on the scene, the narrator drops the direct discourse in favor of the free indirect style. The opening stanza, quoted in full, reads: "'*La Pologne? La Pologne?* Isn't it terribly cold there?' she asked, and then sighed with relief. So many countries have been turning up lately that the safest thing to talk about is climate." In view of this modulation of address, the remark about these nations and their effect on the talk of the day can express several ideas: (1) the narrator's inference concerning the woman's anxiety and the waning of her

nervousness; (2) the woman's own thinking apart from the narrator's perspective on it; and (3) a widely held belief by individuals who see themselves as belonging to a nation that has existed for a lengthy period of time, in contrast with one that they take to be just popping up. The first meaning, arguably, dominates, given the prominence of the narrator's point of view throughout the poem and the fact that the narrator has already described the woman's sigh as an expression of relief, thus offering her own reading of it. Nonetheless, all three meanings are operative. As a result, Szymborska's deployment of address at once gives a solid, wide-ranging reality to the content of the woman's conviction and injects it with doubt, revealing the nature of the woman's belief as a highly subjective geopolitical and social assessment.

28. Ironies multiply here in light of the history of Polish poetry. Poets of Szymborska's generation resisted the heroic pose of the national poet who speaks for the nation, a stance that goes back to Romanticism and a history of social uprisings in Poland, and that ironically, in the twentieth century, drew nourishment from the émigré status of dissident poets in Western Europe, notably in France. An illustrious and complex example of this is Czesław Miłosz. For a discussion of Szymborska's oeuvre in this context, see Clare Cavanagh, *Lyric Poetry and Modern Politics: Russia, Poland, and the West* (New Haven, CT: Yale University Press, 2009), 1–5, 22, 177, 180, 253–60. Joelle Biele alerts us in this connection to Szymborska's figuration of address. She describes how Szymborska shrugs off the demand to speak "for and to the nation" by having her speakers address particular audiences, which frees the poet to explore the "philosophical complexity" of her themes. Joelle Biele, "Here and There: Wisława Szymborska and the Grand Narrative," *Kenyon Review* 35, no. 1 (2013): 168–84, 178. The poem offers an instance of this strategy that comments self-mockingly on itself.

29. The French woman's question suggests that she believes that it is cold in Poland. The weather question thus is a rhetorical one, conveying its own positive answer, and urging (inciting, provoking, encouraging) the narrator to address the topic of the climate. Responding to this illocutionary act, the narrator sardonically imbues the question with an altogether different constitutive role, that of occasioning a coldness that we can understand it to be asking or speaking about. Picking up on one type of illocutionary force, the poet remolds it to fuel another kind of illocutionary function. Szymborska thereby transforms a question that shuts itself down into a philosophically generative field of open questions regarding the relation between language and the world. In this strategy, we can discern the importance of the form of a questioning address in Szymborska's oeuvre as a whole, remarked on not only by commentators but also self-consciously by the poet herself. See, for example, Stanisław Barańczak, "The Szymborska Phenomenon," *Salmagundi* 103 (Summer 1994): 252–65. Szymborska, the columnist, explicitly invokes the figure of questioning regarding the bonds and differences among people(s) from varied nations in two newspaper sketches, "Many Questions" and "In Praise of Questions," in Wisława Szymborska, *Nonrequired Reading: Prose Pieces*, trans. Clare Cavanagh (New York: Harcourt, 2002). Philosophically speaking, we also see here how a literary analysis in terms of address uncovers registers of meaning that go well beyond what the framework of speech act theory can recognize.

30. Shifting from direct speech to free indirect style, the observation about the many countries that have lately shown up (qtd. in note 27, above), rendering the climate the safest topic of conversation, dissociates the woman's state of mind from the narrator's representation of it. Thus the comment alerts us to the ways in which the narrator's reading of the woman's questions could be missing a portion of what the woman's remarks might be about. The free indirect discourse also accords an independence to the woman's outlook,

placing it on a par with the narrator's. We are consequently invited to contemplate ways in which these characters' perspectives may be at once different and similar, which opens the way for seeing the woman as having a view of the situation that the narrator has no idea about.

31. On this view of lyric poetry, see Cavanagh, *Lyric Poetry*, 7–44.
32. On Szymborska's resistance to readerly protocols hell-bent on deciphering clandestine meanings, see Biele, "Here and There," 175–77.
33. Several lines of commentary speak to these dimensions of Szymborska's work. In Cavanagh's reading, Szymborska grounds an unstable form of collectivity in a lyrical mobilization of elements of singularity and uncertainty that elude authorized histories (Cavanagh, *Lyric Poetry*, 190–96). Bogdana Carpenter underscores the poet's ironical perspective on official politics in "Wisława Szymborska and the Importance of the Unimportant," *World Literature Today* 71, no. 1 (1997): 8–12, 9–10. Relevant for an understanding of the interplay Szymborska creates between interiority and the political, broadly conceived, is what commentators have described as her philosophical deployment of tensions between subjectivity and history, personal identity and collectivity, public and private, general and particular, immanence and transcendence, and individual experience and abstract apprehension. On these tensions, see Stephen Tapscott and Mariusz Przybytek, "Sky, The Sky, A Sky, Heavens, The Heavens, A Heaven, Heavens: Reading Szymborska Whole," *American Poetry Review* 29, no. 4 (2000): 41–47. Other critics approach these dynamics at the level of language—and its constraints and possibilities—in the terminology of the mutually intertwining Lacanian registers of the symbolic, the imaginary, and the real. On Szymborska's use of language as a provisional means of situating the self in space and time in a manner that is publicly readable, see Charity Scribner, "Parting with a View: Wisława Szymborska and the Work of Mourning," *The Polish Review* 44, no. 3 (1999): 311–28 [320, 324–25]. Examining Szymborska's engagement with loss, Scribner shows how the poet creates apertures to an alternative future by circumscribing loss actively in publicly communicable speech, in contrast with collective rituals that drive off gaps in language's symbolic schematisms (327–28). Helen Vendler, meanwhile, emphasizes the ethical and historical import that suffuses the imagination for Szymborska and calls attention to her entwinement of the personal and intimate with the impersonal, anonymous, and allegorical. Helen Vendler, "Unfathomable Life," in *New Republic* 214, no. 1 (Jan. 1, 1996): 36–39.
34. The stone proclaims in a direct address to the speaker that she has only "a sense of what [the sense of taking part] should be, / only its seed, imagination." Szymborska, "Conversation with a Stone." Barbara Johnson argues that the stone is incapable of warding off an anthropomorphic form of address without itself taking recourse to that form. Barbara Johnson, *Persons and Things* (Cambridge, MA: Harvard University Press, 2008), 16–17. For a rich reading of the manifold permutations Szymborska attributes to the relations among, on the one hand, people (e.g., Thomas Mann) and, on the other, animals, plants, and things (including an onion) and of her "anti-anthropocentric" stance, which can be detected in "Conversation," see Edyta M. Bojanowska, "Wisława Szymborska: Naturalist and Humanist," *The Slavic and East European Journal* 41, no. 2 (1997): 199–223. Anastasia Graf shows how Szymborska affirms the object's inexhaustibility as well as its socialized character, featuring speakers who at once acknowledge and cross subject–object demarcations. Anastasia Graf, "Representing the Other: A Conversation Among Mikhail Bakhtin, Elizabeth Bishop, and Wisława Szymborska," *Comparative Literature* 57, no. 1 (2005): 84–99. Graf describes a "self-reserved lingering" with the object on the part of these speakers that encounters the world as a task and employs language as a way of achieving success by partially falling short (93). This, she argues, creates a mutually transformative, intercorporeal encounter between speaker and thing, self and other, in Szymborska's poetry.

35. Among other works, she does this in the poems "Warning," "No Title Required," and "We're Extremely Fortunate." Szymborska notes in her Nobel acceptance speech that there is no "obvious world." Indeed, "in the language of poetry," she observes, "where every word is weighed, nothing is usual or normal. Not a single stone and not a single cloud above it. Not a single day and not a single night after it. And above all, not a single existence, not anyone's existence in this world." Wisława Szymborska, "I Don't Know: The 1996 Nobel Lecture," trans. Stanisław Barańczak and Clare Cavanagh, *World Literature Today* 71, no. 1 (1997): 5–7 [7]. On the centrality of the ordinary in Szymborska's poetry, see Carpenter, "Importance." Of course, the trouble with small talk, from this perspective, is precisely that it reinforces received conceptions about common reality rather than, as is customary in Szymborska, turning on their heads the familiar hierarchies in which humdrum existence is entrapped. Nevertheless, the process of questioning to which Szymborska treats the trivial experiences with which she sides in "Vocabulary" (Carpenter, "Importance," 9–10) refuses to stop at a denunciation of chitchat as a diminished form of speech.
36. By attending to address in "Vocabulary," we can see how the two interlocutors collaboratively bring about subtle linguistic effects that work alongside the illocutionary force of the appellations "La Pologne" and "Madame." Szymborska's feminist stance thus resides markedly in her deployment of address. (And a parallel argument would presumably apply to her outlook on the label "feminist" itself.) On the resistance to masculinist conceptions in Szymborska's poetry and the feminist worldview inherent in her oeuvre, along with her reservations about writing under the banner of a feminist program, see Bożena Karwoska, "The Female Persona in Wisława Szymborska's Poems," *Canadian Slavonic Papers / Revue Canadienne des Slavistes* 48, no. 3–4 (2006): 315–33. A broader philosophical implication of our discussion that becomes apparent, once again, is that an examination of address is capable of bringing to light registers of linguistic and artistic meaning that elude the apertures of speech act theory. See also note 29 of this chapter.
37. Szymborska, "I Don't Know," 6.
38. Also of note here is that it is address in a much broader sense than what falls within the purview of the apparatus of speech act or performativity theory that is in effect in the two cases discussed in this chapter (viz. notes 25, 29, and 36, above).

2. Kant, Hume, and Foucault as Theorists of Address

1. Immanuel Kant, "An Answer to the Question: 'What is Enlightenment?,'" in *Political Writings*, 2nd ed., ed. Hans Reiss, trans. H. B. Nisbet (Cambridge, UK: Cambridge University Press, 1991), 54; Immanuel Kant, "Beantwortung der Frage: Was ist Aufklärung?," in *Kants gesammelte Schriften*, vol. 8, ed. Königliche Preussische Akademie der Wissenschaften (Berlin: Walter de Gruyter, 1902), 35. Where both the English and German editions are cited, page numbers are given consecutively.
2. These commentators include Allen W. Wood, "Unsociable Sociability: The Anthropological Basis of Kantian Ethics," *Philosophical Topics* 19, no. 1 (1991): 325–51; Allen W. Wood, "Kant and the Problem of Human Nature," in *Essays on Kant's Anthropology*, ed. Brian Jacobs and Patrick Kain (Cambridge, UK: Cambridge University Press, 2003); Allen W. Wood, *Kant* (Malden, MA: Blackwell, 2005), 3, 12–14; Allen W. Wood, "Kant's Philosophy of History," in Immanuel Kant, *"Toward Perpetual Peace" and Other Writings on Politics, Peace, and History*, ed. Pauline Kleingeld, trans. David L. Colclasure (New Haven, CT: Yale University Press, 2006); Allen W. Wood, *Kant's Ethical Thought* (Cambridge, UK: Cambridge University Press, 1999), ch. 6, 7, and 9; Allen W. Wood, *Kantian Ethics* (Cambridge, UK: Cambridge University Press, 2008), 120–21; Pauline Kleingeld, "Kant, History,

and the Idea of Moral Development," *History of Philosophy Quarterly* 16 (1999): 59–80; Werner Stark, "Historical Notes and Interpretive Questions about Kant's Lectures on Anthropology," in Jacobs and Kain, *Essays on Kant's Anthropology*, 15–37; Katerina Deligiorgi, *Kant and the Culture of Enlightenment* (Albany: State University of New York Press, 2005); Kate A. Moran, *Community and Progress in Kant's Moral Philosophy* (Washington, DC: Catholic University of America Press, 2012); Theodor W. Adorno, *Problems of Moral Philosophy*, ed. Thomas Schröder, trans. Rodney Livingstone (Stanford, CA: Stanford University Press, 2000), 83–88, 122–23, 176; Hannah Arendt, *Lectures on Kant's Political Philosophy*, ed. Ronald Beiner (Chicago: University of Chicago Press, 1982), 38–46, 55–60; Axel Honneth, "The Irreducibility of Progress: Kant's Account of the Relationship between Morality and History," trans. Robert Sinnerbrink and Jean-Philippe Deranty, *Critical Horizons: A Journal of Philosophy and Social Theory* 8, no. 1 (2007): 1–17; Michel Foucault, "What Is Critique?," "What Is Revolution?" and "What Is Enlightenment?," in *The Politics of Truth*, ed. Sylvère Lotringer, trans. Lysa Hochroth and Catherine Porter (New York: Semiotext(e), 1997); James Schmidt, "The Question of Enlightenment: Kant, Mendelssohn, and the *Mittwochsgesellschaft*," *Journal of the History of Ideas* 50, no. 2 (1989): 269–91; and James Schmidt, "Misunderstanding the Question: 'What Is Enlightenment?': Venturi, Habermas, and Foucault," *History of European Ideas* 37 (2011): 43–52 [51–52].

3. Among these writers are Arendt, *Lectures on Kant's Political Philosophy*; Theodor W. Adorno, "Culture Industry Reconsidered," trans. Anson G. Rabinbach, in *The Culture Industry*, ed. J. M. Bernstein (New York: Routledge, 1991); Theodor W. Adorno and Hellmut Becker, "Education for Maturity and Responsibility," trans. Robert French, Jem Thomas and Dorothee Weymann, *History of the Human Sciences* 12, no. 3 (1999): 21–34; Foucault, "What Is Enlightenment?," 105–9, and "What Is Critique?," 43–45, 50–52, 56; Michel Foucault, *The History of Sexuality: An Introduction*, vol. 1, trans. Robert Hurley (New York: Vintage, 1990), 8–13, series hereafter cited as HS with volume number; Michel Foucault, "An Aesthetics of Existence," interview with Alessandro Fontana conducted on April 15–16, 1984, trans. John Johnston, in *Foucault Live (Interviews, 1961–1984)*, ed. Sylvère Lotringer, trans. Lysa Hochroth and John Johnston (New York: Semiotext(e), 1989); Jane Kneller, "The Aesthetic Dimension of Kantian Autonomy," in *Feminist Interpretations of Immanuel Kant*, ed. Robin May Schott (University Park: Pennsylvania State University Press, 1997); and Jane Kneller, *Kant and the Power of Imagination* (New York: Cambridge University Press, 2007).

4. Along the lines of Christine Korsgaard's conception of the grounds for work in the history of philosophy, and specifically on Kant, I see Kant's philosophy not as a solidified doctrine, but as a living project or evolving method that we can render usable in view of the need to develop responses to current dilemmas and that can yield Kantian insights into areas of investigation that Kant himself did not engage. Christine M. Korsgaard, "Rawls and Kant: On the Primacy of the Practical," in *Proceedings of the Eighth International Kant Congress*, vol. 1, pt. 3, ed. Hoke Robinson (Milwaukee, WI: Marquette University Press, 1995), 1165–67.

5. The notion of critique, as I use it here, crisscrosses theory–practice oppositions, participating in both sides of these divides. The same goes for my notion of the aesthetic.

6. Kant, "Answer," 54/35. My own comment does not mean to suggest that all address involves speech.

7. Katerina Deligiorgi links the term *mündig* with the word *Mund*, understood as denoting the mouth (Deligiorgi, *Culture of Enlightenment*, 202n48). In an editorial note to a translation of Kant's essay, Pauline Kleingeld recognizes an affiliation between *Unmündigkeit* and *Mund*, in the sense of the mouth. Adumbrating this link, she associates *Unmündigkeit* with an inability "to speak (and decide) for oneself," an incapacity that necessitates

legal decision-making or representation by a *Vormund*, a person who, the German term suggests, speaks for someone else (Kleingeld, editorial note, in Kant, "Toward Perpetual Peace," 17n1).

8. Kluge leads *Mund* (feminine) back to a general Indo-European r/n root designating the hand (mə-r, mə-n-es). This stem, it indicates, is also at work in the Greek μάρη (hand, feminine) and the Latin *manus* (hand, feminine). The Latin root proliferates in words like "emancipation," "manuscript," "manumission," "manner," "manual," "mandate," and "amanuensis," though not in "Immanuel." The word *Mund* (masculine) for the mouth involves an altogether different stem. Crosscurrents emerge, however. While etymologically distinguishing the juridical use of *Mundtot* (since the seventeenth century signaling an inability to legally represent oneself) from its colloquial use (which resignified *Mundtot* to mark a silencing [transitive], that is, the silencing of a person), Kluge witnesses in the nonjuridical, everyday context of *Mundtot* an importation of the name for the mouth into the syllable denoting protection. Friedrich Kluge, *Etymologisches Wörterbuch der deutschen Sprache* 24th ed., ed. Elmar Seebold (New York: De Gruyter, 2002). Citing Grimm's *Deutsches Wörterbuch*, Rüdiger Bittner points to false associations between *Mündig* and *Mund* (masculine, meaning mouth) occurring in Martin Luther and Gotthold Ephraim Lessing. Rüdiger Bittner, "What is Enlightenment?," in *What is Enlightenment? Eighteenth-Century Answers and Twentieth-Century Questions*, ed. James Schmidt (Berkeley: University of California Press, 1996), 357n3. Given the colloquial cross-fertilization between the two homonyms, noted also by Duden, it is rash to reject the linkages Deligiorgi and Kleingeld identify as simple etymological errors. *Duden Herkunftswörterbuch: Etymologie der deutschen Sprache* 3rd ed., vol. 7 (Mannheim: Dudenverlag, 2001). I prefer to read the ties between *mündig* and the mouth as openings for an inquiry into the forms of agency, embodiment, social order, normativity, and power that come into play in Kant's plea for *Mündigkeit*. An intriguing gender constellation would appear to shimmer in the movements between a masculine term for a corporeal organ of speech and a feminine term for institutionalized symbolic forms that presumably tend to privilege masculinity yet that at some point were apprehended metaphorically in terms of a feminine label for a typically nonspeaking body part (*Mund* designating protection and legal representation while alluding to the hand).

9. By "symbolic participation," I mean a form of engagement that fundamentally involves symbolic (or representational) processes, rather than an activity deemed narrowly restricted to symbolic (or representative) functions such as, say, tokenism.

10. For a rich account of aspects of the forms of mouthlessness that Kantian enlightenment purports to overcome, see McCance's reading of the founding fantasy of a mute mouth (and deaf ear) in Kant, among others, a fantasy that she argues must be seen at work in the institution of the university. Dawne McCance, *Medusa's Ear: University Foundings from Kant to Chora L.* (Albany: State University of New York Press, 2004).

11. Kant, "Answer," 54–55. While the German statement, "[Es] gibt ... nur Wenige, denen es gelungen ist, durch eigene Bearbeitung ihres Geistes sich aus der Unmündigkeit heraus zu wickeln" (Kant, "Beantwortung," 36) puts less explicit emphasis on the cultural dimension of the emergence from maturity by the few than does the English translation, the implications of a culturally expansive developmental process are nonetheless present in the notion of productive labor and change Kant is sketching here, and find support in his broader historical, anthropological, and geographical views of cultivation. On these views, see the works referred to in note 2 by Wood, Kleingeld, Moran, and Stark.

12. Kant, "Answer," 55.

13. Kant, "Answer," 55/37. While "private" expression, as Kant defines it, also takes place among persons, the relational space in the case of public address assumes a more expansive

character, one centrally involving publicity conceived in terms of an inclusive forum harboring human beings generally. On structural exclusions inherent in this forum as understood by Kant, see Pauline Kleingeld, "The Problematic Status of Gender-Neutral Language in the History of Philosophy: The Case of Kant," *Philosophical Forum* 25, no. 2 (1993): 134–50; Robin May Schott, "The Gender of Enlightenment," in Schmidt, ed., *What is Enlightenment?*; Carolyn Korsmeyer, "Perceptions, Pleasures, Arts: Considering Aesthetics," in *Philosophy in a Feminist Voice: Critiques and Reconstructions*, ed. Janet A. Kourany (Princeton, NJ: Princeton University Press, 1998); Emmanuel Chukwudi Eze, "The Color of Reason: The Idea of Race in Kant's Anthropology," in *Anthropology and the German Enlightenment: Perspectives on Humanity*, ed. Katherine M. Faull (Lewisburg, PA: Bucknell University Press, 1994); Robert Bernasconi, "Kant as an Unfamiliar Source of Racism," in *Philosophers on Race: Critical Essays*, ed. Julie K. Ward and Tommie L. Lott (Oxford, UK: Blackwell, 2002); Robert Bernasconi, "Kant's Third Thoughts on Race," in *Reading Kant's Geography*, ed. Stuart Elden and Eduardo Mendieta (Albany: State University of New York Press, 2011); and Mark Larrimore, "Antinomies of Race: Diversity and Destiny in Kant," *Patterns of Prejudice* 42, no. 4–5 (2008): 341–63.

14. Kant, "Answer," 57.
15. Kant, "Answer," 54, 59.
16. Kant, "Answer," 59–60.
17. Kant's term, translated as "barbarism" ("Answer," 59), is *Roheit* ("Beantwortung," 41; see also *Rohigkeit* in Immanuel Kant, "Idee zu einer allgemeinen Geschichte in weltbürgerlicher Absicht," in *Kants gesammelte Schriften*, 20–21; and Immanuel Kant, "Zum ewigen Frieden," in *Kants gesammelte Schriften*, 354, 357n). The notion of barbarism in these contexts carries pronounced associations of pejoratively marked cultural differences entwined with coordinates of racialization and ethnicity, among other intersecting variables. Emmanuel Eze discusses the notion's functioning in Enlightenment discourses, including Kant's writings, in his introduction to *Race and the Enlightenment: A Reader*, ed. Emmanuel Chukwudi Eze (Malden, MA: Blackwell, 1997), 4–5. On its functioning in Kant's anthropology, see Eze, "Color of Reason," 211–12, 223–28, 231–33. For a discussion of Kant's understanding of race as involving hierarchically conceived, differential natural dispositions toward civilization, see Bernasconi, "Kant as an Unfamiliar," 158–62, and "Kant's Third Thoughts." Kant's reference to barbarism raises the questions of what criteria of applicability for the concept of "enlightenment" are in operation; what social, racial, ethnic, gendered, class-inflected, and geographical attributes these criteria presuppose on the part of allegedly enlightened and unenlightened populations; and what counts as evidence or disproof of the presence of enlightenment.
18. The question that Kant answers self-consciously in his text had been formulated in the *Berlinische Monatsschrift*, in which his article was first published, and was being debated in various venues for address. For a discussion of the article in this context, see Schmidt, "Question of Enlightenment."
19. Kant, "Answer," 54.
20. The modes of address of Kant's text are, of course, far more intricate than this brief discussion indicates. The question of how the form of address of Kant's own writing shapes the contours of the enlightenment process that he envisions and enacts, and of how this form affects the public standing of his discourse, is an involved one that exceeds the scope of my discussion. On stylistic dimensions of Kant's reasoning, which are among the elements that bear on these topics, see Jean-Luc Nancy, *The Discourse of the Syncope: Logodaedalus*, trans. Saul Anton (Stanford, CA: Stanford University Press, 2007).
21. Kant, "Answer," 54.

22. Kant, "Answer," 55, 55/37.
23. This inclusivity is underscored in Dorothea von Mücke, "Authority, Authorship, and Audience: Enlightenment Models for a Critical Public," *Representations* 111, no. 3 (2010): 60–87, 65; and Deligiorgi, *Culture of Enlightenment*, 62–63, 72. See the theorists mentioned in note 13 on operative exclusions.
24. Here, the affairs narrowly involve the speaker's workplace and professional circle, but also, more broadly, the nation. On the political forces that Kant's essay negotiates, see Schmidt, "Question of Enlightenment." The listed items can be found in Kant, "Address," 56–59/37.
25. Von Mücke ("Authority," 62, 65–67) recognizes two implied audiences in Kant's account, one ideal, the other real.
26. As many scholars have indicated, Kant's universalist, cosmopolitan outlook drastically circumscribes the universe of rational beings. On exclusionist dimensions of his construction of reason, see Eze, "Color of Reason" and introduction; Schott, "Gender of Enlightenment"; and Bernasconi, "Kant as an Unfamiliar" and "Kant's Third Thoughts." On the links between forms of rational argument and limits on inclusion, including the possibilities of modifying such limits, see, among others, Iris Marion Young, "Inclusive Political Communication," in *Inclusion and Democracy* (Oxford, UK: Oxford University Press, 2000). On different notions of practical reason in Kant and their divergent links with rational justification, see Wood, "Kant on Practical Reason," in *Kant on Practical Justification: Interpretive Essays*, ed. Mark Timmons and Sorin Baiasu (New York: Oxford University Press, 2013), 59, 81–85. These links, some of which, Wood suggests, involve our addressing reasons for our actions to others and our being addressed by others in order to take into account their standpoints in decision-making processes, prima facie can be expected to correlate with different delineations of publicity.
27. Or, alternatively, semiprivate? For this concept, see Ellen F. Rooney, "A Semiprivate Room," *differences* 13, no. 1 (2002): 128–56.
28. On this notion of aesthetic relationality and its centrality to the concept of the aesthetic, see Monique Roelofs, *The Cultural Promise of the Aesthetic* (New York: Bloomsbury, 2014), 1–2, 8, 209–11. See also chapter 1 of the present book, p. 41.
29. The term "scholar" in the present chapter signals Kant's usage of the notion rather than our commonsense understanding, which connotes a different position of address than the one he was outlining. Kant's conception of the scholar would appear to be closer to our idea of a public intellectual than of a scholar.
30. Challenging the limits of rationalism in deliberative democracy, Young, in "Inclusive Political Communication," uncovers the differentially inclusive workings of modes of address such as those constituting rational discourse, on the one hand, and, on the other, those characterizing greetings, rhetoric, and narration. She considers these latter forms key to the overcoming of exclusions incurred at the level of rational debate.
31. Evidence that Kant deems such connections significant resides in, among other things, his view that our diets are an area of life about which we should think for ourselves rather than merely following the judgment of our physicians (Kant, "Answer" 54).
32. On eighteenth-century print cultures and their effect on the widespread reach of enlightenment, see, among others, von Mücke, "Authority, Authorship, and Audience," and Jane V. Curran, "Oral Reading, Print Culture, and the German Enlightenment," *The Modern Language Review* 100, no. 3 (2005): 695–708.
33. Gloria Anzaldúa's recurrent figure of the unruly tongue, which resonates with multiple forms of discipline and resistant agency, speaks to these evolving intersecting dimensions. Gloria Anzaldúa, *Borderlands/La Frontera: The New Mestiza* (San Francisco: Spinsters/Aunt Lute, 1987), 53–55, 63; Gloria E. Anzaldúa, "Speaking in Tongues: A Letter to Third

World Women Writers," in *This Bridge Called My Back: Writings by Radical Women of Color*, 3rd ed., ed. Cherríe L. Moraga and Gloria E. Anzaldúa (Berkeley, CA: Third Woman Press, 2002), 183–84, 192. María Lugones's uptake and elaboration of Anzaldúa's image likewise invokes these aspects of the mouth. See Monique Roelofs, "Navigating Frames of Address: María Lugones on Language, Bodies, Things, and Places," *Hypatia: A Journal of Feminist Philosophy* 31, no. 2 (2016): 370–87; and the future sequel to this book, *Aesthetics, Address, and the Making of Culture*.

34. On this point, see, for example, Gayatri Spivak, "Can the Subaltern Speak?"
35. I will explore these questions more fully in this book's sequel, *Aesthetics, Address, and the Making of Culture*.
36. As noted before, by "learned address," I mean a mode of address that Kant somehow links to learning, though he leaves open in many ways how this tie is precisely to be construed and how strong it is.
37. Kant, "Answer," 57.
38. Kant, who allegedly believed in eating carrots, hosted daily dinners for guests, and was given to discussing recipes with his woman friends (Wood, *Kant*, 12–13; Kleingeld, "Problematic Status," 143–44), clearly saw diets as a site of potentially enhanced or diminished enlightenment. In only the second paragraph of his essay, we learn, as mentioned earlier, that we should think for ourselves about what we eat and drink rather than simply go by our doctors' judgments (Kant, "Answer," 54).
39. On such a notion of freedom, see Audre Lorde, "Poetry Is Not a Luxury," "The Master's Tools Will Never Dismantle the Master's House," and "Age, Race, Class, and Sex: Women Redefining Difference," in *Sister Outsider: Essays and Speeches* (Freedom, CA: The Crossing Press, 1984), 36–39, 111–12, 115–23; Cynthia Willett, *Irony in the Age of Empire: Comic Perspectives on Democracy and Freedom* (Bloomington: Indiana University Press, 2008), 5–9, 34–40, 46–48, 51, 64, 114. See also Ewa Płonowska Ziarek, *Feminist Aesthetics and the Politics of Modernism* (New York: Columbia University Press, 2012), 21, 24–26, 42–49.
40. David Hume, "Of the Standard of Taste," in *Selected Essays*, ed. S. Copley and A. Edgar (Oxford, UK: Oxford University Press, 1998), 145. Emphasis mine.
41. Hume, "Standard," 145. Hume's view entails that this norm of address applies to all of a work's aesthetic qualities, given that these qualities would appear to be relevant to the determinations at which observers arrive in virtue of their perception of the work and to the emotions with which these observers respond to the work. Examples of qualities that bear on a work's capacities for persuasion and emotional effect are a desirable kind of clarity or mysteriousness, a dramatic development that ties the spectator's stomach in knots, a slick turn of phrase, an intriguing plot resolution, or an abrupt shift in tone.
42. Hume, "Standard," 145.
43. Hume, "Standard," 145.
44. On this discourse and the place of the aesthetic in it, see, for instance, Mary Poovey, "Aesthetics and Political Economy in the Eighteenth Century: The Place of Gender in the Social Constitution of Knowledge," in *Aesthetics and Ideology*, ed. George Levine (New Brunswick, NJ: Rutgers University Press, 1994).
45. Hume, "Standard," 141.
46. On this entwinement of voices, which centrally involves also the figure of Sancho Panza, who narrates the tale, see Roelofs, *Cultural Promise*, 68. On Hume's endeavor to institute a field of standardized taste over and above his project of theorizing it, see 58–68, 70, 85–86. The temporality of the wine-tasting scenario that he relates exemplifies the temporality of the process of progressively refining and improving taste and the superseding of deficient taste by more propitious taste (see 67).

47. Besides makers, observers, and their works, the fabric of experience Hume theorizes revolves around a set of five criteria of aesthetically appropriate observation, a variety of differentially attuned critics that encounter cultural productions with their receptive dispositions, general rules or principles of taste, and a repertoire of especially excellent works that appeal across geographical and temporal bounds (Hume, "Standard," 138–49).
48. Hume, "Standard," 145–46.
49. Hume, "Standard," 146.
50. Hume, "Standard," 145.
51. Hume, "Standard," 136. While it is not clear how all the elements of his replies to these two explanatory goals line up, Hume, arguably, presents the marks of the true critic (delicacy of imagination, good sense, freedom from prejudice, and a history of practice and comparative evaluations) both as justificatory grounds for judgments of the true artistic qualities of a work (140) and as heuristic indicators by which we can gauge the appropriateness of aesthetic experiences (136, 147). Additional factors assist in these two aims: the joint verdict of true critics enters into the justificatory grounds for judgment that Hume advances (147) and principles of taste also function as relevant yardsticks for assessing critical judgments. For the notion of heuristic yardsticks, see Jerrold Levinson, "Hume's Standard of Taste: The Real Problem," *Journal of Aesthetics and Art Criticism* 60, no. 3 (2002): 227–38.
52. On the entwinement of taste and refinement, see David Hume, "Of the Rise and Progress of the Arts and Sciences," "Of Refinement in the Arts," and "Of Commerce," in Hume, *Selected Essays*; "Standard," 151; and "Of Simplicity and Refinement in Writing," in David Hume, *Of the Standard of Taste and Other Essays*, ed. John W. Lenz (New York: Library of the Liberal Arts, 1965).
53. For Hume's use of the term "refinement," see, for example, his essays "Rise and Progress," "Refinement in the Arts," "Commerce," 154–55, 163–64, "Standard," 151, and "Simplicity and Refinement." Connections between refinement and the fine emerge in, e.g., "Standard," 138, 140–42, 147, 149, and "Commerce," 154–57. Connections with the fine arts are visible in each of these essays.
54. According to Hume, a blooming international trade in delicate and luxurious commodities brings about improvements in the liberal arts and fosters people's delicacy ("Of Commerce," 162–63). Such delicacy is a key feature of taste, as he contends in "Standard," 141–144, 147. Thus the exercise of taste, in his account, results in an increase in taste.
55. For an analysis of the various roles that Hume attributes to taste, see Roelofs, *Cultural Promise*, 31–36, 55–56, 97–98. On taste's ties to public forms of freedom, see in particular Hume, "Refinement in the Arts," 174–75.
56. For arguments to this effect, see Richard Shusterman, "Of the Scandal of Taste: Social Privilege as Nature in the Aesthetic Theories of Hume and Kant," in *Eighteenth-Century Aesthetics and the Reconstruction of Art*, ed. Paul Mattick (Cambridge, UK: Cambridge University Press, 1993), 96–119; Korsmeyer, "Perceptions, Pleasures, Arts"; and Roelofs, *Cultural Promise*, 30–36, 53, 58–71, 119–200.
57. On the emergence of ever-more-refined objects as markets develop, desires for delicate commodities evolve, and trade expands, see "Of Commerce," 161–63 and note 54 of this chapter. Given the criteria of practice and comparisons, which, as Hume argues in "Of the Standard of Taste," are necessary propensities for adequate critical apprehension of cultural productions (143–45, 147), growing refinement as embodied in artifacts makes it necessary for the critic to hone her faculty of taste on new works, which presumably introduce new kinds of aesthetic qualities and values that the critic must learn to experience and assess.

58. I offer a more detailed critical assessment of Hume's account in Roelofs, *Cultural Promise*. See note 55, above.
59. See Michel Foucault, "What Is Critique?," "What Is Enlightenment?," and "What Is Revolution?"
60. Michel Foucault, *Discipline and Punish: The Birth of the Prison*, trans. Alan Sheridan (New York: Vintage, 1995), 139–141, 154–56; Foucault, HS1, 18–22, 46, 53, 146; Foucault, HS3, 57, 63, 100–3; Hume, "Standard," 139, 141–43. For an extended discussion of the functioning of detail in Hume's view of taste, see Roelofs, *Cultural Promise*, chapter 3.
61. Foucault, HS1, 93.
62. Foucault, *Discipline*, 26.
63. Foucault, HS1, 100.
64. Foucault, HS1, 11; 11 (see also 100); 18, 55–56, 77–78.
65. Foucault, HS1, 34–35, 44–45, 55–56, 101. On such forms of temporal and spatial regulation, see Foucault, *Discipline*, 136, 141–69.
66. Foucault notes that power–knowledge mechanisms take effect "on all levels and in forms that go beyond the state and its apparatus" and form "a dense web that passes through apparatuses and institutions" (HS1, 89, 96). In virtue of address's roles in discursive regimes, this point applies also to address itself. Address accordingly permeates the disciplinary and biopolitical formations that Foucault maps (139–57). As such, it informs projects of racialized subject formation and imperial expansion (124–26, 137–43, 148–50). It suffuses the confession and its analogues (58–63). More than that, it shapes bodily regimes of consumption and production (106–7).
67. Address, for Foucault, clearly traverses public–private divides; it amounts to a level of functioning at which these apparent polarities condition each other. On dimension of publicity, see, for example, Foucault, HS1, 23–28. Factors to which he draws attention that are frequently allocated to the private sphere include the family, the conduct of the household, and economic regimens (HS1, 100, 108–14; HS2, 152–84), as well as the zones of secrecy surrounding sexual conduct that Foucault calls "obscure areas of tolerance" (HS1, 101).
68. Foucault, HS1, 23, 27; HS1, 100.
69. Of course, there are meta-discourses that attempt to tidy up these limits. For Foucault, however, these are part and parcel of broader discursive fields and as such do not escape the indefinite borders of the structures they set out to clear up.
70. Foucault, HS1, 30; HS1, 26, 34, 72.
71. Foucault, HS1, 95; HS1, 100.
72. Foucault, HS1, 99–100; HS1, 101; HS1, 100–1. Because both tactics and strategies comprise patterns or structures, I understand the notion of structures of address to include these formations. This usage does not obfuscate a fundamental distinction to which Foucault subscribes, because he refers to both tactics and strategies as discourses when he mentions the nineteenth century's "series of discourses" on types of sexual deviation from the norm, or a "'reverse' discourse" marking homosexuality as natural (101). He also speaks of discourses as "tactical elements or blocks" (101), constituents that, he suggests, can be entered into "strategic envelopes that [make] them work" (100). Accordingly we need not worry that my terminology of structures of address obscures a principled difference that we should be concerned to articulate.
73. Foucault, HS1, 10–13, 27, 33–35, 155–59; HS1, 102.
74. Foucault, HS1, 42–44, 47, 123, 155–56; Foucault, HS2, 3–7, 10–13; Michel Foucault, *The Birth of Biopolitics: Lectures at the Collège de France, 1978–1979*, ed. Michel Senellart, trans. Graham Burchell (New York: Palgrave Macmillan, 2010), 16, 30–37, 146–47, 267–68.
75. This point applies to disciplinary power as well as to biopower. See Foucault, HS1, 89, 144, 148; HS2, 3–4.

76. Foucault, HS1, 18, 62, 111, 120, 123, 157.
77. Foucault, HS1, 45–47, 71; HS2, 51–52, 93; HS3, 44–45, 199; See also "What Is Enlightenment?," 117, 119.
78. Foucault postulates other normative functions that I will not specifically consider here. On epistemic roles, for example, see Linda Martín Alcoff, "Foucault's Normative Epistemology," in *A Companion to Foucault*, ed. Christopher Falzon, Timothy O'Leary, and Jana Sawicki (Malden, MA: Wiley-Blackwell, 2013).
79. On the links between normalization and the norm in Foucault, see *Discipline*, 183–84, 191–93; HS1, 144; Michel Foucault, *"Society Must Be Defended": Lectures at the Collège de France, 1975–1976*, ed. Mauro Bertani and Alessandro Fontana, trans. David Mackey (New York: Picador, 2003), 251–53. For a discussion of the workings of normalization in Foucault and its deployment of norms to locate individuals, events, and actions within grids of normality, see Hubert L. Dreyfus and Paul Rabinow, *Michel Foucault: Beyond Structuralism and Hermeneutics*, 2nd ed. (Chicago: University of Chicago Press, 1983), 193–98, 258. If the norm, in the Foucault texts just mentioned, *informs* the normal, and the disciplining of individuals as well as the biopolitical regulation of populations, he later sees the norm, in the context of biopower's deployment of normalization, as emerging *from* the normal (as an "interplay between . . . different distributions of normality"). Michel Foucault, *Security, Territory, Population: Lectures at the Collège de France, 1977–1978*, ed. Michel Sellenart, trans. Graham Burchell (New York: Palgrave, 2007), 63. This stands in contrast to its workings as an element of disciplinary power where, established prior to its subjectivating operations, it functions as a force of what Foucault calls normation (56–57). At the same time, the norm links disciplinary power and biopower. See Foucault, *Society*, 252–53; and François Ewald, "Norms, Discipline, and the Law," trans. and adapt. Marjorie Beale, *Representations* 30 (Spring 1990): 138–61 [153]. On Foucault's revised understanding of the workings of the norm, see Dianna Taylor, "Normativity and Normalization," *Foucault Studies* 7 (2009): 45–63.
80. Foucault, HS2, 13, 253; "What Is Enlightenment?," 108; "Aesthetic," 452.
81. Foucault, HS2, 3–13, 89–93, 108; HS3, 43–45, 50–54, 67–68, 71, 192; "Aesthetic," 451.
82. Foucault, HS2, 10–11.
83. Foucault, "Aesthetic," 451. Foucault's inquiries into the care of the self provide a genealogy of ethical practices of self-constitution.
84. Foucault, HS2, 8–9. See also "What Is Enlightenment?," 108–9, 113–16, 118–19; and "Aesthetic," 453.
85. Foucault, HS2, 8–9.
86. Current approaches to freedom that recognize these complexities include Willett, *Irony*, 4–17, 114–47; and Wendy Brown, "Neoliberalism's Frankenstein: Authoritarian Freedom in Twenty-First Century 'Democracies,'" *Critical Times: Interventions in Global Critical Theory* 1, no. 1 (2018): 60–79. Affirming the entwinement of positive and negative liberties (freedom to and from) while rethinking both conditions, Willett underscores the interdependence of states of freedom and liberatory politics with registers of equality, solidarity, affiliation, and belonging (5–9, 17, 119, 123–25, 146–47). Venturing a genealogical approach to our present-day, twenty-first-century conjuncture, Brown exposes the fusion of brands of freedom, effected by neoliberal reason in the current epoch with authoritarianism, social exclusion, and violence, and with stances intent on undermining politics, public goods (such as higher education), and social provisions—elements that neoliberalism construes as hampering freedom. Brown identifies an antidemocratic, nihilistic, and disinhibited appeal to freedom that stands in conflict with freedom in the sense of autonomy, self-direction, agency, a capacity to act, and sovereignty (64, 72). On interdependency, difference, community, and art as sources of liberation and freedom, see Lorde, "Master's

Tools," "Age, Race, Class, and Sex," and "Poetry." For insightful discussions of freedom in Foucault, see, among others, Thomas L. Dumm, *Michel Foucault and the Politics of Freedom*, new ed. (Lanham, MD: Rowman and Littlefield, 2002), 117, 141–44, 152–53; Johanna Oksala, *Foucault on Freedom* (Cambridge, UK: Cambridge University Press, 2005); and John Simons, "Power, Resistance, and Freedom" and Amy Allen, "Power and the Subject," in Falzon, O'Leary, and Sawicki, eds., *Companion to Foucault*.

87. Describing freedom, in the sense of a multiplicity of "ways of reacting and modes of behavior" available to "individual or collective subjects" within "a field of possibilities," as a condition for power—with power amounting to "actions upon other actions" in such a field—Foucault postulates a "complicated interplay" among them rather than a bond of mutual exclusiveness. Michel Foucault, "The Subject and Power," in *Power: Essential Works of Foucault 1954–1984*, ed. James D. Faubion, trans. Robert Hurley et al. (New York: The New Press, 2000), 341–42. He understands their relationship as an "agonism," in other words, a "mutual incitement and struggle" that engenders a "permanent provocation" (342).

88. Here I am underscoring the collective dimension of freedom, as does Kincaid, as I have indicated. Audre Lorde highlights this dimension in "Master's Tools," 11–12, and "Age, Race, Class, and Sex," 115–16, 120–23. Drawing on theorists and artists such as Cornel West, Toni Morrison, Lorde, Spike Lee, and Henri Bergson, among others, Cynthia Willett proposes a perspective on freedom as involving intersubjective connections in a field of social interdependency. Willett, *Irony* 35–40, 46–48, 87–88, 114.

89. In a commentary on the "massively impacted structures of address" of *History of Sexuality*, vol. 1, Andrew Parker shows how Foucault, through the modes of ventriloquism and a staging of multiple voices, delineates for himself an authorial stance and for his reader a corresponding interpretive position that avert standardized scenarios of authorship and reading and bypass ingrained models of confessional language. Andrew C. Parker, "Foucault's Tongues," *Mediations* 18, no. 2 (1994): 80–88 [80]. Thus Foucault, in Parker's reading, renders indeterminate the distinction between "repression and its critique" (86) or what Foucault intriguingly describes as the "critical discourse *addressing* itself to repression" (HS1, 10; my emphasis). By as Parker puts it, "putting other tongues in his mouth, others' tongues in his mouth," Foucault "would claim a 'truth' . . . that can be voiced only in and as its radical self-division" (86). Entering with Foucault an internally splitting discursive field, that of sexuality, which he virtually from HS1's start encodes in an explicit language of address, we lose track, I would say, of just who might be putting (or wishing to put) which or whose tongues in whose mouths, and engage in the elaboration of rearticulated, relationally shifting modalities of sexual/linguistic freedom. Ultimately our address enacts not altogether legible proximities as well as distances vis-à-vis the polyvalent strata of sexual liberation and captivity signaled by Foucault's overt rejection of the repressive hypothesis, even if, in our address to our and others' address, we can venture to activate and make readable such proximities and distances. What this reading of Foucault's and the readers' deployment of address brings to light, I would argue, is not (just) an alignment of the queer against the normative, as Parker suggests (80)—although antinormative orientations are in play here—but also a reconfiguration of influential, preconceived *norms* of authorial, readerly, discursive, and sexual address (viz. note 1 of the introduction to this book). For an incisive reading of Foucault's use of the free indirect voice in HS1, see Lynne Huffer, "Foucault and Sedgwick: The Repressive Hypothesis Revisited," *Foucault Studies* 14 (2012): 20–40. Huffer describes Foucault's tone as ironic. I suggest that we should see him as also putting into action his notion of freedom as a characteristic of certain kinds of language. For an analysis of this notion, see Oksala, *Foucault on Freedom*, 81–88.

90. I am here foreshadowing the view of address I will elaborate in chapter 4.
91. In accounting for normalization, Foucault more often and insistently focuses on the operations of "the norm" than on the role of norms, although he not infrequently refers to norms in the plural (see, e.g., *Discipline*, 296–97, where he describes the normalization of normalization). Exemplary in this light are *Discipline*, 183–84; 191–93; HS1, 144; and *Society*, 251–53. Given Foucault's singling out of the workings of *the* norm, his approach leaves ample space for further theoretical reflection on the functioning of norms.
92. This will become clear in our discussion of Julio Cortázar's *Cronopios and Famas* stories in chapter 3.
93. The concept of address, I would argue, can deepen and foster the methodologies we deploy to develop genealogies and archaeologies of social phenomena.
94. See, among others, Ann Laura Stoler, *Race and the Education of Desire: Foucault's History of Sexuality and the Colonial Order of Things* (Durham, NC: Duke University Press, 1995).
95. Foucault, HS2, see esp. 28.
96. HS3, 45; see also 28, 149, 163 and 192; HS2, 10–11 (qtd. on p. 93 of this chapter), 28, 253; "What Is Enlightenment?," 105; "Aesthetic," 451–52. Foucault marks the proximity between an aesthetics of existence and a concern with "personal choice" in his interview "On the Genealogy of Ethics: An Overview of Work in Progress," in Michel Foucault, *Ethics, Subjectivity and Truth: Essential Works of Foucault, 1954–1984*, ed. Paul Rabinow, trans. Robert Hurley et al. (New York: The New Press, 1997), 254, 260, 266; see also 267, 271. His extensive problematization of neoliberalism in his lecture course on biopolitics notwithstanding (*Biopolitics*), his ethics, in our conjuncture, then runs the risk of colluding with a neoliberal privileging of individual aesthetic choice in the marketplace. By paying detailed attention to the workings of norms and forms of address as ingredients of the aesthetics of existence and of art-historically and contextually inflected modes of aesthetic life more generally, we can arguably shore up Foucault's stance on neoliberalism in a manner that he himself cuts short.
97. Foucault, "Genealogy," 261.
98. Foucault, "Genealogy," 254, 260. In Christoph Menke's reading, the sine qua non of the practice of an aesthetics of existence (in contrast to the workings of disciplinary normalization) is an attitude on the part of the subject of free, autonomous self-overcoming for which there are no "pre-given norms" or "self-given goal." This attitude cannot be "acquired . . . or secured by decisions." Christoph Menke, "Two Kinds of Practice: On the Relation between Social Discipline and the Aesthetics of Existence," *Constellations* 10, no. 2 (2003): 199–210 [208–9]. I would argue that the aesthetics of existence as formulated by Foucault nonetheless imposes socially stratified constraints on the field of aesthetic and ethical agency that it broaches, constraints that inhibit forms of freedom to which we should open up aesthetic life.
99. This is not to say that the aesthetics of existence, as construed by Foucault, cannot serve in critical or liberatory capacities but that it needs to be substantially rethought to adequately fulfill those roles. For less skeptical readings of his views of art and aesthetics as sites of critical agency or reconstitution of self, see Michael Kelly, "Foucault on Critical Agency in Painting and the Aesthetics of Existence" and Joseph J. Tanke, "On the Powers of the False: Foucault's Engagements with the Arts," in Falzon, O'Leary, and Sawicki, eds., *Companion to Foucault*.
100. Foucault, "Aesthetic," 451–52.
101. Whereas Foucault significantly decenters the human, this move goes accompanied by tendencies in his reflections on the care of the self to narrow our view of the multiple factors

that, as affirmed by the decentering strand in his theory, go to make up the human subject. To be sure, he states in an interview that the "practices of self" through which the subject actively constitutes itself are "not something invented by the individual himself" but, rather, are "models that [the subject] finds in his culture and are proposed, suggested, imposed upon him by his culture, his society, and his social group." Michel Foucault, "The Ethics of the Concern for Self as a Practice of Freedom," in Foucault, *Ethics*, 291. In his view, the subject, within the attitude of care of self, employs these materials in a relatively autonomous manner as resources for projects of self and labors carried out on the self as she fashions an optimal relation to herself (282; 296, 273–74; see also "Aesthetic," 451, where the French *autonome* [autonomous] is rendered as "anonymous"). But Foucault, here, elides significant relational modalities. What is missing from his account of an aesthetics of existence is a recognition of dimensions of bonds to others and to the culture as valuable in their own right, apart from their instrumentality to the care of the self and independently of the emergence of other-regarding concerns as aspects of a developing concern for the self ("Ethics of Concern," 287). Foucault acknowledges to an insufficient extent that measures of freedom can reside in an affirmative inhabitation of those bonds. The elements of will and intention occasion forms of transcendence of aesthetically modulated connections with other people, language, nonlinguistic idioms, and the material world that elide meanings that such connections can sustain. His embrace of bodily pleasures notwithstanding, more richly collective, participatory forms of aesthetic freedom remain a blind spot for Foucault. For approaches to such aspects of freedom, see Willett, *Irony*, 6–9, 13, 35–40, 46–62, 84–92, 109–47, and Lorde, "Master's Tools," 111–12, and "Age, Race, Class, and Sex," 115–23. For a critique of the role of the personal other in Foucault's ethics, see Oksala, *Foucault on Freedom*, 193–207.

102. Foucault's own activist work in many kinds of collective forums, among others with the prison group Groupe d'Information sur les Prisons, and his brief comments on Walter Benjamin's reading of Baudelaire are likewise suggestive of a potentially wider span of factors (Foucault, HS2, 11). The same goes for Foucault's direct commentary on Baudelaire ("What Is Enlightenment?," 105–9) and his cryptic association, voiced in an interview, of an aesthetics of existence with a contemporary "investigation" that he deems necessary ("Aesthetic," 451). His relatively general idea of "the *bios* as a material for an aesthetic piece of art" ("Genealogy," 260) is also illuminating. Especially telling, finally, is the contagious power of his pronouncedly relational laughter upon reading Borges, from which, as Foucault reports it, arose his reflections on the possibilities and impossibilities of our conceptual orderings in *The Order of Things*. Michel Foucault, *The Order of Things: An Archeology of the Human Sciences*, trans. A. M. Sheridan Smith (New York: Vintage, 1973), xv.

103. While François Ewald details important Foucauldian workings of norms and "the" norm, we also must recognize operations of norms that the resulting view of standardization, the realization of classes of equivalency and differentiation, and the establishment of reference points for comparative assessments do not adequately capture (Ewald, "Norms"). Further, Ewald's view of norms as devices whereby society communicates with itself and generates a common language emphatically stands in need of exploration in terms of the dynamics of address.

104. Foucault, HS1, 157.

105. Foucault, "What Is Critique?," 45; see also 43–44, 50–52, 56; HS1, 57–58; HS2, 93, 108, 139, 153–56, 163, 165, 229, 251–54; HS3, 160, 163, 239. The distinction between arts of address and the arts, as they are standardly conceived, is useful, yet rough and ready rather than sharp, as I have indicated in the introduction to this book. Given that the same would appear to hold for the arts that Foucault mentions here, the notion of arts of address plausibly yields a productive model for thinking about the latter kinds of arts.

3. Saying Hello and Goodbye

1. Julio Cortázar, *Cronopios and Famas*, trans. Paul Blackburn (New York: Pantheon, 1969), 3. Julio Cortázar, *Historias de cronopios y de famas* (Buenos Aires: Ediciones Minotauro, 1962). All references to stories from the collection in this chapter will be to these editions.
2. Cortázar, *Cronopios*, 79.
3. Alicia Borinsky describes the convergence of the distant and near in Cortázar's work in a plane "beyond national borders," in *One-Way Tickets: Writers and the Culture of Exile* (San Antonio: Trinity University Press, 2011), 98. In Brett Levinson's reading, Cortázar associates Latin America with a process of *poiesis* that creates evolving crossovers among colonial modernity, Europe, and the indigenous. Brett Levinson, *The Ends of Literature: The Latin American "Boom" in the Neoliberal Marketplace* (Stanford, CA: Stanford University Press, 2001), 16–19, 24–28.
4. On the dynamics between constraint and alternative possibilities in Cortázar, see Doris Sommer, "Playing to Lose: Cortázar's Comforting Pessimism," *Chasqui: Revista de literatura latinoamericana* 8, no. 3 (1979): 54–62; Doris Sommer, "Pattern and Predictability in the Stories of Julio Cortázar," in *The Contemporary Latin American Short Story*, ed. Rose Minc (New York: Senda Nueva Ediciones, 1979); and Alicia Borinsky, "Juegos: Una realidad sin centros," in *Estudios sobre los cuentos de Julio Cortázar*, ed. David Lagmanovich (Barcelona: Ediciones Hipam, 1975).
5. For discussions of such dimensions and effects in Cortázar's work, see Doris Sommer, "A Nowhere for Us: The Promising Pronouns in Cortázar's 'Utopian' Stories," *Dispositio* 9, no. 24–26 (1984): 65–90 [70, 72–74, 80–82, 85]; and Alicia Borinsky, *Theoretical Fables: The Pedagogical Dream in Contemporary Pedagogical Literature* (Philadelphia: University of Pennsylvania Press, 1993), 56–68.
6. A reader of Plato, Hegel, Heidegger, Bataille, Foucault, Derrida, and Deleuze who perused countless aesthetic treatises, a commentator on contemporary art in several media, and a writer profoundly impelled by philosophical questions, Cortázar engages address as a locus of simultaneously philosophical and aesthetic meaning. Elements of address, in many ways, are the focal point for his examination of the possibilities of freedom, sociality, art, politics, love, sexuality, and creativity. On his fascination with philosophy, see, e.g., his interview with Lucille Kerr, Roberto González Echevarría, David I. Grossvogel, and Jonathan Kittler, "Julio Cortázar: Interview," *Diacritics* 4, no. 4 (1974): 35–40 [37]. Cortázar says, "Curiously enough, I always jump from literature to metaphysics" and explains how, "in the very act of writing," there arise "flashes of light, sudden experiences that emerge from the fiction," which "I [search] through" and "[listen] to . . . with that inner ear that is at work in writing." These happenings then give the fiction a "sense that would escape me if I looked for it rationally" (37). Asked about where, in his latest novel, his "literary/metaphysical/ metaliterary" approach, in his view, stands with respect to the freedom he aspires to in Latin American literature, he describes how, through a leveling of linguistic and thematic differences in the narrative, he has resisted treating themes such as eroticism and imaginative game-playing in a privileged fashion that would ultimately be driven by their taboo status (37). To give in to this tendency would be to accept uncritically a new kind of avoidance that threatens to "repeat the old molds" (38). Cortázar considers this "change—at least on the level of writing—... as revolutionary and as full of positive perspectives for us as the open usage of our idiomatic modalities against the absurd conservatism of educational systems and academies of the language" (38). He thus couples the literary-cum-philosophical interventions of his writing with a mode of leveling address, a mode required to free us from the control exercised by social blind spots and by inhibiting linguistic,

philosophical, and academic idioms alike. On his upending of the distinctions between the genres of theory and fiction, see Borinsky, *Theoretical Fables*, 62.

7. For a discerning exploration of this type of freedom, see Cynthia Willett, *Irony in the Age of Empire: Comic Perspectives on Democracy and Freedom* (Bloomington, IN: Indiana University Press, 2008), 4–17, 114–47; and Audre Lorde, "Poetry Is Not a Luxury," "The Master's Tools Will Never Dismantle the Master's House," and "Age, Race, Class, and Sex: Women Redefining Difference," in *Sister Outsider: Essays and Speeches* (Freedom, CA: The Crossing Press, 1984), 36–39, 111–12, 115–23.

8. While Cortázar, in a 1981 interview, speaks of his growing "awareness" of and "participation in the issue of freedom in countries around the world, and especially in [his] own country" over the almost two decades that had passed since the publication of *Hopscotch* (1963), this concern is also powerfully present in *Cronopios and Famas*. Dan Wohlfeiler, "Interview with Julio Cortázar," *The Threepenny Review* 5 (1981): 12–13 [12]. For Cortázar, experimentation with language is an indispensable element of social change, and he applauds Latin American writers who "open up new mental paths" in their readers (12). He sees literature's task in this regard as the "role of an agitator": in other words, "it must create a certain degree of anxiety in the reader, showing him that things aren't as he's always viewed them—they can be very different" (13). Whereas his books formulate questions that readers then can ask for themselves, the stories he tells don't provide "recipes," which it is "the reader's job" to look for (13). Literature's role, he notes, is "to provoke an intellectual, moral, and ethical uneasiness in the readers—that is, to shake them up" (13). Alicia Borinsky attributes in this context an important generative role to the active reader's own freedom: she observes that *Hopscotch*'s "gift to readers feeds on their capacity for surprise in the exercise of their freedom" (*Theoretical Fables*, 54). Accordingly, the freedom that Cortázar seeks to foster through his writing in the reader and the society is also nourished by freedom as a factor in the readerly process. For a discussion of several Cortázar texts—though not *Cronopios and Famas*—that recognizes the continuity of his political preoccupations, see Carolina Orloff, *The Representation of the Political in Selected Writings of Julio Cortázar* (Woodbridge, UK: Tamesis, 2013). On specific continuities and shifts in his approach to politics, see Sommer, "Nowhere," 78–79, 89–90.

9. Cortázar's political engagement runs deep throughout his oeuvre (viz. note 8) and stands out particularly conspicuously in his well-known story "Apocalypse in Solentiname" and his novel *A Manual for Manuel*, to list just a few examples. For instances of his opposition to consumption as a mode of being in works such as *Hopscotch* and *62: A Model Kit*, see Borinsky, *Theoretical Fables*, 58, 65. Clear-cut examples of his doubtful attitude toward technocratic and finance capital and consumption society pervade his graphic novella *Fantomas versus the Multinational Vampires*.

10. Cortázar's notion of freedom stands in sharp contrast to the policies of corporatist deregulation and cultivated indifference to social and environmental destruction so rampant in our current epoch. For an analysis of neoliberal constructions of freedom that denounce principles of equality and inclusion and reject the social and political spheres in favor of the market while at the same time ushering the personal, familial, and private realms into the public domain, see Wendy Brown, "Neoliberalism's Frankenstein: Authoritarian Freedom in Twenty-First-Century 'Democracies,'" *Critical Times: Interventions in Global Critical Theory* 1, no. 1 (2018): 60–79 [61–66]. This kind of freedom is decidedly not what intrigues Cortázar. Brown documents a nihilist disintegration and an instrumentalization of ethical values that, under neoliberalism, rage in the name of freedom, and she identifies attendant processes of repressive desublimation (Herbert Marcuse's term) (70–73, 75). Cortázar's understanding of freedom is antithetical to these positions because he

grounds freedom fundamentally in meaningful forms of social connectedness, and an affirmation of otherness and social difference. By his reckoning, neither the fungibility of ethical values nor a disinhibiting scrapping of constraint are acceptable conditions. Indeed, we can understand his ethics and politics of freedom as a potent antidote to the neoliberal formations Brown describes.

11. Regenia Gagnier highlights the centrality to Western modernity of the figure of the man of taste, conceived of as an individual consumer. Regenia Gagnier, *The Insatiability of Human Wants: Economics and Aesthetics in Market Society* (Chicago: University of Chicago Press, 2000), chapter 3. Illuminating in this context is David Hume's notion of the aesthetic observer who, by exercising taste, takes charge of his own pleasures. Taste, for Hume, functions as a source of freedom in the sense of individual control and personal autonomy. For analysis, see Monique Roelofs, *The Cultural Promise of the Aesthetic* (New York: Bloomsbury, 2014), 33–34, 71. On relevant notions of freedom, see Willett, *Irony*, 5–9, 119–36.

12. In the absence of sustained attention to the collection, its poetics have remained underexplored and its condensed treatment of themes and forms that will keep occupying Cortázar in *Hopscotch* and *62: A Model Kit*, among other works, has been downplayed, as I hope to show implicitly by way of this book's and its sequel's discussions of *Cronopios and Famas*.

13. Cortázar, *Cronopios*, 4; translation revised. These clouds seem to stand in conversation with their analogues in the author's most famous story, "Blow-Up."

14. Cortázar, *Cronopios*, 3. Cortázar's "paralelepípedo" (*Historias*, 3) signals a slantedness and a baroque fluidity (*el pípi*) that the English "rectangular space" elides.

15. Cortázar, *Cronopios*, 3.

16. Cortázar invokes a baroque reversibility (as in Spanish Baroque writers Luis de Góngora and Francisco de Quevedo) between mouth and anus, organs of ingestion/digestion and of expulsion. I am grateful to Maya Chakravarti and Blair Talbot for drawing my attention to the eschatological resonance of the story's first lines during our discussion of *Cronopios and Famas* in my address course at Hampshire College.

17. I will resume this project in *Aesthetics, Address, and the Making of Culture*.

18. Cortázar, *Cronopios*, 4; translation revised.

19. Cortázar, *Cronopios*, 3–4.

20. The term "réplica," which Cortázar uses for the image of the cloud retained in memory, is ambiguous between copy and reply. Cortázar, *Historias*, 12.

21. There are obviously differences between the way in which we apprehend a thing like a spoon as making a request and the way in which we do this in the case of a person, differences that we need to take into account. An object that addresses us with a request, in a given cultural context, is felt (in a partially literal sense) to extend an appeal to us or to exercise a force on us that we metaphorically experience in terms of the idea of a request. How exactly, theoretically speaking, we should construe the content of this experience is something I wish to leave to a considerable degree open, although the notion of a request gives us a lot to go by and specifies a rich array of specific descriptive elements, normative implications, and connections with other forms of address. What, to my mind, is clear is that there is an actual phenomenon at work that we conceptualize by way of a metaphorical designation. The language of address predicates functions and roles of objects that we experience, say, in terms of their touching us, making claims on us, or requiring or inviting behaviors on our part, as the case may be. While I wish to avoid committing the theory of address to wholly literal construals of the relevant notions of touching, demanding, encouraging, coaxing, and so on, I do believe, as noted in the introduction, that the language of address captures dimensions of the cultural meanings that objects have for human

beings and that stand in need of elucidation. Cortázar, indeed, investigates and alerts us to aspects of the functioning of objects that the vocabulary of address clarifies, even if it does not exhaustively characterize and explain those workings.

22. Cortázar, *Cronopios*, 4; translation revised.
23. Cortázar, *Cronopios*, 4; translation revised.
24. Cortázar, *Cronopios*, 4–5; translation revised.
25. Cortázar, *Cronopios*, 4; translation revised.
26. Throughout his work, Cortázar seeks to create openings at points where the intersubjective relations among his characters strand in blockages, without, however, idealizing unlimited connectedness. On necessary encounters between characters and between author and reader, see Borinsky, *Theoretical Fables*, 54, 132–33; on gendered "traps of identity" that restrict the openness to chance and the reverberation of surprise within the linkages among characters that he embraces, see pp. 65 and 68. These pitfalls resonate with abysses and all-encompassing sorts of violence to which Cortázar, as Borinsky points out, keeps returning (70). In her essay "A Nowhere for Us," Doris Sommer offers a useful discussion of Cortázar's attempts to, as she insightfully puts it, "pry open" intersubjective "closures" in several of his stories (69). Yet, as I hope to show in this chapter, *Cronopios and Famas* reflects on this project more incisively and advances it more rigorously than her comments on the collection suggest (69–70, 75–76, 83). Indeed, I would argue that the collection brings the reader in close contact with precisely those chasms and modalities of violence that, in Cortázar's view, riddle the fabric of human interconnections. Here, the dimensions of humor, play, and imagination he invokes are crucial: in Borinsky's words, "That he also became intertwined in the forms of children's play as they may delineate our desires is testimony to how radical a discovery he foresaw in playing games and forging fictions" (*Theoretical Fables*, 70).
27. This reading finds support in the fact that the bull itself is a repeating figure in the story: the narrator has already imagined pushing his "head like a reluctant bull through the transparent mass at the center of which" he drinks his morning coffee (Cortázar, *Cronopios*, 3). One of the iterative scripts to which the bull-picador couple alludes is the interchangeability of pursuer and pursued, which recurs frequently among characters in Cortázar's texts, as in the well-known story "The Pursuer" and the novel *62: A Model Kit*. Resisting static oppositions between winner and loser, victim and victimizer, complicity and innocence, his narratives typically flip these polarities around, inscribing them into each other and pushing back against familiar scenarios that undergird these stances.
28. I read the instructions as addressing both reader and narrator and thereby also as coming ambiguously from the narrator. Cortázar often places subjects of address or those invoked by it in ambiguous and mutually switching or reversible positions. Such shifts and reversals are prominent in "Blow-Up," to name a famed example. As a consequence of these kinds of alternations and displacements, the epistemic, moral, political, and aesthetic stakes of the narratives play out in an array of intricate, dynamical bonds between disparate positions. On forms of companionship, collaboration, necessary encounter, and complicity among reader and author in Cortázar's narratives, see Borinsky, *Theoretical Fables*, 53, 59–60, 73–74, 132–33, and "Juegos," 63, 66, 71–72. Also of relevance here are Cortázar's remarks on the subject (Wohlfeiler, "Interview," 13; see also note 8 of this chapter). For a discussion of the ties between reader and character in particular, see Borinsky, *Theoretical Fables*, 59–62, 66. On states of closeness as well as interchangeable and analogous positions among reader, author, and character, see Sommer, "Nowhere," 69–70, 73–76.
29. Some of these figures return in other narratives by Cortázar. The glass brick, notably, is a recurring presence in his novel *Hopscotch*, where it assumes further permutations. The

image of a sticky paste resonates with the metaphor of the "devil's drool" in "Blow-Up"'s original Spanish title "Las babas del diablo." For a discussion of this kind of gooey spittle and the linguistic and (inter)subjective slippages it connotes in several stories, see Sommer, "Nowhere," 67, 73–75, 78, 82, 86, 90. Cortázar's exploration in *Cronopios and Famas* of items such as alternately rigid or mutating glass and glutinous, malleable paste contribute shifting shapes, viscous glueyness, and renewed possibility as well as traction to these themes, movements, and figures that stretch across different texts.

30. Cortázar, *Cronopios*, 105.
31. Cortázar, *Cronopios*, 68.
32. Cortázar, *Cronopios*, 83.
33. Cortázar, *Cronopios*, 82; translation revised.
34. Cortázar, *Cronopios*, 67.
35. Cortázar, *Cronopios*, 150.
36. In "The Particular and the Universal," as well as in the next story we will consider, "The Possibilities of Abstraction," Cortázar investigates and plays with the notions of art and the artist. In these stories, we see in operation the fuzzy distinction between the specific arts (e.g., painting) and the arts of address, a distinction sketched in the introduction to this book. Both the parallels and differences between the two kinds of arts are at work in making these two stories funny and in rendering them ironic commentaries on the nature, ambitions, and potentialities of the arts (in the traditional sense). See also note 54 of this chapter.
37. With the story's oral/orgiastic and urinary/defecatory connotations, Cortázar carries further earlier allusions to the baroque in *Cronopios and Famas* (see note 16). On the conjunction of multiple orders of signification, dispersion, and wasteful expenditure in the Baroque and especially the Latin American Neobaroque, see Severo Sarduy, "The Baroque and the Neobaroque," trans. Christopher Winks, in *Baroque New Worlds: Representation, Transculturation, Counterconquest*, ed. Monika Kaup and Lois Parkinson Zamora (Durham, NC: Duke University Press, 2010).
38. Cortázar, *Cronopios*, 65; translation revised.
39. Cortázar, *Cronopios*, 66.
40. For a discussion of these features of the baroque, among other characteristics, see Sarduy, "Baroque and Neobaroque."
41. Cortázar, *Cronopios*, 66.
42. Cortázar, *Cronopios*, 64.
43. Cortázar, *Cronopios*, 66.
44. Cortázar, *Cronopios*, 78–79; translation revised. A great many events in *Cronopios and Famas* happen in the street. While the narrative leaves it open where the encounter of the two friends takes place, other references in the story to gentlemen who can be assumed to be on the street suggest that this is also the setting where our characters meet. This would give the exchange a chance character, which fits the larger questions that the story brings up. Another reason for favoring the street is that the tale makes mention of house doors, roads, and shoes, items that all gain a particular material pertinence if the street is indeed the spot where the two gentlemen come upon each other. A location in the street, further, deepens the dialogue that the story in a variety of ways sets up with the opening tale of *Cronopios and Famas*. Accordingly, I am assuming that the encounter occurs in the street, although it might in principle happen in any kind of public place. On the street as a site of experience and openness to change in Cortázar's work, or, as he puts it, a place "to live and stroll through, to love in and suffer in," see Borinsky, *Theoretical Fables*, 53.
45. Cortázar, *Cronopios*, 79.

46. Cortázar, *Cronopios*, 79; translation revised.
47. Cortázar's term "resbalar" ("Qué tal López" in *Historias*, 82), which expresses this sliding, assumes the connotation of a linguistic slipping that destabilizes positions and orientations and that, in that capacity, can both entrap and open up alternative possibilities. On these aspects and their links with the figure of the sticky spittle, see Sommer, "Nowhere," 65, 86; and note 29 of this chapter. Language, for the gentlemen, bestows a shared mobility that undergoes fixture in their reciprocally individuating linguistic encounter to subsequently allow a usually unrecognized difference to emerge that escapes the coagulation that ensued. As we shall soon see more clearly, joint, intersubjective movement undergoes renewal with the eruption of an unexpected, not readily identifiable, yet ineffaceable otherness in the familiar.
48. Cortázar, *Cronopios*, 78. The story here epitomizes what Alicia Borinsky, in a different context, describes as Cortázar's capacity to endow "the entanglements of love with somber impossibilities, humorous complicities with the reader, and a dangerous imminence of the fantastic." Borinsky, *Theoretical Fables*, 74.
49. Cortázar, *Cronopios*, 78.
50. Cortázar, *Cronopios*, 78–79.
51. Cortázar, *Cronopios*, 79.
52. Cortázar, *Cronopios*, 79.
53. In *Aesthetics, Address, and the Making of Culture*, I will revisit these themes.
54. In situating dimensions of art-making and the experience of art in quotidian situations, *Cronopios and Famas* plays on the proximities as well as the differences between art, in a traditional sense of the term, and the arts of address. The stories examine both sides of this in various ways useful though hazy distinction in light of each other, thus advancing our understanding of both. See also note 36.
55. Foucault's and Cortázar's conceptions of freedom and constraint shed light on the form of address to address that, I am proposing, is reading. Other theorists have outlined further necessary conditions for such reading. To mention a perspective on this widely debated topic that, arguably, resonates profoundly with both authors' interventions, in "A Semiprivate Room," *differences* 13, no. 1 (2002): 128–56, Ellen Rooney offers an incisive discussion of additional conditions delimiting what it is to read and, especially, the formal dimensions of critical reading and the forms and structures of address it involves. On the unfreedom and breaks that of necessity attach to the role of form in reading, as well as on an element of play, see Ellen Rooney, "Live Free or Describe: The Reading Effect and the Persistence of Form," *differences* 21, no. 3 (2010): 112–39 [116, 123–24, 129–34]. Rooney emphasizes the fundamentally relational and political character of reading, conceived of as an activity that sets form to work, and the openness and risk that this practice entails in "Better Read than Dead: Althusser and the Fetish of Ideology," *Yale French Studies* 88 (1995): 183–200. Cortázar's investigation of address sheds light on the nature and implications of the relevant sorts of formal delineation, enabling openness and closure, intimacy, politics, play, and risk, thus markedly furthering our understanding of what it is to read beyond the bare-bones activity that he also elaborates, enacts, and inspires: of reading as a form of address to address.
56. The notion of reading as a conspicuously active form of address to address and the strategies of interpretation that this idea informs are key to the simultaneously aesthetic and political interventions of many of Cortázar's texts. Summarily put, the mode of interpretation that this conception of reading encourages places the reading of the text in the same plane as the reader's day-to-day address in and to the world, suspending certain distinctions between these kinds of address. The reading of the narrative accordingly translates

into a form of engagement in the world that it encourages us to expand further. Alicia Borinsky underscores *Hopscotch*'s hospitality, the active reading it fosters, and the companionship between author and reader it invites, the result of which is an effacement of the separations between literature and the everyday (*Theoretical Fables*, 53–54; see also 59). The notion and reading practice of an active form of address to address, to my mind, is critical to these strategies and effects, not only in *Hopscotch* but also in *Cronopios and Famas*, among other works by Cortázar.

57. On dissatisfaction (and its production in the market) as a condition that sometimes connects these two states, see Elizabeth V. Spelman, *Trash Talks: Revelation in the Rubbish* (New York: Oxford University Press, 2016), chapter 5, "Desire, Dissatisfaction, and Disposability."
58. Among the philosophers who have famously commented on such experiences are Ludwig Wittgenstein, Richard Wollheim, and Arthur Danto. Ludwig Wittgenstein, *Philosophical Investigations*, rev. 4th ed., trans. G. E. M. Anscombe, P. M. S. Hacker, and Joachim Schulte, ed. Hacker and Schulte (Malden, MA: Wiley-Blackwell, 2009); Richard Wollheim, *Art and Its Objects*, 2nd ed. (Cambridge, UK: Cambridge University Press, 1980), sections 11–13 and essay V; Arthur C. Danto, *The Transfiguration of the Commonplace: A Philosophy of Art* (Cambridge, MA: Harvard University Press, 1981).
59. Cortázar plays with experiences of seeing-as and seeing-in in numerous *Cronopios and Famas* stories, more than I can do justice to here. To be compelling, the details of the view that regards seeing-as and seeing-in as modes of address would of course have to be spelled out. While neither the perceptions of the daily as a newspaper or a pile of printed pages, nor those of the abstractionist qualify, strictly speaking, as instances of the type of seeing-in that Wollheim associates with representational seeing, Cortázar's story "Instructions on How to Understand Three Famous Paintings," read in the context of the questions of address pursued in *Cronopios and Famas*, clearly brings the notion of address to bear on the theme of the limits of what it is to see certain kinds of phenomena in a painting (Cortázar, *Cronopios*, 10–13). The tales "Simulacra" and "Instructions on How to Climb a Staircase," which I examine in *Aesthetics, Address, and the Making of Culture*, further investigate the bounds of seeing-as. "Instructions on How to Kill Ants in Rome," which I also discuss in that book, examines the nature of seeing-in.
60. I will resume my examination of Cortázar's treatment of address in this story collection in *Aesthetics, Address, and the Making of Culture*.

4. Norms, Forms, Structures, Scenes, and Scripts

1. For examples, see note 24 of the introduction to this book.
2. While address, as I have indicated, presupposes and involves relationality, this does not render my point that it organizes relationships vacuous: address embodies a particular kind of relationality that achieves specific relational effects as it orchestrates forms of relationship.
3. Because "The Nose," like other Gogol stories, as Boris Eichenbaum observes, does not centrally revolve around a central plot or character, but rather foregrounds a playing with language and reality, the tale lends itself especially powerfully to a consideration of address. Boris Eichenbaum, "The Structure of Gogol's 'The Overcoat,'" trans. Beth Paul and Muriel Nesbitt, *Russian Review* 22, no. 4 (1963): 377–99 [378, 382, 395]. Another reason why a reading in terms of address is particularly apt lies in the tale's focus on absurd elements that suffuse day-to-day life. Simon Karlinsky considers the story a surrealist narrative that

offers "a vision of the surreal within the ordinary, a revelation of metaphysical absurdity." Simon Karlinsky, *The Sexual Labyrinth of Nikolai Gogol* (Cambridge, MA: Harvard University Press, 1976), 130. Related in a deadpan style, the story, notes Karlinsky, "sets up several traps for readers who may be expecting familiar situations and logical motivations" (127, see also 129). By bracketing certain kinds of rational explanation, the story opens up questions about the nature of quotidian address and, in particular, about the forms of address with which we encounter, give shape to, or brush off the strange as well as the normal.

4. Nikolai Gogol, "The Nose," in *Diary of a Madman and Other Stories*, trans. Ronald Wilks (New York: Penguin, 1972), 48, 54.

5. One group of commentators regards "The Nose" as a grotesque sendup of the importance of appearance and rank. An example is Herbert Bowman, who suggests that within the frame of the story, "a nose is an officer and an officer is a nose" and that Kovalyov is "without any face" in the sense that he serves as a moral type. Herbert E. Bowman, "The Nose," *Slavonic and East European Review* 31, no. 76 (1952): 204–11 [208, 211]. For other commentators, this sort of approach represents just one side of the existential dilemmas Gogol investigates in the story, an aspect that goes together with a dynamic of self-loss and self-gathering, which the author places at the core of his understanding of the human being. An example of this kind of reading is Sergei Bocharov, "Around 'The Nose,'" trans. Susanne Fusso, in *Essays on Gogol: Logos and the Russian Word*, ed. Susanne Fusso and Priscilla Meyer (Evanston, IL: Northwestern University Press, 1992). Bocharov emphasizes the bifurcated character that subjectivity assumes in the tale as a phenomenon that is at once traversed by inside–outside divides and open to modes of collecting and holding on to an inner self (33) and notes that the figure of the human, in Gogol, became "mysterious and problematic" in an altogether new way (39).

6. Thomas Seifrid regards Kovalyov's inability to tell his tale as emblematic of Gogol's self-reflexive meditation on the question of what a Russian narrative—in contrast to a Western European story or a tale derived from Western literary paradigms—might look like. Thomas Seifrid, "Suspicion toward Narrative: The Nose and the Problem of Autonomy in Gogol's 'Nos,'" *Russian Review* 52, no. 3 (1993): 382–96 [390]. In this reading, Gogol participates in 1830s debates about the status of Russia and Russian writing on the world stage. Interpreting the dislocations and figurations of voids populating "The Nose" as paradigmatic of a fissured notion of Russian identity, Seifrid reads Gogol as affirming emptiness as a site where a kind of autonomous national literary narration can emerge, a genre that the story itself then epitomizes. Gogol, in his account, invokes "Russia's national presence on the page" by "gesturing" toward autonomy from within a plurality of deficient narrations rather than by "narrating as such" (396). The dilemmas surrounding the nose's independence then connote this autonomous status. Gogol's aesthetic and political figuration of autonomy emerges in a different light from another angle. In a reading of William Kentridge's 2010 production of Dmitri Shostakovich's opera *The Nose* at the Metropolitan Opera in New York City and of Kentridge's video installation *I Am Not Me, The Horse Is Not Mine* (2008), Maria Gough argues how Kentridge deemphasizes the element of satire stressed by Gogol and Shostakovich to focus on the nose's metamorphosis and adventures, and the independent life it leads, which ultimately undergo repression. According to Gough, Kentridge contemplates the notion of metamorphosis in its various instantiations, ranging from bodily mutations to forms of social and political change such as the October Revolution and anti-apartheid protests, underscoring, with Shostakovich, not predominantly violent repression but also utopian hope. Maria Gough, "Kentridge's Nose," *October* 134 (2010): 3–27. Both the self-reflexive literary and the metamorphic resonances

7. Gogol, "Nose," 66.
8. Gogol, "Nose," 69.
9. I would like to emphasize that my thesis and the basic framework I have laid out allow for the possibility that there are additional key constituents of address that are worth identifying.
10. An extended legacy in poststructuralist thought points to such differentiation, drawing, for instance, on Lacan's view of the mirror-stage, which involves forms of address, and on Derrida's notion of *différance*, which underlies his account of address's workings. According to Ellen Rooney, an acknowledgement of the workings of address brings into view the constitutive exclusions implemented by modes of signification. These exclusions preclude the possibility of an address to the general public and void pluralist assumptions. Ellen Rooney, *Seductive Reasoning: Pluralism as the Problematic of Contemporary Literary Theory* (Ithaca, NY: Cornell University Press, 1989), 1–63; Ellen F. Rooney, "A Semi-private Room," *differences* 13, no. 1 (2002): 128–56 [135–41]. This, however, is not to discount the vital aesthetic functioning of constructions of public address of the sort examined in regard to David Hume's and Immanuel Kant's accounts in chapter 2.
11. Interestingly, this usage at once marks sharp divides between the address of human beings and that of birds and generalizes across all birds.
12. I explore this tie in this book's sequel, *Aesthetics, Address, and the Making of Culture*.
13. Franz Kafka, *The Castle*, trans. Mark Harman (New York: Schocken Books, 1998); Franz Kafka, *The Trial*, trans. Breon Mitchell (New York: Schocken Books, 1998). For an example of K.'s ignorant readings of the modes of address assumed by the castle, see *The Castle*, 6, 57–58, 70.
14. Gabriel García Márquez, *The Autumn of the Patriarch*, trans. Gregory Rabassa (New York: HarperCollins, 1991).
15. Gogol, "Nose," 42.
16. For an illuminating investigation of orientations, our practices of lining them up, and the role of norms in these practices, see Sara Ahmed, *Queer Phenomenology: Orientations, Objects, Others* (Durham, NC: Duke University Press, 2006).
17. Mierle Laderman Ukeles, "Manifesto for Maintenance Art 1969!—Proposal for an Exhibition 'Care,'" in *Mierle Laderman Ukeles: Maintenance Art*, ed. Patricia C. Phillips (New York: Prestel, 2016), 210.
18. On such aspects of varieties of comedy, humor, and irony, see Cynthia Willett, *Irony in the Age of Empire: Comic Perspectives on Democracy and Freedom* (Bloomington, IN: Indiana University Press, 2008), 6, 52–55, 62, 133–36, 141. Willett also argues that these factors involve registers of human freedom.
19. The limits of our attempts at straightening out or at making things straight stand out clearly in Ahmed's analyses of the ways in which we can queer orientations. See Ahmed, *Queer Phenomenology*. From one perspective, queering can of course involve a kind of straightening out, in the sense of correcting and giving an alternative organization to phenomena misconstrued and inadequately aligned by heterosexist, homo/cisnormative, misogynist, and transphobic gender systems.
20. Gogol, "Nose," 45, 67.
21. Gogol, "Nose," 70.
22. Gogol, "Nose," 70.
23. Gogol, "Nose," 70.
24. Gogol, "Nose," 70.

25. Gogol, "Nose," 67.
26. Gogol, "Nose," 70.
27. Gogol, "Nose," 56, 65–67.
28. Gogol, "Nose," 67, 42.
29. Seifrid places Kovalyov's letter, in which he holds the mother of a young woman he had rejected responsible for the absconding of his nose, in the category of these sorts of occult narratives ("Suspicion toward Narrative," 391). More generally, Seifrid reads the story's references to journalistic and occult discourses as exemplifying the many narrative genres in currency in the 1830s that for Gogol remained inadequate to the task of construing a national literary voice.
30. Sharon Lubkemann Allen highlights the parallelism between Gogol's digressive, elliptical language and his figuration of the city as an eccentric space, one in which one walks and follows a character and self and speech undergo estrangement from each other, in *EccentriCities: Writing in the Margins of Modernism: St. Petersburg to Rio de Janeiro* (Manchester, UK: Manchester University Press, 2013), 197, 202–4, 208–9, 216–17. On the temporal disjunctions signaled by the March and April dates, which correspond with the gap between the Julian and Gregorian calendars, see Seifrid, "Suspicion toward Narrative," 382–84.
31. On Gogol's humor as hovering around a vacuum that the writer gives the impression of filling, see R. W. Hallett, "The Laughter of Gogol," *Russian Review* 30, no. 4 (1971): 373–84 [383]. According to Mikhail Bakhtin, Gogol's texts inspire a profound kind of laughter in the reader in consequence of elements such as a suspension of boundaries, grotesque forms of embodiment, a liberation of forgotten and repressed meanings occasioned by a sendup of literary conventions, and a renewal of discourse fueled in part by colloquialisms. Mikhail Bakhtin, "Rabelais and Gogol: The Art of Discourse and the Popular Culture of Laughter," trans. Patricia Sollner, *Mississippi Review* 11, no. 3 (1983): 34–50 [42–46]. Bocharov suggests that "The Nose" engenders a form of humor that orients itself toward the self: the reader gets to laugh at herself ("Around 'The Nose,'" 33).
32. Through its rigorous questioning of its own address, Gogol's tale enacts a mobile, open-ended, self-othering form of address, a straying and wandering that stages turns and returns, creating distances as well as proximities to various selves, others, institutions, places, and histories. This process of address, the story suggests, remains unscathed by narrative or interpretive attempts to foreclose the absurd and the incomprehensible. A reading in terms of address suggests, then, how "The Nose" hints at registers of address that exceed the formation of a national voice and the dynamic of repression and hope that Seifrid and Gough stress respectively (see note 6). Indeed, we can read the episode of Kovalyov's beating of the nose in Kentridge's rendering of Shostakovich's *Nose* as emblematic of narrative attempts to inhibit the strange amblings that Gogol's story itself ventures to keep alive. The endeavor to enlist literary narration in the service of a national discourse would likewise appear to banish a strangeness that Gogol's "Nose" is at pains to preserve. From the perspective of the question of address, Kentridge's performance, I would argue, remains closer to Shostakovich's and Gogol's works (and Shostakovich's opera remains closer to Gogol's story) than Gough suggests they do (see Gough, "Kentridge's Nose," 25–27). Contrary to what Seifrid suggests, Gogol's digressive style, the form of "articulated play" remarked on by Eichenbaum ("Structure," 381, 391–95), and "The Nose"'s self-reflexive dimension outstrip the conscription of Gogol's literary undertaking in a project of national autonomy. On Shostakovich's musical uptake of Gogol's narrative strategy as read by Eichenbaum along with other Russian formalists such as Viktor Vinogradov, and on the tension between cosmopolitan modernism and

vernacular-nationalist realism in Shostakovich's opera, factors that both lend support to my proposed reading, see Alexander N. Tumanov, "Correspondence of Literary Text and Musical Phraseology in Shostakovich's Opera *The Nose* and Gogol's Fantastic Tale," *Russian Review* 52, no. 3 (1993): 397–414.

5. Address's Key Constituents: Philosophical Views

1. Frantz Fanon, "The Black Man and Language," chapter 2 in Frantz Fanon, *Black Skin, White Masks*, trans. Richard Philcox (New York: Grove Press, 2008). While Fanon's view of address is more involved than I will recognize in this chapter, this particular text is especially fruitful in light of the present inquiry because of its conspicuous, if implicit, recruitment of the categories of address that I wish to clarify.
2. Fanon, *Black Skin*, 1 (see also 21); 2 (see also 19). His term is *assumer*, which means to assume, to take on, or to adopt. Frantz Fanon, *Peau noire masques blanc* (Paris: Éditions du Seuil, 1952), 13, 28, 30. References to the English and French editions will be given consecutively.
3. For a critique of the bond between language and nationality, see Walter D. Mignolo, *Local Histories, Global Designs: Coloniality, Subaltern Knowledges, and Border Thinking* (Princeton, NJ: Princeton University Press, 2000).
4. Fanon, *Black Skin*, 22, 17–18.
5. Fanon, *Black Skin/Peau noire*, 18/27.
6. Fanon, *Black Skin/Peau noire*, 17/27. Fanon's statement is ambiguous between content and form. Even if the example, narrowly conceived, may not demonstrate the role of norms of address, the demand for a specific kind of content imposes restrictions on the modes of address that a film can adopt, so address is clearly pertinent in that regard. On additional aesthetic factors to which Fanon draws attention and that reverberate in the plane of address, see Monique Roelofs, *The Cultural Promise of the Aesthetic* (New York: Bloomsbury, 2014), 44–48, and Monique Roelofs, "Race-ing Aesthetic Theory," in *The Routledge Companion to the Philosophy of Race*, ed. Paul C. Taylor, Linda Martín Alcoff, and Luvell Anderson (New York: Routledge, 2018), 367–69.
7. Fanon, *Black Skin/Peau noire*, 21/30.
8. For an approach along these lines to the entanglements of language and culture in Fanon, an analysis that also considers facets of address, if from different angles than I pursue here, see Homi K. Bhabha, *The Location of Culture* (New York: Routledge, 1994), 35–45, 131–32, 152–57, 236–38.
9. Fanon's view of address implements this kind of boundary-producing, connectivity-generating power in its own right. Foregrounding specific kinds of linguistic address, he discounts certain other modes of bodily address, exemplified, as Rey Chow indicates, by sexuality and touch. Rey Chow, "The Politics of Admittance: Female Sexual Agency, Miscegenation, and the Formation of Community in Frantz Fanon," in *Ethics after Idealism: Theory-Culture-Ethnicity-Reading* (Bloomington: Indiana University Press, 1998), 61, 68. Chow describes Fanon's privileging of male intellectual practice over the sexual agency of women of color and signals his correlative valorization of a rigorously bounded, racially pure, postcolonial community. She shows how he gives pride of place to this masculinist paradigm of the community to come, over and above an alternative model centered in difference, racial sexual intermixing, and heterogeneity, one that includes women of color as active participants in the production of meanings and as initiators of forms of agency (69–73).

10. Patricia Williams highlights analogous dynamics in contemporary settings. Patricia J. Williams, *Seeing a Color-Blind Future: The Paradox of Race* (New York: Farrar, Straus and Giroux, 1997), 35–37.
11. Fanon's account corresponds notably with Benjamin's, for example, in his insistence on the role of stories in patterns of racial embodiment (*Black Skin*, 91).
12. Walter Benjamin, "A Berlin Chronicle," in *Selected Writings*, vol. 2: *1927–1934*, trans. Rodney Livingstone et al., ed. Michael W. Jennings, Howard Eiland, and Gary Smith (Cambridge, MA: Harvard University Press, 1999), 620–21.
13. Benjamin, "Berlin Chronicle," 600.
14. Benjamin, "Berlin Chronicle," 602.
15. Benjamin, "Berlin Chronicle," 602.
16. Miriam Hansen observes that Benjamin, after having read a 1930 article by Gershom Scholem on the subject of a "visionary, self-alienating self-encounter," implicitly introduced the concept of aura in "A Berlin Chronicle," among other writings from the early 1930s. Miriam Hansen, "Benjamin's Aura: The Resurrection of a Concept," *Critical Inquiry* 34, no. 2 (2008): 336–75 [371]. Aspects of the aura she signals, in particular, in "A Berlin Chronicle," are its dimension of a dislocation of self, its entwinement of closeness and distance, its operation in the register of the unconscious, and its invocation of absence and loss (344, 347).
17. For a reading of Benjamin as a peripatetic philosopher and cultural critic, see Beatrice Hanssen, "Physiognomy of a Flâneur: Walter Benjamin's Peregrinations through Paris in Search of a New Imaginary," introduction to *Walter Benjamin and "The Arcades Project*," ed. Beatrice Hanssen (London: Continuum, 2006). On the element of personal loss in "A Berlin Chronicle," see page 11. Benjamin's address of the text explicitly invokes love: the dedication reads "For my dear Stephan." Benjamin, "Berlin Chronicle," 595.
18. Benjamin, "Berlin Chronicle," 611.
19. Benjamin, "Berlin Chronicle," 598.
20. Benjamin, "Berlin Chronicle," 595. I am assuming that Benjamin's commentary here concerns the dune landscape imagined in relation to the train station, mentioned two vignettes earlier in his text, because the possibility of delusion arises plausibly in connection with this experience, which he describes as "like a *fata morgana*" (598). The reference of his term "vista," however, may also be broader than that, and can additionally include the city scenes and sexual encounters he participated in and enjoyed together with Franz Hessel (599).
21. Benjamin, "Berlin Chronicle," 603.
22. Benjamin, "Berlin Chronicle," 611.
23. Of particular relevance in this context are, for instance, Benjamin's remarks in "A Berlin Chronicle" about the way in which he handles the assignment of writing up, "from day to day in a loosely subjective form," a series of "notes" or "glosses on everything that seemed noteworthy in Berlin": he reports going about this task by juggling the "retrospective glance" that he takes "at what Berlin had become for [him] over the years," with the necessary "precaution of the subject represented by the 'I,' which is entitled not to be sold cheap" (603). Benjamin's commercial metaphor attests to the pronounced ethical and political concerns that he navigates by way of this critical mode of address. Another indication of this form of address becomes apparent in his attribution to a staircase of the "power to recognize" him (612). More generally, on the limits of experience that announce themselves in the very notations or figurations (if not representations) of that experience; on the interconnected roles of language, people, places, and things in the molding of experience; and on the ultimately not sharply delineable boundaries between adult and childhood worlds, factors that all affect the relevant identifications and disidentifications, distances and intimacies, see "Berlin Chronicle," 597–606, 611–17. A pronounced limitation

that, meanwhile, in important ways eludes Benjamin's critical strategy of address concerns gender. See, e.g., "Berlin Chronicle," 594–96, 615–17; and Miriam Hansen, "Benjamin, Cinema and Experience: 'The Blue Flower in the Land of Technology,'" *New German Critique* 40 (1987): 179–224 [212–24]. Interwoven blind spots on Benjamin's part, furthermore, surround coordinates of coloniality, race, sexuality, and aspects of class with which these factors entwine. Beatrice Hanssen describes "the encounter between the historic 'now' and the historic 'then' of recognizability" inherent in his notion of the dialectical image, a point that, I would argue, applies also to the structure of temporal address in "A Berlin Chronicle." Hanssen, "Physiognomy," 11. Hanssen mentions the risk of a nostalgic vision (notably in "A Berlin Chronicle"), which, she argues, Benjamin answers with his conception of history as a dialectic of images (2).

24. On dimensions of liberation and freedom in Benjamin, see Miriam Hansen, "Benjamin, Cinema," 182, 185, 190–224; and Hanssen, "Physiognomy," esp. 6 and 9. On the "dream of ... the multiple and unacknowledged possibilities ... lodged within impossibility" as offering for Benjamin "the promise and programme of a *coming* philosophy," see Gerhard Richter, "A Matter of Distance: Benjamin's *One-Way Street* through the *Arcades*," in Hanssen, ed., *Arcades Project*, 156.
25. Benjamin, "Berlin Chronicle," 595–99.
26. Benjamin, "Berlin Chronicle," 595, 597. On the closeness between Benjamin's persona and that of the flaneur, see also Hansen, "Benjamin, Cinema," 194–95.
27. For a detailed analysis of Benjamin's view of the conditions for experience, one that I would argue can be illuminatingly supplemented with a reading in terms of address, see Hansen, "Benjamin, Cinema" and "Benjamin's Aura."
28. Walter Benjamin, "The Storyteller: Observations on the Works of Nicolai Leskov," in *Selected Writings*, vol. 3: *1935–1938*, trans. Edmund Jephcott, Howard Eiland, et al., ed. Howard Eiland and Michael W. Jennings (Cambridge, MA: Harvard University Press, 2002); Walter Benjamin, "Experience and Poverty," in *Selected Writings*, vol. 2; Walter Benjamin, "The Work of Art in the Age of Its Technological Reproducibility," third version, in *Selected Writings*, vol. 4: *1938–1940*, trans. Edmund Jephcott et al., ed. Howard Eiland and Michael W. Jennings (Cambridge, MA: Harvard University Press, 2003).
29. For an exploration of the dimensions of memory and historicity that pervade articulations of these kinds of alternative visions, see Hansen, "Benjamin, Cinema."
30. On Benjamin's philosophical inquiry into the nature of experience, which pervades many of his texts on cities, see Richter, "Matter of Distance," 134–37, 145; and Hansen, "Benjamin's Aura."
31. Althusser, "Ideology and Ideological State Apparatuses (Notes toward an Investigation)," in *Lenin and Philosophy, and Other Essays*, trans. Ben Brewster (New York: Monthly Review Press, 1971), 143, 181, 184. Althusser differentiates ideology in general from the functioning of ideologies in ISAs but remains somewhat cryptic about the precise connections between these two levels.
32. Althusser, "Ideology," 174.
33. Althusser, "Ideology," 178.
34. Althusser, "Ideology," 172–76.
35. Althusser, "Ideology," 173. On the everydayness of interpellation, see also 174n18, 182.
36. Althusser, "Ideology," 168.
37. Althusser, "Ideology," 181.
38. Althusser, "Ideology," 182; 178; 155–56, 176; 131–32; 133, 155–56; 181. See also 147n11.
39. Ellen F. Rooney, "Better Read than Dead: Althusser and the Fetish of Ideology," in *Yale French Studies* 88 (1995): 183–200, see esp. 191–93, 199–200; Ellen F. Rooney, "Form and Contentment," *Modern Language Quarterly* 61, no. 1 (2000): 17–40 [37].

40. Althusser, "Ideology," 133.
41. Althusser, "Ideology," 132.
42. On Benjamin's conception of reading, see Hansen, "Benjamin, Cinema," 190, 195–98, 207–11; and Richter, "Matter of Distance," 137–39, 149–56. For an account of Althusser's notion of reading in connection with his view of ideology as an operation of form, see Rooney, "Better Read than Dead," esp. 191–94, 197–200. On questions of reading in Fanon as tied to aspects of address, see Bhabha, *Location of Culture*, 35–39, 152–57.
43. Roland Barthes, *The Pleasure of the Text*, trans. Richard Miller (New York: Hill and Wang, 1975), 17.
44. On Barthes's eroticization of a new body in his writing, see Pierre Saint-Amand, "The Secretive Body: Roland Barthes's Gay Erotics," trans. Charles A. Porter and Noah Guynn, *Yale French Studies* 90 (1996): 153–71.
45. Barthes, *Pleasure*, 63. While Barthes renders textual pleasure relative to the reader's psychic dispositions, in positing these three figures, he distinguishes reading from a solipsistic artifact of the reader's fantasy and hence avoids collapsing these positions into a single point. Of course, his notion of aesthetic interpretation and meaning-making is more multifaceted than my formulation suggests here. For some of the complexities that arise, see, for example, Naomi Schor's analysis of Barthes's desublimating aesthetics and strategies of reading in *Reading in Detail: Aesthetics and the Feminine* (New York: Methuen, 1987), 3–7, 79–97; and Martin Jay, "Roland Barthes and the Tricks of Experience," *Yale Journal of Criticism* 14, no. 2 (2001): 469–76.
46. Barthes, *Pleasure*, 64; 34, 37.
47. Barthes, *Pleasure*, 62–63.
48. The comfortable aspect is necessary for the element of disturbance. Viz. Barthes, *Pleasure of the Text*, 6–7, 14.
49. Barthes, *Pleasure*, 24–25.
50. Barthes, *Pleasure*, 34.
51. For Barthes the *punctum* "rises from the scene, shoots out of it like an arrow, and pierces me." Roland Barthes, *Camera Lucida: Reflections on Photography* trans. Richard Howard (New York: Hill and Wang, 1981), 26. He also speaks of the "kairos" of desire (59). This precision marks not only the text of pleasure but also the text in which desire points to love and death (73). An instance of this can be found in the famed Winter Garden photograph, which allows Barthes to "discover" his mother, to find the "truth" of her being (109, 67). In this photo of his mother, he encounters a "just image, an image which would be both justice and accuracy" (70). The accuracy in question amounts to an affective precision and guarantee (see 113). Exactitude of address's orientations is of great importance to certain kinds of aesthetic experience and meaning, in Barthes's view.
52. Barthes, *Pleasure*, 27; 5.
53. Barthes, *Pleasure*, 5; 6; 5, 25. This proof Barthes finds in the writing itself.
54. Barthes, *Pleasure*, 4; 27.
55. Given Barthes's notion of the productivity of desire in creating textual form, the link between desire and address is in fact more involved than this formulation suggests: desire also shapes the text's modes of address in the process of molding textual form.
56. Barthes, *Pleasure*, 14.
57. Barthes, *Pleasure*, 18, 34–35.
58. For a suggestive discussion of the ways in which Barthes's writing gestures toward utopia through a mode of address that abounds in conditionals and, hence, introduces a lightness and a floating dimension to the body it figures, see Raymond Bellour, "'. . . *rait*': Sign of Utopia," trans. Jeffrey Boyd, *Yale Journal of Criticism* 14, no. 2 (2001): 477–84. I am

importing the term "address" into Bellour's analysis, which does not use it explicitly. On a different note, Barthes's conception of desire can be faulted for eliding important systemic factors pertaining to facets of social difference. However, the weight that he ascribes to such coordinates is to be assessed in conjunction with, among other things, the significance he attributes to mass-cultural discourses and desires in, for instance, *Mythologies*, selected and translated by Annette Lavers (New York: Hill and Wang, 1972). Notwithstanding the systemic registers that he affirms, his conception of textual address stands in (a not necessarily irreconcilable) tension with the role of certain institutionalized structures of address in the realization of desire and pleasure. In his essay "The Mass Public and the Mass Subject" in *The Phantom Public Sphere* (Minneapolis: University of Minnesota Press, 1993), Michael Warner points to the public articulation of forms of attraction and desire, which, mobilizing practices of collective witnessing, activates logics of self-abstraction. Warner observes that consumption and politics share a metalanguage for delineating conceptions of "what a public or a people is" (242–43) and, hence, for shaping public references and foci for our desires. Barthes's notion of desire can be combined with such accounts. Moreover, his invocation of the bodily erotics of textual pleasure also goes athwart certain dimensions of symbolic abstraction. Thus it hints at unforeseen reconfigurations of the public and private, the personal and impersonal, the general and particular, the universal and the singular, mind and body, reason and emotion.

59. For a different account of reading as a formal practice that is productive of form, see Rooney, "Form and Contentment." On reading as a relation between readers and between readings, see Rooney's discussion of Althusser's theory of reading in "Better Read than Dead," 184, 194, 197.
60. Pierre Saint-Amand analyzes Barthes's vision of a slow, loitering, cruising, and ambling erotics in his essay "Barthes's Laziness," trans. Jennifer Curtis-Gage, *Yale Journal of Criticism* 14, no. 2 (2001): 519–26. Saint-Amand indicates how Barthes associates this form of desire with freedom and a liberated kind of writing (524–25). Clearly Barthesian eroticism also strays far from any sort of homonormative frame of experience. Naomi Schor points to the moment of degendering in Barthes' aesthetics, in *Reading in Detail*, 4, 6, 97. On dimensions of regendering and multiple gendering, see Roelofs, *Cultural Promise*, 58–59, 78–87. For a discussion of the "diffraction" of gender and sexual binaries in Barthes, the plurality of sensualities, and the "deflation" of phallic paradigms of sexuality, masculinity, and the body, see Saint-Amand, "Secretive Body," 158–59, 163–64, 171. On elements of freedom inherent in Barthes's erotics, see 161 and 171.
61. Gloria E. Anzaldúa, "Speaking in Tongues: A Letter to Third World Women Writers," in *This Bridge Called My Back: Writings by Radical Women of Color*, 3rd edition, ed. Cherríe L. Moraga and Gloria E. Anzaldúa (Berkeley, CA: Third Woman Press, 2002), 183.
62. Anzaldúa, "Speaking," 185.
63. Anzaldúa, "Speaking," 183, 187.
64. Anzaldúa, "Speaking," 183.
65. Anzaldúa, "Speaking," 183.
66. Anzaldúa, "Speaking," 189.
67. Anzaldúa, "Speaking," 190; 188.
68. Anzaldúa, "Speaking," 191; 187–88. For an illuminating reading of the functioning of writing in Anzaldúa's *Borderlands/La Frontera* as "an affective technique" that, arguably, also sheds light on the shifting sense of self that she recognizes in the current text, see Cynthia M. Paccacerqua, "Gloria Anzaldúa's Affective Logic of *Volverse Una*," *Hypatia* 31, no. 2 (2016): 334–51 [344–45]. For a useful discussion of the collaborative, productive, critical, and sensuously and affectively embodied epistemic affordances of various modalities of

302 5. Address's Key Constituents

writing that Anzaldúa practices and envisions, see Andrea J. Pitts, "Gloria E. Anzaldúa's *Autohistoria-teoría* as an Epistemology of Self-Knowledge/Ignorance," *Hypatia* 31, no. 2 (2016): 352–69 [357–66]. Pinpointing forms of reading between Anzaldúa and her audience that are part of this process of critical engagement, Pitts signals elements of what I would call patterns of mutually interlacing forms of address (360, 363, 365–66).

69. Anzaldúa, "Speaking," 187. While opposing white masculinist norms of address that demand a distancing of life in order to qualify as successful writing (185), Anzaldúa, in these comments, valorizes a form of authorial distance nonetheless. This latter kind of distance, in her view, does not undermine but lends support to the lives of women of color. One way of reconciling these two points would be on the assumption that the kind of distance that Anzaldúa favors emerges partially in the course of writing rather than being merely presupposed by it. In this reading, we can understand it as a partial product of rather than simply a prerequisite for writerly address.
70. Anzaldúa, "Speaking," 191–92.
71. Anzaldúa, "Speaking," 192.
72. Anzaldúa, "Speaking," 188–89.
73. Anzaldúa, "Speaking," 186, 189–90.
74. Judith Butler, "Performative Acts and Gender Constitution: An Essay in Phenomenology and Feminist Theory," *Theatre Journal* 40, no. 4 (1988): 519–31 [521].
75. Judith Butler, "Doing Justice to Someone: Sex Reassignment and Allegories of Transsexuality," *GLQ* 7, no. 4 (2001): 621–36; Butler, *Giving an Account of Oneself* (New York: Fordham University Press, 2005); Judith Butler, "Violence, Non-Violence: Sartre on Fanon," *Graduate Faculty Philosophy Journal* 27, no. 1 (2006): 3–24.
76. Butler, *Giving an Account*, 30–34, 43, 45–49, 60–64.
77. Judith Butler, *Precarious Life: The Powers of Mourning and Violence* (London: Verso, 2004), 32–38, 146–51.
78. Butler, *Precarious Life*, xii–xiii, 20, 30, 33, 42–45.
79. George Yancy, Interview with Judith Butler, "What's Wrong with 'All Lives Matter?,'" *New York Times*, "The Stone" column, January 12, 2015. http://opinionator.blogs.nytimes.com/2015/01/12/whats-wrong-with-all-lives-matter.
80. Butler in Yancy, "What's Wrong?"
81. Judith Butler, *Notes toward a Performative Theory of Assembly* (Cambridge, MA: Harvard University Press, 2015), 9–17.
82. Butler, *Notes*, 71, 75, 85, 166.
83. Butler, *Notes*, 168–70; 184–88; 218.
84. On these various dimensions of objects and spaces, see, among many others, Adrian Forty, *Objects of Desire: Design and Society since 1750* (London: Thames and Hudson, 1986); Mary Guyatt, "The Wedgwood Slave Medallion: Values in Eighteenth-Century Design," *Journal of Design History* 13, no. 2 (2000): 93–105; Barbara Johnson, *Persons and Things* (Cambridge, MA: Harvard University Press, 2008); Jane Bennett, *Vibrant Matter: Toward a Political Ecology of Things* (Durham, NC: Duke University Press, 2010); Roelofs, *Cultural Promise*; Mabel O. Wilson, "Carceral Architectures," *E-flux Architecture*, Oct. 4, 2016, http://www.e-flux.com/architecture/superhumanity/68676/carceral-architectures/; Bonnie Honig, *Public Things: Democracy in Disrepair* (New York: Fordham University Press, 2017); and Mabel O. Wilson, "Mine Not Yours," *E-flux Architecture*, July 4, 2018, https://www.e-flux.com/architecture/dimensions-of-citizenship/178292/mine-not-yours/.
85. Peter Stallybrass, "Marx's Coat," in *Border Fetishisms: Material Objects in Unstable Spaces*, ed. Patricia Spyer (New York: Routledge, 1998).
86. Stallybrass, "Marx's Coat," 184.

87. Stallybrass, "Marx's Coat," 186.
88. Stallybrass, "Marx's Coat," 187.
89. Stallybrass, "Marx's Coat," 188.
90. Stallybrass, "Marx's Coat," 199, 203.
91. This point of criticism, of course, needs qualification in light of the fact that Fanon's and Anzaldúa's understandings of linguistic address are more extensive than the views discussed in the current chapter.
92. Accordingly, our account of address complements approaches such as the ones mentioned in note 84 of this chapter.

6. Transforming Aesthetic Relationships

1. Jane Weinstock, "Interview with Martha Rosler," *October* 17 (1981): 77–98 [78].
2. Helen Molesworth notes how the video belongs to a body of feminist work whose artistic strategies have been misrecognized because they fell through the cracks of a feminist outlook centered on the contrasts between, on the one hand, allegedly second-wave stances and, on the other, what are considered theoretical or poststructuralist approaches, as well as on the antagonisms dividing 1970s from 1980s art practices. Helen Molesworth, "House Work and Art Work," *October* 92 (2000): 71–97 [71–77]. She also documents how these strategies remained invisible within reigning artistic paradigms of Conceptualism, Minimalism, and Institutional Critique and call for adjustments in those models (80–82). Molesworth observes how the works' "public address," in particular, has been elided or diminished by various institutions of art (94). Approaching *Semiotics* yet more extensively through the optic of address can bring to light the integral scope of the video's simultaneously aesthetic and political agenda and reveal the rich contributions that the notion of address can make to feminist cultural criticism beyond the purview of this particular work. Running across the fault lines between the different artistic and analytical models that converge here, without obfuscating the distinctiveness of each perspective, address reveals its analytical usefulness as a critical concept with respect to Rosler's piece as well as in regard to a broader array of cultural contexts. On this point, see also note 12 of this chapter.
3. Rosler, fascinatingly, uses the vocabulary of address in her commentary on the intertextual register of her video work, which, in *Semiotics*' case, involves televised cooking shows. She states, "Most of the video I do addresses television" (Weinstock, "Interview," 77). More generally, she describes her choice of medium as a choice of address: "If a text unfolds in my mind, I may wind up with something written. If I want a greater intensity of address, something seen, that may become a script for a videotape" (77). The category of address, for her, involves not only the work's medium, theme, and outreach to other cultural productions, but also the public: explaining that her postcard pieces were not works of "mass address," she observes, "My work in video is my closest approach to a general audience" (77). Other moments when Rosler uses the notion of address as an analytical concept appear in Benjamin Buchloh, "A Conversation with Martha Rosler," in *Martha Rosler: Positions in the Life World*, ed. Catherine de Zegher (Birmingham, UK: Ikon Gallery/ Vienna: Generali Foundation/Cambridge, MA: MIT Press, 1999), 32, 46. Commentators have echoed and amplified her idiom of address. Molesworth glosses Rosler's project, in *Semiotics*, as envisioning an "art practice that addresse[s] "a more diffuse notion of the public sphere and a more expansive notion of art" than the notions implied by established modes of art making as well as by other feminist art focused on maintenance

labor, and describes the work's "address" to "the public institutions of art" ("Work," 94–95). The broadened artistic structures of address and parameters of public life toward which it gestures dovetail with aspects of popular culture and design. On the video's engagement with images of white femininity in the media, see Molesworth, "Work," 79, 93; on the interplay between feminism and aesthetics, politics, and culture in the everyday, see 93–96. Commenting on the making of *Semiotics* in a later video, Rosler describes its setting "midway between an artist's loft posing as a kitchen and the television studio of people like Julia Child." MOCAtv, West Coast Video Art, *Martha Rosler: Semiotics of the Kitchen, 1975*, 2001. https://www.youtube.com/watch?v=oDUDzSDA8qo. She continues by noting that the piece "also is meant to evoke late-night commercials of a Ginsu-knife variety, where you have amateur performers kind of hacking away." *Semiotics* tags these different facets of space, design, media, and the everyday as a part of the formation of address it seeks to engage. Part and parcel of the address with which the work encounters both the art world and the capitalist marketplace with which art is imbricated is its intentionally deskilled quality. Rosler achieves this, as she notes in the later video, by way of a low-tech camera, in-camera edits, and the piece's anticommodifying exposure of its own means of representation.

4. Rosler says about the video: "I was concerned with something like the notion of 'language speaking the subject,' and with the transformation of the woman herself into a sign in a system of signs that represent a system of food production, a system of harnessed subjectivity." Weinstock, "Interview," 85. The performer's donning of the apron is telling in light of the harnessing operation to which this remark alludes. The apron shields the body, wrapping it in a coating that restrains at the same time that it invests the body with a domestic function. Both restrictively sheathing the body (including a layer of clothes) and interpellating it, the apron mounts a symbolic barrier between a corporeal interior and a gaze from the outside. Thus, the garment holds off the viewer. Given that Rosler's mode of address in the video is not simply one of liberating a fundamentally free, gendered body that can be found beyond the social masks it is forced to wear, the apron's manifold enveloping operations point to more complex artistic capacities for creative reinvention of the white feminine body. The apron itself, indeed, suggestively exemplifies some of these potentialities: while the splatters it carries on one level connote food stains, they look every bit as much—I'd say even more—like paint marks. As such, they signal the possibility of an alternative aestheticization of the body by way of artistic forms—forms that can be realized by means of culinary materials and templates of popular representation, as well as in traditional media of high art, such as paint. Throughout, language is of course a formative part of this process. On Rosler's notion of the disjunction between language and experience, see Buchloh, "Conversation," 45.

5. On Rosler's interest in food "as a metaphor for artmaking," see Weinstock, "Interview," 83. This metaphor clearly runs into limits for Rosler, who rejects adamantly the view that sees everyone as an artist. On her opposition to this idea, see Buchloh, "Conversation," 31.

6. On *Semiotics*' recognition of blind spots in semiotic theory when it comes to apprehending various feminized roles that do not apply exclusively to women, see Molesworth, "Work," 79.

7. Alluding to these aspects of the work's emotional politics, Rosler observed in 1981, "The very expression of anger in a context of everyday life is liberating for women" (Weinstock, "Interview," 86), and added, "The expression of anger is a step toward resistance and change" (83). Moreover, she regards such articulation as a necessary step: "Unless you face your own anger, you can't get rid of it or channel it constructively" (86).

8. On the dimension of humor, both caustic and slapstick, and its "deliberate foiling of the maintenance labor of cooking," see Molesworth, "Work," 90–91. Molesworth attributes

the ambivalence of the audience's response to *Semiotics* (laughter/shudder) to the work's combination of "an aesthetic of identification . . . with one of distanciation" (91). She also stresses the utopian aspect of Rosler's art generally, its investment in a different organization of the world (94–96). This point, I would argue, also applies to *Semiotics*. For further artistic sources and registers resonating in the work, including the dimension of humor, and on Rosler's view of art's capabilities for social intervention, see Buchloh, "Conversation," 25–42, 46–55.

9. In contemplating the scope of the relevant "we" or "our" in this phrase and in the questions that we will soon encounter, it is worth keeping in mind that Rosler aims to address her art to a general audience. Weinstock, "Interview," 77–78, 89–90 [89]. Asked whether she assumes a female spectator, she replies, "Not necessarily, but yes, I do," and goes on to explain that, at least at the time of *Semiotics*, she produced her work for women, and though decidedly valuing men's interest, cared more about being heard and understood by women than by men (89). Questions of whiteness, race, and sexuality in connection with *Semiotics* are complex, as the performance video appears to presuppose a prevalent white heterosexual middle- or working-class arrangement of domesticity, yet aspires to a general audience. A specific address to material histories, subject positions, and social configurations that fall outside of the purview mentioned here is absent in the video. I have tried—ultimately somewhat unsatisfactorily—to mark this limitation of its address by signaling the presumed whiteness of its addressee, yet do not wish thereby to simplify or foreclose alternative or broadened experiential possibilities that the work decidedly can encompass and in which audience response plays a marked part, the limits of its frame of reference notwithstanding.

10. On the challenges Rosler's works pose for the public–private distinction and the implications of this distinction for the positioning of (classes of) women, see Weinstock, "Interview," 81–82, 89–90, 93. This point also bears in different ways on her (implicit) figuration of other (partially intersecting) subject positions that fall outside the ambit of the social locations privileged by various kinds of universalizing perspectives. On *Semiotics*' simultaneous critique and negotiation of the boundaries between public and private, and its attempt to rethink the nature of the public through that of the private, see also Molesworth, "Work," 77–84, 90–91, 93–95. Molesworth shows that the work's critical uptake the institution of art is a crucial site where this tense web of engagements plays out (80–82, 93–95).

11. This structure and its gendering are clearly inflected by variables of class, race, sexuality, and ability. See also note 9 of this chapter.

12. Traversing the registers of theory and practice and the divides between different sorts of theory and practice, the notion of address works productively in the gaps between the divergent artistic and analytical approaches that, Molesworth argues, have stood in the way of an adequate recognition of the work's artistic strategies (see note 2 of this chapter). Thus the concept of address proves not only to be indispensable to a suitably complex and capacious reading of *Semiotics* but, more broadly, to undergird a form of feminist cultural criticism that averts certain prominent conceptual pitfalls.

13. For a rich reading of the film's figuration of subjectivity, history, imagination, and desire, see Maureen Turim, *The Films of Oshima Nagisa: Images of a Japanese Iconoclast* (Berkeley: University of California Press, 1998), 61–81. Turim explores *Death by Hanging* in light of Oshima's complex, broader iconoclastic stance toward conventional notions of Japanese identity and aesthetics (18–26); his purported interventions into history and the shaping of global culture (2, 25–26); the film's intertextual invocation of Japanese aesthetic figures (23–26); its specific uptake of, among other things, Nietzschean, Freudian, Kafkaesque, Foucauldian, Brechtean, and Lacanian motifs and forms (25, 61–65, 79–81), and its links with four other Oshima films of that period, which are comparable for their approach to the "unconscious of history" and the "poetics of the psyche" (123–24).

306　6. Transforming Aesthetic Relationships

 Catherine Russell underscores Oshima's uptake of the "nationalist character of Japanese ethnography and aesthetics" in *Death by Hanging* and his attempt to construct a "radical Japanese subject position that would be neither the universal humanism of the 1950s or the imperialist/conformist passivity of traditionalist ideology," in part through a "revision of Japanese narrative conventions." Catherine Russell, "Oshima Nagisa: The Limits of Nationhood," in *Narrative Mortality: Death, Closure, and New Wave Cinemas* (Minneapolis: University of Minnesota Press, 1995), 106, 110. On the address to the spectator in Oshima's films and *Death by Hanging* in particular, an address targeted at Japanese as well as international audiences; see also 107, 134–35, and Turim, *Oshima*, 61–62, 68–69, 76, 80. While Oshima challenges the limits of certain constructions of masculinity and coloniality, among other things, through a series of role reversals (criminal/victim, colonizer/colonized, man/woman), he, arguably, also subscribes to a masculinist conception of social critique. For a discussion of the film's gender politics through readings of two twenty-first-century films by Soni Kum that cite *Death by Hanging*, see Brett de Bary, "Looking at *Foreign Sky*, Desperately Seeking Post-Asia: Soni Kum, Nagisa Oshima, Ri Chin'u," *Asian Cinema* 26, no. 1 (2015): 7–22. De Bary describes the film aptly as a "critique of the continuity in the exercise of violence between pre-war Japanese colonialism and the post-war Japanese state" and notes how topical the 1968 "allegory of Japanese post-war amnesia about its war crimes" remains today (15). On gender positioning in the film, including figurations of the imaginary that, I would argue, elude the gendered delineations de Bary identifies, see also Turim, *Oshima*, 72, 78–81.

14. On the role of this historical precedent in the film, including the gender positioning surrounding the character "Sister," who is based loosely on the Korean journalist Bok Junan, who maintained a correspondence with Ri Chin'u, see Turim, *Oshima*, 66–67, 76–79; and de Bary, "Looking," 16–19.
15. This script is marked as transnational by way of a reference in the soundtrack to a German Nazi rally, the introduction of a US flag, and the Education Officer's disparaging remark that if R were black ("or someone with a different skin"), then it somehow would make the matter of his racial, ethnic, and national identity "easier" to explain. For a more detailed discussion of the soundtrack, see Turim, *Oshima*, 69, 80.
16. Turim observes how long takes that track and bring into focus the performers' movements and interactions energize the lines of the characters' debates (*Oshima*, 70).
17. In a scene on the rooftop of R's high school, the Education Officer apparently strangles a schoolgirl during his enactment of a portion of the narrative of R's crime. More generally, the officials have trouble conforming to their roles when playing R. See Turim, *Oshima*, 71–72.
18. Turim emphasizes the "free play and the open logic of imaginary processes" connoted by the lyrical, dreamlike sequences between the two Korean characters, and reads this lyricism as indicative of the "polysemy of their relationship, its poetry" (*Oshima*, 79–81). She also indicates how these images "replete with references to a diverse cultural past suggest a possible future, if the context of the past could be elided" (80). In my reading, such signs, rife with future possibilities, proliferate more widely across the film, a point that becomes visible when we attend to its countless incongruous forms of address and the aesthetic dimensions introduced by the encounters among those different modes.
19. Oshima's own deployment of multiple divergent tactics of aesthetic address, such as documentary, fictional, dreamlike, theatrical, and performative genres, provides evidence for this reading. Turim illuminatingly sees R's wish to integrate the registers of the imaginary and the real as exemplary of Oshima's inscription of his own film theory into the film. Turim, *Oshima*, 80. My reading expands this insight into the parallelism between R's and Oshima's poetics into a point about the aesthetic forms of address in and by the

film more generally. Of particular interest in this light are the placards interspersing the narrative, which draw attention to subjective and epistemic states on R's part. Showing self-reflexively how subjectivity and epistemic positioning are continually in the process of receiving aesthetic shape, the written intertitles are suggestive of possibilities other than a relentless push toward R's death, instigated by a dominant carceral, medical, colonialist, religious, legal, and narrative apparatus. Likewise, besides connoting a cipher within an encompassing symbolic system, R's abstract name—ready to be filled in by a variety of contents—opens out onto alternative, aesthetically inflected kinds of meanings.

20. Both Turim and de Bary call attention to a dimension of expiation of past crimes (Turim, *Oshima*, 78; de Bary, "Looking," 18–19). De Bary suggests that R, partly through "Sister"'s mediations, provides a model to the Japanese majority that exemplifies a (possibly redemptive) attitude that seeks to come to terms with irreversible historical colonial crimes. By contrast, Turim claims, to my mind convincingly, that the film's scenes of political controversy, as in other Oshima films, give prevalence to a wryly humorist "absurdist logic, where individuals talk past each other and rebuttal of each point is always possible" (*Oshima*, 78). In Turim's interpretation, the intertitle "R Accepts Being R for the Sake of All Rs" points to the difficulties attendant on a postcolonial identity, an identity that it becomes "a task to accept" (80). My reading of the film in terms of manifold forms of address highlights the sumptuous, incongruous, pluriform fabric of aesthetic registers that the film suggests marks this complex postcolonial condition.

21. Clarice Lispector, *The Hour of the Star*, trans. Giovanni Pontiero (1977; Manchester, UK: Carcanet Press, 1986), 50.

22. Lispector, *Hour*, 51, 71; 51–52; translation revised.

23. Lispector, *Hour*, 68.

24. For a more extensive discussion of these aspects of the novel, see Monique Roelofs, *The Cultural Promise of the Aesthetic* (New York: Bloomsbury, 2014), 89–93, 102–5, 178–86, 195, 198–99, 203–5. In Jean Franco's reading, *The Hour of the Star* probes the existential status of aesthetic pleasure, reveals the violence of acts of social othering on the part of dominant subjects, and contemplates the possibility that the agency and presence of the subaltern is "necessary for beauty, for conspicuous consumption, for the aesthetic." Jean Franco, "Going Public: Reinhabiting the Private," in *On Edge: The Crisis of Contemporary Latin American Culture*, ed. George Yúdice, Juan Flores, and Jean Franco (Minneapolis: University of Minnesota Press, 1992), 75–76.

25. Lispector, *Hour*, 13–17, 35–36, 46, 81; 8, 81.

26. Lispector, *Hour*, 69, 22.

27. Lispector, *Hour*, 20.

28. Lispector, *Hour*, 8.

29. Lispector, *Hour*, 33, 68. On the ways in which straightforwardly taking on the voice of the subaltern for Latin American (women) writers does not solve the problem of literature's engagement with class stratifications, a problem that requires a more rigorous critical engagement with constructions of social privilege and publicity, see Jean Franco, "Going Public," 70, 73–75, 80–81. While the novel in various respects observes the kinds of reservations about subaltern speech and hegemonic hearing expressed by Gayatri Spivak in her renowned essay "Can the Subaltern Speak?," the novel's decolonial or postcolonial critique reaches further than Spivak's in the sense that Lispector elaborates the multiple discursive relations I have mentioned and explores their social, political, affective, and aesthetic import. Gayatri Chakravorty Spivak, "Can the Subaltern Speak?," in *Marxism and the Interpretation of Culture*, ed. Cary Nelson and Lawrence Grossberg (Urbana: University of Illinois Press, 1988). I explore the question of voice in *The Hour of the Star* further in "Superfast and Superslow," a chapter of a book in progress coauthored

with Norman S. Holland, provisionally titled *The Super-Reader and the Super-Shopper: Aesthetic Politics in the Americas*.
30. Lispector, *Hour*, 15, 19, 24.
31. Lispector, *Hour*, 35, 58.
32. Lispector, *Hour*, 26, 86.
33. Lispector, *Hour*, 17, 47; 12, 17, 47, 82–83.
34. A groundbreaking treatment of the position of literature in Latin America along these lines is Ángel Rama, *The Lettered City*, trans. and ed. John Charles Chasteen (Durham, NC: Duke University Press, 1996). See also John Beverley, *Against Literature* (Minneapolis: University of Minnesota Press, 1993). Jean Franco ("Going Public," 76) observes succinctly how the novel explores the power of authorship along with the silence of the subaltern.
35. Lispector, *Hour*, 85–86.
36. I bring out further facets of the tensions in Rodrigo's poetics, of Macabéa's aesthetic stance, and of Lispector's figuration of aesthetics and temporality in "Super-Reader and Super-Shopper."
37. Lispector, *Hour*, 21; translation revised.
38. Lispector, *Hour*, 76, 43, 62.
39. Lispector, *Hour*, 84, 8, 9, 13.
40. Lispector, *Hour*, 9. Hélène Cixous suggests that each title could provide a point of entry into the text. Hélène Cixous, *Reading with Clarice Lispector*, ed. and trans. Verena Andermatt Conley (Minneapolis: University of Minnesota Press, 1990), 146.
41. Aesthetic promises made in and by the novel play an important part in its posing of this task for the reader. See Roelofs, *Cultural Promise*, 178–86, 195, 198–99.
42. Accordingly, a reading in terms of address unearths complex elements of the novel's decolonial feminist critique. The novel's deployment of address shapes the work's fundamental figuration of subaltern experience and agency and fashions its outreach to its audience. The problems of violence, aesthetics, power, publicity, authorship, and silence that, as Franco argues, Lispector takes up (see notes 24, 29, and 34 of this chapter) are significantly at stake in the question of address.
43. Pope.L in an untitled interview with Aliza Hoffman and Bennett Simpson, in Pope.L, *Pope.L: Proto-Skin Set* (New York: Mitchell-Innes & Nash, 2017), n.p.
44. For an extensive discussion of reading in detail, especially in connection with questions of gender, sexuality, and class, see Naomi Schor, *Reading in Detail: Aesthetics and the Feminine* (New York: Methuen, 1987).
45. The work, meanwhile, to some extent marks the English language as multiple, in consequence of the variability in accents signaled by the difference between what sound like white mainstream types of English (which are prevalent) and the Southern black English of the song.
46. Pope.L, *Whispering Campaign: Kassel* (Chicago, New York, and Los Angeles: Gray Center for Arts and Inquiry, Mitchell-Innes & Nash, and Susanne Vielmetter Los Angeles Projects, n.d.).
47. For a reflection on the racialized, gendered, and class-inflected power differences between horizontal and vertical positions, recall Pope.L's city crawl performances. See also his remarks in Martha Wilson "William Pope.L," *Bomb* 55 (1996): 50–55 [51, 53]; and Darby English, *How to See a Work of Art in Total Darkness* (Cambridge, MA: MIT Press, 2007), 265–88.
48. On Pope.L's understanding of language's role as conferring order on the body and on the connections between freedom and the street in his thought, see Wilson, "William Pope.L," 53. A pronounced register of the work's critique involves flows of commodity exchange

and consumption goods as well (see, e.g., fig. 6.16). As a substantially evanescent performance work, the campaign also runs athwart certain kinds of commodified art practices. On Pope.L's broader "aesthetics of dispossession," see English, *How to See*, 259, 264–70, 281–311.

49. Pope.L signals details explicitly in a text fragment called "SPY TEXT," which indicates how directors in charge of covert, politically sensitive operations were not supposed to know things that they could betray. Pope.L, *Whispering Campaign: Kassel*. The vignette describes details as "a form of contamination." This kind of view of detail has an intricate aesthetic history. For some of its implications for aesthetic constructions of social difference, see Schor, *Reading in Detail* and Roelofs, *Cultural Promise*, chapter 3.

50. Through its quiet, soft-spoken mode of address, the *Whispering Campaign* gives public form to dimensions of vulnerability and interiority of a kind that for Kevin Quashie exemplify the agency of black inner lives, and the vibrant possibilities for forms of black being and becoming that elude prefabricated social narratives. Thus we can apprehend the campaign as enacting the crucial role of modalities of quiet in black culture and as an instantiation of quiet's multitudinous dimensions of aliveness. For this understanding of quiet, its ties to black aliveness, and its links to questions as to what such aliveness involves, see Kevin Quashie, *The Sovereignty of Quiet: Beyond Resistance in Black Culture* (Rutgers, NJ: Rutgers University Press, 2012). Quashie discloses an element of surrender that characterizes certain kinds of quiet (27–45, 72, 129), a point that resonates powerfully with Pope.L's address to the emissaries and the viewer/listener/wanderer's address to the whispers. I then see the campaign as an instance of what Quashie calls "an aesthetics of quiet" (24). This aesthetics inheres in the work's as well as the audience's form of address. Margo Natalie Crawford's association of the act of whispering with Pope.L's *Skin Set* project is also poignant in connection with the register of quiet. By reference to the *Skin Set Drawings* (though not to the campaign), along with work by poets and playwrights Tom Dent and Amiri Baraka, among others, she reads whispering as exemplary of the ways in which twenty-first-century black aesthetics engages the vulnerabilities and complexities inherent in forms of black public interiority. Margo Natalie Crawford, *Black Post-Blackness: The Black Arts Movement and Twenty-First-Century Aesthetics* (Chicago: University of Illinois Press, 2017), 189–91. Indeed, one of the campaign's remarkable strategies is the way in which it brings into being what we can call a *public* genre of quiet.

51. On Pope.L's interest in a playful, open-ended rethinking of categories of whiteness, blackness, brownness, and race, see Wilson, "William Pope.L," 53. See also Pope.L's remarks on the playfulness and self-reflexivity of his writing and language in the *Skin Set* project, in the untitled interview in Pope.L, *Proto-Skin Set*, n.p.

52. In John Cage's groundbreaking work *4′33″* (1952), a pianist (or other instrumentalist) gives a recital without playing a single note on the instrument. For the duration of this piece in three movements, namely 4:33 minutes, the public listens to the ambient sound that is audible in the recital hall. The work subverts the conventional hierarchy between music and environmental noise, between predesigned musical signs that are part of a score and sounds that occur randomly or coincidentally.

53. Darby English stresses the readymade character of the form of the color equation, which forges a ground for a vast range of imaginative elaborations. Darby English, *To Describe a Life: Notes from the Intersection of Art and Race Terror* (New Haven, CT: Yale University Press, 2019), 72. English underscores the laughter that rises up from the formula's objectifying character, "so indifferent to so many aspects of what it *costs* to exist" (72) and the low-tech, everyday materials, which—besides ordinary paper, ballpoint ink, watercolor, and marker ink—also include things like coffee stains, dropped and fixated hairs, and

tears. He also points to a fundamental seriousness attendant on the tension that the works create between the normative and the experiential, by which he refers to the contrast between preconceived color differentiations and the ones that Pope.L puts into effect in the drawings (47, 72). English highlights how the *Skin Set Drawings* playfully make up a people without converting these imaginings into insights, yet while speaking emphatically to racial cultural and political realities, including regimes of abstract calculation and measurement that threaten to render life unlivable (75–85). In his reading, the works undermine the "cultural logic of colored people grouped by set" and investigate color's roles of "institution and division" in society, along with "the possibility of human significance without meaning" (79–80, 83). According to Iain Kerr, the declarative statements in the *Skin Set Drawings* establish a "structure of essentialism" while parodying and ironically challenging commonsense understandings of identity and foregrounding the complexity and absurdity—as well as the political stakes—of our attempts to define identity. Iain Kerr, "Working in (the) Color," in William Pope.L, *Black People Are Cropped: Skin Set Drawings 1997–2011* (Zurich: JRP/Ringier, 2012), 32. Kerr suggests that Pope.L also raises the question of what alternative kinds of subjective trajectories our color concepts could enact. Several commentators associate the *Skin Set Drawings* with registers of intimacy and interiority, and with a publicizing of the private (Crawford, 190–91; English, 67–68, 73, 76–78). Helen Molesworth likewise remarks on the feel of a doodle, which, she notes, intimates "a kind of unconscious at play" or an attempt to "force order on the unorderable," Helen Molesworth, "When Pope.L Shakes His Head . . . ," in Pope.L, *Black People*, 24. Orthogonally to this, she suggests, the notations appear "really public, like graffiti" (24). She signals their rebellious aspect, and marks an aspect of "taunting" (24). In this regard, I see them as paralleling the kind of graffiti that spurs further graffiti: in Molesworth's words, "Go ahead, they seem to say, explain me. Shit, explain this, all of it. Go ahead. Try" (24). This kind of incitement to further whispering also characterizes the aphorisms and fragments that make up the *Whispering Campaign*.

54. I am here invoking and expanding Frantz Fanon's notion of the "historical-racial" body schema, a trope that denotes the complex shaping of black embodiment in a multilayered process of engagement with white aesthetic figurations of black life, including "a thousand details, anecdotes, and stories." Frantz Fanon, *Black Skin, White Masks*, trans. Richard Philcox (New York: Grove Press, 2008), 91.

55. In his action *I Like America and America Likes Me* (1974), Joseph Beuys, upon arriving in the United States from Germany, shields his eyes and travels by ambulance, wrapped in felt, from the airport to a New York gallery. There, he spends three days in an enclosure with a coyote, carrying out ritualized exchanges with the animal, before being transported back by ambulance to the airport for his return to Germany. Assuming the role of a shaman, Beuys sought to enact a healing of the traumas inflicted by settler-colonialist societies on the native cultures of the American continent. Pope.L supplants Beuys's copiously narrativized, thick felt with a profligate array of paper-thin, colored, visual "skins."

56. In its critical intervention into configurations of public space, the *Whispering Campaign* parallels previous works by Pope.L. See, e.g., English, *How to See*, 261–64, 271. The mutual address between artwork and audience; among people; and between artwork and street, city, and other forums of aesthetic publicity are among the vectors of address that fuel Pope.L's intervention into webs of aesthetically mediated relationships. In a conversation about earlier performances, he expresses his intent to "poetically recreate street images and experiences that reconfigure the troublesome feelings we all go through when we encounter [the] 'sides' in the street" (Wilson, "William Pope.L," 53). He says, "Humans can make a difference with culture. It's a leap of faith to do any sort of cultural work.

I choose to make troubled culture" (53). Amplifying on this process of making a difference, he notes, "And if I can construct works that allow people to enter themselves, thus, enter the mess, then it's a collaboration and maybe, possibly, who knows, why not—I've nudged something" (55). Pope.L thus has explicitly in mind a wide field ("culture") of small-scale alterations (nudgings) as the relational plane that his work activates in engagement with its audience.

57. The form of a typescript supplemented with written emendations resonates with earlier writings on Pope.L's part, such as the text *Hole Theory, Parts Four and Five* (January 2002). See *William Pope.L: The Friendliest Black Artist in America*, ed. Mark H. C. Bessire (Cambridge, MA: MIT Press 2002), 76–110.
58. Pope.L, *Whispering Campaign*, broadcast by Freies Radio Kassel (Free Radio Kassel) during Documenta 14 (2017).
59. Pope.L, *Whispering Campaign: Kassel*.
60. The quoted statements, from "The environment in which . . ." through the next passage, were whispered in a women's voice.
61. What one hears after this passage on the radio is a long silence and, following that, at least five times, the question "What does Europe look like in the daylight?" This question confirms the gap between a view mediated by a screen and an eyewitness perception. The whisper score, however, moves on to different vignettes. When, later in the broadcast, the English and German reverse places, the phrase "Wie sieht Europa bei Tageslicht aus?" is recited only once, after the passage about the metal posts and the fire escape. Perhaps in the absence of digital mediation, the German question might be metaphorical, whereas the English is more factual. Whatever the reason, Pope.L appears to be traversing shifts between a digitally experienced reality and an actual world (or a portion thereof). Moreover, the ambiguous standing that the *Whispering Campaign* confers on Europe itself, which appears to oscillate between the real and the unreal, confers further twists on these transitions.
62. Pope.L, *Whispering Campaign: Kassel* (my translation from the German).
63. On the centrality of questions of social categories such as blackness, whiteness, masculinity, and class in Pope.L's oeuvre, see, among others, Bessire, *Pope.L*; and English, *How to See*, 259–60, 270, 281–84, 288. Pope.L describes racial categories such as blackness as involving a "negotiation"—"something . . . to be chosen and re-chosen; thus reevaluated in the process." Lowery Stokes Sims, "Interview with Pope.L," in Bessire, *Pope.L*, 66. The artists adds, "I suppose this is why, in part, I work in so many settings and mediums—I want to create a practice that can interpolate the process and centrifugal qualities of blackness as a function of form and style. It's the lack in black that makes me what I am" (66). A statement such as this one makes clear how formal, aesthetic qualities of Pope.L's use of color (especially in the *Skin Set Drawings*) or color-designations (in the *Whispering Campaign*) enter into entwinements with mobile, constructive, and deconstructive registers of racial meaning.
64. On Pope.L's engagement with these facets of our race categories, see Wilson, "William Pope.L," 53–54; Sims, "Interview," 66; Pope.L, "Some Notes on the Ocean . . . ," in Pope.L, *Black People*; and Pope.L's comments on blackness as productive of an "over-writing, a palimpsest of meanings, that may obscure or delete or redefine who or what a person is as a person," in an untitled interview in Pope.L, *Proto-Skin Set*, n.p.; English, *How to See*, 288, 297–312; and English, *Describe a Life*, 47, 75, 79–80.
65. Pope.L, meanwhile, does not see his project of aesthetic remaking vis-à-vis racial categories as one of invention out of nowhere, but understands it as a negotiation with constraints, possibilities, and differentiations, one that involves an at once critical and celebratory

engagement with social constructions and the tensions and multiple valorizations they entail. See Wilson, "William Pope.L," 53–54; Bessire, *Pope.L*, 22; Sims, "Interview," 66; English, *How to See*, 265, 286–88, 312; English, *Describe a Life*, 47.

66. Pope.L in conversation with C. Carr on 27 January 2002, qtd. in C. Carr, "In the Discomfort Zone," in Bessire, *Pope.L*, 53.
67. Wilson, "William Pope.L," 54–55.
68. Wilson, "William Pope.L," 55. Pope.L's comment on his philosophy of language generally is also of relevance here: "Yowza, you can create a three-dimensional chain of words, a whole nebulae [*sic*]; a flurry of language events in some kind of oscillating network. By layering events, subtending celebration beneath contradiction, you can get depth as well as flowing narrative" (55). This principle also guides the *Whispering Campaign* and the *Skin Set* project, which, I would argue, besides that, envelop contradiction within celebration.
69. Wilson, "William Pope.L," 55.
70. Darby English underscores the operation of "differing" in the *Skin Set* project (*Describe*, 63, 75, 84–85). I, in addition to that, want to acknowledge a crucial dimension of commonality. At the same time, this facet does not cease to develop and metamorphose in ways on which English sheds light.
71. Pope.L in untitled interview, in Pope.L, *Proto-Skin Set*, n.p.
72. On the "speech freedom" pronounced in the *Skin Set* project, see English, *Describe*, 77. Bessire reads Pope.L's use of humor in his oeuvre as embodying a movement toward freedom. Bessire, *Pope.L*, 23. We can extend this point to the *Whispering Campaign* and the *Skin Set Drawings*.
73. In the sequel to this volume, *Aesthetics, Address, and the Making of Culture*, I will bring out further aspects of the web of address that the *Whispering Campaign* posits and energizes.
74. This kind of paratactical juxtaposition marks many other of Pope.L's actions and works, including his scraping over the street in a business suit in *Tompkins Square Crawl* (1991); his imprinting of bags of manure with the image of Martin Luther King, Jr. in *Rebuilding the Monument* (1995–1999); and his yoking of his half-naked, dollar-bills-dispensing body via a chain of sausages to an icon of abstract capitalist exchange in *ATM Piece* (1997).

Afterword

1. Walter Benjamin, "A Berlin Chronicle," in *Selected Writings*, vol. 2: *1927–1934*, trans. Rodney Livingstone and others, ed. Michael W. Jennings, Howard Eiland, and Gary Smith (Cambridge, MA: Harvard University Press, 1999), 617.
2. Benjamin, "Berlin Chronicle," 617.

INDEX

Note: Page numbers in *italics* indicate figures.

abstraction, 129–30, 134
absurd, the, 30, 119, 137, 214; in "The Nose," 163–66
address: aesthetics and, 3, 17–21, 30, 77–78, 80–81, 146, 169–200, 255–61; agency and, 18, 36–37, 245, 254, 258, 262; arts of, 12, 31–33, 249, 258, 286n105, 291n36; artworks and, 3–6, 33, 245–47; audience for, 28–29; body as site of, 1, 23; by this book, 3–6, 15, 21, 250–54; colloquial senses of, 7, 158–59; 161; culture and, 3, 10–11, 17–19, 23–24, 40–41, 45, 198, 255–59, 262; defining, 7, 23–24, 27, 157; desire and, 7, 152–53, 250–51, 258–59; directionality of, 1, 7–10, 22–23, 147–150, 158–67; discourse and, 88–90; egalitarian dimension of, 14, 153, 156–57, 168; enlightenment and, 61–78; experience and, 177; evacuation of meaning and, 45–46, 49–50, 58–59, 113–14, 144, 244, 252–53; five key constituents of, 7, 18, 146–47, 151–53, 156–57, 167–70, 197, 199, 261–62; freedom and, 94, 137–38, 258; as ground of normativity, relationality, agency, order, and aesthetic meaning, 36–37, 58–60, 72, 77, 86–87, 100, 113, 146; historical perspective on, 61; illocutionary force and, 25, 36, 51, 273n29, 275n36; inclusivity of concept of, 21–29, 49; indirection and, 160–62, 166–67, 182; interactions in, 7, 146; intimacies of, 7, 9, 49, 138, 176; language of, 8–9, 13–14, 23–24, 27–28, 197, 199, 267n24, 267n29; media of, 68–73, 187, 241; model of, 18, 151, 153, 157, 197, 199, 254, 261–62; as motor of cultivation, 63–78, 84–87; multidimensionality of, 162, 167–68; multifocal, granular view of, 99–101, 144, 196–200; multimodal character of, 1, 7, 40, 89, 147; as navigational tool, 12, 153–54; nonaddress and, 9–10; normativity and, 2, 4, 12, 26, 33, 180; objects and, 22–23, 191–96, 198, 264n6, 267n29, 289n21; as organizational linchpin, 35, 60, 112, 137, 143, 146–48, 157–60, 174; orientations in, 9–10, 12, 17, 120–21, 146–47, 158–61; performative acts and, 25, 28, 36, 51, 188–90, 272n25; philosophy on, 25–26, 28, 60, 135, 169; in philosophy and cultural critique, 13; places and, 22–23, 191–96, 198; politics and, 1, 17, 155–56, 169–200, 258–61; in power and knowledge, 88–100, 282n66; in publics and platforms of publicity, 28–29, 65–87, 89, 229–35; reading and, 29, 102, 140–41, 144, 152, 180–81, 256–57, 292nn55–56; as

314 Index

address (continued)
 regulatory device, 37–39, 155–62, 167–68; relationality of, 1, 7–10, 22–24, 31, 146–51, 158; replenishing meaning and, 51–59, 113–14, 144, 244, 252–53; scope of, 23–25, 49; as site of aesthetic incongruities, 255–56; social difference and, 2, 20–21, 30–31, 180, 197, 220, 243; speech acts and, 25, 28, 51, 272n25, 274n38; stakes in, 34, 107, 143–45; subjectivity and, 15–17, 92, 170, 189, 201; successful, 259, 267n32; taste and, 84–87, 183, 218–19; theory of, 1–2, 4–6, 13–15; as tool of criticism and critique, 28–31, 258–59; transdisciplinary form of, 4; as vehicle of aesthetic, ethical, and political modalities and meanings, 103–4, 246, 258–59; by women of color, 184–87. *See also* concept of address; forms of address; modes of address; norms of address; scenes of address; scripts of address; structures of address
addressors: addressees and, 107, 117, 153, 160–61; women of color as, 184
Adorno, Theodor W., 29, 256, 268n35, 276nn2–3
aesthesis, 19
aesthetic, the: concept of, 19–20; as grounded in address, 19–20, 266n26. *See also* aesthetics
aesthetic concepts, 57
aesthetic desire, 97, 99, 181–84, 218. *See also* desire
aesthetic experience, 19–20, 41, 59, 78–87, 97, 98, 105–6, 113. *See also* experience
aesthetic incongruities, 122–23, 130–31, 133–36, 251, 255–56
aesthetic judgment, 78–86
aesthetic meaning, 18–20, 35–37, 50, 60–61, 75, 85–87, 100, 113, 146, 220–21, 256, 263n1
aesthetic normativity, 19–20, 85
aesthetic pleasure, 182–83
aesthetic publicity, 20, 76–77, 83, 259; Hume on, 78–87; platforms for 221, 229, 238, 247, 259, 310n56. *See also* publicity
aesthetic relationality, 20, 41–42, 212, 215–17, 220–21, 140, 243, 245–47, 255, 258, 269n14. *See also* relationality
aesthetics: address and, 3, 17–21, 30, 77–78, 80–81, 146, 169–200, 255–61; of Barthes, 181–84; of Benjamin, 177–78; critical political, 3, 104, 138, 144, 177–78, 199, 220–21, 261; culture and, 23, 255;

decolonial, critical race feminist, 20–21, 202, 219, 246–47, 260, 266n28; of existence, 93, 95–100; of Fanon, 172–73; of Foucault, 93, 95–100; in "Girl," 36–42, 47, 98; in *The Hour of the Star*, 216–21; of Hume, 19, 78–87; of interconnectedness, 144; of Kant, 19, 75–78; politics and, 3, 17, 21, 104, 138, 144, 246; in self-creation, 93, 97–98; social difference and, 20; taste, 78–87. *See also* aesthetic, the; aesthetic relationality; *specific artists, artworks, and theorists*
agency: 2, 16, 25, 30; address and, 49, 75, 79, 92, 97, 100, 156–57, 168, 202, 207, 230, 245, 254, 258; address as ground of, 36–37, 58–60, 72, 77, 86–87, 100, 113, 146; aesthetic, 62, 247; Cortázar on, 102, 104, 115, 134, 140, 250; female, 38, 40; of objects, 83, 124–26, 198; sexual, 297n9
Ahmed, Sara, 295n16, 295n19
Al-Kassim, Dina, 265n13
Alcoff, Linda Martín, 283n78
Alexander, Simone James, 271n22, 271n24, 296n4
Allen, Amy, 284n86
Allen, Sharon Lubkemann, 296n30
Althusser, Louis, 2, 14–15, 170, 178–81, 196–98; on address and social differentiation, 180; Benjamin, Fanon and, 180–81; on ideological state apparatuses (ISAs) as structures of address, 178; on interpellation and subjection, 178–79; on norms and forms of address, 179–80; on reading, 178, 180–81; on scenes and scripts of address, 178
ambivalence, 29–30, 95, 112–13, 120, 127, 139, 155, 161, 206, 232, 242; aesthetic, 46–47, 87, 139, 217–19, 304n8
"Answer to the Question, An" (Kant), 19, 61–78
antinormativity, 263n1, 284n89
Anzaldúa, Gloria, 4, 17–18, 146, 196–98; on binaries, 11, 187; critical political aesthetics of, 30, 170, 184, 187; on culture and boundaries, 10–12; on feminists of color, 170, 184, 187; free indirect discourse of, 11–12; on intimacy, 184–86; on intermediality, 187–88; on normativity and norms of address, 10, 12, 184; on objects, 10, 188; on relationality, 10–11, 30–31; on scenes and structures of address, 184–85, 187; "Speaking in Tongues" by, 184; to

women-of-color readers, 185–86, 188; on writing, 185–88
apostrophe, 32
Arendt, Hannah, 276nn2–3
Aristotle, 32–33
art: arts of address and, 31–33, 291n36, 292n54; theory and, 4–6, 18, 262. *See also specific topics*
arts of address, 12, 31–33, 249, 258, 286n105, 291n36; concept of, 31–33, 292n54. *See also specific topics*
artworks and other cultural productions: address and, 3–6, 33, 245–47; aesthetic, ethical, and political meanings of, 17, 246, 258–59; aesthetic perception and judgment of, 78–86; audience for, 28–29, 79–87; Benjamin on, 177; creators of, 78–79, 81–86, 128; Fanon on, 172–73; Foucault on, 93, 97–98; Hume on, 78–86; politics of, 17, 246, 258–59; as public objects, 83, 86; publics and, 13, 17, 28–29, 33, 81–84. *See also* reading; *specific artists and artworks*
attachments, 10, 32, 95, 168, 174, 177, 186, 188, 193
audiences. *See* publics
Austin, J. L., 2, 14, 25, 256
Autobiography of My Mother, The (Kincaid), 271n23
Autumn of the Patriarch, The (García Márquez), 156

Bailey, Carol, 272n25
Bakhtin, Mikhail, 25, 264n12, 296n31
Barańczak, Stanisław, 273n29
barbarism, Kant on, 64–65, 72, 278n17
baroque, the, 127–31, 245, 289n14, 289n16, 291n37
Barthes, Roland, 15, 170, 196–98; on aesthetic binaries, 181; on artistic form, 181, 183; on desire, 181–84; direct address by, 182–83; on the erotic, 181–83; on freedom and gender, 181, 184, 301n60; on language, 181, 221; on play, 181, 183; *The Pleasure of the Text* by, 181–83; Pope.L on, 221; on *punctum*, 181, 183; queering aesthetics in, 184; on reading and readers, 181–83
Bary, Brett de, 305n13, 306n14, 307n20
beauty, 57, 81–82, 93, 129–31, 183, 194, 217–20, 242
being alive to language and world, 49, 57, 131, 138, 141, 161, 197, 250, 253

Bellour, Raymond, 300n58
Benjamin, Walter, 15, 23, 170, 196–98; on address as condition of experience, 173–78; Althusser, Fanon and, 180–81; "A Berlin Chronicle" by, 174–77, 251–52; on "Brauhausberg," 251–54; on coldness, 174; critical political aesthetics in, 175–78; on freedom, 176; on interconnectedness, 174, 177, 298n23; on language, 174–75, 251–54; on modes of address, 173–78; on norms of address, 175–76; on reading and critique, 174–76, 180–81, 298–99n23; on stories, 180–81; on structures of address, 173–78; on technology, 177; on time and space, 174–77, 251–53
Bennett, Jane, 302n84
"Berlin Chronicle, A" (Benjamin), 174–75, 177, 251–52, 298n16, 298n23
Bernasconi, Robert, 277–78n13, 278n17, 279n26
Beuys, Joseph, 235
Beverley, John, 308n34
Bhaba, Homi, 265n13
binaries, 11, 16, 88, 118, 124, 128, 187, 290, 266n23; aesthetic, 181, 276
Black Lives Matter movement, 189
"Black Man and Language, The" (Fanon), 171–73
blackness: and address, 44, 171–73, 189, 272n25; in *Whispering Campaign*, 223, 225–26, 229, 242–43
Black People Are the Wet Grass at Morning (drawing) (Pope.L), 234, 237
Black Skin, White Masks (Fanon), 171
Bocharov, Sergei, 294n5, 296n31
bodies, 1–2, 23; bread and, 46–47; in *Cronopios and Famas*, 105–9, 109, 111, 134–36; erotic, 181, 221; female, 40–41, 118; and historical-racial schema, 310n54; objects, spaces and, 190–96; power and, 245; in *Semiotics of the Kitchen*, 206–7; as site of address, 107; structures of address and, 153–54
Bojanowska, Edyta M., 274n34
borders, 10–11, 53, 64, 116, 154–55; crossing, 79–87, 223, 229, 140–45; establishing 170;
Borges, Jorge Luis, 286n102
Borinsky, Alicia, 287nn3–5, 288n6, 288nn8–9, 290n26, 290n28, 291n44, 292n48, 293n56
Bowman, Herbert, 294n5
"Brauhausberg," 251–54
Braziel, Jana Evans, 269n13, 272n25
Breton, André, 172

316 Index

Brown, Wendy, 283n86, 288–89n10
Butler, Judith, 2, 15–16, 170, 196–98, 264n12; on address, 188–90; on Black Lives Matter movement, 189; on norms of intelligibility and recognizability, 188, 266n24; on performativity, 188, 190; on public assembly, 190; on relationality, normativity, and ethics, 188–90; on structures of address, 189; on vulnerability and precarity, 189–190

Cage, John, 234
Capital (Marx), 191
capitalism, 104, 177–80, 191–96, 218, 288n9, 303n3, 312n74; late capitalism, 30. *See also* marketplace; neoliberalism
Carby, Hazel V., 264n13
Carpenter, Bogdana, 274n33, 275n35
Castle, The (Kafka), 155
Cavanagh, Clare, 273n28, 274n31, 274n33
Cavarero, Adriana, 265n13
Césaire, Aimé, 172
Chicana/Latina readers, 185
Chow, Rey, 297n9
Cixous, Hélène, 308n40
class, 3, 9, 20–21, 34, 44, 49, 85, 98, 153–54, 179, 182–84, 187, 196, 199, 204, 206–7, 212–15, 216–21, 246, 258–61
closure, and openness, 30, 57, 123–24, 235, 290n26, 292n55
coalition politics, 16, 25–26
coldness, 50–58, 108, 174, 217, 250; as aesthetic concept, 54–55, 57
collectivity, 9, 18, 20–21, 29, 31, 53–54, 63–64, 67–69, 71–72, 75–77, 89, 95, 98–99, 154–56, 168, 170, 173–74, 177, 180, 187, 190, 196–97, 231, 239, 254–55, 258
coloniality, 22, 30, 58, 104, 139, 208, 232, 243–46, 269n13, 307n20; and gender and race, 2–3, 12, 34, 41, 20–21, 44, 48–49, 97–98, 171–73, 201–2, 218–19, 258, 260–61, 270n19. *See also* neocoloniality
commands, 42, 58, 65, 99, 107–9, 113–14, 185–86. *See also* orders; rules
commodity: consumption and, 193–96; exchange and, 191–93; fetishism, 191–92
community, 45–47, 61, 155, 171–73, 186–90, 194–95
concept of address: divergent vocabularies of address and, 13–14, 197, 199, 262; initial definition of, 7; inclusivity of, 21–29, 49; more frequently used than theorized, 13; referring to capacities and functions of address, 49, 101, 138, 167, 199, 247, 256, 259–61; referring to five key constituents, 7, 18, 146–47, 151–53, 156–57, 167–70, 197, 199, 261–62; referring to interpretive and explanatory model of address, 151, 153, 157, 197, 199, 254, 261–62; as unified, 254, 262; used in "address" as shorthand for modes of address, 7; used in "address," unmodified, as designating the whole complex of address, 7. *See also* address
confinement, 95–96, 172–72, 213, 242, 255; confining structures of address, 50, 218–21, 244–45; Cortázar on confining structures of address, 30, 103–20, 123–39, 143–44, 244–45
contingency, 47, 55, 138, 182, 198, 259
"Conversation with a Stone" (Szymborska), 54
Cortázar, Julio, 3; on address, 17–18, 25, 30, 33–34, 102–45, 157, 159, 190–91, 200, 250, 287n6; on aesthetic incongruity, 122–23, 130–131, 133–36, 255–56; on agency and invention, 134–36, 139, 260; "Apocalypse in Solentiname" by, 288n9; on art and artists, 128, 291n36; on the baroque, 127–31, 245, 289n14, 289n16, 291n37; "Blow-Up" by, 289n13, 290n28, 290–91n29; on confining structures of address, 30, 103–20, 123–39, 143–44, 244–45; critical political aesthetics of, 104, 137–38, 144; on cosmopolitanism, the local, and the global, 103–14, 140, 145; on decoloniality and temporal and spatial refraction, 30, 104, 110–11, 260–61; "The Daily Daily" by, 124–27, 141–42; and direct address, 109, 114; *Fantomas versus the Multinational Vampires* by, 288n9; Foucault and, 104, 144–45, 161; on freedom, 30, 102–4, 109–10, 114, 117, 135–38, 143–44, 161; on glass brick image, 105–18, 120–24, 127–31, 136–37, 143, 174, 244–45, 250, 261, 290n29; on habit, 33, 105–16, 124, 127, 133, 135–36; *Hopscotch* by, 139, 288n8–9, 289n12, 290n29, 293n56; "Instructions on How to Understand Three Famous Paintings" by, 293n59; on interconnectedness, 103–4, 136–37, 144; on intersubjectivity, 111–13, 135, 138, 290n26; on language, 104–28, 131–44; "The Lines of the Hand" by, 117–18, 120, 126, 132, 144; on literature, powers of, 102, 111, 114–15, 118, 122, 133, 139–40; on love, 111–12, 115, 133–34, 136; *A Manual for Manuel* by, 288n9; 62: *A Model Kit* by, 288n9, 298n12, 290n27; on modes of

address, 106, 108–9, 112, 139–40, 144, 244, 250; on normativity, in address, 103–4, 113, 117, 137–40, 143; on norms of address, 102–3, 106, 108, 112–13, 139–40, 143–45, 157, 256; on organizational role of address, 112, 126, 137, 143; "The Particular and the Universal" by, 127–28, 135; on play, 30, 137–38, 260; "The Possibilities of Abstraction" by, 129–31; "Progress and Retrogression" by, 123–24; "The Pursuer" by, 290n27; on repetition, 105, 109–12, 118–20, 122, 125–27, 131–36, 250; on reading, 114–15, 140–41, 292nn55–56; on seeing-in and seeing-as, 141–44; "A Small Story" by, 118–20; on structures of address, 106–7, 110–11, 113–15, 128–29, 136–40, 143, 244–45; on transformations, of structures of address, 103, 109–18, 120–21, 124, 127–31, 136–39, 244–45; "A Very Real Story" by, 121–23, 133. See also *Cronopios and Famas* (Cortázar)

cosmopolitanism, 48, 52, 66, 79, 103, 114, 140, 145, 175, 219, 226, 229, 244–45, 255, 279n26

Crawford, Margo Natalie, 309n50, 310n53

creation: of artworks, 78–86, 128; and reception in Hume, 78–86; self-creation, 93–94, 97–98

Creole, 48, 171–73

criteria of successful address, 154, 259, 267n32

critical aesthetic address, 260–61

critical political aesthetics, 3, 104, 138, 144, 177–78, 199, 220–21, 261

criticism, 4, 13, 28–31, 258–59

critique, 31, 246–47, 258, 266n28

cronopios, 127–28

Cronopios and Famas (Cortázar), 102–45, 156–57; bodies in, 105–9, 111, 134–36; everyday objects in, 102–4, 114–17, 152, 190–91, 289n21; mobility and stasis in, 105–39, 143–44, 250; relationality in, 102–4, 107–9, 111–17, 121–23, 126, 132, 137–40, 142–43, 207, 258, 260; streets in, 109–15, 131–35, 140, 261. See also Cortázar; "The Instruction Manual" (Cortázar)

cultivation: address as motor of, 63–78, 84–87; enlightenment as, 61, 75; taste, refinement and, 85

cultural criticism, 4, 13, 28–31, 258–59

cultural productions. *See* artworks and other cultural productions

culture: and address, 3, 10–11, 17–19, 23–24, 40–41, 45, 198, 255–59, 262; aesthetics and, 2–3, 24, 255; cultural agency and critique, 258–59; cultural order, 157–58, 164–66; making of, 62–66, 75–87; print cultures and publics, 72; as source of demands, 40–41, 45, 257–58

"Daily Daily, The" (Cortázar), 124–27, 141–42
Danto, Arthur C., 293n58
Darwall, Stephen, 265n13
Death by Hanging (1968), 207; aesthetic address in, 208–16, 306n19; aesthetic relationality in, 212, 215–16; carceral structure of address in, 208, 214–15; decoloniality in, 208, 246–47; direct address in, 208, 213; education of the senses in, 209–10, 213, 215; freedom in, 213; interpellation in, 209–12; modes of address in, 212–16, 306n19; race, nation, gender, and class in, 212–15; structure of address, transformation of, 215–16, 246–47; as transnational, 306n15. *See also* Oshima

decolonial, critical race feminist aesthetics, 20–21, 202, 219, 246–47, 260, 266n28

decoloniality, 25, 104, 173, 244, 246, 272n25, 307n29, 308n42; temporal and spatial refraction and, 30, 110–11, 218–19, 246, 260–61

deconstruction, 25–26

Deleuze, Gilles, 25

Deligiorgi, Katerina, 276n2, 276n7, 277n8, 279n23

Derrida, Jacques, 2, 14, 16, 25–26, 266n24, 295n10

desire: address and, 7, 152–53, 247, 250–51, 258–59; Anzaldúa on, 184–87; Barthes on, 181–84; Cortázar on, 103, 106, 108, 113, 250–51; in *Death by Hanging*, 210–13; Foucault on, 91–95, 97, 99; in "Girl," 47–49; in *The Hour of the Star*, 217–19; objects and, 192, 194–99; in *Semiotics of the Kitchen*, 206–7. *See also* aesthetic desire

details, 32, 56, 87, 260–61

digital technology, 9, 240–42, 253, 311n61. *See also* technology

direct address, 39, 56, 65, 80–81, 109, 114, 164, 182–83, 185, 203–6, 208, 213, 273n30, 274n34

directionality: of address, 1, 7–10, 22–23, 147–50, 158–67; control, elusiveness and, 156, 160–62, 167–68; deregulation and, 167; indirection and, 160–62, 166–68; normativity, order and, 158–62; regulation and, 158–62, 167–68; relationality and, 147–51, 158–59; 161–62, 164, 167, 169–70, 182. *See also* orientations

discipline, 39, 43, 46, 95, 116, 119, 155–56, 161, 168, 171–73, 190–91, 197, 256; disciplinary and biopower, Foucault on, 95, 99, 282n66, 285n96

discourse: address and, 88–90; Foucault on, 88–91, 94, 98–99; power and, 88–89, 98–99; rational, 61, 63, 279n30; as structures of address, 89–92

disinterestedness, 82–83, 219–20

distance, as register of address, 9, 52, 111–13, 120–21, 131, 140, 153, 176, 186, 217, 244–46, 255, 284n89

Doane, Mary Ann, 265n13

domesticity, 10–12, 39, 89, 93, 109, 111, 135, 186, 202–7

Dreyfus, Hubert L., 283n78

Dumm, Thomas L., 284n86

economic, the, 5, 7–8, 12, 19, 25, 41, 47, 89, 91–92, 99–101, 104, 119, 138, 155–56, 180, 191–96, 220. *See also* marketplace

egalitarian, horizontal dimension of address, 14, 38, 139–40, 153, 156–57, 162, 168, 241, 254, 287n6

Eichenbaum, Boris, 293n3, 296–97n32

emotions, address in, 9, 147

empirical public, 28–29

English, Darby, 308n47, 308–9n48, 309–10n53, 310n56, 311nn63–64, 312n65, 312n70, 312n72

enlightenment: address and, 61–78; aestheticization of, 75–77; as cultivation, 61, 75; freedom and, 61–69, 77; Kant on, 17–19, 61–78; mouthliness and, 73–74; process of, 61; public use of reason in, 63–67; *Sapere aude* motto of, 65

epistemic, the: and the aesthetic, 19–20, 184; epistemic and aesthetic registers of address, 78, 100–101, 103, 133–34. *See also* unsettlement

erotic, the, 46–49, 133, 181–83, 185, 221, 287n6

ethics, 13, 62, 93–101, 134–35, 138, 254–45, 263n1; address as vehicle for ethical modalities and meanings, 103–4, 246, 258–59; ethical address, 188–89

Europe, 53, 104; in *Whispering Campaign*, 223, 226, *228*, *230*, 230–33, *233*, 239–45

existence, aesthetics of, 93, 95–100

experience: address as condition of, 173–78; of objects, 289n21; poverty of, 177; sensory, 116. *See also* aesthetic experience

extraordinary, the, as register of address: Cortázar on, 121–22, 126, 133, 137; in "The Nose," 157, 165–66

Ewald, François, 283n79, 286n103

Eze, Emmanuel Chukwudi, 278n13, 278n17, 279n26

famas, 127–28

Fanon, Frantz, 25, 170, 196–98; on address, culture, and cultural politics, 171–73; on address, racial identity and community, 171–73; Althusser, Benjamin and, 180–81; black and white forms of address, 173; on colonialism, 172–73; on film, 172–73, 297n6; on French and Creole, 171–72; on historical-racial body schema, 310n54; on language, 171–73; on masculinist address, 297n9; on normative forms of address, 171–72; on racial scripts of address, 171–73; on racialized norms of address, 172–73; on reading, 171–73, 180–81

female agency, 38, 40

femininity, 56, 58, 63, 118, 153–54, 204–7; standards of acceptable, 36–49

feminism, 2, 20–21, 25–26, 184–88, 202, 219, 246–47, 260, 266n28, 272n25, 275n36, 303n2–3, 305n12, 308n42

feminists of color, 170, 184–88, 219

fetishism, commodity, 191–92

Fichte, Johann Gottlieb, 25

figures of speech, as a subspecies of address, 28

five key constituents of address, 7, 18, 146–47, 151–53, 156–57, 167–70, 197, 199, 261–62

flash philosophy, 253–54

form, textual, 181–83

forms of address, 157, 168. *See also* modes of address; *specific artists, artworks, theorists, and topics*

Forty, Adrian, 302n84

Foucault, Michel, 29–30, 255; on address, 60–61, 87–101; on address in knowledge and power, 88–101; address of, 95–96, 101, 284n89; on aesthetics of existence, 93, 95–100; on care and creation of the self, 93–94, 97–98; on collectivity of address, 89, 95; Cortázar and, 104, 144–45, 161; on disciplinary and biopower, 95, 99, 282n66; on discourse, 88–91, 96, 99–100; on freedom, 93–101, 104, 144; Kant, Hume and, 100–101; Kincaid and, 95–96, 98, 100; on multimodal character of address, 89, 95–96; on neoliberalism and biopolitics, 285n96; on normativity, norms, and normalization, 92–94, 96, 98–101, 283n79,

285n91; on race, gender, and coloniality, 97–99, 282n66; on structures of address, 89–92; on systematicity of address, 89–92

4′33″ (1952) (Cage), 234, 309n52

Franco, Jean, 307n24, 307n29, 308n34, 308n42

freedom, 2, 21, 25, 30, 213, 219; address and, 176, 187, 258; Cortázar on, 30, 102–4, 109–10, 114, 117, 135–38, 143–44, 161; critical political aesthetics and, 138, 144; enlightenment and, 61–69, 77; equality, inclusiveness and, 104; Foucault on, 93–101, 104, 144; interconnectedness and, 137; linguistic experimentation and, 104; power and, 96; relative, 94–96; taste and, 85

free indirect discourse, 11, 80, 95, 264n5, 264n7, 272n27, 273n30

Freud, Sigmund, 269–70n17, 305n13

Gagnier, Regenia, 289n11

García Márquez, Gabriel, 156; *The Autumn of the Patriarch* by, 156

Gates, Henry Louis Jr., 264n7

gender, 3, 20–21, 56, 98, 184, 187, 207–8, 246; in "Girl," 40, 44–45, 48–49; norms, 45; race, coloniality, and, 40, 44–45, 48–49, 219; social constructionist approach to, 188

gendered address, neocolonial regime of, 36–50

gendered framework, of racialized colonial address, 270n19

Gilmore, Leigh, 271n24

"Girl" (Kincaid), 26, 35, 95; address in, 35–50, 60, 96, 249, 251, 255–58, 260–61; address and emptying of meaning in, 45–46, 49, 58–59, 253; aesthetic relationality in, 41–42; bread in, 46–47, 98, 190–91; decolonizing gendered order of address in, 36–50, 161, 260–61; desire in, 47–49; direct address in, 39; the erotic in, 46–47; female agency in, 40; figuration of mother in, 18–40, 48; gender, race and coloniality in, 36, 38, 40–41, 44–45, 48–49, 58; Kant and, 61; normativity in, 36–37, 39–41, 45, 58–59; norms of address in, 44, 48, 58; objects in, 40, 47, 190–91; play in, 41, 47–49; relationality in, 36–37, 40–42, 48–49, 258; rules in, 35–49, 159–61, 190–91, 257; on "sluts," 38, 40, 43–46; spatial and temporal regulation in, 37, 42; standards of acceptable femininity in, 36–49; structures of address in, 42–50, 58

global, the, 48, 52–58, 67–69, 86–87, 103–14, 140, 145, 149, 152, 218, 246, 253, 260. *See also* the transnational

Gogol, Nikolai: on powers of literature, 150, 163–66. *See also* "Nose, The" (Gogol)

Gough, Maria, 294n6, 296n32

Graf, Anastasia, 274n34

Green & Black's, 193–96

Green People Are a Recent Invention (drawing) (Pope.L), 234, 236

greetings, in "How's it Going, López?," 131–36

Guyatt, Mary, 302n84

habit, 6–7, 20, 61–63, 77, 82, 149, 152, 195–96, 207; Cortázar on, 33, 105, 108–12, 118–20, 122, 125–27, 131–136, 250

Hall, Stuart, 2–3, 25–26

Hansen, Miriam, 17, 264n13, 267n34, 298n16, 299nn23–24, 299nn26–27, 299nn29–30, 300n42

Hanssen, Beatrice, 298n17, 298–99n23, 299n24

Hegel, G. W. F., 25, 263n2

Hessel, Franz, 177

Honig, Bonnie, 302n84

Honneth, Axel, 276n2

Hopscotch (Cortázar), 139, 288n8–9, 289n12, 290n29, 293n56

Huffer, Lynne, 284n89

Hour of the Star, The (Lispector), address in, 216–20; aesthetic abandonment in, 216–17, 219; aesthetic agency and relationality in, 218–221, 247, 258; aesthetic experience and pleasure in, 216, 219; aesthetic unsettlement in, 219–20, 255–56; aestheticization of poverty in, 218, 220; critical political aesthetics in, 221, 258–261; decoloniality and, 219, 246, 260–61, 308n42; details in, 216, 251, 260–61; dilemma of address in, 217; direct address by, 220; freedom in, 219; language in, 217, 219–20; love in, 216–17; self-deflecting modes of address in, 217, 220; and structures of address, transformation of, 220–21, 246–47, 251, 255–56, 258–59; temporality in, 218–19. *See also* Lispector, Clarice

"How's it Going, López?" (Cortázar): address in, 131–36; aesthetic incongruity in, 133, 135–36; agency and invention in, 134–36; greetings in, 131–36; language in, 131–36; love in, 133–34, 136; repetition and habit in, 131–36. *See also* Cortázar; *Cronopios and Famas* (Cortázar)

human and the nonhuman, the: address and, 1, 91–92, 104, 121, 146, 188, 245
humanities, the, 21, 29
humanity, 44, 61, 64, 85
Hume, David, 17–19; on address, 60–61, 78–87; on address as ground of the aesthetic, 17, 19, 78; address of, 80–81, 101; on addressing the public, 78–79, 81–84; on aesthetic experience, 78–87; on aesthetic judgment, 78–86; on artworks as public, 83, 86; on basic, reciprocal structure of address, 78–79, 84; Cortázar and, 145; on creation and reception, 78–86; direct address in, 80–81; on enlarged, global plan of address, 79–87; Foucault and, 100–101; on freedom, 85; on the global, 145; on humanity, 85; Kant and, 86–87, 100–101, 145, 255; on normativity, 80, 85–87, 145; on norms of address, 79, 83, 85, 146; on the public, as general, 78, 80–87; on the public, as specifically historical, 78–84, 86; on relationality, in address, 86–87; "Of the Standard of Taste" by, 19, 78–87; on taste, 80–81, 84–85, 146, 289n11

iciness. *See* coldness
identity, 173, 238; gender, 188; norms of address and, 172; racial, 234–35; social, 91, 156, 207, 246. *See also* social difference and identity
ideological state apparatuses (ISAs), 178–79
ideology, 178–80
I Like America and America Likes Me (performance) (Beuys), 235
illocutionary force, 25, 36, 51, 273n29, 275n36
immigration, 208, 212, 228, 223, 226, 229, 238, 239–40, 243–44. *See also* migration
imperialism, 48, 212, 270n19, 282n66
improvisation, 31, 137, 152
incitements to address, 116, 140–41
incongruities, aesthetic, 122–23, 130–31, 133–36, 251, 255–56
institutionality, 130, 148, 215–16, 150; Althusser on, 178–81
"Instruction Manual, The" (Cortázar): first part of *Cronopios and Famas* (Cortázar), 105, 116; instructions in, 106–10, 113–14, 116, 140–41, 159; untitled opening story of, 102–124, 126–28, 130–141. *See also* Cortázar; *Cronopios and Famas* (Cortázar)
instructions, 37–38, 42–47, 58, 207. *See also* rules; "The Instruction Manual"

interconnectedness: aesthetics of, 144; Benjamin on, 298n23; Cortázar on, 103–4, 136–37, 144; freedom and, 136–37
intermediality, 187–88
interpellation, 28, 36, 188, 212–14; 272n25, 304n4; ideological, 178–80, 195–98
interpretation, 7–8, 19, 26–29, 79–86, 88, 122, 136, 152, 155, 163, 199, 214, 231, 246. *See also* reading
intersubjectivity, 34, 41, 92, 95, 170, 173, 176–78, 181, 184–88, 197–98, 201, 253; Cortázar on, 111–13, 135, 138, 290n26. *See also* subjectivity
intimacy, 7, 9, 49, 111–12, 138, 176, 184–88
Irwin, John, 365n21
ISAs. *See* ideological state apparatuses

Jagose, Annamarie, 263n1
Jay, Martin, 300n45
jargon, 154, 182
Johnson, Barbara, 2–3, 16–17, 23, 25–26, 264n7, 264n13, 266n24, 267n31, 274n34

Kafka, Franz, 16, 123, 155, 266n23, 305n13
Kamuf, Peggy, 265n13
Kant, Immanuel: on address, 60–78; address as man of learning, 65–69; address of, 62, 65, 78, 101; aesthetics of, 19, 62, 71, 75–78; "An Answer to the Question: 'What is Enlightenment?'" by, 61–78; on barbarism, 64–65, 72, 278n17; Cortázar and, 145; on cultivation, 63–78; on enlightenment, 17–19, 61–78; on forms and norms of address, 67–68; on freedom, 61–69, 77; Foucault and, 100–101; Hume and, 86–87, 100–101, 145, 255; Kincaid and, 78, 86–87; on maturity (*Mündigkeit*), the mouth, and the mouthly, 62–64, 68, 73–74, 76–77; on media of address, 68–73; on private use of reason, 63–64; on public as general, 66–76, 78; on public as specifically historical, 67–75; on public and private, 87; on publicity, 65–78; on public use of reason, 63–67; on reading public, 65–70; on relationality, 72, 86–87; on system of address, 66–68; on technology, 62, 69
Karlinsky, Simon, 293n3
Karwoska, Bożena, 275n36
Kelly, Michael, 285n99
Kentridge, William, 294n6, 296n32
Kerr, Iain, 310n53

Kleingeld, Pauline, 275n2, 276n7, 277n8, 277n11, 278n13, 280n38
Kincaid, Jamaica, 17–18, 33; *Annie John* by, 271n21; *The Autobiography of My Mother* by, 271n23; *At the Bottom of the River* by, 268n1, 269n30, 271n24, 272n25; Foucault and, 95–96, 98, 100; Kant and, 78, 86–87. See also "Girl" (Kincaid)
Kneller, Jane, 276n3
knowledge: Foucault on, 88; Kant on, 66; power, address and, 88–100, 282n66; power, norms and, 92–93; technology and, 123
Korsgaard, Christine, 276n4
Korsmeyer, Carolyn W., 278n13, 281n56

Lacan, Jacques, 14, 16, 25–26, 217n19, 274n33, 295n10, 305n13
Langton, Rae, 25–26, 267n33
language: of address, 8–9, 13–14, 23–24, 27–28, 197, 199, 267n29, 267n24; aesthetic idioms, world and, 260; Barthes on, 181, 221; being alive to, 49, 57, 131, 138, 141, 161, 197, 250, 253; Benjamin on, 174–75, 251–54; cold, 51–57, 174; Cortázar on, 104–28, 131–44; difference and, 179, 197; Fanon on, 171–73; in *The Hour of the Star*, 217, 219–20; identity and, 56, 171–72; in modes of address, 1; mouth and, 63; poetry and, 54; racialized vernacular, 171–73; rhetorical use of, 28; semantic evacuation and replenishing and, 45–46, 49–59; 113–14, 144, 244, 252–53; in *Semiotics of the Kitchen*, 206–7; sensory experience and, 116; in structures of address, 118–19; in "A Very Real Story," 122; "Vocabulary" and, 50–59; "Water" and, 54–55, 57–58, 252–54; in *Whispering Campaign*, 221, 226–30, 233, 243, 308n48; world and, 49, 57, 141, 161, 197, 250, 253
Larrimore, Mark, 278n13
laughter, as register of address, 47, 80–81, 148–48; 207–8, 286n102, 296n31, 304n8
law, 1, 6, 12, 14, 16, 31–32, 63, 77, 119, 147, 156, 158, 208, 213–15, 277nn7–8
Levinson, Brett, 287n3
Levinson, Jerrold, 281n51
life, as art, 97–98
lifeworlds, feminist, 187–88
"Lines of the Hand, The" (Cortázar), 117–18, 120, 126, 132, 144
linguistic experimentation, 104
linguistic groups and divisions, 154–55, 171–73

Lispector, Clarice, 201, 216–21; on powers of literature, 218–21. See also *Hour of the Star, The*
literature, powers of: Cortázar on, 102, 111, 114–15, 118, 122, 133, 139–40; Gogol on, 150, 163–66; Lispector on, 218–21; Szymborska on, 53–58; and critical political aesthetics, 143–44, 220–21
local, the, 76, 81–87, 91, 103, 114, 119, 124, 128, 136, 140, 152, 176, 185, 246, 260
López Springfield, Consuelo, 272n25
Lorde, Audre, 263n2, 280n39, 283n86, 284n88, 286n101, 288n7
love, 6, 12, 77, 192–93, 244; in Cortázar, 111–12, 115, 133–34, 136; in Foucault, 92, 99; in Gogol, 149–50; in Kincaid, 38, 40, 46–49; in Lispector, 216–19; in Pope.L, 230, 232–33, 239–40
Love Text (Pope.L), 228, 230–34, 238–40, 243–45
Lugones, María, 16, 25–26, 265n13, 270n19, 280n33

Man, Paul de, 25–26
"Manifesto for Maintenance Art 1969!" (Ukeles), 159–60
marketplace, 72, 80, 85, 104, 158, 192–96, 281n54, 281n57, 298n23. See also capitalism; neoliberalism
Marx, Karl, 191–93, 195–96, 263n2
masculinity, 63, 76, 104, 109, 118, 153–54, 184, 187, 208–13, 218–19, 297n9
mass communication, 125
maturity: and enlightenment, 73, 76, 277n8
McCance, Dawne, 277n10
meaning, 137; address and, 30–31, 36; aesthetic, 20, 36–37, 256, 263n1; details and, 87; of "to address," 157–58, 161
media, 139, 156, 253–54; intermediality, 187–88. See also multimodal character of address
media of address, 68–73, 187, 241
mediation, 4, 20, 23–24, 34, 41, 69, 71, 84, 114, 140, 152, 156, 201, 229, 231, 238, 242
medicine, 6, 31, 37, 77, 90, 147, 150, 153, 155, 180, 208
Menke, Christoph, 285n98
Merleau-Ponty, Maurice, 2, 15, 23, 25, 264n12
Metamorphosis, The (Kafka), 16, 266n23
metaphysics, of aesthetics, 183–84
Mignolo, Walter D., 297n3
migration, 8, 238, 243–44, 252. See also immigration

modernity, 30, 87, 95, 104, 177; and coloniality, 243–45; and coloniality, gender, and race, 20–21, 219, 260–61, 269n13, 270n19
modes of address, 1, 147–68; address's relational, directional, and normative functioning and, 152, 167–68, 261; artistic, 151; of artworks, 83, 215–16; attachments and, 10; Benjamin on, 174–77; capacities and roles of, 18, 168–70, 199, 254, 262; concept of, 7, 152, 266n24; directing and receiving, 1, 147; as element of model of address, 171, 197, 199, 261–62; in emotions, 147; individual and collective agency, aesthetic and political life and, 18, 156, 254; as key constituent of address, 18, 146–47, 151–53, 156–57, 168; multimodal character of, 1, 7, 40, 89, 147; multiple, Foucault on, 89, 95–96; power in, 152, 158; profuse operations of, 145, 156. *See also* forms of address; *specific artists, artworks, theorists, and topics*
Molesworth, Helen, 303nn2–3, 304n6, 304n8, 305n10, 305n12, 309–10n53
Moran, Kate A., 276n2, 277n11
Moran, Richard, 265n13
Moretti, Franco, 264n7
mouth, 276n7, 277n8; activities of, 73–74; language and, 63; *Mündigkeit* and, 73; procuring, 62–63; speech and, 73
mouthliness, 62, 64, 68, 73–74; and relationality, 76–77
multidimensionality, of address, 162, 167–68
multimodal character of address, 1, 7, 40, 89, 147
Mund, 276n7, 277n8. *See also* mouth
Mücke, Dorothea von, 279n23, 279n25, 279n32
Mündigkeit, 73, 76, 277n8

Nancy, Jean-Luc, 278n20
nation, 8, 20, 48–58, 79–87, 98, 112, 114, 139, 156, 164, 170–72, 210–15, 219, 223, 229, 232, 245–47, 255, 279n24, 296n32
navigational tool, address as, 12, 153–43
neocoloniality, 158, 226, 258, 260. *See also* coloniality
neocolonial regime, of gendered address, 36–50
neoliberalism, 190, 285n96, 288n10. *See also* capitalism; marketplace
newspapers, 150, 156, 177, 229; Cortázar on, 106–7, 109–19, 119–21, 124–27, 135, 139–42, 244, 260; in "The Nose," 149, 154, 163, 165

nonaddress, 9–10
nonhuman and the human, the: address and, 1, 91–92, 104, 121, 146, 188, 245
normalization, 92–93, 98–99, 163–66, 283n79, 285n91
normativity: address and, 2, 4, 12, 26, 33, 180; address as ground of, 36–37, 58–60, 72, 77, 86–87, 100, 113, 146; address's directionality and organizational and regulatory roles and, 150–62, 167; aesthetic, 19–20, 85; collectivity and, 155; Cortázar on, 103–4, 113, 117, 137–40, 143; Foucault on, 92–93, 96, 99–101; in "Girl," 35–37, 39–41, 45, 58–59; Hume on, 80, 85–87, 145; objects and, 108; power, knowledge, aesthetics and, 98–99; putting straight or in order and, 158, 160–62, 167; regulation, deregulation and, 167; relationality and, 156; structures of address and, 8, 113, 156. *See also* norms; norms of address; *specific artists, artworks, theorists, and topics*
norms, 158–62; Foucault on, 92–94, 96, 98–100, 283n79, 285n91; gender, 45; of intelligibility and recognizability, 188, 266n24
norms of address: address's relational, directional, and normative functioning and, 152, 167–68, 261; capacities and roles of, 18, 168–70, 199, 254, 262; concept of, 7, 152; domestic, 10–11; as element of model of address, 157, 171, 197, 199, 261–62; existing lexicon of address and, 266n24; identity and, 172; institutionalized, 180; individual and collective agency, aesthetic and political life and, 18, 156, 254; ISAs and, 179; as key constituent of address, 18, 146–47, 151–53, 156–57, 168; norms of intelligibility and recognizability and, 188, 266n24; notion of, newly coined, 18, 157, 261-2; and objects, 113, 140, 195–96; profuse operations of, 140, 145, 156–57; power in, 152. *See also* normativity; *specific artists, artworks, theorists, and topics*
"Nose, The" (Gogol): absurdity in, 163–66; address in, 148–51, 153–55, 157–58, 162–67, 257–58, 260; direct address by, 164; directionality and relationality of address in, 148, 150, 158, 162; indirection of address in, 160–62, 166–67; institutionality in, 148–50, 167, 296n32; modes of address in, 150–51, 153, 162–67; multidimensionality of address in, 162; normalization in, 163–66;

norms of address in, 149, 151, 164–65, 167, 257–58; organizational role of address in, 148, 150, 153; play in, 163, 260; on reading, 162–66; on the strange, 148, 157–58, 162–67; structures of address in, 149–50, 157–58, 165–67. *See also* Nikolai Gogol

objects, 17, 22–23, 41, 102–15, 141, 152, 159, 190–96, 198, 221; address by, literal and metaphorical dimensions of, 23, 264n6, 267n29, 289n21; agency of, 124–26; Anzaldúa on, 10–12, 188; artworks as public, 83, 86; audience and, 29; bodies, spaces and, 190–96; everyday, 102–4, 152, 207; experience of, 289n21; forms of address by, 190–91, 195–96; in *Cronopios and Famas*, 102–4, 114–17, 152, 190–91, 289n21; in marketplace, 191–96, 281n54; Marx and, 191–93; modes of address and, 191–92, 194–96; normativity and, 108; norms of address and, 113, 140, 195–96; orientations of, 22; public, 83, 86; refinement and, 85; in *Semiotics of the Kitchen*, 203–7; structures of address and, 196; subjects and, 16–17, 41, 126, 191–96

October 18, 1977 (1988) (Richter), 231
Oksala, Johanna, 284n86, 284n89, 286n101
openness, 65–66, 116, 120, 138, 175–76, 204, 242–43, 252–54, 257; and closure, 30, 57, 123–24, 143–44, 234–35, 290n26, 292n55
Orange People the Way Things Used to Be When They Were in Power (drawing) (Pope.L), 234, 237
orators, 9, 32, 78–80
order: address as ground of, 36–37, 58–60, 72, 77, 86–87, 100, 113, 146; aesthetic, 81, 177, 245; collectivity and, 98; directionality and, 157–62; disorder and, 102, 137, 158–59; in "Girl," 45–46, 49, 159–60; meaning and, 137; modes of address and, 158–62, 166–67; sexual, 38; social, cultural, and institutional order and address, 58–59, 151, 179, 206, 219, 257–58
orders, 42, 47–48, 159–60, 180. *See also* commands; rules
organization, of structures of address, 90–91
organizational role, of address, 12–13, 35, 60, 71, 100–101, 112, 126, 137, 143, 146–48, 157–60, 174, 177, 207, 215, 221, 247, 255. *See also* regulatory role, of address

orientations: in address, 9–10, 12, 17, 120–21, 146–47, 158–61; of modes of address, 147–48; of objects, 22; of readers and texts, 182. *See also* directionality
Ortega, Mariana, 264n8
Oshima, Nagisa, 201. See also *Death by Hanging* (1968)

Paccacerqua, Cynthia M., 264n10, 301n68
Parker, Andrew C., 284n89
"Particular and the Universal, The" (Cortázar), 127–28, 135
pedagogy, 36, 39, 48, 81, 93, 98, 161, 166, 204, 258; cultural pedagogy, 63–64, 72–78, 84–85
performative acts and performativity theory, 25, 28, 36, 51, 188–90, 197–98, 272n25
performative theory of gender: and address, 188
perplexing, the, 33, 121–23, 133–34, 162–66, 201, 251
phenomenology, 23, 267n31
Pitts, Andrea J., 301–2n68, 264n8
places: and address, 22–23, 191–96, 198. *See also specific topics*
Plato, 25
play, 30–31, 41, 47–49, 72, 137–38, 163, 181, 183, 204–5, 213, 232, 246, 250–51, 260; free play, 213
Pleasure of the Text, The (Barthes), 181–83, 300n45
political aesthetics, critical, 3, 104, 138, 144, 177–78, 199, 220–21, 261
politics: address and, 1, 17, 155–56, 169–200, 258–61; aesthetics and, 3, 17, 21, 104, 138, 144, 246; of cultural productions, 17, 246, 258–59
Poovey, Mary, 280n44
Pope.L, 201, 312n74; *Black People Are the Wet Grass at Morning* by, 234, 237; *Green People Are a Recent Invention* by, 234, 236; *Love Text ([Unclassified] I love Europe Text)* by, 228, 230–34, 238–40, 243–45; *Orange People the Way Things Used to Be When They Were in Power* by, 234, 237; *Red People Are My Mother When She Sick and Visiting Me in the Hospital* by, 234, 235; *Skin Set* project by, 221, 234, 243; *White People Are God's Way of Saying I'm Sorry* by, 234, 236. See also *Whispering Campaign* (Pope.L)
"Possibilities of Abstraction, The" (Cortázar), 129–31
poverty, 177, 191, 195, 216–21

power: Adorno on, 29–30, 256; body and, 245; colonial, 171; Foucault on, 29–30; 88–89, 98–99; freedom and, 96; knowledge, address and, 88–100; knowledge, norms and, 92–93; modes of address and, 75–76; as productive force, 88; in scenes and scripts of address, 152. *See also* literature, powers of
"Progress and Retrogression" (Cortázar), 123–24
promise, 65, 109, 120, 171, 191, 194–95, 216, 229
Proust, Marcel, 177, 252
psychoanalysis, 13, 25–26, 264–65n13
public, the: as empirical 28–29; as general, 66–76, 78, 80–87; as specifically historical, 17, 29, 67–75, 78–84, 86, 243. *See also* publics
public address, 65–70, 81–82, 84, 149–50, 231–33, 242, 277n13
public and private, 89, 274n33; address, 87, 282n67; arenas, 103; distinctions between, Cortázar on, 103, 109, 140; distinctions between, Rosler on, 206–7, 305n10; divisions between, 170, 181, 187, 282n67; freedom, 85; Kant on, 87
public assembly: and address, 66, 190
publicity: conditions for, 235; Kant on, 65–78. *See also* aesthetic publicity
public life, 71–72, 89, 109, 156, 245, 262
public objects, artworks and other cultural productions as, 83, 86
public platforms of address, 69, 76, 89, 221, 229–34, 242–43
public protest, 188–90
publics: address to, 165, 176, 183, 203; art and, 13, 17, 28–29, 33, 81–84; Hume on addressing, 78–79, 81–84; Kant on, 61, 63, 66–76; addressing as man of learning, 65–70; reading, 65–70. *See also* public, the
public sphere, 80, 85, 89, 234, 303n4
public use, of reason, 63–67, 75
punctum, 181, 183, 300n51

Quashie, Kevin, 309n50
queering, 184, 295n19
Quijano, Aníbal, 269n13
Quintilian, 32–33

Rabinow, Paul, 283n78
race, 2, 20–21, 85–86, 98, 103, 137, 243–44, 278n13, 278n17; gender, coloniality and, 40, 44–45, 48–49, 219; newly aestheticized, 242; in scripts of address, 171–72; space and, 226;
in structures of address, 153–54, 184–85, 187; 208–16
racial identity, 173, 212, 234–35. *See also* identity; social difference and identity
racialized norms of address, 172–73
racialized vernacular languages, 171–73
Rama, Ángel, 218, 308n34
Rancière, Jacques, 25
rational discourse, 279n30, 61, 63; private use of reason, 63–64; public use of reason, 63–67
reading, 102, 120–21; address and, 114–15, 144, 152, 180–81, 256–57; as address to address, 140–41, 292nn55–56; desire, pleasure, and, 181–84; structures of address and, 181; writing and, 69–70, 174–75. *See also* interpretation
reading public, in Kant, 65–70
reception and creation in Hume, 78–86
Red People Are My Mother When She Sick and Visiting Me in the Hospital (mixed media) (Pope.L), 234, 235
regulation, 181; deregulation and, 167; freedom and, 30; institutionality and, 37, 173
regulatory role, of address, 30, 37–39, 43–44, 92, 142, 146, 155–62, 167–68, 170, 173, 181–82, 201, 255, 257, 266n24; control, elusiveness and, 156, 160–62, 167–68, 255. *See also* organizational role, of address
relationality: of address, 1, 7–10, 22–24, 30–31, 146–151, 158; address as ground of, 36–37, 58–60, 72, 77, 86–87, 100, 113, 146; directionality and, 147–51, 158–59; 161–62, 167, 169–70, 182; normativity and, 156. *See also* aesthetic relationality; *specific artists, artworks, theorists, and topics*
repetition, 53–58, 204; Cortázar on, 105, 109–12, 118–20, 122, 125–27, 131–36, 250; orders and rules and, 35–38, 160; in *Whispering Campaign*, 223, 233–34
resistance, 139, 250, 261
rhetoric, 28, 32–33
Richter, Gerhard (artist), 231
Richter, Gerhard, (author), 299n24, 299n30, 300n42
Roelofs, Monique, 265n13, 266nn23–27, 267n31, 269n14, 279n28, 280n33, 280n46, 281n55–56, 282n58, 282n60, 289n11, 297n6, 301n60, 302n84, 307n24, 308n41, 309n49
Rooney, Ellen, 179, 263n3, 265n13, 279n27, 292n55, 295n10, 299n39, 300n42, 301n59
Rosler, Martha, 201–3. *See also Semiotics of the Kitchen* (1975) (Rosler)

rules, 30, 73, 77, 93, 98, 119, 146, 159–60, 172–73, 179–80, 208; in "Girl," 35–49, 159–61, 190–91, 257, 261. *See also* commands; instructions; orders
Russell, Catherine, 306n13

Saint-Amand, Pierre, 300n44, 301n60
Salt (Szymborska), 54
Sarduy, Severo, 291n37, 291n40
scenes of address, 52, 55, 75–76, 135, 180, 189; address's relational, directional, and normative functioning and, 152, 167–68, 261; Althusser on, 178; Anzaldúa on, 185; Barthes on, 183; capacities and roles of, 18, 168–70, 199, 254, 262; concept of, 7, 152, 266n24; as element of model of address, 171, 197, 199, 261–62; Fanon on, 172; individual and collective agency, aesthetic and political life and, 18, 156, 254; as key constituent of address, 18, 146–47, 151–53, 156–57, 168; power in, 152
Schmidt, James, 276n2, 278n13, 278n18, 279n24
Schor, Naomi, 300n45, 301n60, 308n44, 309n49
Schott, Robin May, 278n13, 279n26
science, 1, 4–5, 12, 14, 21, 29, 31, 92, 123, 133, 165–66, 182, 218
scripts of address, address's relational, directional, and normative functioning and, 152, 167–68, 261; Althusser on, 178; capacities and roles of, 18, 168–70, 199, 254, 262; concept of, 7, 152, 266n24; Cortázar on, 106, 112, 118, 125, 132, 138, 142–43; as element of model of address, 171, 197, 199, 261–62; Hume on, 78–79, 84; individual and collective agency, aesthetic and political life and, 18, 156, 254; as key constituent of address, 18, 146–47, 151–53, 156–57, 168; racial, 171, 184; power in, 152
seeing-as, seeing-in and, 141–44, 251, 256–57, 293n59
Seifrid, Thomas, 294n6, 296nn29–30, 296n32
self, 98, 285n101, creation of, 93, 97; fashioning of, 196
Semiotics of the Kitchen (1975) (Rosler), 205; address in, 202–7, 251; bodies, language, and objects in, 203–7; direct address in, 203–6; relationality in, 207, 258; and structure of address, transformation of, 207, 246–47
sexuality, 20–21, 38, 46–49, 212, 297n9; and discourse, 88–91, 94; norms of, 99; power and, 36–49; structures of address and, 153–54
Shostakovich, Dmitri, 294n6, 296n32
Shusterman, Richard, 281n56
Simons, John, 284n86
Skin Set Series (1997–) (Pope.L), 221, 234, 243
"Small Story Tending to Illustrate the Uncertainty of the Stability Within Which We Like to Believe We Exist, or Laws Could Give Ground to the Exceptions, Unforeseen Disasters, or Improbabilities, and I Want to See You There, A" (Cortázar), 118–20
social difference, 20–21, 30–31, 180, 197, 220, 243
social difference and identity, 2–3, 8, 13, 17, 76, 85, 91, 156, 171–73, 188, 229, 234–35, 246, 254; aesthetics of, 3, 20–21, 207, 212, 215, 234–35, 246, 258, 260
social differentiation, address as tool of, 2, 17, 30–31
Sommer, Doris, 287nn3–5, 288n8, 290n26, 290n28, 290–91n29, 292n47
"Speaking in Tongues" (Anzaldúa), 184
speech acts and speech act theory, 25, 28, 51, 272n25, 274n38
Spelman, Elizabeth V., 293n57
Spivak, Gayatri, 265n13, 270n19
Stallybrass, Peter, 191–93
"Standard of Taste, Of the" (Hume), 19, 78–87
Stark, Werner, 276n2, 277n11
Stoler, Ann Laura, 285n94
strange, the, as register of address, 153, 234; Cortázar on, 111, 121, 132–36; in "The Nose," 148, 157–58, 162–67
strategy of address, 81, 187
structures of address, 8, 28, 47, 153–54; address's relational, directional, and normative functioning and, 152, 167–68, 261; Anzaldúa on, 184–85, 187; Benjamin on, 173–78; Butler on, 189; capacities and roles of, 18, 168–70, 199, 254, 262; concept of, 7, 152, 266n24; as element of model of address, 171, 197, 199, 261–62; on emplacement in, Cortázar on, 33, 106–45; Foucault on, 89–92; Hume on, 78–79, 84–85; individual and collective agency, aesthetic and political life and, 18, 156, 254; institutional, 196; ISAs as, 178; as key constituent of address, 18, 146–47, 151–53, 156–57, 168; objects and, 196; reading and, 181. *See also specific artists, artworks, theorists, and topics*

studium, 181, 183
subjectivation, 97–99, 207
subjectivity, 15–17, 26, 34, 44, 92, 97–98, 113, 170, 173–78, 180–84, 189, 196–99, 201, 208, 247, 253, 259. *See also* intersubjectivity
subjects: aesthetic, 104; differentiation of, 180; desire, textual form, and pleasure and, 181–83; experience and, 173–78; interpellated, 179; ISAs and, 178–79; lifeworlds of, 173; objects and, 16–17, 41, 126, 191–96; relationality and, 189; under capitalism, 180
surprise, as register of address, 146, 246; Cortázar on, 109, 113, 122, 126, 288n8, 290n26
systematicity, of address, 25, 49–50, 66–68, 75, 88–92, 137, 158–59, 244, 246
Szymborska, Wisława, 17, 33; "Conversation with a Stone" by, 54; "I Don't Know: The 1996 Nobel Lecture" by, 57, 275n35; "Many Questions" by, 273n29; "No Title Required" by, 257n35; on powers of literature, 53–58; "In Praise of Questions" by, 273n29; *Salt* by, 54; "The Tower of Babel" by, 54–55; "Warning" by, 257n35; "We're Extremely Fortunate" by, 257n35. *See also* "Vocabulary" (Szymborska); "Water" (Szymborska)

Tanke, Joseph J., 285n99
taste: Hume on, 80–81, 84–85, 146, 289n11
Taylor, Diana, 283n79
technology, 3, 8, 12, 189, 198, 251; Benjamin on 177; Cortázar on, 104, 108, 123, 135–39; Kant on, 62, 69. *See also* digital technology
things. *See* objects
threat, 46–47, 65, 229
Trial, The (Kafka), 155
to address, meaning of term, 157–58, 161
"Tower of Babel, The" (Szymborska), 54–55
transdisciplinarity, 3–4, 254, 262; as a form of address, 4
transnational, the, 52, 119–20, 137–38, 175, 196, 201–2, 222, 229, 243, 252, 306n15. *See also* the global
tropes, or figures of speech, as a subspecies of address, 28
Turim, Maureen, 305–6n13, 306nn14–19, 307n20

Ukeles, Mierle Laderman, 159–60
(Unclassified) I love Europe Text (Pope.L). See *Love Text*
Unmündigkeit, 61, 276n7, 277n8
unsettlement: aesthetic, epistemic, of structures of address, 58, 95, 113–14, 170, 144–45, 182–83, 215–20, 240–42, 245–46, 261, 292n47, 298n16

vernacular languages, racialized, 171–73
"Very Real Story, A" (Cortázar), 121–23, 133
violence, 111–12, 138–39, 188–90, 290n26
virtue, 80, 85, 232; ignorance as, 226, 229, 232, 240, 244
"Vocabulary" (Szymborska), 35; address and, 51–59, 252–54; address and replenishing of meaning in, 51–59, 253; aesthetic concepts in, 57; coldness in, 51–58; cosmopolitan, transnational address in, 50, 52–53, 58, 103; direct address in, 56, 273n30, 274n34; free indirect discourse in, 273n30; illocutionary force in, 273n29, 275n36; language and, 50–58; national and gender interpellation in, 56; performative acts in, 51–52; scene of address in, 50, 52, 55; "Water" and, 55, 57–58

Warner, Michael, 301n58
"Water" (Szymborska), 54–55, 57–58, 252–54; scene of address in, 55, 57
whispering, as mode of address, 232–34, 238, 240
Whispering Campaign (Pope.L): address in, 221–47, 251; aesthetic racialization and racialized aestheticization in, 235, 242; baroque reversibility in, 245; Beuys parody in, 235; blackness in, 223, 225–26, 229, 242–43; and Cage; decoloniality in, 144, 232, 242–47; Europe in, 223, 226, 228, 230, 230–33, 233, 239–45; cosmopolitanism in, 226, 229, 244–45, 260; epistemic and aesthetic destabilization in, 239–42; freedom in, 243, 247; ignorance in, 233, 244; ignorance as virtue in, 226, 229, 232, 240, 244; immigration in, 223, 226, 228, 229, 238, 239–41; language in, 221, 226–30, 233, 243, 308n48; love in, 230, 244; love and hate in, 232–33, 239–40, 244; *Love Text* of, 228, 230–34, 238–40, 243–45; modes of address in, 221, 231–34, 238, 240–43; play in, 232; platforms of publicity in, 221, 229–35, 238,

242–43; quiet in, 309n50; on racial identity, 234–35; reading in, 221, 234–35, 243; relationality in, 221, 238–40, 242–47, 258; repetition in, 223, 233–34; social identity and difference in, 229, 234–35, 238, 242–46; structures of address in, transformations of, 231, 244–47, 255–56, 258–59; sotto-voce speech in, 221, 229–30, 233–34. *See also* Pope.L

White People Are God's Way of Saying I'm Sorry (mixed media) (Pope.L), 234, 236

whiteness: and address, 44, 76, 104, 155, 159, 171–73, 184, 187, 196, 204–7, 242, 270n19

Wiegman, Robyn, 263n1

Willett, Cynthia, 263n2, 280n39, 283n86, 284n88, 286n101, 288n7, 289n11, 295n18

Williams, Patricia J., 16, 298n10

Wilson, Elizabeth A., 263n1

Wilson, Mabel O., 302n84

Wittgenstein, Ludwig, 14, 293n58

women of color: address by, 184; feminists, 170, 184, 187; readers, 184–88, 302n69

Wollheim, Richard, 293n58

Wood, Alan W., 275n2, 277n11, 279n26, 280n38

world, language and, 49, 57, 131, 138, 141, 161, 197, 250, 253

writing: Anzaldúa on, 186–87, 301n68; intermediality and intimacy in, 184–88; instruments of, 70, 120–21, 188, 191; motifs of, 139; publicity and, 69; reading and, 69–70, 174–76; potentialities of, 102, 115, 139; scenes of, 185–86

Young, Iris Marion, 279n26, 279n30

Ziarek, Ewa Płonowska, 280n39

**COLUMBIA THEMES IN PHILOSOPHY,
SOCIAL CRITICISM, AND THE ARTS**

Lydia Goehr and Gregg M. Horowitz, Editors

Lydia Goehr and Daniel Herwitz, eds., *The Don Giovanni Moment: Essays on the Legacy of an Opera*

Robert Hullot-Kentor, *Things Beyond Resemblance: Collected Essays on Theodor W. Adorno*

Gianni Vattimo, *Art's Claim to Truth*, edited by Santiago Zabala, translated by Luca D'Isanto

John T. Hamilton, *Music, Madness, and the Unworking of Language*

Stefan Jonsson, *A Brief History of the Masses: Three Revolutions*

Richard Eldridge, *Life, Literature, and Modernity*

Janet Wolff, *The Aesthetics of Uncertainty*

Lydia Goehr, *Elective Affinities: Musical Essays on the History of Aesthetic Theory*

Christoph Menke, *Tragic Play: Irony and Theater from Sophocles to Beckett*, translated by James Phillips

György Lukács, *Soul and Form*, translated by Anna Bostock and edited by John T. Sanders and Katie Terezakis with an introduction by Judith Butler

Joseph Margolis, *The Cultural Space of the Arts and the Infelicities of Reductionism*

Herbert Molderings, *Art as Experiment: Duchamp and the Aesthetics of Chance, Creativity, and Convention*

Whitney Davis, *Queer Beauty: Sexuality and Aesthetics from Winckelmann to Freud and Beyond*

Gail Day, *Dialectical Passions: Negation in Postwar Art Theory*

Ewa Płonowska Ziarek, *Feminist Aesthetics and the Politics of Modernism*

Gerhard Richter, *Afterness: Figures of Following in Modern Thought and Aesthetics*

Boris Groys, *Under Suspicion: A Phenomenology of the Media*, translated by Carsten Strathausen

Michael Kelly, *A Hunger for Aesthetics: Enacting the Demands of Art*

Stefan Jonsson, *Crowds and Democracy: The Idea and Image of the Masses from Revolution to Fascism*

Elaine P. Miller, *Head Cases: Julia Kristeva on Philosophy and Art in Depressed Times*

Lutz Koepnick, *On Slowness: Toward an Aesthetic of Radical Contemporaneity*

John Roberts, *Photography and Its Violations*

Hermann Kappelhoff, *The Politics and Poetics of Cinematic Realism*

Cecilia Sjöholm, *Doing Aesthetics with Arendt: How to See Things*

Owen Hulatt, *Adorno's Theory of Philosophical and Aesthetic Truth: Texture and Performance*

James A. Steintrager, *The Autonomy of Pleasure: Libertines, License, and Sexual Revolution*

Paolo D'Angelo, *Sprezzatura: Concealing the Effort of Art from Aristotle to Duchamp*

Fred Evans, *Public Art and the Fragility of Democracy: An Essay in Political Aesthetics*

Maurizio Lazzarato, *Videophilosophy: The Perception of Time in Post-Fordism*, translated by Jay Hetrick

GPSR Authorized Representative: Easy Access System Europe, Mustamäe tee 50, 10621 Tallinn, Estonia, gpsr.requests@easproject.com

www.ingramcontent.com/pod-product-compliance
Lightning Source LLC
Chambersburg PA
CBHW021933290426
44108CB00012B/827